Photographer's Guide to the Sony DSC-RX100 II

Photographer's Guide to the Sony DSC-RX100 II

Getting the Most from Sony's Pocketable Digital Camera

Alexander S. White

WHITE KNIGHT PRESS
HENRICO, VIRGINIA

Published by
White Knight Press
9704 Old Club Trace
Henrico, Virginia 23238
www.whiteknightpress.com
contact@whiteknightpress.com

ISBN: 978-1-937986-18-6 (paperback)
 978-1-937986-19-3 (e-book)

Printed in the United States of America

To my wife, Clenise.

Contents

CHAPTER 3:
Shooting Modes 50

CHAPTER 4:
Shooting Menu 99

CHAPTER 6:
Playback and Printing 238

CHAPTER 7:
Custom, Setup, and Other Menus 263

CHAPTER 8:
Motion Pictures 319

CHAPTER 9:
Other Topics 352

APPENDIX A:
Accessories 394

APPENDIX B:
Quick Tips 426

APPENDIX C:
Resources for Further Information 431

Author's Note

In 2012, after having written several guide books to advanced compact cameras, I read about the forthcoming model from Sony, the DSC-RX100. It seemed clear from preview articles and discussions about that model that Sony had created a winner. Subsequent events confirmed that view, and I published my guide book for the RX100 in October of that year.

When Sony announced in June 2013 that it was releasing an updated version of the RX100, I had no hesitation in deciding to write a book about the RX100 II. With the new model, Sony preserved the features that made the original version so popular, including pocketable size, great image quality, and strong features for creative shooting, while adding a few key enhancements that addressed concerns expressed by users of the RX100. With the addition of Wi-Fi capability, a hot shoe that can accept a flash, an electronic viewfinder, and other accessories, along with improvements to the image sensor and display screen, the ability to use a wired remote control, and some other tweaks to the controls, the new camera remains at or near the top of its class in the world of compact cameras.

I used a production model of the RX100 II to take all of the sample photographs included in this guide. I believe it is important to give readers the benefit of seeing photographs that were taken by the camera that is being discussed, even when images taken by another model could illustrate a particular feature adequately.

If you have seen any of my previous camera guides, you may notice that the interior of this book has a significantly different

appearance than the earlier titles. This new look resulted from the efforts of Jill Cooper, an editor and book designer who I found through Elance. I am very grateful to Jill for applying her great expertise in improving the book's layout and contributing to its accuracy through her editing skills.

Finally, as with all of my earlier books, the greatest support in every possible way, from joining me on trips to take photographs for this book to checking and proofreading the final text, has come from my wife, Clenise.

Introduction

This book is a guide to the operation of the Sony Cyber-shot DSC-RX100 II digital camera, one of the most capable compact digital cameras on the market today. You probably already believe the RX100 II is one of the best small cameras available, but I'll still outline some features that make this camera stand out above other advanced compact models.

As with Sony's earlier model, the RX100, the single factor that distinguishes the RX100 II from the large number of competing compacts is its very small size. This camera, unlike most current models with such advanced features, is not just portable but "pocketable." It will fit easily into a pocket or purse and can be held unobtrusively in one hand when you don't want to call attention to your camera. But, despite this great degree of portability, the camera doesn't give up much in the way of capability.

Perhaps the greatest feature of the RX100 II apart from its small size is the relatively large size of its image sensor, the crucial component where light is gathered to form your images and videos. This very small camera comes equipped with a "one-inch-type" sensor, which is twice as large as the sensor in the Fujifilm X20, for example, and more than twice as large as those in many other small cameras in this class. The sensor in the upgraded model, using back-side illuminated technology, is more sensitive to light than the original version; therefore, you can use ISO settings as high as 25600. The RX100 II boasts 20.2 megapixels of effective resolution, and it has a 3-inch (7.5-cm) LCD display, which is capable of tilting up or down, with more than 1,000,000 pixels of resolution.

The RX100 II also is well equipped with advanced shooting features. You can set the camera to its Intelligent Auto or Superior Auto shooting mode and get great results most of the time with no further settings. However, the camera also offers full manual control of focus and exposure, continuous shooting, exposure bracketing, Raw format, excellent low-light performance, and numerous special features, including a variety of Scene mode choices and Picture Effect settings. The RX100 II, like many of its contemporaries, includes a built-in HDR (high dynamic range) shooting option. The RX100 II also provides HD (high-definition) video shooting with the ability to control aperture and shutter speed while recording movies.

The camera includes a hot shoe that can accept an external flash, high-resolution electronic viewfinder, stereo microphone, external LCD display, or other items. The RX100 II includes Wi-Fi (wireless) connectivity with the ability to connect to compatible smartphones and tablets using the very convenient near field communication (NFC) system, which lets you just touch two devices together to connect them wirelessly.

The RX100 II is not the ideal tool for all situations, of course. For example, if you want to photograph wildlife or other subjects from a distance, you do not have much telephoto power with the modest zoom range of this camera: 28mm to 100mm. The ability to control the camera remotely by Wi-Fi is quite limited, and the control buttons are quite small, making it difficult to press the correct one at times. I have to say, though, that with this updated model, Sony has addressed three of the shortcomings I mentioned in my guide to the RX100: the lack of a hot shoe, the inability to attach filters, and the problem of inadvertently pressing the red Movie button. The new camera, as noted above, has a versatile hot shoe, and Sony now sells an optional filter adapter. In addition, it is possible to lock out the Movie button, so it cannot be activated accidentally.

This brief introduction to the camera's features shows that the Sony RX100 II has capabilities that should be attractive to serious

photographers—those who want a camera with many options for creative control of their images that can be carried around at all times, so they will have a substantial piece of equipment with them when a picture-taking opportunity arises.

My goal is to provide a thorough guide to the camera's features, explaining how they work and when you might want to use them. The book is aimed largely at beginning and intermediate photographers who are not satisfied with the documentation that comes with the camera and who prefer a more user-friendly explanation of the camera's controls and menus. For those seeking more advanced information, I discuss some topics that go beyond the basics, and I include in the appendices information about additional resources. I will provide updates at my website, whiteknightpress.com, as warranted, and I will include further information there about the camera and its capabilities.

Finally, one note on the scope of this guide: I live in the United States, and I bought my camera here. I am not very familiar with the variations for cameras sold in Europe or elsewhere, such as different chargers. The photographic functions are generally not different, so this guide should be useful to photographers in all locations. I should note that the frame rates for HD video are different in different areas: the version of the RX100 II sold in the U.S. uses the 60 frames per second (fps) setting for video, whereas cameras sold in Europe use 50 fps. The video functions and operations are not different, just the frame rates. I have stated measurements of distance and weight in both the Imperial and metric systems, for the benefit of readers in various countries around the world.

CHAPTER 1:
Preliminary Setup

Setting Up the Camera

When you purchase your Sony RX100 II, the box should contain the camera itself, battery, charger, wrist strap, two adapters for attaching a shoulder strap (though no shoulder strap is supplied), micro USB cable, and brief instruction pamphlet. There may also be a warranty card and some advertising flyers. There is no CD with software or a user's guide; the software programs supplied by Sony are accessible through the Internet.

To install PlayMemories Home, the Sony software for viewing and working with images and videos on Windows-based computers, you need to go to the following Internet address: http://www.sony.net/pm. If you have a Macintosh computer, you can use software that is available on your computer, such as iPhoto or iMovie, or for some purposes, software available from Sony; the details are set forth on the Internet at http://www.sony.co.jp/imsoft/Mac/.

You also can install Sony's Image Data Converter software, which converts the camera's Raw images, so you can edit them on the computer. That software is available for download for both Windows-based computers and Macs at the web addresses listed above.

You might want to attach the wrist strap as soon as possible because it can help you keep a tight grip on the camera. The strap can be attached to the small mounting lug on either the left or right side of the camera. I have never attached the strap, though, because the camera is so small that I can hold it firmly without much risk of dropping it, even without a strap. See APPENDIX A for discussion of a custom grip that can also be of use.

CHARGING AND INSERTING THE BATTERY

The Sony battery for the DSC-RX100 II is the NP-BX1. With this camera, the standard procedure is to charge the battery while it's inside the camera. To do this, you use the supplied USB cable, which plugs into the camera and into the supplied Sony charger or a USB port on your computer. There are pluses and minuses to charging the battery while it is inside the camera. On the positive side, you don't need an external charger, and the camera can charge automatically when it's connected to your computer. You also can find many portable charging devices with USB ports; many newer automobiles have USB slots where you can plug in your RX100 II to keep up its charge.

One of the main drawbacks is that you cannot use the camera while the battery is being charged inside the camera with the Sony charger. (If you try, the camera will display an error message saying you cannot operate the camera, though, oddly enough, you can still shoot images, but they will be blocked from view by the error screen.)

Also, the Sony charger does not let you charge another battery outside of the camera. One solution to this situation is to purchase at least one extra battery and a device that will charge your batteries externally. I'll discuss batteries, chargers, and other accessories in APPENDIX A.

For now, get the battery charged by inserting it into the camera and connecting the charger. You first need to open the battery compartment door on the bottom of the camera and put in the

battery. You can only insert it fully into the camera one way; the way I prefer to do this is to look for the four gold-colored metal contact squares on the end of the battery, and insert the battery so those four squares are positioned close to the front of the camera as the battery goes into the compartment, as shown in FIGURE 1-1 and FIGURE 1-2.

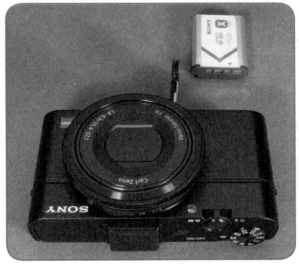

Figure 1-1. Battery Lined Up to Go into Camera

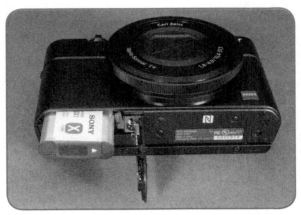

Figure 1-2. Battery Going into Camera

You may have to nudge aside the small blue latch that holds the battery in place, which is seen in FIGURE 1-3.

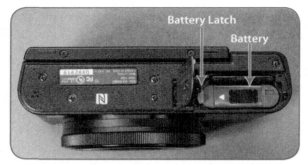

Figure 1-3. Battery Secured by Blue Latch

With the battery inserted and secured by the latch, close the battery compartment door and slide the ridged latch on the door to the closed position. Then plug the larger, rectangular end of the USB cable into the corresponding slot on the provided AC charger, which is model number AC-UB10 in the United States. Plug the smaller end of the cable into the micro USB port on the upper part of the camera's right side as you hold it in shooting position, as shown in FIGURE 1-4.

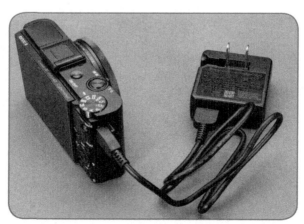

Figure 1-4. Battery Charger Connected to Camera

Plug the charger's prongs into a standard electrical outlet. An orange lamp in the center of the Power (On/Off) button on top of the camera will light up steadily while the battery is charging; when it goes out, the battery is fully charged. The full charging cycle should take about 230 minutes. (If the charging lamp flashes, that indicates a problem with the charger or a problem with the temperature of the camera's environment.)

CHOOSING AND INSERTING A MEMORY CARD

The RX100 II does not ship with any memory card. If you turn the camera on with no card inserted, you will see the error message "NO CARD" in the upper-left corner of the screen. If you ignore this message and press the Shutter button to take a picture, don't be fooled into thinking that the camera is storing it in internal memory because that is not the case. Actually, the camera will temporarily store the image and play it back if you press the Playback button, but the image will not be permanently stored. Some other camera models have a small amount of built-in memory, so you can take and store a few pictures even without a card, but the RX100 II does not have any such safety net.

To avoid the frustration of having a great camera that can't save any images, you need to purchase and insert a memory card. The RX100 II uses two basic types of memory storage. First, it can use all varieties of SD cards, which are quite small—about the size of a large postage stamp. These cards come in several varieties, as shown in FIGURE 1-5.

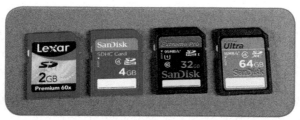

Figure 1-5. Card Types: SD 2GB, SDHC 4GB, SDHC 32GB, SDXC 64 GB

The standard card, called simply SD, comes in capacities from 8 MB to 2 GB. A higher-capacity card, SDHC, comes in sizes from 4 GB to 32 GB. The newest, and highest-capacity card, SDXC (for extended capacity) comes in sizes of 48 GB, 64 GB, 128 GB, and 256 GB; this version of the card can have a capacity up to 2 terabytes (TB), theoretically, and SDXC cards generally have faster transfer speeds than the smaller-capacity cards. There also is a special variety of SD card called an Eye-Fi card, which I will discuss a bit later in this chapter.

The RX100 II also can use micro-SD cards, which are smaller cards, often used in smartphones and other small devices. These cards operate in the same way as SD cards, but you have to use an adapter that is the size of an SD card to use this tiny card in the RX100 II camera, as shown in FIGURE 1-6.

Figure 1-6.
Micro-SD Card and Adapter

In addition to using the various types of SD cards, the RX100 II, being a Sony camera, also can use Sony's proprietary storage devices, known as Memory Stick cards. These cards are similar in size and capacity to SD cards, but with a slightly different shape, as shown in FIGURE 1-7.

Figure 1-7.
Memory Stick PRO Duo

Memory Stick cards come in various types, according to their capacities. The ones that can be used in the RX100 II are the Memory Stick PRO Duo, Memory Stick PRO-HG Duo, Memory Stick XC-HG Duo, and Memory Stick Micro (M2). The Memory Stick Micro, like the micro-SD card, requires an adapter for use in the camera.

In my experience, the type of card you use does not matter. Any of the various types of SD or Memory Stick cards should work well. The factors that really matter are capacity and speed. The

capacity to choose depends on your needs. If you're planning to record a good deal of HD video or a large number of Raw-format photos, you should get a large-capacity card, but don't get carried away—the largest cards have such huge capacities that you may be wasting money purchasing them.

There are several variables to take into account in computing how many images or videos you can store on a particular size of card, such as which aspect ratio you're using (16:9, 3:2, 4:3, or 1:1), picture size, and quality. Here are a few examples of what can be stored on an 8 GB SD card or Memory Stick card. If you're using the standard 3:2 aspect ratio, you can store about 360 Raw images (the highest quality), 700 high-quality JPEG images (Large size and Fine quality), or about 1,200 of the lower-quality Standard images (Large size).

Here are some guidelines for video. You can fit about 40 minutes of the highest-quality HD video on an 8 GB card. That same card will hold about five hours of video at the lowest quality, 640 x 480 pixels, also known as VGA quality. Note, though, that the camera is limited to recording no more than about 29 minutes of video in any format in any one sequence. The high-quality MP4 format can be recorded only for 15 minutes in one sequence, because of the 2 GB file size limit.

One other consideration is the speed of the card. A high rate of speed is important to get good results for recording images and video with this camera. You should try to find a card that writes data at a rate of 6 MB/second or faster to record HD video. If you go by the Class designation, a Class 4 card should be sufficient for shooting stills, and a Class 6 card should suffice for recording video. Newer cards, such as the Lexar Professional and SanDisk Extreme Pro, shown in FIGURE 1-8, come with the UHS designation, for ultra high speed; these cards have roughly the same speed as a Class 10 card.

Figure 1-8. High-Speed SDHC Cards

If you choose one of these cards, you should have no problems with any level of video recording. A fast card also will help when you set the camera for continuous shooting of still images.

Finally, you need to realize if you have an older computer with a built-in card reader, or just an older external card reader, there is some chance it will not read the newer SDHC cards. In that case, you would have to either get a new reader that will accept SDHC cards or download images from the camera to your computer using the USB cable. Using the newest variety of card, SDXC, also can be problematic with older computers.

If your computer has a recent version of its operating system, it will be able to read SDXC cards if you use a compatible card reader.

As I write this, 64 GB SDXC cards cost about $35 and up, and prices are dropping. So, if you don't mind the risk of losing a great many images or videos if you lose the card, you might want to choose an SDXC card with an enormous capacity of 64 GB, or even 128 GB. At this writing, the 256 GB SDXC cards are selling for about $500. Those cards are extremely fast, but I question whether it is a good idea to risk $500 on your ability to keep track of a tiny item that can slip into a pocket and end up in the laundry without too much trouble.

You also may want to consider getting an Eye-Fi card. This special type of device looks very much like an ordinary SDHC card, but it includes a tiny transmitter that lets it connect to a Wi-Fi network and send your images to your computer on that network as soon

as the images have been recorded by the camera. You also may be able to use Direct Mode, which lets the Eye-Fi card send your images directly to a computer, smartphone, tablet, or other device without needing a network, though Direct Mode can be tricky to set up.

I have tested a 16 GB Pro X2 Eye-Fi card with the RX100 II, and it works well. Within a few seconds after I snap a picture with this card in the camera, a thumbnail image appears in the upper-right corner of my computer screen showing the progress of the upload. When all images have been uploaded, they are available in the Pictures/Eye-Fi folder on my computer. The Pro X2 models, shown in FIGURE 1-9, can handle Raw files and video files as well as the smaller JPEG files.

Figure 1-9. Eye-Fi Pro X2 SDHC Memory Cards

Another type of Eye-Fi card, the Mobi, is designed for easy transfer of your images and videos (up to 2 GB per file) directly from the camera to a smartphone or tablet. There are similar types of card available from other companies, such as the Toshiba FlashAir, the ez Share, and the Transcend Wi-Fi card.

Of course, with the RX100 II, Sony has included built-in Wi-Fi capability, as discussed in CHAPTER 9, so you no longer need to use an Eye-Fi card or the equivalent to transfer images. If you already have one or more wireless SD cards, you should be able to use them in your RX100 II, but you have other options for wireless transfer that may make more sense.

14 | Photographer's Guide to the Sony DSC-RX100 II

If you decide to use a Memory Stick card, be sure that you have a card reader that can accept those cards, which, as noted above, are not the same shape as SD cards and require readers with compatible slots.

In summary, you have several options for choosing a memory card. I like to use a 64 GB SanDisk Ultra SDXC card just to have extra capacity and speed in case they are needed.

Once you have chosen a card, open the same door on the bottom of the camera that covers the battery compartment, and slide the card in until it catches. An SD card is inserted with its label pointing toward the back of the camera, as shown in FIGURE 1-10; a Memory Stick card is inserted with its label pointing toward the front of the camera.

Figure 1-10. Memory Card Being Inserted into Camera

Once the card has been pushed down until it catches, close the compartment door and slide the blue latch to the outside position. To remove the card, push down on its edge until it releases and springs up, so you can grab it.

Although the card may work fine when newly inserted in the camera, it's a good idea to format a card when first using it in a camera, so it will have the correct file structure and will have any bad areas blocked off from use. To do this, turn on the camera by pressing the Power button, then press the Menu button at the center right of the camera's back. Next, press the Right button (right edge of the Control wheel on the camera's back) multiple times until the small orange line near the top of the screen is positioned under the number 1, next to an icon representing a memory card, as shown in FIGURE 1-11.

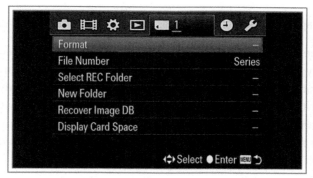

Figure 1-11. Memory Card Tool Menu

That icon indicates the Memory Card Tool menu. The orange highlight rectangle should already be positioned on the top line of the menu, on the Format command; if not, press the top or bottom edge of the Control wheel, or turn the wheel, until the Format command is highlighted.

Press the button in the center of the Control wheel (called the "Center button" in this book) when the Format line is highlighted. On the next screen, seen in FIGURE 1-12, highlight Enter and press the button again to carry out the command.

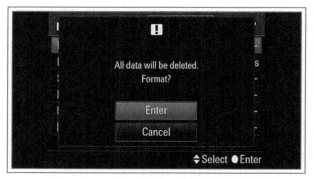

Figure 1-12. Format Confirmation Screen

SETTING THE DATE, TIME, AND LANGUAGE

You need to make sure the date and time are set correctly before you start taking pictures because the camera records that information (sometimes known as "metadata," meaning data beyond the information in the picture itself) invisibly with each image and displays it later if you want. It is, of course, important to have the date (and the time of day) correctly recorded with your archives of digital images.

To get these items set correctly, turn the camera on, then press the Menu button. Press the right side of the Control wheel, marked with a lightning bolt, to move the orange line underneath the number 1 next to the clock icon, representing the Clock Setup menu, as shown in FIGURE 1-13.

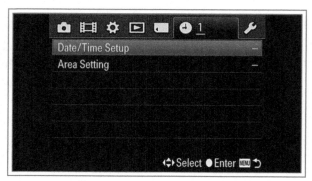

Figure 1-13. Clock Setup Menu

Press the upper edge of the Control wheel, if necessary, to move the orange highlight rectangle to the Date/Time Setup line at the top of the menu screen, and press the Center button to activate the date and time settings, as shown in FIGURE 1-14.

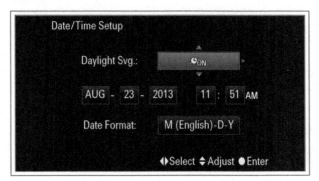

Figure 1-14. Date/Time Setup Screen

By pressing the left and right edges of the Control wheel or by turning the wheel, move left and right through the Daylight Saving Time, month, day, year, time, and date format settings, and change them by pressing the Up and Down buttons (top and bottom edges of the Control wheel). When everything is set correctly, press the Center button to confirm. Then press the Menu button to exit from the menu system.

If you need to change the language that the camera uses for menus and other messages, press the Menu button as discussed above to enter the menu system, and navigate to the fourth screen of the Setup menu, which is marked by a wrench icon, as shown in FIGURE 1-15.

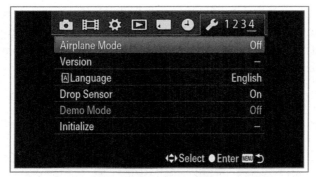

Figure 1-15. Setup Menu: Fourth Screen

Then navigate with the direction buttons, if necessary, to the Language item on the screen and press the Center button to select it. You then can select from the available languages on the menu, as shown in FIGURE 1-16.

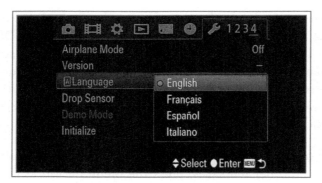

Figure 1-16. Language Menu Option

CHAPTER 2:
Basic Operations

Overview of Shooting Still Images

Now that the Sony RX100 II has the correct time and date set and a charged battery inserted along with a memory card, I'll discuss some scenarios for basic picture-taking. For now, I won't get into details about the various options and why you might choose one over another. I'll just describe a reasonable set of steps that will get your camera into action and will result in putting a usable image on your memory card.

INTRODUCTION TO MAIN CONTROLS

Before I discuss options for setting up the camera using the menu system and controls, I will introduce the main controls to give a better idea of which button or dial is which. I won't discuss all of the controls here; they will be covered in some detail in CHAPTER 5. For now, here is a series of images showing the main controls and other features of the camera. As I mention each item for the first time in the text, I will describe its position and function; you may want to refer back to these images for a reminder about each control.

Top of Camera

On top of the camera are some of the most important controls and dials, as shown in FIGURE 2-1.

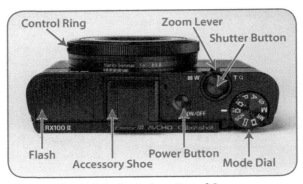

Figure 2-1. Controls on Top of Camera

The Mode dial is used to select a shooting mode for stills or video. For basic shooting without having to make other settings, turn the dial so the green or tan camera icon is next to the white marker; this will set the camera to one of its most automatic modes. The large, black Shutter button is used to take pictures. Press it halfway to evaluate focus and exposure; press it all the way to take a picture. The Zoom lever, surrounding the Shutter button, is used to zoom the lens in and out between its telephoto and wide-angle settings. The lever also is used to change the views of images in playback mode. The Power button turns the camera on and off. An orange light in the center of the button glows when the battery is being charged in the camera. The flash is normally stored inside the top of the camera; it pops up when called for by the camera's programming and settings.

Back of Camera

FIGURE 2-2 shows the main controls on the camera's back.

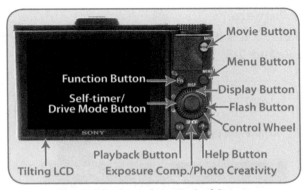

Figure 2-2. Controls on Back of Camera

The red Movie button starts and stops the recording of a video sequence. The Menu button calls up the camera's system of menu screens with various settings for shooting and other values, such as control button functions, audio features, and others. In shooting mode, the Function (Fn) button calls up a menu of camera functions for easy access. In playback mode, it lets you rotate an image. The Playback button places the camera into playback mode, so you can view your recorded images. The In-Camera Guide (Help) button, marked by a question mark, calls up screens of shooting advice and tips; in playback mode, it acts as the Delete button for erasing images.

The Control wheel is a rotary dial for setting values such as aperture and shutter speed and for navigating through menu screens. In addition, each of its four edges acts as a button when you press it in, for controlling items including flash mode, exposure compensation, continuous shooting, and the display screen. The button in the center of the dial is used to confirm selections and for some miscellaneous operations. The LCD screen—which displays the scene viewed by the camera along with the camera's settings, and plays back your recorded images— tilts up or down to allow you to hold the camera in a high or low position to view a scene from unusual angles.

Front of Camera

There are only a few items to point out on the camera's front, as shown in FIGURE 2-3.

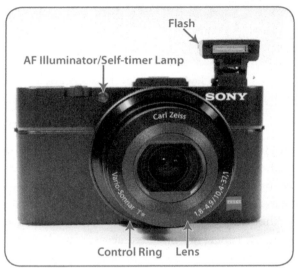

Figure 2-3. Controls and Other Items on Front of Camera

The AF Illuminator/Self-timer Lamp lights up to signal the operation of the self-timer and to provide illumination so the camera can use its autofocus system in dark areas. The Control ring, which surrounds the lens, can be used to adjust various items, such as aperture, manual focus, and others, depending on the shooting mode and menu options that are in effect. The lens itself has a 35mm equivalent focal length range of 28mm to 100mm and an aperture range of f/1.8 to f/11.0. (The actual focal length of the lens is 10.4mm to 37.1mm; the "35mm equivalent range" is commonly used to state the focal length in a way that can easily be compared to lenses of other cameras.)

Right Side of Camera

On the right side of the camera are two small flaps, marked Multi and HDMI, as seen in FIGURE 2-4. Under those flaps are two ports, as shown in FIGURE 2-5.

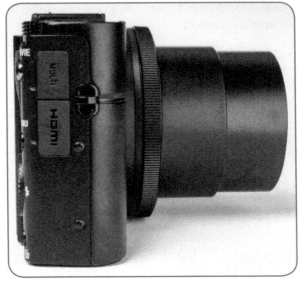

Figure 2-4. Right Side of Camera, Showing Flaps Covering Ports

The top port, called the Multi port, is where you connect the USB cable that is supplied with the camera to charge the battery, to connect the RX100 II to a computer to manage images, or to connect to a printer to print images directly from the camera. The HDMI port is for connecting the camera to an HDTV to view your images and videos.

Bottom of Camera

Finally, as shown in FIGURE 2-6, on the bottom of the camera are the tripod socket, the battery and memory card compartment, the speaker that produces sound for videos, and the "N" that marks the active area for an NFC connection, where you touch

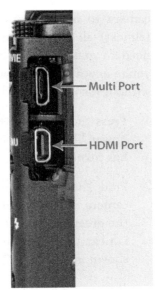

Figure 2-5.
Ports on Right Side of Camera

an NFC-enabled smartphone or tablet to establish a wireless connection with the camera.

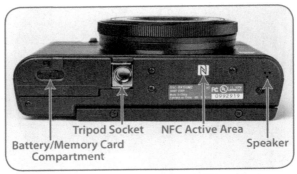

Figure 2-6. Items on Bottom of Camera

FULLY AUTOMATIC: INTELLIGENT AUTO MODE

Now I'll discuss how to use these controls to start taking pictures and videos. Here's a set of steps to take if you want to set the camera to one of its most automatic modes and let it make (almost) all decisions for you. This is a good approach if you need to grab a quick shot without fiddling with settings, or if you're new at this and would rather let the camera work its magic without having to provide much input.

1. Press the Power button on top of the camera to turn on the power. The LCD screen will illuminate to show that the camera has turned on.

2. Find the Mode dial on top of the camera at the right, and turn it so the green camera icon with a letter "i" is next to the white indicator line, as shown in FIGURE 2-7.

 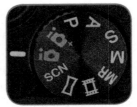

 Figure 2-7. Intelligent Auto

 This sets the camera to the Intelligent Auto shooting mode. If you see the help screen that describes the mode

(called the Mode Dial Guide by Sony), as seen in FIGURE 2-8, press the Center button to dismiss it. (I'll explain how to dispense with that help screen altogether in CHAPTER 7.)

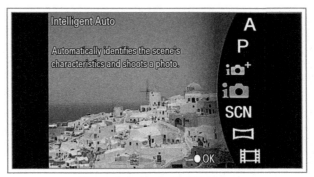

Figure 2-8. Mode Dial Guide

3. Press the Menu button at the right center of the camera's back to activate the menu system. As I discussed in CHAPTER 1, navigate through the menu screens by pressing the right and left edges of the Control wheel. You can tell which menu screen is active by looking at the small orange line (cursor) beneath the numbers. When a given screen is selected, navigate up and down through the options on that screen by pressing the Up and Down buttons or by turning the Control wheel right or left. When the orange selection bar is on the option you want, press the Center button to select that item. Then, pressing the Up and Down buttons or turning the Control wheel, highlight the value you want to set for that option, and press the Center button to confirm it. You can then continue making menu settings; when you are finished with the menu system, press the Menu button to go back to the live view, so you can take pictures.

4. Using the procedure described in STEP 3, make the settings shown in TABLE 2-1 using the menu system.

Table 2-1. **Suggested Settings for
Intelligent Auto Mode**

Image Size	L: 20M
Aspect Ratio	3:2
Quality	Fine
Drive Mode	Single Shooting
Flash Mode	Autoflash
Focus Mode	Single-shot AF
Soft Skin Effect	Off
Smile/Face Detection	Off
Auto Object Framing	Off
Clear Image Zoom	Off
Digital Zoom	Off
AF Illuminator	Auto
SteadyShot	On
Color Space	sRGB
Shooting Tip List	Use as needed
Write Date	Off
Memory	No setting needed

If you don't want to go through the steps to make all of these settings, don't worry; you are likely to get very usable images even if you don't adjust most of these settings at this point.

5. Press the Menu button again to make the menu disappear, if it hasn't done so already.

6. Press the Right button on the Control wheel, marked with a lightning bolt. A vertical menu will appear at the left side of the screen, as shown in FIGURE 2-9.

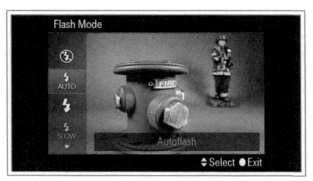

Figure 2-9. Flash Mode Menu: Autoflash Selected

Make sure the Auto selection is highlighted with the orange selection block. If it is not, press the direction buttons or turn the Control wheel to highlight it, so the Flash Mode is set to Autoflash. Press the Center button to dismiss this menu.

7. Using a procedure like that in STEP 6, press the Left button, marked with a timer dial and an icon showing a stack of images, and make sure the top option, showing a single rectangular frame, is selected, as shown in FIGURE 2-10. This sets the camera to take single shots, rather than continuous bursts.

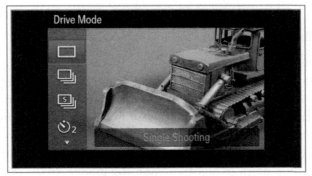

Figure 2-10. Drive Mode Menu: Single Shooting Option

8. Aim the camera toward the subject and compose the picture. Locate the Zoom lever on the ring that surrounds the Shutter

button on the top right of the camera. Push that lever to the left, toward the letter "W" on the camera body, to get a wider-angle shot (including more of the scene in the picture), or to the right, toward the letter "T," to get a telephoto, zoomed-in shot.

9. If you're indoors or in an area with low light, be careful not to hold your finger on top of the flash at the top left of the camera. The camera may try to pop the flash up, but it can't if your finger is blocking it.

10. Once the picture looks good on the display, gently press the Shutter button halfway and pause in that position. You should hear a little beep and see one or more sets of green focus brackets on the LCD screen indicating that the subject will be in focus. You also can look for a green disc in the extreme lower-left corner of the screen. If that green disc lights up steadily, the image is in focus; if it flashes, the camera was unable to focus. In that case, you can re-aim and see if the autofocus system does better from a different distance or angle.

11. After you have made sure the focus is sharp, push the Shutter button all the way to take the picture.

VARIATIONS FROM FULLY AUTOMATIC

Although the RX100 II takes care of the basic settings for you when it's set to Intelligent Auto mode, this camera, unlike some other compact models, still lets you make a number of adjustments to fine-tune the shooting process. The same method applies when the camera is set to the Superior Auto shooting mode (designated on the Mode dial by the tan-colored camera icon with a plus sign). In all other shooting modes, these adjustments, to the extent they can be made, are made using different controls. I will discuss those adjustments in later chapters.

With that introduction, I will explain features you can use to fine-tune the appearance of your images, use the self-timer or flash, and adjust other settings when using the Intelligent Auto or Superior Auto shooting mode.

Photo Creativity Feature

The RX100 II comes equipped with an interesting feature that Sony calls "Photo Creativity." This option, which is available only in the Intelligent Auto and Superior Auto shooting modes, gives you a simple way to dial in certain adjustments to the appearance of your still images and videos. I can understand why Sony presents these adjustments in this way, making them easy to use and giving them non-technical names such as "Background Defocus" and "Brightness," rather than "aperture control" and "exposure compensation." However, it is somewhat confusing (to me, at least) that you have to remember to make these adjustments using different controls, depending on what shooting mode is in effect.

In any event, for now I will discuss how to make adjustments in the Intelligent Auto mode. In CHAPTER 3, I will discuss all of the shooting modes, and in CHAPTER 4 and CHAPTER 5 I will discuss how to make settings in other modes. For example, I will discuss aperture control in CHAPTER 3 in connection with the Aperture Priority shooting mode, and I will discuss exposure compensation in CHAPTER 5, in connection with the button that controls that function (the Down button, in the bottom position on the Control wheel).

With that introduction, here are details about how to make various settings in the most automatic shooting modes using the Photo Creativity feature.

First, it's important to note that the Photo Creativity feature is not available if the Quality option on the Shooting menu is set to Raw or Raw & JPEG. So you should make sure that Quality is set to Fine. (If you try to use Photo Creativity with Raw in effect, you

will get an error message.) To use the Photo Creativity feature, press the Down button on the Control wheel—the button marked with the plus and minus icon and the camera icon with three plus signs at its right side, as shown in FIGURE 2-2. When you press that button, you will see some new icons and virtual controls appear on the LCD screen, as shown in FIGURE 2-11.

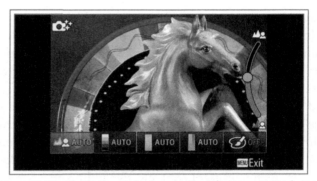

Figure 2-11. Photo Creativity Screen: No Adjustments Made Yet

At the bottom of the screen there are five blocks, each with an icon that represents a particular setting or effect you can change. When this group of blocks first appears, each of the first four blocks at the left should contain the word "AUTO," and the block at the far right, with an icon of an artist's palette and brush, should show the word "OFF." Use the Right and Left buttons on the Control wheel to move through these five blocks; each one will be highlighted in orange when it is selected. You can keep pressing the Right or Left button to wrap around to the other side of the group of icons if you want. So, for example, when the artist's palette is highlighted, you can press the Right button one more time to move directly to the block at the far left of the screen.

When one of the blocks is highlighted in orange, you can change the value for that setting or effect by turning the Control wheel or by pressing the Up or Down button to move an indicator disc or icon along a curved scale that will appear at the right side of the display. The camera's display will change as appropriate to show

the effect of your adjustment. For example, if you move the Color slider to the top of the curved scale, the image will appear more reddish, or "warm."

With the first four blocks, as you turn the wheel, a virtual disc will move along a scale at the right of the screen. The disc will be green at first, but it will turn orange as soon as the setting for that block is changed. Also, the appearance of the icon for that block will change to show how the setting is changing, as seen in FIGURE 2-12.

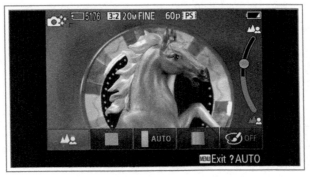

Figure 2-12. Photo Creativity Slider at Right of Screen

When a block is first selected, a word or phrase describing the setting for that block will appear briefly on the screen and then disappear. The settings that are controlled by the five blocks are as follows, from left to right:

Background Defocus. This first setting on the left is designed to let you leave the foreground sharply focused while the background is defocused, or blurry. This effect, sometimes called "bokeh," can help separate the main subject from a background that might be distracting or unpleasant.

In technical terms, what happens is that the camera's aperture (its opening to let in light) is opened up wider, which causes the depth of field to be shallower, allowing the background to go out of focus. When the indicator disc is at the bottom of the scale,

the aperture is opened as much as possible, resulting in a more defocused background; as the disc approaches the top of the scale, the background should become sharper as the aperture is narrowed and the depth of field is increased. I will talk about this effect again in CHAPTER 3, in the discussion of the Aperture Priority shooting mode. FIGURE 2-13 provides an example of an image with a defocused background.

Figure 2-13. Image with Defocused Background

Brightness. The second setting from the left controls the brightness of your images. The indicator disc for this setting starts in the middle of the scale, with normal brightness. As you turn the Control wheel to move the disc higher on the scale, the image gets brighter; as the disc moves below the mid-point, the image becomes darker. In technical terms, this setting controls exposure compensation, which can be used in situations when the normal exposure calculated by the camera would not be ideal. For example, if a light-colored object, such as an eagle's head, is photographed against a dark background, the camera's automatic exposure control is likely to overexpose the light object, because the camera takes into account the broad expanse of dark tones in the image and increases the exposure level. With the Brightness

control, you can decrease the brightness level so the subject will appear properly exposed, as shown in FIGURE 2-14.

Figure 2-14. Photo Creativity: Brightness Adjustment

Color. The third setting from the left lets you adjust the white balance of your images, though Sony uses the term "Color" to simplify things. As I will discuss in CHAPTER 4, white balance is a setting that adjusts the camera's processing of colors according to the "color temperature" of a given light source. For example, light from sources such as incandescent bulbs has a lower color temperature than light from a bright blue sky. The lower color temperatures are considered "warmer," with a reddish or yellowish cast, and the higher ones yield colors that are considered "cooler," with a more bluish appearance. (In this case, "warm" and "cool" have to do with the appearance, rather than the actual temperature, of the subjects.)

With this setting, again, the normal value is in the center of the curved scale. To make the colors of the scene appear cooler, or more bluish, turn the Control wheel to the left to move the indicator disc toward the bottom of the scale; reverse that process to make the colors warmer, or more reddish. FIGURE 2-15 shows the Color setting adjusted to the bluish side.

Figure 2-15. Photo Creativity: Color Adjustment

Note that this adjustment does not change the actual White Balance setting; that setting is fixed at Auto White Balance (AWB) for the automatic shooting modes; it merely tweaks that setting toward the warm or cool end of the scale. In the more advanced shooting modes, as discussed in CHAPTER 4, you can make more precise adjustments to the camera's white balance through the White Balance menu option.

Vividness. The fourth setting from the left gives you a way to adjust the intensity, or saturation, of the colors in your images.

Again, the standard setting is in the middle of the curved scale; move the indicator upward for more intense colors and downward for softer, less-saturated colors. In the more advanced shooting modes, you can adjust saturation in finer detail, along with contrast and sharpness, using the Creative Style menu option, as discussed in CHAPTER 4. FIGURE 2-16 shows Vividness set to its maximum.

Figure 2-16. Photo Creativity: Vividness Adjustment

Picture Effect. The final setting at the right of the screen, marked with the artist's palette, gives you access to settings from the Picture Effect menu option, which is available through the Shooting menu in the more advanced shooting modes. When the Picture Effect block is highlighted, you can select from the following settings by moving the indicator along the scale: Toy Camera, Pop Color, Posterization Color, Posterization B/W, Retro Photo, Soft High-key, Partial Color: Red, Partial Color: Green, Partial Color: Blue, Partial Color: Yellow, and High Contrast Monochrome. These settings can have dramatic effects on your images, as indicated by their labels. These same settings are available through the Picture Effect item on the Shooting menu, though there are some settings and adjustments that are available through that menu item that cannot be made from the Photo Creativity system, such as different varieties of the Toy Camera setting. I will discuss those settings and provide examples in CHAPTER 4.

You also can combine more than one Photo Creativity setting to achieve various effects. For example, if you activate the Partial Color effect using the rightmost block at the bottom of the screen, you can then move the highlight to the Color or Vividness block and change the color tint or the saturation of the color that you selected for the Partial Color effect. Or, you can decrease the

exposure of the image and also decrease the intensity of the colors by using the Brightness and Vividness controls together.

When you have the disc for a particular setting moved to the position you want, leave it in that position, and then go ahead and take the picture with the slider still on the screen. (Or, as noted above, you can go to another setting and adjust it as well before taking the picture.) Don't press the Menu button because doing that will cancel the setting you just made.

To reset any one of the five settings to its default value, highlight its block and press the In-Camera Guide button (marked with a question mark). For the first four blocks, this action will reset the indicator to its default value (bottom of the scale for Background Defocus; middle of the scale for the other three). For the Picture Effect setting, this action will turn the selected effect off, leaving no effect active. If you want to reset all of the blocks at once, you can do so by turning the Mode dial to another shooting mode (such as Superior Auto or Program) and then back to Intelligent Auto. To exit from the Photo Creativity screen altogether, press the Menu button.

The Photo Creativity settings are a very useful feature of the RX100 II, and it is quite convenient to be able to select one or more of them while the camera is in this automatic mode, so you don't have to invest too much effort into figuring out what settings to use. However, if you want to exercise more control over the settings, you will probably want to use one of the more advanced shooting modes and use the menu options and controls that allow you to make more precise settings.

Flash

Now I'll go into a bit more detail about using the RX100 II's built-in flash unit because that is something you may want to use on a regular basis. In CHAPTER 4 I'll provide more details about the Flash Mode settings and Flash Compensation, and I'll discuss

prevention of "red-eye" in CHAPTER 7. In APPENDIX A, I'll discuss using external flash units.

The built-in flash on the RX100 II is not especially powerful, but it can provide enough illumination to let you take pictures in dark areas and to brighten up subjects that would otherwise be lost in shadows, even outdoors on a sunny day.

The flash unit will pop up on its own in certain situations, or you can force it to pop up using the menu system. However, you should never try to force the flash to pop up manually; the key to controlling the behavior of the flash is to use the Right button at the right edge of the Control wheel on back of the camera. That button has a lightning bolt icon on it to announce its identity as the Flash button.

For this discussion, I'm assuming the camera is set to Intelligent Auto mode; in some other situations, including some of the Scene mode settings, the Flash button will not operate. In Intelligent Auto mode, press the Right button once to call up the Flash Mode menu, and then press the Up and Down buttons or turn the Control wheel to select the flash mode you want from that list. (You also can summon the Flash Mode menu from the Shooting menu: Flash Mode is the second item down on the second screen of the Shooting menu. See CHAPTER 4 for a discussion of all items on those menu screens.)

The vertical menu at the left of the screen, shown in FIGURE 2-17, contains icons representing the five flash mode options—a lightning bolt with the universal "no" sign crossing it out, for Flash Off; a lightning bolt with the word "Auto," for Autoflash; a lightning bolt alone, for Fill-flash (meaning the flash will always fire); a lightning bolt with the word "Slow," for Slow Sync; and a lightning bolt with the word "Rear," for Rear Sync. When the camera is set to Intelligent Auto mode, the last two choices will appear dimmed; if you highlight one of those and press the Center

button to select it, the camera will display a message saying you cannot make that selection in this shooting mode.

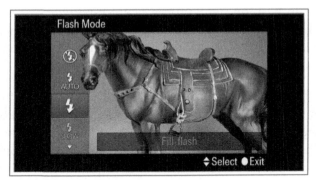

Figure 2-17. Flash Mode Menu

I discussed earlier how to set the flash unit to the Autoflash mode. If, instead of Autoflash, you choose Fill-flash, you will see the lightning bolt icon on the screen at all times, and the flash will fire regardless of whether the camera's exposure system believes flash is needed. You can use this setting when you are certain that you want the flash to fire, such as in a dimly lighted room. This setting also can be of use in some outdoor settings, even when the sun is shining, such as when you need to reduce the shadows on your subject's face. The bottom image in FIGURE 2-18 was taken with Fill-flash to reduce shadows. The difference between that shot and the top image, taken without flash, is fairly dramatic.

Figure 2-18. Top Image: No Flash, Bottom Image: Fill-Flash

When the camera is set for certain types of shooting, such as using the self-timer with multiple shots, the flash is forced off and cannot be turned on. With some other settings, such as continuous shooting, the flash will fire if you set it to do so, but the use of flash will limit the use of the other setting. In other words, instead of doing rapid continuous shooting, the camera will take multiple images but at a very slow rate because the flash cannot recycle fast enough to fire multiple times in quick succession. In some shooting modes, such as the Night Scene setting of Scene mode, you cannot even get the Flash Mode menu to appear; if you press the Flash button, the camera will display a message saying the flash is not available in that shooting mode, as shown in FIGURE 2-19.

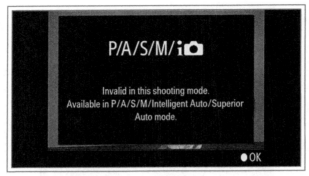

Figure 2-19. Error Message for Pressing Flash Button in Some Shooting Modes

If you set the Mode dial to P, for Program mode, and then press the Flash button to select a flash mode, you will see the same five options for Flash Mode on the menu, but this time the Autoflash option will be dimmed because that selection is available only in the more automatic modes.

In summary, when using Intelligent Auto mode, if you don't want the flash ever to fire, because you are in a museum or similar location, you can select the Flash Off mode. If you want to leave the decision whether to use flash up to the camera, you can select Autoflash mode. If you want to make sure that the flash will fire no matter what, you can select Fill-flash mode. In CHAPTER 4, I'll explain the other flash options, Slow Sync and Rear Sync, and I'll discuss some other flash-related topics. For now, you have the basic information you need to select a flash mode when the camera is set to the Intelligent Auto shooting mode.

Drive Mode: Self-Timer and Continuous Shooting

The Drive Mode menu includes more adjustments you can make when using Intelligent Auto mode that are worth discussing here. If you press the Control wheel's Left button, which is marked with a timer dial and an icon that looks like a stack of images, the camera will display a vertical menu for Drive Mode, as shown in FIGURE 2-20.

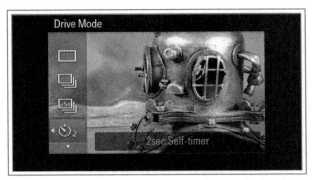

Figure 2-20. Drive Mode Menu with Self-Timer Highlighted

You navigate through the options on this menu by pressing the Up and Down buttons or by turning the Control wheel.

I will discuss the Drive Mode menu options more fully in CHAPTER 4. For now, you should be aware of a few of the options. (I will skip over some others.) If you select the top option, represented by a single rectangular frame, the camera is set for Single Shooting mode; when you press the Shutter button, a single image is captured. With the second option, whose icon looks like a stack of images, the camera is set for continuous shooting, in which it takes a rapid burst of images while you hold down the Shutter button.

If you choose the fourth option, whose icon is a timer dial with a number beside it, the camera uses the self-timer. Use the Left and Right buttons to choose either 2 or 10 seconds for the timer delay. After the timer has been set, press the Shutter button. The shutter will be released after the specified number of seconds. The 10-second delay is useful when you need to place the camera on a tripod and then join a group photo; the 2-second delay is useful when you want to make sure the camera is not jiggled by the action of pressing the Shutter button. This option helps greatly when you are taking a picture for which focusing is critical, such as an extreme close-up. I will discuss the use of the self-timer and other Drive Mode options in more detail in CHAPTER 4.

Note that the Drive Mode menu also can be reached through the normal menu system. Drive Mode is the top option on the second screen of the Shooting menu.

Tracking Focus

Finally, there is one more setting that is available in Intelligent Auto mode that I will discuss in this chapter. This is Tracking Focus, which sets the camera to maintain its focus on a moving object. When the camera is using its normal display screen, you will see a prompt for Tracking Focus at the bottom of the display, as shown in FIGURE 2-21, indicating that you can press the Center button to turn on this feature.

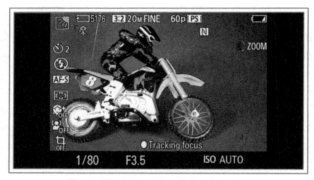

Figure 2-21. Tracking Focus Prompt

(If this prompt does not appear on the display screen with shooting information, that probably means that you have assigned a different function to the Center button using the Function of Center Button option on the Custom menu. See CHAPTER 7 for a discussion of that option. To use Tracking Focus, reset that menu option to Standard.)

When you press the Center button, a focus frame will appear in the center of the screen, as shown in FIGURE 2-22.

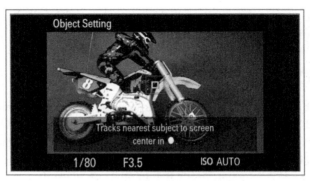

Figure 2-22. Tracking Focus Frame Ready to Set

Move the camera so that frame is over the item you want to track, such as a child or pet, or a motorcycle. Then, with that subject in the frame, press the Center button again, and the camera will try to keep that item centered in the focus frame, which will change to a double frame, as shown in FIGURE 2-23.

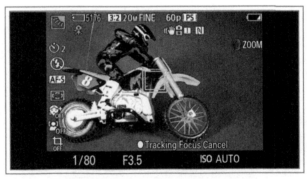

Figure 2-23. Tracking Focus Feature in Use

As long as the subject stays within that double frame, the camera will attempt to keep it in focus. When you are ready, press the Shutter button to take the picture.

There are other settings that can be made when the camera is set to Intelligent Auto mode, including Focus Mode, Face Detection, Digital Zoom, and others. I included suggested settings for those

items in TABLE 2-1 earlier in this chapter, and I will discuss the details of those settings later, in CHAPTER 4.

Overview of Movie Recording

Now let's take a look at recording a short movie sequence with the RX100 II. Once the camera is turned on, turn the Mode dial to select the green camera icon, for Intelligent Auto mode. There is a special Movie mode setting marked by the movie-film icon on the Mode dial, but you don't have to use that mode for shooting movies; I'll discuss the use of that option and provide more details about movie-recording options in CHAPTER 8.

For now, press the Menu button to get access to the menu system, and press the Right button enough times to move the small orange cursor underneath the number 1 next to the movie-film icon, which represents the Movie menu, as shown in FIGURE 2-24.

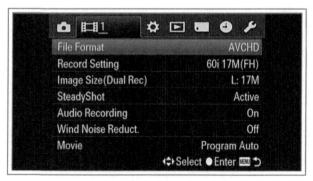

Figure 2-24. Movie Menu

There is only one screen with seven items on that menu, because there are few options that can be controlled just for shooting movies. On the top line of the Movie menu, with File Format highlighted, press the Center button to go to the sub-menu with the two choices for the format of movie recording. For now, be sure the top option, AVCHD (Advanced Video Coding High

Definition), is highlighted; that format provides the highest quality for your videos.

For the rest of the settings, I will provide a table like the one included earlier in this chapter for shooting still images. The settings shown in TABLE 2-2 are standard ones for shooting high-quality movies.

Table 2-2. **Suggested Movie Menu Settings for Movies in Intelligent Auto Mode**

File Format	AVCHD
Record Setting	60p 28M (PS)
Image Size (Dual Rec)	L: 17M
SteadyShot	Active
Audio Recording	On
Wind Noise Reduction	Off

There are some other settings you can make on the Shooting menu for still images that will affect your movie recording; I will discuss that topic in CHAPTER 8. For now, if you are going to be shooting a movie that shows people's faces, you may want to go back to the Shooting menu and set the Face Detection item to On. You can leave the other items set as they were for shooting still images, as listed in TABLE 2-1 for still shooting.

Now you have made all of the necessary settings for recording a movie. Aim the camera at your subject, and when you are ready to start recording, press and release the red Movie button at the upper-right corner of the camera's back. (If you see an error message, go to the third screen of the Custom menu, marked by a gear icon, and set the Movie Button option to Always.)

The screen will display a flashing red REC icon in the lower-left corner of the display, next to a counter showing the elapsed time in the recording, as shown in FIGURE 2-25.

Figure 2-25. Movie Recording Screen

Hold the camera as steady as possible (or use a tripod), and pan (move the camera side to side) slowly if you need to.

The camera will keep shooting until it reaches a recording limit, or until you press the red Movie button again to stop the recording. (The maximum time for continuous recording of any one scene is about 29 minutes in most recording modes.) Don't be concerned about the level of the sound that is being recorded, because you have no control over the audio volume while recording.

The camera will automatically adjust exposure as lighting conditions change. You can zoom the lens in and out as needed, but you should do so sparingly if at all, to avoid distracting the audience and to avoid putting the sounds of zooming the lens on the sound track. When you are finished, press the Movie button again, and the camera will take a while to save the footage, displaying the "Recording" message for a time on the screen.

Those are the basics for recording video clips with the RX100 II. I'll discuss movie options in more detail in CHAPTER 8.

Viewing Pictures

Before I talk about more advanced settings for taking still pictures and movies, as well as other matters of interest, I will discuss the basics of viewing your images in the camera.

REVIEW WHILE IN SHOOTING MODE

Each time you take a still picture, the image will show up on the LCD screen for a short time, if you have the Custom menu's Auto Review option set to turn on this function. I'll discuss the details of that setting in CHAPTER 7. By default, your image will stay on the screen for 2 seconds after you take a new picture. If you prefer, you can set that display to last for 5 or 10 seconds, or to be off altogether.

REVIEWING IMAGES IN PLAYBACK MODE

If you want to review images that were taken previously, you enter playback mode by pressing the Playback button—the one with the small triangle icon to the lower left of the Control wheel. One possibly confusing feature of the RX100 II is that you can review only still images or movies at any one time. In other words, you will not be able to scroll through both movies and still images in the same sequence; you have to select one format or the other. To do that, you can use the Still/Movie Select option on the Playback menu. I discuss that and other options for selecting stills or movies in CHAPTER 6.

Once you have selected still images or movies, you can scroll through the recorded images (or the first frames of the movies) by pressing the Left and Right buttons or by turning the Control wheel. Hold down the Left or Right button to move more quickly through the images. You can enlarge the view of any still image by moving the Zoom lever on top of the camera toward the T position, and you can scroll around in the enlarged image using the four direction buttons. If you press the Zoom lever in the other direction, toward the wide-angle setting, you will see

index screens with increasing numbers of thumbnail images; you can select any image from those screens by pressing the Center button. I'll discuss more of your playback options in CHAPTER 6.

PLAYING MOVIES

To play movies in the camera, you first need to set the camera to play movies as opposed to stills. To do this, go to the Playback menu and select the fourth item, Still/Movie Select, and choose either MP4 or AVCHD files for playback. The RX100 II will then display only files from that category when you press the Playback button.

Move through the recorded files by the methods described above until you find the movie you want to play. You should see the word "Play" next to a white disc in the lower-right corner of the screen, as shown in FIGURE 2-26.

Figure 2-26. Movie Ready for Playback in Camera

(If you don't see that icon, press the Display button to bring up the detailed information screen.) Press the Center button to start the movie playing. Then, as seen in FIGURE 2-27, you will see prompts at the bottom of the screen showing the controls you can use, including the Center button to pause. To change the volume, press the Down button and then use the Up and Down buttons or the Control wheel to make the adjustments. To exit from playing

the movie, press the Playback button. (I'll discuss other movie playback options in CHAPTER 8.)

Figure 2-27. Movie Playback Controls on Screen

If you want to play the movies on a computer or edit them with video-editing software, you can use the PlayMemories Home software that comes with the camera, for use with a Windows computer. If you are using a Macintosh computer, you can use the iMovie program or any other program that can deal with AVCHD and MP4 video files, such as Adobe Premiere Elements or Premiere Pro.

CHAPTER 3:
Shooting Modes

Until now, I have discussed the basics of setting up the camera for quick shots: using Intelligent Auto mode to take pictures with settings controlled mostly by the camera's automation. As with other advanced cameras, though, with the Sony RX100 II there is a large range of options available, particularly for taking still images. One of the main goals of this book is to explain this broad range of features. To do this, I need to discuss two subjects—shooting modes and the Shooting menu options. In this chapter, I'll discuss the shooting modes; in CHAPTER 4, I will discuss the Shooting menu.

Whenever you set out to record still images, you need to select one of the available shooting modes: Intelligent Auto, Superior Auto, Program Auto, Aperture Priority, Shutter Priority, Manual Exposure, Memory Recall, Sweep Panorama, and Scene Selection. (The only other mode available is for movies.) So far, we have worked primarily with the Intelligent Auto mode. Now I will discuss the others, after some review of the first one.

Intelligent Auto Mode

I've already discussed this shooting mode in some detail. This is the one you probably want to select if you just need to have the camera ready for a quick shot, such as in an environment with fast-paced events when you won't have much time to fuss with settings of things such as ISO, white balance, aperture, focus, or

shutter speed. It's also a good mode to select when you hand the camera to someone else to take a photo of you and your companions.

To set this mode, turn the Mode dial to the icon of a green camera with the letter "i" (for "intelligent") next to it, as shown in FIGURE 3-1. When you select this mode, the camera makes several decisions for you and limits your options in some ways. For example, you can't set ISO or White Balance to any value other than Auto, and

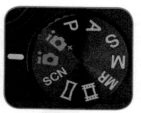

Figure 3-1.
Intelligent Auto

you can't choose a metering method or use exposure bracketing. You can, however, use quite a few features, as discussed in CHAPTER 2, including the Photo Creativity options, Drive Mode, Flash Mode, Tracking Focus, and others. You also can use sophisticated options such as the Raw format, which I will discuss in CHAPTER 4 when I discuss the various other Shooting menu options.

One interesting aspect of the Intelligent Auto setting is that, in this mode (and also in Superior Auto mode, discussed next), the camera uses its built-in programming to attempt to figure out what sort of subject or scene you are shooting. Some of the subjects the camera will attempt to detect are Baby, Portrait, Night Portrait, Night Scene, Landscape, Backlight, Low Brightness, and Macro. It also will try to detect certain conditions, such as whether a tripod is in use or whether the subject is walking, and it will display appropriate icons for those situations. So, if you see different icons when you aim at various subjects in this shooting mode, that means the camera is evaluating the scene for factors such as brightness, backlighting, the presence of human subjects, and the like, so it can use the best possible settings for the situation.

For FIGURE 3-2, the camera evaluated a scene with bushes and flowers and appropriately used its Landscape setting. The Landscape icon is seen in the upper-left corner of the screen.

Figure 3-2. Scene Detection Icon: Landscape

FIGURE 3-3 shows the use of automatic detection for a subject closer to the lens. The camera interpreted the scene as a macro, or closeup shot, and switched automatically into Macro mode, indicated by the flower icon. In addition, the camera correctly detected that it was attached to a tripod, as indicated by the tripod icon to the lower right of the macro symbol.

Figure 3-3. Scene Detection Icons: Macro and Tripod

Of course, scene detection depends on the camera's programming, which may not interpret every scene the same way that you would. If that becomes a problem, you may want to make individual

settings using one of the more advanced shooting modes, such as Program, Aperture Priority, Shutter Priority, or Manual. Or, you can use the SCN setting on the Mode dial and select a scene setting that better fits the current situation.

Superior Auto Mode

With many compact cameras, there is only one largely automatic shooting mode. The RX100 II, however, provides you with two choices, both of which provide high degrees of automation but which have significant differences. The second automatic mode, called Superior Auto, is designated on the Mode dial by the icon of a tan-colored camera with the letter "i" and a plus sign next to it, as shown in FIGURE 3-4.

Figure 3-4. Superior Auto

Superior Auto mode includes all features and functions of Intelligent Auto mode, but it adds an extra level of sophistication. In Superior Auto mode, as in Intelligent Auto mode, the camera uses its scene recognition capability to try to determine what subject matter or conditions are present, such as a portrait, a dimly lit scene, and the like. For many of these scenes, the camera will function just as it does in Intelligent Auto mode. However, in a few specific situations, the camera will take a different approach: it will take a rapid burst of multiple shots and then process them internally and combine them digitally into a single composite image that has higher quality than would be possible with a single shot. The higher quality can be achieved because the camera generally has to raise the ISO setting to a fairly high level, which introduces visual "noise" into the image. By taking multiple shots and then combining them, the camera can average out and cancel some of the noise, thereby increasing the quality of the resulting image.

One problem with this system is that you, the photographer, have no control over when the camera decides to use this burst shooting technique. There are only three situations in which the camera will do this: when it detects scenes that call for settings called Anti Motion Blur, Hand-held Twilight, or Backlight Correction HDR. When the camera believes this multiple-shooting method is appropriate, it fires several shots in a quick burst; you will hear the rapid firing of the shutter several times. Then, it will take longer than usual for the camera to process the multiple shots into a single composite image; you will likely see a message saying "Processing" on the screen for several seconds. When the camera is using this mode, which Sony calls "Overlay," you will see a small white icon in the upper-left corner of the display that looks like a small stack of frames with a plus sign at its upper-right corner, as shown in FIGURE 3-5, to the right of the tripod icon.

Figure 3-5. Overlay Mode Icon to Right of Tripod Icon

You should note that two of these shooting scenarios—Anti Motion Blur and Hand-held Twilight—are available as selections in Scene mode, discussed later in this chapter. The third, Backlight Correction HDR, is available only in Superior Auto mode, and only when the camera decides to use it. Also, you should note that none of the three multiple-shot settings will function when the Quality is set to Raw or Raw & JPEG on the Shooting menu.

I have not found much advantage from using the Superior Auto setting. However, it is similar to Intelligent Auto, which is a very useful shooting mode, and there may be some cases in which the burst-shooting feature will improve the quality of an image, so it is not a bad idea to set the camera to the Superior Auto mode when you are shooting in low-light or backlit conditions. As a general rule, though, I prefer to use a mode such as Program, discussed below, and set my own values for items such as DRO, HDR, ISO, and metering mode.

Program Mode

Choose this mode by turning the Mode dial to the P setting, as shown in FIGURE 3-6.

Figure 3-6.
Program Mode

Program mode lets you control many of the settings available with the camera, apart from shutter speed and aperture, which the camera chooses on its own. You still can override the camera's automatic exposure to a fair extent by using exposure compensation, as discussed in CHAPTER 5, as well as exposure bracketing, discussed in CHAPTER 4, and Program Shift, discussed later in this chapter. You don't have to make a lot of decisions if you don't want to because the camera will make reasonable choices for you as defaults. However, you should note that, even though shutter speeds as long as 30 seconds are available in the Shutter Priority and Manual exposure modes, the camera will never choose a shutter speed longer than one second in Program mode.

The Program Shift function is available only in Program mode; it works as follows. Once you have aimed the camera at your subject, the camera will display its chosen settings for shutter speed and aperture in the lower-left corner of the display. At that point, you can turn the Control wheel on the back of the camera, and the values for shutter speed and aperture will change, if possible

under current conditions, to select different values for both settings while keeping the same overall exposure of the scene. You also can use the Control ring (the large ring around the lens) to make this setting, if the Control Ring option is set to the Standard setting on the Custom menu, as discussed in CHAPTER 7.

With this option, the camera "shifts" the original exposure to any of the matched pairs that appear as you turn the Control wheel. For example, if the original exposure was f/2.0 at 1/30 second, you may see equivalent pairs of f/2.2 at 1/25, f/2.5 at 1/20, and f/2.8 at 1/15, among others. When Program Shift is in effect, the P icon in the upper-left corner of the screen will have an asterisk to its right, as shown in FIGURE 3-7.

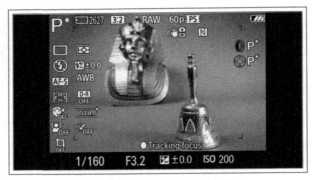

Figure 3-7. Program Shift in Effect

To cancel Program Shift, turn the Control wheel until the original settings are back in effect or select any flash mode using the Flash button, which is also the Right button. (Program Shift cannot function when the flash is in use.)

Why would you want to use the Program Shift feature? You might want a slightly faster shutter speed to stop action better or a wider aperture to blur the background more, or you might have some other creative reason. Of course, if you really are interested in setting a particular shutter speed or aperture, you probably are better off using Aperture Priority mode or Shutter Priority mode. However, having the Program Shift capability available is a good

thing for a situation in which you're taking pictures quickly using Program mode, and you want a fast way to tweak the settings somewhat.

Another important aspect of Program mode is that it greatly expands the choices available through the Shooting menu, which controls many of the camera's settings. You will be able to make choices involving ISO sensitivity, metering method, DRO/HDR, white balance, Creative Style, and others that are not available in the Auto modes. I won't discuss those settings here; if you want to explore that topic, see the discussion of the Shooting menu in CHAPTER 4 for information about all of the different selections that are available.

Aperture Priority Mode

You set the camera to the Aperture Priority shooting mode by turning the Mode dial to the A setting, as shown in FIGURE 3-8.

In this mode, you select the aperture setting, and the camera will select a shutter speed that will result in proper exposure.

Figure 3-8.
Aperture Priority

Before discussing the nuts and bolts of the settings for this mode, here is some information about aperture and why you would want to control it. The camera's aperture is a measure of the width of its opening that lets in light. The aperture's width is measured numerically in f-stops. For the RX100 II, the range of f-stops is from f/1.8 (wide open) to f/11.0 (most narrow). The amount of light that is let into the camera to create an image on the camera's sensor is controlled by the combination of aperture (how wide open the lens is) and shutter speed (how long the shutter remains open to let in the light).

One reason to control the aperture is because of its effect on depth of field. Depth of field is a measure of how well a camera is able to keep multiple objects or subjects in focus at different distances. For example, suppose three people are lined up so you can see them all, but they are at different distances—five, seven, and nine feet (1.5, 2.1, and 2.7 meters) from the camera. If the camera's depth of field is quite shallow at a particular focal length, such as five feet (1.5 meters), then, in this case, if you focus on the person at that distance, the other two will be out of focus and blurry. But if the camera's depth of field when focused at five feet is broad, then it may be possible for all three people to be in sharp focus in your photograph, even if the focus is set for the person at five feet.

What does that example have to do with aperture? One rule of photographic optics is that a wider aperture results in a shallower depth of field at a given focal length. So, in our example above, if you have the camera's aperture set to its widest opening, f/1.8, the depth of field will be relatively shallow, and it will be difficult to keep several items in focus at varying distances from the camera. If the aperture is set to the narrowest opening, f/11.0, the depth of field will be greater, and it will be possible to have more items in focus at varying distances.

In FIGURE 3-9 and FIGURE 3-10, the distances and settings were the same except for the aperture values. I focused on the bell in the foreground in each case. For FIGURE 3-9, the aperture of the RX100 II was set to f/1.8, the widest possible. With this setting, because the depth of field at this aperture was quite shallow, the King Tut figure in the background is quite blurry. FIGURE 3-10 was taken with the camera's aperture set to f/11.0, the narrowest possible setting, resulting in a broader depth of field, and consequently making the focus on the King Tut figure considerably sharper.

Figure 3-9. Shallow Depth of Field with Aperture at f/1.8

Figure 3-10. Broad Depth of Field with Aperture at f/11.0

These two photos illustrate the effects of varying your aperture by setting it wide (low numbers) when you want to blur the

background and narrow (high numbers) when you want to enjoy a broad depth of field and keep subjects at varying distances in sharp focus.

This situation arises often in the case of outdoor portraits and other images. For example, you may want to take a photo of a subject outdoors with a background of trees and bushes, and possibly some other, more distracting objects, such as a swing set or a toolshed. If you can achieve a shallow depth of field by using a wide aperture, you can keep your subject in sharp focus but leave the background quite blurry and indistinct. As was discussed in CHAPTER 2, this effect is sometimes called "bokeh," a Japanese term describing an aesthetically pleasing blurriness of the background. In this situation, the blurriness of the background can be a great asset, reducing the distraction from unwanted objects and highlighting the sharply focused portrait of your subject.

In FIGURE 3-11, I took a closeup shot of a flower blurring the background of trees and bushes by setting the aperture as wide as possible to emphasize the focus on the flower.

Figure 3-11. Image with Bokeh Effect: Blurred Background

Now that I have discussed some reasons for selecting a specific aperture, here are the technical steps involved. Once you have

moved the Mode dial to the A setting, the next step is simple. Use either the Control ring (the large, ridged ring around the lens) or the Control wheel to change the aperture. (If the Control ring does not change the aperture, check the setting for the Control Ring item on the Custom menu, as discussed in CHAPTER 7; that menu option should be set to Standard.)

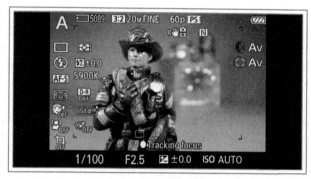

Figure 3-12. Aperture Number Displayed in Aperture Priority Mode

As shown in FIGURE 3-12, the number of the f-stop (f/2.5 in this case) will appear in the bottom center of the screen next to the shutter speed. The camera will select a shutter speed that will result in a proper exposure given the aperture you have set. Although, in most cases, the camera will be able to select a corresponding shutter speed that results in a normal exposure, there may be times when this is not possible. For example, if you are taking pictures in a very bright location and have set the aperture to f/1.8, the camera may not be able to set a shutter speed fast enough to yield a proper exposure. In that case, the display will become unusually bright to show how the image will look at those settings, and the designation of the fastest possible shutter speed (1/2000) will flash on the camera's display to show that the exposure cannot be set using that aperture. The camera will still let you take the exposure, but it may be too bright to be usable. Similarly, if conditions are too dark for a good exposure at the aperture you have selected, the slowest shutter speed (8", meaning 8 seconds) will flash.

One more note on Aperture Priority mode that might not be immediately obvious and could lead to confusion: not all apertures are available at all times. In particular, the widest-open aperture, f/1.8, is available only when the lens is zoomed out to its wide-angle setting (Zoom lever moved toward the W). At the highest zoom levels, the widest aperture available is f/4.9.

To see an illustration of this point, here is a quick test. Zoom the lens out by moving the Zoom lever all the way to the left, toward the W label. Then select Aperture Priority mode and set the aperture to f/1.8 by turning the Control wheel or the Control ring all the way in the direction for lower numbers. Now zoom the lens in by moving the Zoom lever to the right, toward the T setting. After the zoom action is finished, you will see that the aperture has been changed to f/4.9 because that is the limit for the aperture at the telephoto zoom level. (The aperture will change back to f/1.8 if you move the zoom back to the wide-angle setting.) Also, as with Program mode, the full range of the camera's shutter speeds is not available. When set to Aperture Priority mode, the RX100 II can set shutter speeds from 1/2000 second to 8 seconds.

Shutter Priority Mode

In Shutter Priority mode, you choose the shutter speed you want, and the camera will set the corresponding aperture to achieve a proper exposure of the image.

In this mode, designated by the S position on the Mode dial, as shown in FIGURE 3-13, you can set the shutter to be open for a time ranging from 30 seconds to 1/2000 of a second. If you are photographing fast action, such as a baseball swing or a hurdles event at a track meet, and you want to stop the motion

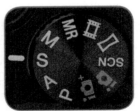

Figure 3-13.
Shutter Priority

with a minimum of blur, you should select a fast shutter speed, such as 1/1000 of a second. For FIGURE 3-14 and FIGURE 3-15, I

poured a pitcher full of white plastic BBs into a tub, and changed only the shutter speed for the two shots.

Figure 3-14. Shutter Speed 1/2000 Second

Figure 3-15. Shutter Speed 1/25 Second

In FIGURE 3-14, with the shutter speed set at 1/2000 second, you can see each individual BB. In FIGURE 3-15, with the shutter speed set to 1/25 second, the BBs blend together into a continuous stream. In this case, by varying the shutter speed you can dramatically change the nature of the image.

You select this shooting mode by turning the Mode dial on top of the camera to the S indicator, as shown in FIGURE 3-13. Then you select the shutter speed by turning the Control wheel or the Control ring—the large, ridged ring that surrounds the lens. (Again, as with Aperture Priority mode, the Control Ring function on the Custom menu must be set to Standard for the ring to control shutter speed.)

If you use the Control ring, the LCD screen will display a circular scale showing the changing shutter speeds, as seen in FIGURE 3-16, and the selected speed will appear on the left side of the screen, next to the aperture setting.

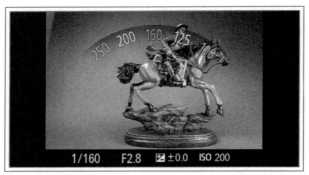

Figure 3-16. Control Ring Display Showing Shutter Speed

(You can turn off the circular display on the Custom menu, as discussed in CHAPTER 7.)

If you use the Control wheel, the shutter speed will just change in place at the lower left of the display as you turn the wheel. There is one possibly confusing aspect of the camera's display for Shutter Priority mode. Although the Mode dial uses the letter "S" to stand for Shutter Priority, on the detailed display screen, the camera's screen uses the notation Tv in the upper-right corner. Tv stands for time value, a notation often used for this shooting mode.

As you cycle through various shutter speeds, the camera will select the appropriate aperture to achieve a proper exposure, if possible.

As I discussed in connection with Aperture Priority mode, if you select a shutter speed for which the camera cannot select an aperture that will yield a normal exposure, the LCD screen will change appearance to indicate how dark or light the resulting shot will be, and the aperture reading at the bottom of the display will flash. The flashing aperture means that proper exposure at that shutter speed is not possible at any available aperture, according to the camera's calculations.

For example, if you set the shutter speed to 1/320 second in a fairly dark indoor environment, the aperture number (which will be f/1.8, the widest setting, if the zoom is set to wide angle) will flash, indicating that proper exposure is not possible, and the display will be quite dark. As I discussed for Aperture Priority, you can still take the picture if you want to, though it may not be usable. A similar situation may take place if you select a slow shutter speed (such as 4 seconds) in a relatively bright location.

When setting the shutter speed, note that the fractions of a second are easy to interpret, because they are displayed as standard fractions, such as 1/5 or 1/200. A few values are displayed as decimals, including 0.4, 0.5, and 0.8 second.

Manual Exposure Mode

One of the many features of the RX100 II that distinguish it from more ordinary compact cameras is that it has a fully manual exposure mode, a tremendous tool for serious photographers who want to exert full creative control over exposure decisions.

Figure 3-17.
Manual Exposure

The technique for using this mode is not too different from what I discussed for the Aperture Priority and Shutter Priority modes. To control exposure manually, set the Mode dial to the M indicator, as shown in FIGURE 3-17.

You now have to control both shutter speed and aperture by setting them yourself. To set the aperture, turn the Control ring around the lens (assuming the Control ring is set for this function through the Custom menu, as discussed in CHAPTER 7); to set the shutter speed, turn the Control wheel on the back of the camera.

If the Control ring is not set to control aperture, or if you prefer not to use the ring for that purpose, you can use the Control wheel to control both aperture and shutter speed. To do that, press the Down button on the Control wheel to switch between those two selections. When you press that button, either the shutter speed number or the aperture number on the display will turn orange for about 10 seconds to indicate that that value is currently being controlled by the Control wheel.

As you adjust the shutter speed and aperture, a third value, to the right of the aperture value, will also change. That value is shown by a positive, negative, or zero number next to a box containing the letters "M.M." (which stand for "metered manual"), as shown in FIGURE 3-18.

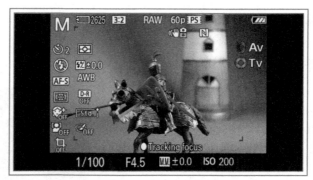

Figure 3-18. M.M. Indicator at Zero in Manual Exposure Mode

That figure represents any deviation from what the camera's metering system considers to be a normal exposure. So, even though you are setting the exposure manually, the camera will still let you know whether the selected aperture and shutter speed will produce a standard exposure.

For example, if the values you have selected will result in a dark exposure, the M.M. value will be negative, and the LCD display will appear dark; with a positive value, it will be unusually bright. The M.M. value can go up or down only to +2.0 or -2.0 EV (exposure value) units; after that point, the value will flash, indicating that the camera considers the exposure to be excessively abnormal.

Of course, you can ignore the M.M. indicator; it is there only to give you an idea of how the camera would meter the scene. You very well may want part or all of the scene to be darker or lighter than the metering would indicate to be "correct."

With Manual exposure mode, the settings for aperture and shutter speed are independent of each other. When you change one, the other one stays unchanged until you adjust it manually. The camera is leaving the creative decision about exposure entirely up to you, even if the resulting photograph would be washed out by excessive exposure or underexposed to the point of near-blackness.

The range of apertures you can set in this mode is the same as for Aperture Priority mode: f/1.8 to f/11.0. The range of shutter speeds is the same as for Shutter Priority (1/2000 to 30 seconds), with one important addition: in Manual mode, you can set the shutter speed to the BULB setting, just beyond the 30-second mark, as shown in FIGURE 3-19.

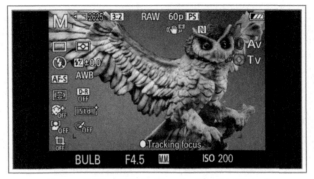

Figure 3-19. BULB Setting for Shutter Speed

With this setting, you have to press and hold the Shutter button; as long as it is held down, the shutter will stay open. You can use this setting to take photos in almost-complete darkness by holding the shutter open for a minute or longer. One problem with doing so is that it is very difficult to avoid jiggling the camera and thereby causing blur to the image. In APPENDIX A, I discuss using Sony's wired remote control to trigger the camera without touching it.

Note that you need to be aware of the procedure for setting the camera's ISO in Manual mode. In CHAPTER 4, I'll talk more about the ISO setting, which controls how sensitive the camera's sensor is to light. With a higher ISO value, the sensor is more sensitive and the image is exposed more quickly, so the shutter speed can be faster or the aperture more narrow, or both, depending on conditions. In other shooting modes, the camera can set ISO automatically, but in Manual mode, you have to set the ISO value yourself. If you try to select Auto ISO while in Manual mode, the camera will display an error message. If you have selected Auto ISO while in another shooting mode and then switch to Manual mode, the camera will set the ISO to 160.

To set the ISO value, press the Menu button to access the Shooting menu, go to the third screen, and highlight the ISO item at the top of screen. Press the Center button to bring up the ISO menu, as shown in FIGURE 3-20, and scroll through the selections using the Up and Down buttons or turning the Control wheel.

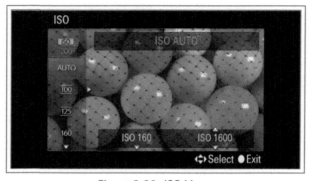

Figure 3-20. ISO Menu

Use a low number like 100 or 125 to emphasize image quality when there is plenty of light; use a higher number in dim light.

You also need to realize that higher ISO settings are likely to cause visual "noise," or graininess, in your images, so you need to weigh the advantages of being able to take pictures in dim light against the risk of having images that are excessively coarse in appearance. Generally speaking, you should try to set the ISO no higher than 800 if you need to ensure the highest quality for your images. You can still get quite acceptable results with ISO 1600 or higher, though, unless you need to make very large prints.

I use Manual exposure mode often, for various purposes. One use is for taking a series of images at different exposures to be combined with software into a composite HDR (high dynamic range) image. I will discuss that technique in CHAPTER 4. I also use Manual mode when using external flash with the RX100 II, as discussed in APPENDIX A. In that situation, the flash does not interact with the camera's autoexposure system, so it's necessary to set the exposure manually.

Manual mode also is useful for some special types of photography, such as photographing collisions of water drops. To do this, I set up the RX100 II in a dark room with a shutter speed of 0.5 second and an aperture of f/8.0 with ISO set at 160. I used a device called the StopShot (made by Cognisys Systems), which fired an external flash unit as the first of two drops passed an infrared beam. I turned on the 2-second self-timer to avoid jiggling the camera, and pressed the Shutter button. Just as the timer triggered the half-second exposure, I pressed a button to release the two water drops, so they could fall past the infrared beam into a tray of water. The flash fired during that long exposure, bouncing off of colored background paper to illuminate the collision of the two drops in a tray of water, freezing the action with the high speed of the flash. One result is shown in FIGURE 3-21.

Figure 3-21. Image of Water Drop Collision Using Manual Exposure Mode

In this case, the long exposure was necessary to give me time to trigger the StopShot device, and the narrow aperture was necessary to have sufficient depth of field to keep the water drop collisions in focus. Automatic exposure would not work because the flash was not connected to the camera's automatic exposure system. Manual exposure mode was the only way to accomplish this type of shot.

Scene Mode

Scene mode, represented by the SCN setting on the Mode dial, as shown in FIGURE 3-22, is quite different from the other shooting modes I have discussed.

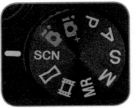

This mode does not have a single defining feature, such as permitting control over one or more aspects of exposure. Instead,

Figure 3-22.
Scene Mode

when you select Scene mode and then choose a particular scene type within that mode, you are telling the camera what sort of environment the picture is being taken in and what type of image you are looking for, and you are letting the camera make the decision as to what settings to use to produce that result.

One aspect of using Scene mode is that with most of its settings, you cannot select many of the options that are available in Program, Aperture Priority, and Manual Exposure mode, such as Creative Style, Picture Effect, Metering Mode, White Balance, Autofocus Area, and ISO. There also are some menu settings and control settings that are available with certain scene settings but not others, as discussed later in this chapter.

Although some photographers may not like Scene mode because it seems to take creative decisions away from you, I have found it to be useful in various situations. Remember that you don't have to use these scene types only for their labeled purposes; you may find that some of them offer a group of settings that is well suited for some shooting scenarios that you regularly encounter. I'll discuss how Scene mode works, and you can decide for yourself whether you might take advantage of it on some occasions.

You enter Scene mode by turning the Mode dial to the SCN indicator, shown in FIGURE 3-22. Now, unless you want to use the setting that is already in place, you need to pick one from the fairly impressive list of 13 Scene settings. There are several ways to do this, depending on current settings.

If the Mode Dial Guide is turned on through the Setup menu, then, whenever you turn the Mode dial to the SCN setting, the Scene Selection menu, shown in FIGURE 3-23, will appear.

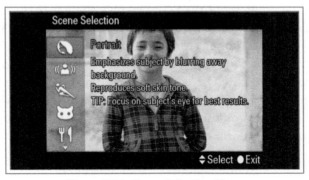

Figure 3-23. Scene Selection Menu

If the Mode Dial Guide is not turned on, or if the camera is already set to Scene mode, then you need to use the Shooting menu to call up the Scene Selection screen. Press the Menu button, navigate to the fifth screen, and choose the Scene Selection item.

Once you have the Scene Selection menu on the display, scroll through the 13 selections on the vertical Scene Selection menu using the Up and Down buttons or the Control wheel. Press the Center button to select one of the settings and return to the shooting screen. You will then see an icon representing that setting in the upper-left corner of the LCD display. (You may need to press the Display button to see the screen that includes the scene setting icon.) For example, FIGURE 3-24 shows the display when the Anti Motion Blur setting is selected.

Figure 3-24. Anti Motion Blur Icon in Upper-Left Corner of Display

One helpful point about the Scene menu system is that each scene type has a main screen with a brief description of the setting's uses as you move the selector over it, as shown in FIGURE 3-23, so you are not left trying to puzzle out what each icon represents. As you keep pushing the Up or Down button or moving the Control wheel to move the selector over the other scene types, when you reach the bottom or top edge of the screen, the selector wraps around to the first or last setting and continues going.

Finally, there is one more way to select a scene type. If the Control ring is set to its Standard setting, then when the camera is in

Scene mode, you can just turn the Control ring to cycle through the various scene types. You will see a circular display as the ring turns, as shown in FIGURE 3-25. Then, as shown in FIGURE 3-26, after you stop turning the ring, the icon for the selected type will appear in the upper-left corner of the screen. (If you are using manual focus or DMF this will not work because the Control ring will adjust focus; therefore, it will not be available to display scene types.)

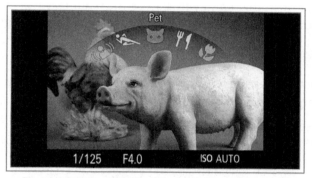

Figure 3-25. Control Ring Display for Scene Selection

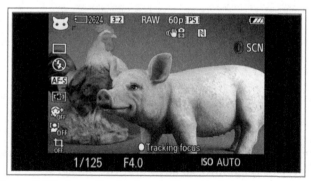

Figure 3-26. Scene Setting Icon in Upper-Left Corner of Display

That's all you have to do to select a Scene type. But there are numerous choices, and you need to know something about each option to decide whether it's one you would want to use. In general, each scene setting carries with it a variety of values,

including things like focus mode, flash status, range of shutter speeds, sensitivity to various colors, and others.

It's helpful to note that some settings are designed for certain types of shooting rather than particular environments such as sunset or fireworks. For example, the Anti Motion Blur and High Sensitivity settings are designed for difficult shooting environments, such as dimly lighted areas.

With that introduction, I will discuss the main features of each of the 13 choices, with sample images for some of the settings.

PORTRAIT

The Portrait setting is designed to produce flesh tones with a softening effect, as shown in FIGURE 3-27.

Figure 3-27. Portrait Example

You should stand fairly close to the subject and set the zoom to some degree of telephoto, so as to blur the background if possible; the camera will try to use a wide aperture to assist in this blurring. The flash mode is initially set to Flash Off, but you can set the mode to Autoflash or Fill-flash if you want to even out the lighting or reduce shadows on your subject's face. If you want to improve the lighting, consider using off-camera flash with a softbox, as discussed in APPENDIX A.

If you are shooting a portrait in front of a busy background, such as a house, try to position the subject's head in front of a plain area, such as a light-colored wall, so the head will be seen clearly.

You can use the self-timer or the self-portrait settings of Drive Mode, but you cannot use bracketing or continuous shooting.

ANTI MOTION BLUR

As noted earlier, this Scene mode setting is not meant for a particular subject, but for a certain type of situation. This option is useful for an area with dim lighting or when the lens is zoomed in to a telephoto setting. In either of those situations, the image is subject to blurring because of camera motion. In dim lighting, this blurring can happen when the camera uses a slow shutter speed to expose the image properly because it is hard to hold the camera perfectly steady for an exposure longer than about 1/30 second. In the telephoto case, any camera motion is exaggerated because of the magnification of the image.

To counter the effects of this blurring, with Anti Motion Blur the camera raises the ISO to a higher-than-normal level, so the camera can use a fast shutter speed and still let in enough light to expose the image properly. Because higher ISO settings result in increased visual noise, the camera takes a rapid burst of shots and combines them through internal processing into a single composite image with reduced noise. What is remarkable about this setting, though, is that the camera also counteracts blur from motion of the subject to a fair extent, by analyzing the shots and rejecting those with motion blur as much as possible.

Anti Motion Blur is useful as the light is fading if you don't want to use flash, as shown in FIGURE 3-28. For this image, taken shortly after sunset, the camera used a high ISO setting along with its multiple-shot processing.

Figure 3-28. Anti Motion Blur Example: 1/250 Sec., f/4.9, ISO 3200

You should not expect good results if you use this setting with fast-moving subjects because the camera will not be able to eliminate the motion blur. With slower-moving subjects, though, like those in FIGURE 3-28, the RX100 II can do a good job of reducing the blur. With this setting, you cannot set the Drive Mode or the Flash Mode.

SPORTS ACTION

The Sports Action setting is for use when lighting is bright and you need to freeze the action of your subjects, such as athletes, children at play, pets, or other objects in motion. Depending on conditions, the camera may set a high ISO value, so it can use a fast shutter speed to stop action. The flash is initially forced off, but you can turn on Fill-flash if you want. The camera sets itself for continuous shooting, so you can hold down the Shutter button and capture a burst of images. In that way, you increase your chances of capturing the action at a perfect moment. You can switch to the fastest level of continuous shooting if you want, but you cannot set Drive Mode to single shooting. Somewhat oddly, though, you can set Drive Mode to use the self-timer, which can result in a single shot or multiple shots, depending on how you set it. (I'll discuss the Drive Mode and self-timer options in CHAPTER 4.)

Figure 3-29. Sports Action Example

For the rodeo shot in FIGURE 3-29, the camera set itself to f/4.9 with an ISO setting of 2000, so it could use a shutter speed of 1/250 second to freeze the action.

PET

The Pet setting is designed for taking photos of cats, dogs, and other animals in motion. It is similar to Sports Action to some extent, in that the flash is off but can be set to Fill-flash. The Pet setting is different, though, because it lets you use the Soft Skin Effect setting on the Shooting menu, and it does not let you use continuous shooting. I would recommend that you use this setting when you are shooting a relatively posed or calm shot of your dog, cat, or other pet; if the animal is running around, you might be better off with the Sports Action selection.

I used this setting at the rodeo to take the picture seen in FIGURE 3-30 of some horses waiting for their turns to participate.

Figure 3-30. Pet Example

Gourmet

The Gourmet setting, according to Sony, is meant to let you shoot food so that it looks "delicious." In more ordinary terms, with this setting, the RX100 II raises the brightness and vividness of the colors in the scene to enhance the appearance of food. This setting is useful for people who write food blogs, or who just like to record their meals for posterity. The camera lets you have the flash either forced off or set to Fill-flash. Continuous shooting is not available, but you can use the self-timer. In FIGURE 3-31, the color and brightness enhancements of this setting gave the image a bit of a boost, possibly making the fruit look more appealing than it would with the normal appearance of Program mode, for example.

Figure 3-31. Gourmet Example

MACRO

With the Macro setting, the RX100 II sets itself up to take close-ups. Although you can focus at close range in other shooting modes, it is convenient to use this single setting to call up a group of options that are well suited for taking extreme close-ups of flowers, insects, or other small objects.

When you select the Macro option, the camera will let you set the flash to Forced Off, Fill-flash, or Autoflash. You cannot use continuous shooting, but you can use the self-timer.

With the RX100 II, there is no special setting for macro focus; in any focus mode, the camera can focus as close as about 2 inches (5 cm) when the lens is zoomed out to its wide-angle setting. When the lens is zoomed in all the way to its telephoto setting, it can focus as close as about 22 inches (55 cm). One important point about macro focusing, though, is that even when the camera is set to the Macro setting in Scene mode, you can use the manual focus option. This can be an excellent approach when using Macro because you can fine-tune the focus, which becomes critical and

hard to measure precisely when you are taking pictures of insects or other objects in extreme close-ups. To use manual focus, select Focus Mode from the second screen of the Shooting menu and select the bottom option, Manual Focus. Then, use the Control ring to adjust the focus. I will discuss the use of manual focus further in CHAPTER 4.

Figure 3-32. Macro Example

The image in FIGURE 3-32 was taken using the Macro scene setting, with autofocus. I will discuss other aspects of macro shooting in CHAPTER 9.

LANDSCAPE

Landscape is one of the Scene mode settings that I use often. It is very convenient to turn the Mode dial to the SCN position and pull up the Landscape setting when I'm taking pictures at a scenic location. The camera lets you use Fill-flash in case you want to shoot an image of a person in front of a scenic vista or other attraction, and it boosts the brightness and intensity of the colors somewhat. Otherwise, it limits your choices; you cannot use continuous shooting, but you can use the self-timer. FIGURE 3-33 is an example taken using the Landscape setting at a railroad bridge beside the James River.

Figure 3-33. Landscape Example

Sunset

This setting is designed to capture the rich, reddish hues of the sky when the sun is rising or setting. The camera will let you use the Fill-flash setting if you want to, so you can take a portrait of a person with the sunset or sunrise in the background. You cannot use continuous shooting, but you can use the self-timer. The main feature of this setting is that the camera boosts the intensity of the reddish hues in the scene.

Of course, as I have mentioned earlier, you don't have to confine the use of this, or any Scene setting, to the particular subject its name implies. For example, if you are photographing red and orange leaves of trees that are changing colors in autumn, you might want to try the Sunset option as one way to create an enhanced view of the brightly colored foliage.

In FIGURE 3-34, I used the Sunset option to photograph a traditional scene of the setting sun.

Figure 3-34. Sunset Example Showing Actual Sunset

In FIGURE 3-35, I set up an indoor shot using a candle with a shadow-casting figure attached to it, along with an antique pitcher and kettle. With the Sunset setting, the image took on a much warmer look than normal, with an appearance somewhat like firelight.

Figure 3-35. Sunset Example Using Candle Indoors

NIGHT SCENE

The Night Scene setting is meant for use when you want to preserve the natural darkness of a night-time setting. The camera disables the use of the flash completely; if the scene is quite

dark, you should use a tripod to avoid camera motion during the long exposure that may be required. You cannot use continuous shooting, but you can use the self-timer. This setting is good for landscapes and other outdoor scenes after dark when flash would not help. The camera does not raise the ISO or use multiple shots, as it does with other modes used in dim lighting, such as Anti Motion Blur and Hand-held Twilight.

In FIGURE 3-36, I used the Night Scene setting to photograph the downtown skyline about a half-hour after sunset. I had the camera on a tripod and used the self-timer with its 2-second setting to avoid camera shake.

Figure 3-36. Night Scene Example: 2.0 Sec., f/4.0, ISO 160

HAND-HELD TWILIGHT

This Scene mode setting gives you another option for taking pictures in low light without flash or tripod. With this special setting, as with Anti Motion Blur, the camera boosts the ISO to a higher level, so it can use a fast shutter speed, and takes a rapid burst of shots. The camera combines these shots internally into one composite image to counteract the effects of high ISO, which often causes visible "noise," or grain, in an image.

However, the Hand-held Twilight setting is likely to use a lower ISO setting than Anti Motion Blur to minimize noise and emphasize image quality. Although the camera will attempt to select frames with minimal motion blur, the final result with this setting is more likely to show motion blur than a shot made with the Anti Motion Blur setting.

Hand-held Twilight is a great option if you are shooting a landscape or other static subject when you cannot use a tripod or flash and the light is dim. If you can use a tripod, you might be better off using the Night Scene setting, discussed above. Or, if you don't mind using flash, you could just use Intelligent Auto, Program, or one of the more ordinary shooting modes. Hand-held Twilight is a very useful option when it's needed, but it will not yield the same overall quality as a shot at a lower ISO with the camera on a steady support.

Figure 3-37. Hand-Held Twilight Example

In FIGURE 3-37, I made use of this setting at an evening event. The camera shot this image at f/3.5 and set the ISO to 800, making it possible to use a shutter speed of 1/40 second, fast enough to hand-hold the camera without noticeable motion blur. The camera took its multiple shots in very rapid succession, so there is no problem from the motion of the people standing in line.

Night Portrait

This night-oriented setting is for situations when you are taking a portrait and are willing to use the camera's built-in flash. The main differences from the settings discussed above are that with Night Portrait, the camera takes only one shot and it activates the flash, in Slow Sync mode. You cannot turn the flash off. I will discuss Slow Sync and provide an example in Chapter 4. Basically, with this setting, the camera uses a slow shutter speed, so that as the flash illuminates the portrait subject in the foreground, there is enough time for the natural light to illuminate the background also. You can use the self-timer, but not continuous shooting. You also can use Raw quality if you wish, so this setting is a good choice for a high-quality portrait outdoors at night. Because of the slow shutter speed, you should use a tripod if possible to avoid motion blur.

In Figure 3-38, the background shows up fairly clearly because the camera used a slow shutter speed of 2 seconds. I used a tripod, which eliminated camera shake, but you also need to advise the subject not to move during the long exposure.

Figure 3-38. Night Portrait Example

FIREWORKS

This scene type is designed to capture vivid images of fireworks bursts. It sets the camera to a 2-second shutter speed and intensifies colors. If you can, you should set the camera on a tripod or other sturdy support and turn off the SteadyShot image stabilization option on the Shooting menu. The camera disables the flash and continuous shooting. I didn't get my camera until after the Fourth of July, and I didn't get to any other events with fireworks, but I used this setting for a broad view of the city skyline and the river, as shown in FIGURE 3-39. This setting is one you can use as an alternative to the Night Scene setting when you are using a tripod after dark. You might want to try this approach to take advantage of the different color processing that the camera uses with this option.

Figure 3-39. Fireworks Setting: 2.0 Sec., f/5.6, ISO 160

HIGH SENSITIVITY

With this setting, you have one more option for shooting in low-light environments. In this case, the camera disables the flash and continuous shooting, but it allows use of the self-timer. The camera is likely to set a high ISO, in the range of 3200 or higher,

all the way to the camera's maximum of 25600 if the lighting is sufficiently dim to call for that high a setting. However, unlike the case with Hand-held Twilight, the camera takes only a single shot. As a result, there is no special processing of multiple images to reduce visual noise, so the image may be rather grainy.

If you need to produce an image that is smooth and as noise-free as possible, you probably should use Hand-held Twilight or Anti Motion Blur instead of High Sensitivity. However, there might be occasions when you don't mind the grainy, noisy appearance that a high ISO can bring. It's very good to have these various choices available when you are confronted with a dimly lit location.

Figure 3-40. High Sensitivity Example

Note that you cannot set the camera's ISO to 25600 with the normal ISO setting on the Shooting menu; as discussed in CHAPTER 4, the highest setting on that menu is 12800. To get the camera to use the 25600 value for ISO, you have to use the Multi Frame Noise Reduction setting on the ISO menu or this High Sensitivity setting of Scene mode.

In FIGURE 3-40, I used the High Sensitivity setting to photograph an exhibit of ancient artifacts in a history museum. The camera set the ISO to 3200 and exposed the image for 1/100 second at an aperture of f/1.8. As discussed in CHAPTER 9, I also have found the High Sensitivity option to be quite useful for street photography.

Sweep Panorama Mode

The next setting on the Mode dial is designed for a very specific purpose—the shooting of panoramic images. The RX100 II, like many other Sony cameras, has an excellent capability for automating the capture of panoramas. If you follow the fairly simple steps involved, the camera will stitch together a series of images internally and produce a high-quality final result that sets forth a dramatic, wide (or tall) view of a scenic vista or other subject that lends itself to panoramic depiction.

It is significant that Sony has given this shooting mode its own spot on the Mode dial, indicating the importance of this type of photography nowadays. (Some other cameras include the panorama setting as a Scene mode type that has to be selected from a menu.) Because of this placement on the dial, you can very

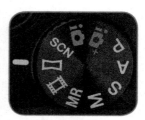

Figure 3-41.
Sweep Panorama

quickly set the camera to take panoramas. Just turn the Mode dial to select the icon that looks like a long, squeezed rectangle, as shown in FIGURE 3-41. You will immediately see a message telling you to press the Shutter button and move the camera in

the direction of the arrow that appears on the screen, as shown, in FIGURE 3-42.

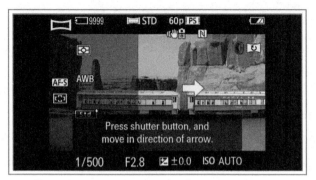

Figure 3-42. Initial Screen for Shooting Panorama

At that point, you can follow the directions and likely get excellent results. However, because the RX100 II is designed for the more-advanced photographer, the camera allows you to make a number of choices for your panoramic images using the Shooting menu. Just press the Menu button, and you will go to the menu screen that is currently being displayed.

Navigate to the Shooting menu, which limits you to fewer choices than in most other shooting modes because several options are not appropriate for panoramas. For example, the Image Size, Aspect Ratio, and Quality settings are dimmed and unavailable. Also, options such as Drive Mode, Flash Mode, and Autofocus Area are of no use in this situation and cannot be selected. In addition, you will not be able to zoom the lens in; it will be fixed at its wide-angle position. (If the lens was zoomed in previously, it will zoom back out automatically when you switch the Mode dial to the Sweep Panorama selection.)

You will, however, see two options on the first screen of the Shooting menu that are not available for selection in any other shooting mode: Panorama Size and Panorama Direction, as shown in FIGURE 3-43.

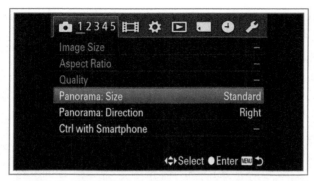

Figure 3-43. Panorama Size and Panorama Direction Menu Options

If you select Panorama Size, you will see two options, Standard and Wide.

With Standard, a horizontal panorama will have a size of 8192 by 1856 pixels, which is a resolution of about 15 megapixels (MP). If you choose Wide, a horizontal panorama will have a size of 12416 by 1856 pixels, resulting in a resolution of about 23 MP. (This figure is larger than the camera's maximum resolution of 20 MP because with the panorama settings, the camera is taking multiple images and stitching them together.)

A vertical panorama at the Standard setting is 3872 by 2160 pixels, or about 8.3 MP; a vertical panorama at the Wide setting is 5536 by 2160 pixels, or about 12 MP.

The Panorama Direction option lets you choose Right, Left, Up, or Down for the direction in which you will sweep the camera to create the panorama. If you have the Control ring set to use its Standard settings through the Custom menu and you are not using manual focus or DMF, you can just turn the Control ring, and the camera will cycle through the four arrows for the four panorama directions, so you will not have to use the Shooting menu for that purpose.

Also, you can use the Direction settings with different orientations of the camera to get different results than usual. For example, if

you set the direction to Up and then hold the camera sideways while you sweep it to the right, you will create a horizontal panorama that has 2160 pixels in its vertical dimension rather than the standard 1856.

Those are the main settings for most panoramas. There are a few other options you can select for panoramas on the Shooting menu, including Focus Mode, Metering Mode, White Balance, Creative Style, and SteadyShot. I will discuss all of these menu options in CHAPTER 4. In my opinion, the best options for these settings for shooting panoramas are the ones shown in TABLE 3-1, at least as a starting point.

Table 3-1. **Suggested Settings for Panoramas**

Focus Mode	Single-shot AF
Metering Mode	Multi
White Balance	Auto White Balance
Creative Style	Standard
SteadyShot	On (unless using a tripod)

One other setting you can make when shooting panoramas is exposure compensation, which is set using the Down button on the Control wheel. I will discuss that function in CHAPTER 5. In the context of shooting panoramas, this feature can be quite useful because the camera will not change the exposure if the camera is pointed at areas with varying brightness. So, for example, if you start sweeping from a dark area on the left, the camera will set the exposure for that area. If you then sweep the camera to the right over a bright area, that part of the panorama will be overexposed and possibly washed out in excessive brightness. To correct for this effect, you can reduce the exposure using exposure compensation. In this way, the initial dark area will be underexposed, but the brighter area should be properly exposed. Of course, you have to decide what part of the panorama is the one you most want to have the proper exposure.

Another way to deal with this issue is to point the camera at the bright area before starting the shot and press the Shutter button halfway to lock the exposure, and then go back to the dark area at the left and start sweeping the camera. In that way, the exposure will be locked at the proper level for the bright area.

Once you have made all of the settings you want for your panorama, follow the directions on the screen. Press and release the Shutter button, and start moving the camera at a steady rate in the direction you have chosen. I tend to shoot my panoramas moving the camera from left to right, but you may have a different preference. You will hear a steady clicking as the camera takes multiple shots during the sweep of the panorama. A white box and arrow will proceed across the screen; your task is to finish the camera's sweep at the same moment that the box and arrow finish their travel across the scene. If you move the camera either too quickly or too slowly, the panorama will not succeed; if that happens, just try again.

Generally speaking, panoramas work best when the scene does not contain moving objects such as cars or pedestrians because when items are in motion, the multiple shots are likely to capture images of the same object more than once in different positions.

It is advisable to use a tripod if possible, so you can keep the camera steady in a single plane as it moves. If you don't have a tripod available, you might try using the excellent electronic level that Sony provides with the RX100 II. You have to activate the level with the Display Button option on the first screen of the Custom menu, as discussed in CHAPTER 7. Then press the Display button until the screen with the electronic level appears. Make sure the outer tips of the level stay green as much as possible, and the resulting panorama should benefit from the level shooting.

In addition to exposure, as discussed above, focus and white balance are fixed as soon as the first image is taken for the panorama.

When a panoramic shot is played back in the camera, it is initially displayed at a small size so the whole image can fit on the display screen. You can then press the Center button to make the panorama scroll across the display at a larger size, using the full height of the screen.

Figure 3-44 and Figure 3-45 are sample panoramas, both shot from left to right using the Standard setting, hand-held. Although I often use the Sweep Panorama shooting mode to take panoramic images in color of outdoor scenes, I included here one indoor scene, taken in the local history museum, and one panoramic view that uses the Black and White setting of the Creative Style menu, just to show that panoramas do not have to be color images of landscapes or buildings.

Figure 3-44. Panorama: Virginia Historical Society Exhibition, Richmond

Figure 3-45. Panorama: Skyline of Richmond, Virginia

Memory Recall Mode

There is one more shooting mode left to discuss, apart from Movie mode, which I will discuss in CHAPTER 8. This last mode, called Memory Recall, is an extremely convenient and powerful tool that gives you expanded options for your photography.

When you turn the Mode dial to the MR position (shown in FIGURE 3-46) and then select one of the three groups of settings that can be stored there, you are, in effect, selecting a custom-made shooting mode that you have created yourself with your own favorite settings. You can set up the camera just as you want it—with stored

Figure 3-46.
Memory Recall

values for items such as shooting mode, shutter speed, aperture, zoom amount, white balance, ISO, and other menu settings—and then recall all of those values instantly just by turning the Mode dial to the MR position and selecting option 1, 2, or 3 on the Memory Recall screen. And with the RX100 II, unlike some other camera models, you can store settings for any shooting mode, including the Auto and Scene modes.

Here is how this works. First, take your time and set up the camera with all of the settings you want to be able to recall. For example, suppose you are going to do street photography. You may want to use a fast shutter speed, say 1/250 second, in black and white, at ISO 400, using continuous shooting with autofocus, Large and Fine JPEG images, and shooting in the 4:3 aspect ratio.

The first step is to make all of these settings. Set the Mode dial to Shutter Priority and use the Control wheel to set a shutter speed of 1/250 second. Then press the Menu button to call up the Shooting menu and, on the first screen, select L for the image size, 4:3 for Aspect Ratio, and Fine for Quality. Then move to the second screen and choose Continuous Shooting for Drive Mode and Continuous AF for Focus Mode. On the third screen, set ISO

to 400, then scroll down three items to White Balance and select Daylight. Next, scroll down two more positions to the Creative Style option, and select the B/W setting for black and white. You also may want to push the Zoom lever all the way to the left for wide-angle shooting. You can set any other available menu options as you wish, but the ones listed above are the ones I will consider for now.

Once these settings are made, press the Menu button (if the menu isn't still on the screen) to call up the Shooting menu, and navigate to the Memory item, shown in FIGURE 3-47, which is the final item on the last screen of the Shooting menu.

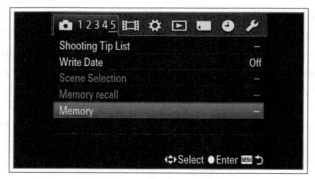

Figure 3-47. Memory Option on Shooting Menu

After you press the Center button, you will see a screen like the one in FIGURE 3-48, showing icons and values for all of the settings currently in effect and the numbers 1, 2, and 3 at the upper-right corner of the display. The message "Select Register" appears at the upper left of the screen, indicating that you can now assign all of the settings shown on the display to register number 1, 2, or 3 of the Memory Recall mode. In the example shown here, the number 2 is highlighted. Now press the Center button, and you will have selected register 2 to store all of the settings you just made.

Note that there is a short gray bar at the right side of the Memory screen shown in FIGURE 3-48. That bar indicates that you can

scroll down through other screens to see additional settings that are in effect, such as ISO Auto Maximum and Minimum, Clear Image Zoom, AF Illuminator, SteadyShot, and several others. Use the Up and Down buttons to scroll through those screens.

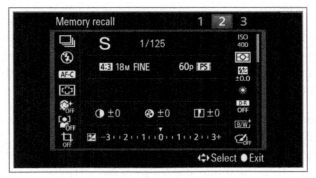

Figure 3-48. Memory Menu Option Screen

Next, to check how this worked, try making some very different settings, such as setting the camera for Manual exposure with a shutter speed of 1 second, Creative Style set to Vivid, Continuous Shooting turned off, the Zoom lever moved all the way to the right for telephoto, and Quality set to Raw. Then turn the Mode dial back to the MR position, make sure the number 2 for Register 2 is highlighted, and press the Center button to exit back to the shooting display. You will see that all of the custom settings you made have instantly returned, including the zoom position, shutter speed, and everything else.

This is a wonderful feature, and it is more powerful than similar options on some other cameras, which can save menu settings but not values such as shutter speed and zoom position, or can save settings only for the less-automatic shooting modes, but not the Scene and Auto modes. What is also quite amazing is that if you now switch back to Manual exposure mode, the camera will restore the settings that you had in that mode before you turned to the MR mode. (The position of the zoom lens will not revert to where it was, though.)

Note that this mode is very versatile because you can store settings for any shooting mode, including Program, Aperture Priority, Shutter Priority, Manual Exposure, and even the Scene, Auto, Sweep Panorama, and Movie modes. You can store settings from the Shooting menu and the Movie menu, as well as the Aperture, Shutter Speed, Exposure Compensation, and optical zoom settings. So, for example, you could set up one of the three memory registers to recall Scene mode, set to the Macro setting, with the lens zoomed back to its wide-angle position. In that way, you could be ready for closeup shooting on a moment's notice.

The Memory Recall feature is especially useful with a camera as small as the RX100 II because there are not many physical controls and it can be cumbersome to change settings when you have to dig into the menu system to make settings for ISO, white balance, focus mode, and other basic items. With one twist of the Mode dial and the press of a button, you can call up a complete group of settings tailored for a particular type of shooting. It is worth your while to experiment with this feature and develop three groups of settings that work well for your shooting needs.

CHAPTER 4:
Shooting Menu

M uch of the power of the Sony RX100 II lies in the many options on the Shooting menu, which provides you with numerous areas of control over the appearance of your images and how you capture them. Depending on your preferences, you may not have to use this menu too much. You may prefer to use the camera's physical controls, with which you can make many settings, or you may want to take advantage of the Scene mode or Auto mode settings, which choose many options for you. However, it's nice to know that you have this degree of control over many functions available if you want it, and it is useful to understand what types of settings you can make. In addition, with the RX100 II, more than with many other compact cameras, you can control a fair number of settings on the Shooting menu even when the camera is set to one of the Scene or Auto modes. Therefore, you will be giving up a lot of potential control over your photographic results if you avoid using this powerful menu.

The Shooting menu is easy to use once you have played with it a bit. The available menu options can change depending on the setting of the shooting Mode dial on top of the camera. For example, if the camera is set to Intelligent Auto mode, the Shooting menu options are fairly limited because that mode is for a user who wants the camera to make many decisions without input. If the camera is set to Sweep Panorama mode, the available Shooting menu options also are quite limited because of the

specialized nature of that mode, which is designed for creating panoramas. For the following discussion, I'm assuming you have the camera set to Program mode because with that mode you have access to most of the options on the Shooting menu.

Turn the Mode dial on top of the camera to P, which represents Program mode, as shown in FIGURE 4-1.

Enter the menu system by pressing the Menu button and move through the numbered screens of the menu system by pressing the Right button on the Control wheel. With each press of that button,

Figure 4-1.
Program Mode

the small orange line (cursor) at the top of the screen moves underneath a number beside an icon.

When the menu system first appears, the cursor should sit beneath the number 1 beside the camera icon, which represents the Shooting menu, as shown in FIGURE 4-2.

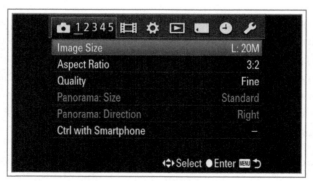

Figure 4-2. Shooting Menu: First Screen

As you keep pressing the Right button, the cursor will move through all five screens of that menu.

As you continue to move the cursor through the menu screens with the RX100 II set to shooting mode, after the Shooting menu

comes the Movie menu, marked at the top by a movie-film icon. Then comes the Custom menu, marked by a gear icon, followed by the Playback menu, headed by an icon with a playback triangle. The last three menus are the Memory Card Tool, Clock Setup, and, finally, the Setup menu, marked by a wrench icon. In this chapter, I am going to discuss only the Shooting menu; the other menu systems will be discussed in CHAPTER 6 (Playback), CHAPTER 7 (Custom, Memory Card Tool, Clock Setup, and Setup), and CHAPTER 8 (Movie).

The Shooting menu contains numerous options divided into five numbered screens. In most cases, each option (such as Image Size) occupies one line, with its name on the left and its current setting (such as L: 20M) on the right. In other cases (such as Shooting Tip List, Scene Selection, and Memory), there may be only a small dash on the right side of the screen, meaning that you have to press the Center button (middle of the Control wheel) to get access to further options, or that the selection is not currently applicable. For example, if the camera is set to Program mode, the Scene Selection item on the fifth screen of the Shooting menu will be followed by a dash because no Scene type can be selected when the camera is set to Program mode.

You also will see that some items on the menu screens are dimmed, as the Scene Selection and Memory Recall options are in FIGURE 4-3, for example. This means that those options are not available for selection in the current context. In this case, the camera was set to Program mode; the Scene Selection option is available only when the Mode dial is set to Scene mode, and the Memory Recall option is available only when the Mode dial is set to Memory Recall mode.

Figure 4-3. Dimmed Options on Shooting Menu

To follow the discussion below of the options on the Shooting menu, leave the shooting mode set to Program, which gives you access to all but a few options on the Shooting menu. (I'll also discuss the options that are available in other modes as I come to them.) I'll start at the top of screen 1 and discuss each option on the way down the list for each of the five screens.

Image Size

This first option on the Shooting menu lets you select the resolution, or pixel count, of your still images. The Image Size setting is related to the next two entries on the menu, Aspect Ratio and Quality, to control the overall appearance and "quality" of your images, in a broad sense.

The Image Size setting itself controls only the size in pixels of the image that is recorded by the camera. The Sony RX100 II has an unusually large digital sensor for a camera of its size, and that sensor has a high maximum resolution, or pixel count. The sensor is capable of recording a still image with 5472 pixels, or individual points of light, in the horizontal direction and 3648 pixels vertically. When you multiply those two numbers together, the result is about 20 million pixels, often referred to as megapixels, or MP, or M.

The resolution of the still images is important mainly when it comes time to enlarge or print your images. If you need to produce large prints (say, 8 by 10 inches or 20 by 25 cm), then you should select a high-resolution setting for Image Size. You also should choose the largest Image Size setting if you believe you may need to crop out a small portion of the image and enlarge it for closer viewing. For example, if you are shooting photos of wildlife and the animal or bird you are interested in is in the distance, you may need to enlarge the image digitally to see that subject in detail. In that case, also, you should choose the highest setting for Image Size.

The available settings for Image Size with the RX100 II are L, M, S, and VGA, for Large, Medium, Small, and VGA, as shown in FIGURE 4-4.

Figure 4-4. Image Size Menu Option

When you select one of the first three of these options from the Shooting menu, the camera will display a setting such as L: 20M, meaning Large: 20 megapixels. The number of megapixels will change depending on the setting for Aspect Ratio, discussed below. This change occurs because when the shape of the image changes, the number of horizontal pixels or the number of vertical pixels changes also to form the new shape. For example, if the Aspect Ratio setting is 3:2, the maximum number of pixels is used because 3:2 is the aspect ratio of the camera's sensor. However,

if you set Aspect Ratio to 16:9, the number of horizontal pixels (5472) stays the same, but the number of vertical pixels is reduced from 3648 to 3080 to form the 16:9 ratio of horizontal to vertical pixels. When you multiply those two numbers (5472 and 3080) together, the result is about 17 million pixels, which the camera states as 17M, as shown in FIGURE 4-5.

Figure 4-5. Image Size Option When Aspect Ratio Is Set to 16:9

The VGA option, the smallest size possible, is available only if the Aspect Ratio is set to 4:3. Otherwise, this option is dimmed and cannot be selected. VGA stands for video graphics array, the designation used for older-style computer screens, which have a 4:3 aspect ratio. The pixel count for this setting is very low— just 640 by 480 pixels, yielding a resolution of 0.3 M, much less than one megapixel. This very small size is suitable if you need to send images by e-mail or need to store a great many images on a memory card.

In my view, one of the few reasons to choose an Image Size smaller than L would be if you were running out of space on your memory card and had to keep taking pictures in an important situation. TABLE 4-1 shows approximately how many images can be stored on an 8 GB memory card for various settings.

Table 4-1. **Number of Images That Fit on an 8 GB Card (Image Size vs. Quality at 3:2 Aspect Ratio)**

	Large	Medium	Small
Raw & JPEG	243	284	309
Raw	368	-----	-----
Fine	719	1,257	1,937
Standard	1,238	1,969	2,793

As you can see, if you are using an 8 GB memory card, which is a fairly reasonable size nowadays, you can fit about 243 images on the card even at the maximum settings of 3:2 for Aspect Ratio, Large for Image Size, and Raw & JPEG for Quality. If you limit the image quality to Fine, with no Raw images, you can fit about 719 images on the card. If you reduce the Image Size setting to Small, you can then store 1,937 images. I am unlikely ever to need more than about 200 or 300 images in any one session. And, of course, I can use a larger memory card or multiple memory cards.

If space on your memory card is not a consideration, then I recommend you use the L setting at all times. You never know when you might need the larger-sized image, so you might as well use the L setting and be safe. Your situation might be different, of course. If you were taking photos purely for a business purpose, such as making photo identification cards, you might want to use the Small setting to store the maximum number of images on a memory card and reduce expense. For general photography, though, I rarely use any setting other than L for Image Size. (One exception could be when I want to increase the range of the optical zoom lens without losing image quality; see the discussion of Clear Image Zoom and related topics later in this chapter.)

One more note: when Quality, discussed later in this chapter, is set to Raw, the Image Size option is dimmed and unavailable for selection because you cannot select an image size for Raw images;

they are always at the maximum size, as is shown above on the table of images that can fit on a memory card.

Aspect Ratio

This second option on the Shooting menu lets you choose the shape of your still images.

Figure 4-6. Aspect Ratio Menu Option

The choices are the default of 3:2, as well as 16:9, 4:3, and 1:1, as shown in FIGURE 4-6. As I discussed briefly under Image Size above, these numbers represent the ratio of the units of width to the units of height. For example, with the 16:9 setting, the image is 16 units wide for every 9 units of height. The aspect ratio that uses all pixels on the image sensor is 3:2; with any other aspect ratio, some of the pixels are cropped out. So, if it matters to you to record every possible pixel, you should use the 3:2 setting. If you shoot using the 3:2 aspect ratio, you can always alter the aspect ratio of the image later in editing software such as Photoshop by cropping away parts of the image. However, if you want to have your images in a certain shape and don't plan to do post-processing in software, the aspect ratio settings of this menu item may be just what you want. It's also helpful to set the aspect ratio if you know what shape you want the final image to be in, so you can compose your image in the camera using the appropriate aspect ratio on the display.

The RX100 II provides more options in this area than many other cameras do, so let's go through the list of possibilities. After each of the aspect ratios discussed below, I am including an image I took of a mural using that setting from the same location at the same time, to give a general idea of what the different aspect ratios look like.

Figure 4-7. Aspect Ratio Set to 3:2

The default 3:2 setting, which was used for FIGURE 4-7, includes the maximum number of pixels, and it is the same ratio used by traditional 35mm film. This aspect ratio can be used without cropping to make prints in the common U.S. size of 6 inches by 4 inches (15 cm by 10 cm).

Figure 4-8. Aspect Ratio Set to 16:9

The 16:9 setting, illustrated in FIGURE 4-8, is normally considered to be the "widescreen" mode, like that found on many modern HD television sets. You might use that setting when you plan to show your images on an HDTV set. Or, it might be suitable for a particular composition in which the important subject matter is stretched out in a horizontal arrangement. As you can see in the sample images, with this setting some pixels are cropped out at the top and bottom, though none are lost at the left or right.

Figure 4-9. Aspect Ratio Set to 4:3

The 4:3 setting, shown in FIGURE 4-9, is in the shape of a traditional (non-widescreen) computer screen, so if you want to view your images on that sort of display, this may be your preferred aspect ratio. Also, as was discussed earlier in connection with Image Size, if you want to use the VGA setting for Image Size, the camera must be set to the 4:3 aspect ratio. With this setting, some pixels are lost at the left and right sides of the image.

The 1:1 ratio, illustrated in FIGURE 4-10, represents a square shape, which some photographers prefer because of its symmetry and because the neutrality of the shape leaves open many possibilities for composing the images. With the 1:1 setting, the camera crops pixels from the left and right sides of the image to achieve the final shape.

Figure 4-10. Aspect Ratio Set to 1:1

The Aspect Ratio setting is available in all shooting modes except Sweep Panorama. However, although you can set Aspect Ratio when the camera is in Movie mode (Mode dial turned to movie-film icon), that setting will have no effect until you switch to another mode, such as Program, in which that setting can be made. This is because when the Mode dial is set to the Movie position, you cannot take still images except during the recording of a movie, and those images will have the same aspect ratio as the movie.

Quality

The Quality setting, below Aspect Ratio, is one of the most important Shooting menu options. The choices are Raw, Raw & JPEG, Fine, and Standard, as shown in FIGURE 4-11.

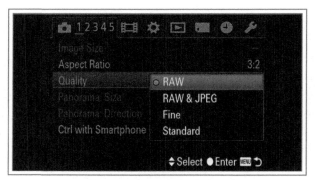

Figure 4-11. Quality Menu Option

The term "quality" in this context concerns the way in which digital images are processed. In particular, JPEG (non-Raw) images are digitally "compressed" to reduce their size without losing too much information or detail from the picture. However, the more an image is compressed, the greater the loss of detail and clarity in the image. Raw files, which are really in a class by themselves, are the least compressed of all and have the greatest level of quality, though they come with some complications, as discussed below. All other (non-Raw) formats used by the RX100 II (as with most similar cameras) are classified as JPEG, which is an acronym for Joint Photographic Experts Group, an industry group that created the JPEG standard. The JPEG files, in turn, come in two varieties on the RX100 II: Fine and Standard. The Fine setting provides the least compression; images captured with the Standard setting undergo more compression, resulting in smaller files with somewhat reduced quality.

Here are some guidelines about using these settings. First, you need to choose between Raw and JPEG images. Raw files are larger than other files, so they take up more space on your memory card, and on your computer, than JPEG files. But Raw files offer some great advantages over JPEG files. When you shoot in the Raw format, the camera records as much information as it can about the image and preserves that information in the file that it saves to the memory card. Then, when you open the Raw

file later on your computer, you will have the ability to extract that information in various ways. This means, for example, that you can change the exposure or white balance of the image when you edit it on the computer, just as if you had changed your settings while shooting. In effect, the Raw format gives you what almost amounts to a chance to travel back in time to improve some of the settings that you didn't get quite right when you pressed the Shutter button.

Raw is not a cure-all; you cannot fix bad focusing or really excessive underexposure or overexposure. But you can improve exposure-related issues such as brightness and white balance very nicely with your Raw-processing software. You can use the Image Data Converter software that comes with the RX100 II to view or edit Raw files, and you also can use other programs, such as Adobe Camera Raw, that have been updated to handle Raw files from this camera.

Using Raw can have some disadvantages, depending on your needs. As noted above, the files take up a lot of storage space on your memory card or computer; Raw images taken with the RX100 II are about 20 MB in size, while Large JPEG images I have taken have been between about 2 to 10 MB, depending on the settings used. Also, Raw files have to be processed on a computer; you can't take a Raw file and immediately send it by e-mail or print it on photo paper; you first have to use Raw-processing software to convert it to JPEG, TIFF, PSD, or some other standard format for printing and manipulating digital photographs. If you are pressed for time, you may not want to take that extra step. Finally, some features of the RX100 II are not available when you are using the Raw format, such as the Auto HDR, Digital Zoom, and Picture Effect settings on the Shooting menu.

If you're undecided as to whether to use Raw or JPEG, you have the option of selecting Raw & JPEG, the second choice for the Quality menu item. With that setting, the camera records both a Raw and a JPEG image when you press the Shutter button.

The advantage with that approach is that you have a Raw image with the highest quality and with the ability to do extensive post-processing manipulation, and you also have a JPEG image that you can use more quickly for viewing, e-mailing, printing, and the like. The disadvantages are that this setting consumes your storage space more quickly than saving your images in just Raw or JPEG format, and it can take the camera longer to store the images, so there may be a short delay before you can take your next shot or a slowdown in the rate of continuous shooting, if you are using that option.

When you select Raw & JPEG, you can still select an Image Size setting that will apply only to the JPEG image; the Raw image, as noted earlier, is always of the maximum size. You cannot select a Quality setting for the JPEG image with the Raw & JPEG selection; the JPEG image will always be fixed at the Fine setting for Quality.

In short, your best bet for preserving the quality of your images and your options for post-processing and fixing exposure mistakes later is to choose Raw files. However, if you want to use features such as Sweep Panorama mode, some Scene mode types such as Anti Motion Blur, the Picture Effect menu option, and others, which are not available with Raw files, then choose JPEG. If you do choose JPEG, I strongly recommend that you choose the Large size and Fine quality, unless you have an urgent need to conserve storage space on your memory card or on your computer. If you want Raw quality and are not concerned about storage space or speed of shooting, choose Raw & JPEG. However, you will still not be able to use Picture Effect and some other options.

Panorama Size and Panorama Direction

The next two commands on the Shooting menu are available only when the Mode dial is set to Sweep Panorama mode. I discussed these settings in CHAPTER 3, in connection with the discussion of that shooting mode. Note that when the Control ring is set to

its Standard setting through the Custom menu, you can set the panorama direction by turning that ring (unless you are using manual focus or DMF, which take over the use of the ring).

Control with Smartphone

This last option on the first screen of the Shooting menu is for use with the built-in Wi-Fi features of the RX100 II. I will discuss those features in more detail in CHAPTER 9. This menu option is what you use to set up the camera to be controlled remotely by a smartphone or tablet, either an Apple iPhone or iPad, or an Android device. The basic steps for using this option are as follows:

For an Apple Device

1. On the RX100 II, select Control with Smartphone on the Shooting menu.

2. On the Apple device, go to Settings, select Wi-Fi, and select the Wi-Fi network that appears on the screen of the RX100 II. If this is the first time this connection is made, you will have to enter the password that appears on the camera's screen.

3. On the Apple device, open the PlayMemories Mobile app.

4. Use the options in that app to control the camera.

For an Android Device That Has NFC Capability

1. On the RX100 II, select Control with Smartphone on the Shooting menu.

2. Touch the NFC points of the camera and the phone or tablet together.

3. On the Android device, open the PlayMemories Mobile app if necessary. (The app may start automatically.)

4. Use the options in that app to control the camera.

For more details about the above steps, see CHAPTER 9.

Drive Mode

This first option on the second screen of the Shooting menu gives you access to the continuous-shooting features of the RX100 II, a powerful set of capabilities for shooting bursts of images, bracketing exposures, using the self-timer, and other functions. You can also get access to this menu option by pressing the Drive Mode button (Left button), as discussed in CHAPTER 5.

When you highlight this menu option and press the Center button, a vertical menu appears at the left of the screen as shown in FIGURE 4-12, with eight choices represented by icons: Single Shooting, Continuous Shooting, Speed Priority Continuous Shooting, Self-timer, Self-portrait Timer, Self-timer (Continuous), Exposure Bracketing, and White Balance Bracketing. (You have to scroll down to see the last four choices.)

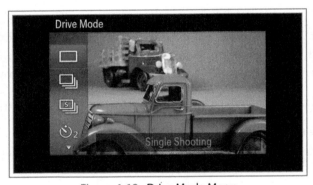

Figure 4-12. Drive Mode Menu

The details for each of these Drive Mode settings are discussed below. Before discussing them, though, I will provide a brief introduction to the concept of continuous shooting.

With film cameras, continuous shooting involves the use of a special motor to advance the film rapidly, and often the use of an extra-large cassette to hold a large quantity of film. This setup is bulky and expensive, and of course, shooting and developing large numbers of exposures is itself quite expensive. With digital

cameras like the RX100 II, expense is not a factor. Continuous shooting is available at your fingertips whenever you want to take advantage of it.

The usefulness of shooting rapid bursts of exposures is more obvious in some contexts than in others. For example, when you're shooting sports events, it's clearly worthwhile to fire off a swift sequence of shots to catch the instant when a baseball player tags a runner heading for home plate, or to catch a soccer ball as it bounces off a player's head toward the goal. But continuous shooting also can be helpful in more ordinary situations, such as when you're taking pictures of children at play. You have a better chance of capturing a fleeting smile, laugh, or cute gesture if you keep the exposures rolling. And even when your subject is not moving noticeably at all, it can be advantageous to take multiple shots. For example, when you're taking a portrait, there may be subtle changes in the subject's expression, in the way sunlight falls on a cheek, or in the subject's posture. Taking a series of shots gives you some insurance against coming away from the photo session with no winning images.

With that introduction, I'll discuss the variety of continuous-shooting options the RX100 II provides. All of the settings (except the first one, for single shots, and some of the self-timer options) offer ways to take multiple shots with a press (or press and hold) of the Shutter button. Neither of the two burst-shooting options is available when the Mode dial is set to the Movie or Sweep Panorama position. Also, burst shooting is not available with any of the Scene mode settings except Sports Action. (With that setting, single shooting is not available.) Following are details for each of the options on the Drive menu.

SINGLE SHOOTING

This is the normal mode for shooting images. Select this option, the top choice on the Drive Mode menu, when you want to turn off all continuous shooting. Note that in some cases, having

one of the continuous Drive Mode options selected will make it impossible to make other settings, such as Soft Skin Effect and Long Exposure Noise Reduction. So, if you find you cannot make a certain setting, it can be helpful to select single shooting to see if that fixes the problem.

As noted earlier, this option is not available with the Sports Action setting of Scene mode.

CONTINUOUS SHOOTING

This second option on the Drive Mode menu, highlighted in FIGURE 4-13, gives the RX100 II the ability to shoot a continuous series of still images as you hold down the Shutter button.

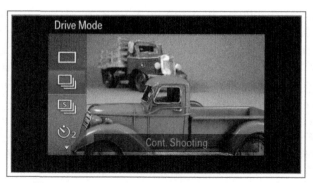

Figure 4-13. Continuous Shooting Menu Option

This capability is useful in many contexts, from shooting an action sequence at a sporting event to taking a series of shots of a portrait subject to capture changing facial expressions.

The Continuous Shooting option is the first of two types of general burst shooting available with the RX100 II. When you select this choice, the camera will shoot continuously when you hold down the Shutter button, and if you have autofocus enabled, it will adjust its focus (but not the exposure) with each shot.

Depending on the conditions, including lighting and other settings on the camera and the speed of the memory card, the

rate of burst shooting can vary considerably. When conditions are optimal, the camera can shoot at roughly 2 fps using this option. I tested this option using a Lexar Professional 128 GB SDXC card, Class 10, one of the fastest cards available. With Quality set to Fine, the camera fired a long series of shots at a rate between 1 and 2 fps. With Quality set to Raw & JPEG, the camera started shooting its burst at a similar pace but shooting slowed markedly after about 15 shots. With slower memory cards, the camera shot at slower speeds.

Although you can turn on the flash when Continuous Shooting is selected, and the camera will actually take a series of shots as you hold down the Shutter button, the time between shots will be several seconds because the flash cannot recycle quickly enough to take a rapid series of shots. The Image Size setting does not appear to affect the shooting rate.

The speed of this first continuous-shooting mode is not very great compared to that of the Speed Priority option, discussed below. However, being able to take a stream of shots with focus being adjusted for each one can be worth the reduction in speed when your subject is moving or you need to focus on subjects at varying distances.

This first option also gives you the ability to do time-lapse photography, though in a limited way. That technique is discussed in APPENDIX B.

SPEED PRIORITY CONTINUOUS SHOOTING

If you need to shoot a series of images at the fastest rate possible, then the Speed Priority Continuous Shooting option, highlighted in FIGURE 4-14, is the one to choose.

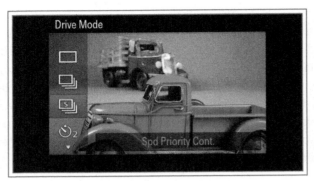

Figure 4-14. Speed Priority Continuous Shooting Option

With this selection, the camera will capture images at a rate up to 10 fps. The trade-off for speed is that the camera will not adjust its focus between shots (and, as with the first continuous-shooting mode, it will not adjust exposure either).

Also, the Quality setting affects the efficiency of the Speed Priority setting. When I used my fastest memory card and set the camera to take either Raw & JPEG or just Raw shots, the continuous shooting came to a complete stop after the first rapid burst of about 10 shots and then slowed to a pace of less than 1 fps. With Quality set to Fine, the camera took one rapid burst of about 15 shots and then eased off to a slower pace of about 2 shots per second. As with the standard continuous shooting option, using the flash slows down the shooting drastically. Also, using slower memory cards has a noticeable impact on the speed of continuous shooting.

Once you have finished shooting a burst of shots, you will notice that it can take the camera quite awhile to record them all to the memory card; the LCD display will remain dark while the camera writes the images to the card.

Figure 4-15. Image Taken with Speed Priority Continuous Shooting Setting

FIGURE 4-15 is one of a series of images I took using this setting, which can be very useful for street photography. When I saw these bicycle riders approaching, I fired off a quick burst and captured several clear images as they rode past.

SELF-TIMER

The next icon down on the menu of Drive Mode options represents the self-timer, as shown in FIGURE 4-16.

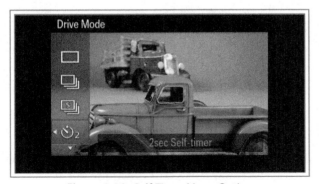

Figure 4-16. Self-Timer Menu Option

The self-timer is useful when you need to be the photographer and also appear in a group photograph. You can place the RX100 II on a tripod, set the timer for 10 seconds, and then insert yourself into the group before the shutter clicks. The self-timer also is

helpful when you are taking a picture under conditions in which you don't want to cause blur by jiggling the camera as you press the Shutter button. For example, when you're taking a macro shot very close to the subject, the focusing can be very critical, and any bump to the camera could cause motion blur. Using the self-timer means the camera has a chance to settle down after the Shutter button is pressed, before the image is actually recorded.

Once you select the self-timer option, you are presented with two choices: 10 seconds and 2 seconds. When the Self-timer option is highlighted, just press the Left or Right button on the Control wheel to choose between these options. Once you have made this selection, the self-timer icon will appear in the upper-left corner of the display with the chosen number of seconds (10 or 2) displayed next to the icon, as shown in FIGURE 4-17. (If you don't see the icon, press the Display button [Up button] until the screen with the various shooting icons appears.)

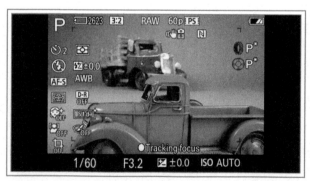

Figure 4-17. Self-Timer Icon Displayed on Shooting Screen

Once the self-timer is set, when you press the Shutter button to take a picture, the timer will count down for the specified number of seconds and then take the picture. The reddish lamp on the front of the camera will blink, and the camera will beep during the countdown.

Also, don't forget that the camera has several other potentially very useful timer functions, besides this traditional self-timer. Those features are discussed next.

Self-Portrait Timer

The next option on the Drive Mode menu, Self-portrait timer, as shown in Figure 4-18, is another variety of self-timer. In this case, instead of choosing a time interval of 10 seconds or 2 seconds, you have the choice of setting the Self-portrait timer to take a picture of one person or two people. As was the case with the self-timer, you use the Left and Right buttons to make this selection. Once the selection is made, the camera will wait until it detects the chosen number of human faces, and then it will fire the shutter.

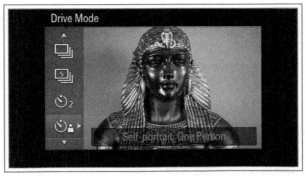

Figure 4-18. Self-Portrait Timer Menu Option

For example, you can set the Self-portrait timer to look for one person, then point the camera at yourself. Once the camera detects your face, it will initiate the 2-second self-timer operation. The lamp on the front of the camera will blink, and the camera will beep as it counts down and then will snap an image of your face. Similarly, if you have set the camera to look for two people, it will take the picture after detecting two faces. In my experience, you need to have the lens zoomed back to its wide-angle position for this feature to work.

The idea with this option is that it is difficult to take a self-portrait because you cannot see when your face is properly framed in the display. With this feature, the camera verifies that your face (with or without a companion face) is in the picture, and then captures the image. I don't have much interest in taking self-portraits, so I haven't found that much use for this capability. However, it could be useful when you are photographing children: by setting the camera on a tripod and telling the child that the camera will automatically take a picture when he or she walks up to a certain point and looks toward the camera might win the child's interest and result in an interesting shot. You may find other uses for the feature as well, so don't consider it to be solely a way to take your self-portrait.

Self-Timer (Continuous)

The next item down on the Drive Mode menu, shown in FIGURE 4-19, gives you another variation on the self-timer.

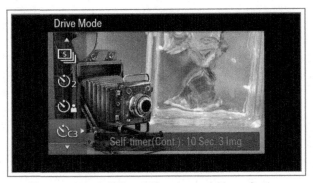

Figure 4-19. Self-Timer (Continuous) Menu Option

In this case, the menu option lets you set the timer to take multiple shots after the timer counts down. The delay for this timer is set at 10 seconds and cannot be changed. Using the Left and Right buttons, you can set the camera to take either three or five shots after the delay. This option can be useful when you are taking a group photo; when a series of shots is taken, you are increasing your chances of getting at least one shot in which no

one's eyes are closed and everyone is looking at the camera and smiling. You can choose any settings you want to for Image Size and Quality, including Raw & JPEG, and you will still get three rapidly fired shots, though the speed of the shooting will decrease slightly at the highest Quality settings. You cannot use the Continuous AF setting for Focus Mode with this option.

EXPOSURE BRACKETING

This next option on the Drive Mode menu, shown in FIGURE 4-20, lets you set up the camera to take three images continuously with one press of the Shutter button but with different exposure levels for each image; thereby, giving you a greater chance of having one image that is properly exposed. This feature also can be used for taking three exposures at different values that you can later combine in editing software to create a composite HDR image.

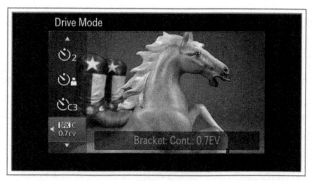

Figure 4-20. Exposure Bracketing Menu Option

Once you highlight this option, you will see a horizontal triangle indicating that you can select either 0.3 EV or 0.7 EV using the Left and Right buttons, as with the self-timer options discussed above. These numbers represent the difference in EV, or exposure value, between the three exposures that the camera will take. For example, if you select 0.7 EV as the interval, the camera will take three shots—one at the metered exposure level; one at a level 0.7 EV (or stop) below that, resulting in a darker image; and one at a level 0.7 EV above that, resulting in a brighter image.

Once you have set this option as you want it and composed your shot, press the Shutter button and the camera will take three shots in rapid succession. In this case, unlike the situation with burst shooting, you do not have to hold down the Shutter button because the camera is programmed to make three exposures no matter how long the button is held down.

The first exposure will be at the metered value, the second one underexposed by the selected interval, and the third one overexposed to the same extent. You cannot turn on the flash when using this option. You can use exposure compensation, in which case the camera will use the image with exposure compensation as the base level, and then take exposures that deviate under and over the exposure of the image with exposure compensation.

Neither of the bracketing options—exposure or white balance—is available in the Intelligent Auto or Superior Auto shooting modes.

WHITE BALANCE BRACKET

The final option at the bottom of the Drive Mode menu, White Balance Bracket, seen in FIGURE 4-21, works in the same way as Exposure Bracketing, except that the value that is varied for the three shots is white balance rather than exposure.

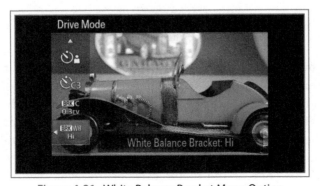

Figure 4-21. White Balance Bracket Menu Option

Using the Left and Right buttons, you first select either Low or High for the amount of deviation from the normal white balance setting. The camera will then take a series of three shots—one at the normal setting; the next one setting a lower color temperature, resulting in a "cooler," more-bluish image; and the last one setting a higher color temperature, resulting in a "warmer," more-reddish image. See the discussion of the White Balance setting later in this chapter for more information about color temperature. When you use this form of bracketing, unlike Exposure Bracketing, you will hear only one shutter sound because the camera takes just one image and then electronically creates the other two exposures with the different white balance values.

Flash Mode

In CHAPTER 2, I discussed the use of the RX100 II's built-in flash, which is controlled with the Flash Mode menu option. As I discussed earlier, that menu option can be reached by pressing the Flash button, which is the Right button on the Control wheel. Flash Mode also is the second option on the second screen of the Shooting menu.

There are five options on the Flash Mode menu—Flash Off, Autoflash, Fill-flash, Slow Sync, and Rear Sync—the first four of which are shown in FIGURE 4-22.

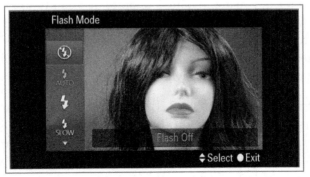

Figure 4-22. Flash Mode Menu in Program Mode

There is no single shooting mode in which all five of the options are available. Here is a brief summary of the options I discussed in CHAPTER 2, followed by a discussion of the options I did not discuss there.

FLASH OFF

If you want to make sure the flash will not fire, choose Flash Off. This is a good choice when you are in a museum or other location where it would be inappropriate or embarrassing for the flash to fire, or when you know you will not want to use the flash. It also could be helpful to avoid depleting a battery that is running low. This option is available in all shooting modes except for the Night Portrait setting of Scene mode.

AUTOFLASH

When you select the Autoflash option, you are leaving it up to the camera's programming to determine whether or not the flash should be fired. The camera will analyze the lighting and other aspects of the scene and decide whether to use the flash without any further input from you. This selection is available only in the Intelligent Auto and Superior Auto modes, and with the Portrait and Macro settings of Scene mode.

FILL-FLASH

With Fill-flash, you are making a definite decision to use flash. No matter what the lighting conditions are, if you choose this option, the flash will fire. This is the setting to use when the sun is shining and you need to soften shadows on a subject's face, or when you need to correct the lighting when a subject is backlit.

For example, for FIGURE 4-23, I took two shots of a mannequin outdoors: one using Flash Off (top image) and one using Fill-flash (bottom image). Although the differences between the two images are not that dramatic, you probably can see that the bottom image, in which flash was used, has additional highlights on

the mannequin's hair and lips, and that the skin tone is slightly altered. (For a more obvious example of the effects of Fill-flash, see FIGURE 2-18.)

With this option, the camera uses what could be called "Front Sync," as opposed to Rear Sync, the final option on the Flash Mode menu, which is discussed below. The Fill-flash option is available for selection in all shooting modes except Movie and Sweep Panorama, and some Scene settings.

Figure 4-23. Top Image: Flash Off, Bottom Image: Fill-Flash

SLOW SYNC

Slow Sync is one of the settings I did not discuss in detail in CHAPTER 2. This option is designed for use when you are taking a flash photograph of a subject at night or in dim lighting. With this setting, the camera uses a relatively slow shutter speed so that the ambient (natural) lighting will have time to register on the image. In other words, if you're in a fairly dark environment and fire the flash normally, it will likely light up the subject (say a person), but because the exposure time is short, the surrounding scene may be black. If you use the Slow Sync setting, the slower shutter speed allows the surrounding scene to be visible also.

I took the two images in FIGURE 4-24 with identical room lighting and camera settings, except that I took the top image with the flash set to Fill-flash and exposure set to f/4.9 at 1/500 second, and I took the bottom image with the flash set to Slow Sync, resulting in an exposure at f/4.9 for one full second. In the top image, the flash illuminated the doll in the foreground, but the background is dark. In the bottom image, the contents of the room behind the doll are illuminated by ambient light because of the much slower shutter speed.

When you use the Slow Sync setting, you should plan to use a tripod because, in many cases, the camera will choose a very slow shutter speed, in the range of three seconds or even longer. Also, note that you can choose Slow Sync even when the camera is set to Shutter Priority mode. If you do so, you should select a slow shutter speed because the whole point of this setting is to use a slow shutter speed to light the background with ambient light. If you set the camera to Shutter Priority mode, you can decide precisely which shutter speed to use, but it would not make sense to select a relatively fast speed, such as, say, 1/30 second. The same considerations apply for Manual exposure mode; the camera also will let you select Slow Sync for the Flash Mode setting in that shooting mode.

Figure 4-24. Top Image: Fill-Flash, Bottom Image: Slow Sync

REAR SYNC

The last setting on the Flash Mode menu is Rear Sync. This option is one you should not often need unless you encounter the particular situation it is designed for. If you don't activate this setting (that is, if you select any other flash mode in which the flash fires), the camera uses the unnamed default setting, which

could be called "Front Sync." In that case, the flash fires very soon after the shutter opens to expose the image. If you choose the Rear Sync setting instead, the flash fires later: just before the shutter closes.

The reason for using Rear Sync is to help you avoid a strange-looking result in some situations. This issue arises, for example, with a relatively long exposure, say one-half second, of a subject with lights, such as a car or motorcycle at night, moving across your field of view. With normal (Front) sync, the flash will fire early in the process freezing the vehicle in a clear image. However, as the shutter remains open while the vehicle keeps going, the camera will capture the moving lights in a stream extending in front of the vehicle. If, instead, you use Rear Sync, the initial part of the exposure will capture the lights in a trail that appears behind the vehicle, while the vehicle itself is not frozen by the flash until later in the exposure. With Rear Sync in this particular situation, if the lights in question are taillights that look more natural behind the vehicle, the final image is likely to look more natural than with the Front Sync (default) setting.

Figure 4-25. Top Image: Front Sync, Bottom Image: Rear Sync

The images in FIGURE 4-25 illustrate this concept using a remote-controlled model car with headlights and a taillight. I took both pictures using the RX100 II's flash, using an exposure

of 0.6 second in Shutter Priority mode. In the top image, using the normal (Fill-flash) setting, the flash fired quickly, and the light beam continued on during the long exposure to make the streaks of bright light appear in front of the car.

In the bottom image, using Rear Sync, the flash did not fire until the car had traveled to the left, overtaking the place where the lights had made their streaks visible. If you are trying to convey a sense of natural motion, the Rear Sync setting, as seen here, is likely to give you better results than the default setting.

A good general rule is to use Rear Sync only when you have a definite need for it. Using this option makes it harder to compose and set up the shot because you have to anticipate where the main subject will be when the flash finally fires late in the exposure process. But, in the relatively rare situations when it is useful, Rear Sync can make a dramatic difference. Rear Sync is available in the more advanced shooting modes: Program, Aperture Priority, Shutter Priority, and Manual Exposure.

Focus Mode

The Focus Mode option gives you four choices for the method the camera uses for focusing. This is one of the more important choices you can make for your photography.

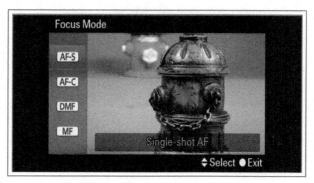

Figure 4-26. Focus Mode Menu

Following are details about each of the four selections, which are shown in FIGURE 4-26.

SINGLE-SHOT AF

The first option on the vertical menu that appears when you select Focus Mode is called Single-shot AF, designated by the AF-S icon on the menu. With this option, the camera does its best to focus automatically on the scene the camera is aimed at, using the focus area that is selected using the Autofocus Area menu option, discussed below. The RX100 II continuously adjusts its focus; you may hear faint sounds of the autofocus mechanism adjusting and see the image waver as the focus changes when you move the camera over subjects at differing distances.

With the Single-shot AF setting, the focus will be locked in when you press the Shutter button halfway down.

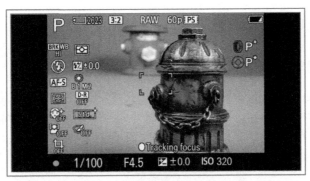

Figure 4-27. Green Bracket Indicating Focus Achieved

At that point, you will see one or more green focus brackets on the screen indicating the point or points where the camera achieved sharp focus, as shown in FIGURE 4-27, and you will hear a beep. In addition, a green disc in the lower-left corner of the display will light up steadily indicating that focus is confirmed. If focus cannot be achieved, the green disc will blink and no focus brackets will appear on the screen.

Once you have pressed the Shutter button halfway to lock focus (and exposure), you can use the locked focus on a different subject that is at the same distance as the one the camera originally locked its focus on. For example, if you have focused on a person at a distance of 15 feet (4.6 m), and then you decide you want to include another person or object in the scene, once you have locked the focus on the first person by pressing the Shutter button halfway down, you can move the camera to include the other person or object in the scene as long as you keep the camera at about the same distance from the subject. The focus will remain locked at that distance until you press the Shutter button the rest of the way down to take the picture.

Continuous AF

The next option for Focus Mode, Continuous AF, is designated by the AF-C icon on the menu. With this option, as with Single-shot AF, the RX100 II focuses continuously until you press the Shutter button. The difference with this mode is that the camera does not lock in the focus when you press the Shutter button halfway. Instead, the focus will continue to be adjusted if the subject moves or the distance to the subject changes through camera motion. You will not hear a beep or see any focus brackets to confirm focus. Instead, the green disc in the lower-left corner of the display will change its appearance to show the focus status.

If the green disc is surrounded by curved lines, as shown in FIGURE 4-28, that means focus is currently sharp but is subject to adjustment if needed.

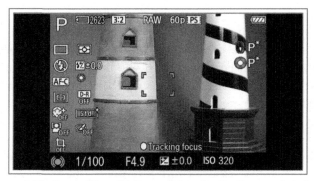

Figure 4-28. Green Disc with Curved Lines for Continuous Autofocus

If only the curved lines appear, that means the camera is still trying to achieve focus. If the green disc flashes, that means the camera is having trouble focusing.

This focusing mode can be useful when you are shooting a moving subject. With this option, you can get the RX100 II to fix its focus on the subject, but you won't have to let up the Shutter button to refocus; instead, you can keep holding the Shutter button down halfway until the instant when you want to take the picture; in this way, you may save some time, rather than having to keep starting the focus and exposure process over by pressing the Shutter button halfway again. However, this focus mode is by no means perfect on the RX100 II. The lens has a tendency to pulsate as it seeks focus, and it can take a long time to lock focus, especially at wider apertures. I generally prefer using Single-shot AF or DMF.

DMF

The third option for Focus Mode is DMF, which stands for Direct Manual Focus. This feature lets you use a combination of autofocus and manual focus, and it can be very useful in some situations. One area in which DMF can be helpful is when you are shooting an extreme close-up of a small object, when focusing can be critical and hard to achieve. You can choose the DMF feature, and then start the focusing process by pressing the Shutter

button halfway down. The camera will make its best attempt to focus sharply using the autofocus mechanism. Then you can use the camera's manual focusing mechanism (turning the Control ring, as discussed below in this chapter) to fine-tune the focus, concentrating on the parts of the subject that you want to be most sharply focused.

Another time DMF can be of considerable assistance is when you are shooting a scene that contains objects at varying distances, and you want to focus on one of the more distant ones. In this case, you can start out using manual focus, to get an approximate focus on the object you want to focus on, thereby letting the camera know which item to focus on. Then you can press the Shutter button halfway to let the camera take over and use autofocus to improve the sharpness of the focus.

If you have used DMF on other cameras, you may not expect to be able to start with either manual focus or autofocus. With some other systems, you are required to start with the camera's autofocus and then use manual focus. With the RX100 II, you can start with either manual focus or autofocus, whichever is best for the situation at hand.

I have increasingly been using DMF as my main focusing method because I can cause the camera to autofocus whenever I want to by pressing the Shutter button halfway, but the RX100 II doesn't use up its battery with constant focus adjustments, as is the case with AF-S. One drawback is that with DMF, the Control ring is dedicated to use for manual focus adjustment, so it cannot be used for any other function.

Another point to note is that when DMF is activated, you can turn on the Peaking feature on the Custom menu, as discussed below, and it will function for autofocus as well as for manual focus.

MANUAL FOCUS

The final selection on the Focus Mode menu, Manual Focus, is another important option to have available. As I indicated above in the discussion of DMF, there are various situations in which you may achieve sharper focus by adjusting it according to your own judgment rather than by relying on the camera's autofocus system. Those situations include shooting extreme close-ups, when focus is critical; shooting a group of objects at differing distances, when the camera will not know which one to focus on; or shooting through a barrier such as a wire fence, which may interfere with focusing.

Also, manual focus gives you the freedom to use a soft focus effect purposely. As I will discuss later in this chapter, the RX100 II includes a setting on the Picture Effect menu called "Soft Focus," which imparts a pleasing softness to your image. If you would rather achieve this sort of effect on your own by controlling the focusing directly, you can set the camera for manual focus and defocus all or part of the subject in precisely the way you want.

Using manual focus with the RX100 II is a pleasure because of the way the controls are set up. All you have to do is turn the Control ring—the large ring around the lens, next to the camera's body. This action is quite intuitive, and it is similar to the way most lenses were focused in the days before autofocus existed.

In addition, there are several functions available to assist with your manual focusing. I will discuss those menu options in CHAPTER 7, but I will briefly describe these focus aids here because you very well may need them when focusing manually.

The first option, MF Assist, is turned on or off through the first option on the third screen of the Custom menu. When MF Assist is turned on, then whenever you start turning the Control ring to adjust focus in Manual Focus mode the image on the display is automatically magnified 8.6 times, as shown in FIGURE 4-29, so you can more clearly check the focus.

transcend

R95 — W60 MB/s

10 SD

3 XG I

64GB

Sony RX100-M2

Figure 4-29. MF Assist Feature in Use

Once the magnified image is displayed, if you press the Center button, the image is magnified further to 17.1 times normal. Press the Center button again to return to the 8.6-times view. You can adjust how long the magnified display stays on the screen using the Focus Magnifier Time option, which is directly below MF Assist on the Custom menu. I prefer to set the time to No Limit, so the magnification does not disappear just as I am getting the focus adjusted as I want it. With the No Limit setting, the magnification remains on the screen until you dismiss it by pressing the Shutter button halfway.

If you don't want the camera to enlarge the image as soon as you start focusing, you can use the Focus Magnifier option instead of MF Assist. The Focus Magnifier option is not turned on by default; to make it available you need to assign it to a control button using the second screen of the Custom menu. With the Function of Center Button and similar menu options, you can set either the Center, Left, or Right button on the Control wheel to activate the Focus Magnifier option.

Once the Focus Magnifier option is assigned to a button, when you press that button a small orange frame appears on the screen, as shown in Figure 4-30.

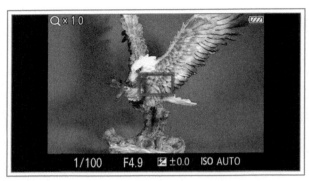

Figure 4-30. Frame to Select Area for Focus Magnifier Option

You can move that frame around the screen using the Control wheel or the direction buttons. The frame represents the area of the scene that will be magnified when you press the Center button. If you want, you can use both the MF Assist and Focus Magnifier options, though I see no need to do so. In most cases, my preference is to use only the MF Assist option, which is sufficient for my needs. I prefer not to give up the standard function of a control button to the Focus Magnifier option, which does not add that much to your focusing options. However, as discussed in Chapter 9, when shooting with the RX100 II through a telescope, I used the Focus Magnifier option because it was easier to deal with that tricky focusing situation by being able to choose exactly when the magnification was used.

The RX100 II provides one more aid to manual focusing, called Peaking, which is the next-to-last item on the first screen of the Custom menu. The Peaking Level option can be left turned off, or it can be set to Low, Mid, or High. When Peaking is turned on, then when you are using manual focus, the camera places bright lines around the areas of the image that it judges to be in focus, as shown in FIGURE 4-31 (without Peaking) and FIGURE 4-32 (with Peaking set to Mid).

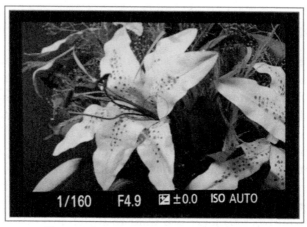

Figure 4-31. Manual Focus Without Peaking

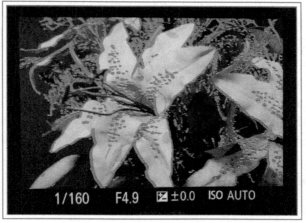

Figure 4-32. Manual Focus with Peaking Set to Mid

Besides setting the intensity of this display, as discussed above, you can set the color the camera uses—either white, red, or yellow—using the Peaking Color option on the Custom menu. I initially did not find much benefit from using Peaking, but as I have worked with it more, I have come to appreciate its advantages. I have found it to be especially useful when focusing in dark conditions because the Peaking color is illuminated and contrasts nicely with the dark display. Also, as noted above,

Peaking works with both the autofocus and manual focus aspects of the DMF option. I will discuss Peaking further in CHAPTER 7.

Finally, there is another way to customize the use of manual focus with the RX100 II that is worth mentioning here. On the second screen of the Custom menu, as noted above, you can assign the Center, Left, or Right button to control any one of a long list of functions. One of these functions, called AF/MF Control Toggle, is especially useful if you anticipate a need to switch back and forth between autofocus and manual focus on frequent occasions. When this function is assigned to a button (the Center button probably is the most convenient choice, at least for me), you can press the button whenever you want to switch instantly between these two focus modes. This is so much more convenient than going back to the Shooting menu and using the Focus Mode menu option, that it may be worthwhile giving up a button to this use.

In summary, the RX100 II has a strong array of aids to offer when you are focusing manually. With some other compact cameras, manual focus is very difficult to use because you have to turn a very small dial or the magnification options are not helpful. I find that with the RX100 II, I prefer using manual focus to autofocus in some situations because it is so powerful and easy to use.

Autofocus Area

The fourth option on the second screen of the Shooting menu, Autofocus Area, lets you choose what area of the image the camera focuses on when it is set to one of the autofocus modes.

There are three choices, shown in FIGURE 4-33.

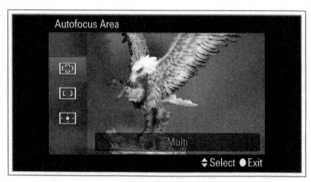

Figure 4-33. Autofocus Area Menu Option

MULTI

With Multi, the default choice, the RX100 II activates 25 focusing zones over the full expanse of its display and tries to detect one or more areas within the scene to focus on based on their location. When it has achieved sharp focus on one or more of those areas, the camera displays a green frame indicating the locations of those areas. You may see one or several green frames on the screen, as shown in FIGURE 4-34.

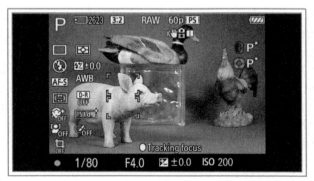

Figure 4-34. Green Focus Frames for Multi Autofocus Area Option

The Multi option is excellent for general photography when you are sightseeing or taking shots of landscapes and the like.

CENTER

If you select Center for the Autofocus Area setting, the camera places a small black focus frame in the center of the display, and it focuses on whatever object it finds within that frame.

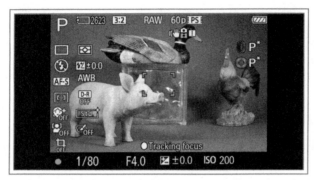

Figure 4-35. Single Green Frame for Center Autofocus Area Option

If the camera is able to focus there, it will beep and the frame will turn green, as shown in FIGURE 4-35. This option is useful if you will be focusing on an object in the center of the scene. Even if you need to focus on an off-center object, though, you can still make use of this focusing method. For example, if you need to focus on an object at the right side of the scene, you can aim the camera so as to place that object within the center focus frame, and press the Shutter button halfway to lock in the focus. Then while keeping the Shutter button pressed halfway down, move the camera back to the position where you want it, with that object on the right side of the scene, and press the Shutter button all the way to take the picture.

FLEXIBLE SPOT

The third and final Autofocus Area option, Flexible Spot, gives you the most control over where the camera directs its autofocus operation.

When you select this option from the Shooting menu, the camera places a small orange focus frame in the center of the image. You can move this frame around to any part of the display by pressing any of the four direction buttons on the Control wheel.

Figure 4-36. Flexible Spot Focus Frame Moved to Right

In Figure 4-36, the frame has been moved to the right side of the image over the rooster. When the focus frame is located where you want it, press the Center button to fix it in place and return to the shooting screen. If you want to move the frame again, press the Center button again to activate it.

This option is an excellent one to use if you are trying to focus on a specific area in a scene, especially if the camera might have difficulty in determining where to direct its focus because of the placement of multiple objects in the same general area.

Soft Skin Effect

This menu option is designed to soften skin tones in the faces of your subjects. The option is dimmed and unavailable in some situations, such as when one of the Drive Mode options or the Raw setting for Quality is selected. Once you select it and turn it on, you can use the Right and Left buttons to set the level at Low, Mid, or High, as shown in Figure 4-37.

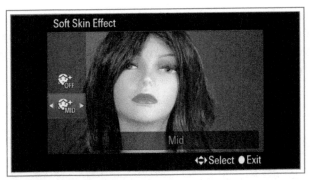

Figure 4-37. Soft Skin Effect Menu Option

This setting reduces the sharpness in areas that the camera perceives as skin tones. In FIGURE 4-38, I tested this setting with a mannequin.

Figure 4-38. Soft Skin Effect Comparison: Off at Left, High at Right

The image on the left was taken with the effect turned off; the image on the right had the setting at its High level. I find that the most noticeable area of softness is seen in the area of the mannequin's nose.

This setting is a potentially useful shortcut when you are doing portraits and don't want to work through manual settings in your post-processing software. With the Soft Skin Effect option, you may be able to produce JPEG images straight from the camera with a pleasing softness.

Smile/Face Detection

This menu option gives you access to two separate functions with fairly different features.

There are four separate entries on the vertical menu that pops up when this menu item is selected, shown in FIGURE 4-39.

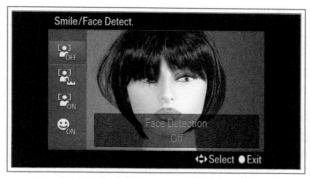

Figure 4-39. Smile/Face Detection Menu Options

You can select the top setting, Off, which leaves all options turned off, or you can select one of the other three that operate as follows:

FACE DETECTION ON (REGISTERED FACES)

This option is designated on the menu screen by an icon of a person's head and a crown. When you select this choice, the camera searches for faces that you have previously registered using the Face Registration option on the Custom menu, as discussed in CHAPTER 7. If it detects a registered face, it should consider that face to have priority, in which case it will place a green frame on the face and adjust the Autofocus Area, Flash Mode, Exposure Compensation, White Balance, and Red Eye Reduction values automatically to produce optimum exposure for that particular face.

In daily shooting, I do not use this feature. It could be useful if you are taking pictures of children in a group setting and you

want to make sure your own child is in focus and has his or her face properly exposed. I tried this feature out by registering one face and then aiming the camera at that face along with an unregistered face. In some cases, the camera picked the registered one as the priority face, but at other times it chose the unregistered one. Other users have reported good results with this feature, though, so, if it would be useful to you, by all means explore it further.

FACE DETECTION ON

This setting is similar to the previous one, except that it does not involve registered faces.

As shown in FIGURE 4-40, the camera will detect any human faces, up to eight in total, and select one as the main face to concentrate its settings on.

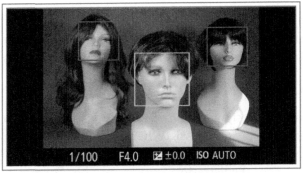

Figure 4-40. Frames Indicating Multiple Faces Detected

Before you press the Shutter button, the camera will display white or gray frames around any faces it finds. When you press the Shutter button halfway to lock focus and exposure, the frame over the face the camera has selected as the main face will turn green. The camera may place multiple green frames if there are multiple faces at the same distance from the camera.

Smile Shutter

The final option for this menu item is the Smile Shutter, which is a sort of self-timer that is activated when the subject smiles.

After highlighting this option, you can use the Left and Right buttons to choose the level of smile that is needed to trigger the camera—Slight Smile, Normal Smile, or Big Smile. Then press the Center button to exit back to the shooting screen, and aim the camera at the subject or subjects. (You can, of course, put the camera on a tripod and aim it at yourself, if you want.)

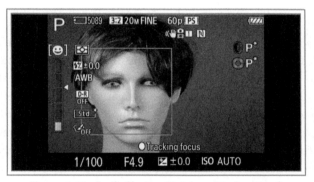

Figure 4-41. Smile Shutter Meter on Display at Left

As shown in FIGURE 4-41, the camera will then show a meter on the left of the screen with a pointer to indicate how large a smile is needed to trigger a shot. As soon as the camera detects a big enough smile from any person, the shutter will fire. The reddish self-timer lamp will illuminate, and you will hear the click of the shutter activating. If a person smiles again, the camera will be triggered again, with no limit on the number of shots that can be taken. So, in effect, this feature acts as a limited kind of remote control with one specific function. Here again, as with the Self-portrait Timer, I consider this option to be something of a novelty, which can be entertaining but is not necessary for everyday photography.

Auto Object Framing

This menu option provides a function that is somewhat unusual for any camera—it rearranges the composition of your shot based on its own electronic judgment. To activate it, set it to Auto on the menu. Then, when you compose your image, the camera will place a green frame around what it believes to be the subject if it finds that the image can benefit by being trimmed to fit the subject better. For this feature to work with faces, you need to have Face Detection turned on with the Smile/Face Detection menu option discussed above. Besides faces, Sony says that the feature will work with macro shots and objects tracked with Tracking Focus.

When you take a picture of the face or other subject, the camera may, if it finds it possible, crop the image and produce a new version of the image with the frame trimmed and resized to emphasize the subject in a more pleasing way. I found that the camera would crop shots of faces fairly often, but I had difficulty getting the camera to crop a shot of any other subject, even when I used the Macro and Tracking Focus settings. I ultimately found that the camera would use this feature for a macro shot of a toy soldier when I left considerable space to the left and right of the subject. However, on most occasions, the camera would not activate the feature unless I also turned on Tracking Focus.

The result is shown in FIGURE 4-42 and FIGURE 4-43, which show the uncropped and cropped versions, respectively, of the toy soldier I photographed using the Macro (closeup) setting of Scene mode, with Tracking Focus activated. The camera's cropping does look appropriate, but I would much rather do the cropping myself in Photoshop or just compose the image in this way to begin with.

Figure 4-42. Auto Object Framing: Original Shot

Figure 4-43. Auto Object Framing: Shot Cropped by Camera

The camera saves both versions, so there is no harm in using this feature. It could be useful if you are pressed for time or are unable to get into position to take the shot you want. If you need a more nicely cropped version of the image quickly for a slide show, perhaps, this could be a good way to fill that need.

This feature is available for selection only if the camera is set for autofocus with Autofocus Area set to Multi, and Quality set to Fine or Standard. (This option does not work with Raw images or with certain other settings.)

ISO

The ISO acronym represents the International Organization for Standardization, which develops international standards for many areas of industry, science, and other fields.

The original use of the ISO standard was to designate the "speed," or light sensitivity, of film. For example, a "slow" film might be rated at ISO 64, or even ISO 25, meaning it takes a large amount of exposure to light to create a usable image on the film. Slow films yield higher-quality, less-grainy images than faster films. There are "fast" films available, some black-and-white and some color, with ISO ratings of 400 or even higher, that are designed to yield usable images in lower light. Such films often can be used indoors without flash, for example.

With digital technology, the industry has retained the ISO concept to rate the light sensitivity of the camera's sensor. The ISO ratings for digital cameras are supposed to be essentially equivalent to the ISO ratings for films. So, if your camera is set to ISO 100, there will have to be a good deal of light to expose the image properly, but if the camera is set to ISO 1600, a reasonably good (but noisier or grainier) image can be made in very low light.

Generally speaking, you should shoot your images with the camera set to the lowest ISO possible that will allow the image to be exposed properly. (One exception to this rule is if you want, for creative purposes, the grainy look that comes from shooting at a high ISO value.) For example, if you are shooting indoors in low light, you may need to set the ISO to a high value (say, ISO 800), so you can expose the image with a reasonably fast shutter speed.

Otherwise, if the camera uses a slow shutter speed, the resulting image would likely be blurry and possibly unusable.

Of course, it's important to realize that high ISO settings are not a cure-all for poor lighting conditions. It is true that the RX100 II, with its backside-illuminated sensor, provides better low-light image quality than most cameras in its class. However, using the higher ISO settings is going to reduce image quality to a certain degree; the higher the ISO, the more such deterioration will be evident.

Figure 4-44. Top Image: ISO 160, Bottom Image: ISO 12800

For example, FIGURE 4-44 includes two images of a firefighter figurine taken with different ISO settings. I took the top shot with the RX100 II set to ISO 160, and the bottom shot with ISO set

to ISO 12800. As you can see, the image shot with the low ISO setting is considerably clearer than the high-ISO version.

To summarize: Shoot with low ISO settings (around 100 or 125) when possible; shoot with high ISO settings (800 or higher) when necessary to allow a fast shutter speed to stop action and avoid blurriness, or when desired to achieve a creative effect with graininess.

With that background, here is how to set ISO on this camera. As is discussed in detail in CHAPTER 5, one good feature of the RX100 II is that you can get quick access to certain important settings, such as ISO, using the Function Button menu, or, if you want, using the left or right control button or the Control ring. However, you can also set ISO from the Shooting menu. So, especially if you want to use the Control ring and control buttons for other purposes, it's good to know how to get access to the ISO setting with this menu item.

ISO is the first item on the third screen of the Shooting menu. After you highlight it, press the Center button to bring up the vertical ISO menu at the left of the screen, seen in FIGURE 4-45.

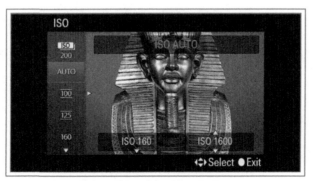

Figure 4-45. ISO Menu Option

Scroll through the options by turning the Control wheel or by pressing the Up and Down buttons to select a value ranging from one of the two options—Multi Frame Noise Reduction and Auto

ISO—through 100, 125, 160, 200, and other specific values, to a maximum of 12800 at the bottom of the scale. (If you want to use an ISO value higher than 12800, you need to use the Multi Frame Noise Reduction feature, discussed below, or the High Sensitivity setting of Scene mode, discussed in CHAPTER 3.)

If you choose Auto ISO (the second option on the menu), the camera will select a numerical value automatically depending on the lighting conditions. However, one great feature of the RX100 II that I have not seen on many compact cameras is that you can select both the minimum and maximum levels for the Auto ISO. In other words, you can set the camera to choose the ISO value automatically within a defined range such as, say, ISO 200 to ISO 1600. In that way, you can be assured that the camera will not select a value outside that range, but you will still leave some flexibility for the setting.

To set minimum and maximum values, while the orange highlight is on the Auto ISO option, press the Right button to move the highlight to the right side of the screen, where there are two rectangles that are labeled when highlighted ISO Auto Minimum and ISO Auto Maximum, as shown in FIGURE 4-46.

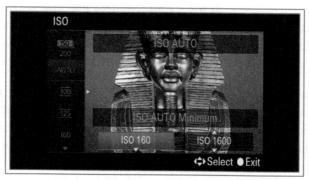

Figure 4-46. ISO Auto Minimum Option

Move the highlight to each of these blocks in turn using the Right button, and change the value as you wish, using the Up and Down buttons or turning the Control wheel. You can set both the

minimum and the maximum to values from 160 to 12800. When both values have been set, press the Center button to exit back to the shooting screen.

Once those values are set, whenever you select Auto ISO, the camera will keep the ISO level within the range you have specified. Of course, you can always set a specific ISO value at any other level by selecting it from the ISO menu—the minimum and maximum values apply only when Auto ISO is selected.

MULTI FRAME NOISE REDUCTION

Finally, I will discuss the top item on the ISO menu, whose icon includes the ISO label and a stack of frames. If you highlight that icon with the orange selection block, you will see that the name of this option is Multi Frame Noise Reduction.

This special setting lets you select an ISO value as high as 25600, twice as high as the maximum value that you can set from the standard ISO menu. This value is an "expanded" setting, derived electronically from the camera's programming. When you select the Multi Frame Noise Reduction option, the camera will take multiple shots in a rapid burst and combine them internally into a composite image with reduced noise. This processing takes place to counteract the effects of using very high ISO values, which introduce a considerable amount of noise into the image. The camera also attempts to select frames with minimal motion blur.

After you have selected Multi Frame Noise Reduction, use the Right button to move the selection highlight to the right side of the screen. The highlight will then be on the selection block for the ISO setting to be used, as shown in FIGURE 4-47. Use the Up and Down buttons or turn the Control wheel to select a value, which can be set to Auto or to a specific value from 200 all the way up to 25600. If you choose Auto for this setting, then the camera will select an ISO value up to 25600 according to the lighting conditions, and it will take multiple shots using that value. You cannot use the flash when Multi Frame Noise Reduction is in

effect. Also, you cannot use Raw quality or continuous shooting with this setting.

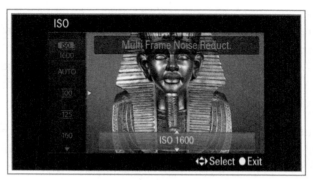

Figure 4-47. Multi Frame Noise Reduction Setting

Using the Multi Frame Noise Reduction setting is the only way to set the RX100 II to the ISO levels above 12800. (You can, however, use the High Sensitivity setting of Scene mode, in which case the camera may use those high settings if it finds it necessary.) If you are faced with the prospect of taking pictures in an unusually dark environment, consider using this specialized setting, which really is more akin to a shooting mode than to an ISO setting.

Figure 4-48. Multi Frame Noise Reduction Example

In FIGURE 4-48, I used this setting to capture a view of people buying tickets at a neighborhood movie theater after dark. The

RX100 II set the ISO up to 2500, enabling the camera to use a shutter speed of 1/100 second despite the darkness. The result was a final image with good detail and no motion blur.

Here are some more notes on ISO: In Manual exposure mode, you cannot select Auto ISO; you have to select a numerical value. In the Auto shooting modes, Scene mode, and Sweep Panorama mode, Auto ISO is automatically set, and you cannot adjust the ISO setting.

Also, note that the settings for ISO 100 and 125 are surrounded by lines on the menu, as shown in FIGURE 4-45. This indicates that those two settings are not "native" to the RX100 II's sensor, whose base ISO is 160. So, although using the two lower settings reduces the sensor's sensitivity to light and darkens the exposure, it does not improve dynamic range or reduce noise in your images significantly.

Metering Mode

This option lets you choose among the three patterns of exposure metering offered by the RX100 II—Multi, Center, and Spot—as shown in FIGURE 4-49.

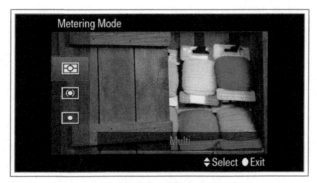

Figure 4-49. Metering Mode Menu Option

This choice tells the camera's automatic exposure system what part of the scene to consider when setting the exposure. With

Multi, the camera uses the entire scene that is visible on the LCD screen. With Center, the camera still measures all of the light from the scene, but it gives additional weight to the center portion of the image on the theory that your main subject is in or near the center. Finally, with Spot, the camera evaluates only the light that is found within the spot metering zone.

In Spot mode, the camera places a small circle in the center of the screen indicating the metered area, as seen in FIGURE 4-50.

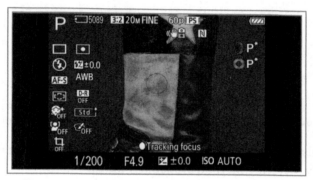

Figure 4-50. Spot Metering Circle in Center of Display

With this setting, you can see the effects of the exposure system clearly by selecting the Program exposure mode and aiming that small circle at various points, some bright and some dark, and seeing how sharply the brightness of the scene in the LCD screen changes. If you try the same experiment in Multi mode, you will still see changes but more subtle and gradual ones.

Note, if you choose Spot metering, the circle you will see is different from the rectangular frames the camera uses to indicate the Center or Flexible Spot Autofocus Area mode settings. If you make either of those Autofocus Area settings at the same time as the Spot metering setting, you will see both a spot-metering circle and an autofocus frame in the center of the LCD screen, as in FIGURE 4-51, which shows the screen with the Spot metering and Center Autofocus Area settings in effect.

Be aware which one of these settings is in effect: if either a circle or a frame is visible in the center of the screen. Remember that the circle is for spot metering, and the rectangular bracket is for Center or Flexible Spot autofocus. (The Center AF frame is slightly larger than the Flexible Spot frame.)

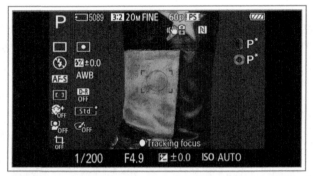

Figure 4-51. Spot Metering Circle and Center AF Frame on Display

Note, also, in the two Auto modes and all varieties of Scene mode, the only metering method available is Multi.

The Multi setting is best used for scenes with relatively even contrast, such as landscapes, and for action shots, in which the location of the main subject may move through different parts of the frame. The Center setting is useful for sunrise and sunset scenes, and for other situations in which there is a large, central subject that exhibits considerable contrast with the rest of the scene. The Spot setting is good for portraits, macro shots, and other images in which there is a relatively small part of the scene whose exposure is critical. Spot metering also is useful when lighting is intense in one portion of a scene, such when a concert performer is lit by a spotlight.

Flash Compensation

The Flash Compensation option lets you control the output of the camera's built-in flash unit. This function works similarly

to exposure compensation, which is available by pressing the Down button in the more advanced shooting modes. (Exposure compensation is discussed in CHAPTER 5.) The difference between the two options is that Flash Compensation varies only the brightness of the light emitted by the flash; whereas, exposure compensation varies the overall exposure of a given shot, whether or not flash is used.

Flash Compensation is a good option to use when you want to use the flash but don't want the subject to be overwhelmed with light. I often use this setting when I am shooting a portrait outdoors with the Fill-flash setting to reduce shadows on the subject. With a bit of negative Flash Compensation, I can keep the flash from overexposing the image.

This menu item is simple to use: just highlight it on the menu screen and press the Center button, then, on the next screen, shown in FIGURE 4-52, press the Left and Right buttons or turn the Control wheel to dial in the amount of positive or negative compensation you want.

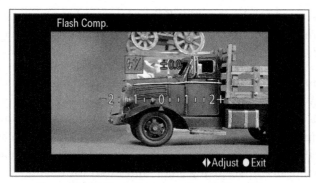

Figure 4-52. Flash Compensation Setting Screen

Be careful to set the value back to zero when you are done with the setting because any setting you make will stay in place even after the camera has been powered off and back on again. Note, also, that Flash Compensation is not available with the Auto, Scene, or Sweep Panorama modes.

If you use a Sony flash that is compatible with the RX100 II, such as the HVL-F20M discussed in APPENDIX A, the Flash Compensation setting will adjust the intensity of the flash from that unit just as it does with the built-in flash.

White Balance

One issue that arises in all photography is that film, or a digital camera's sensor, reacts differently to colors than the human eye does. When you or I see a scene in daylight or under artificial lighting, we generally do not notice a difference in the hues of the things we see depending on the light source. However, the camera does not inherently have this auto-correcting ability. The camera "sees" colors differently depending on the "color temperature" of the light that illuminates the object or scene in question. Color temperature is a numerical value expressed in Kelvin (K). A light source with a lower Kelvin rating produces a "warmer," or more-reddish, light. A light source with a higher Kelvin rating produces a "cooler," or more-bluish, light. For example, candlelight is rated at about 1,800 K, indoor tungsten light (ordinary light bulb) is rated at about 3,000 K, outdoor sunlight and electronic flash are rated at about 5,500 K, and outdoor shade is rated at about 7,000 K.

What does this mean in practice? If you are using a film camera, you may need a colored filter in front of the lens or light fixture to "correct" for the color temperature of the light source. Any given color film is rated to expose colors correctly at a particular color temperature (or, to put it another way, with a particular light source). So, if you are using color film rated for daylight use, you can use it outdoors without a filter. But if you happen to be using that film indoors, you will need a color filter to correct the color temperature; otherwise, the resulting picture will look excessively reddish because of the imbalance between the film and the color temperature of the light source.

With a modern digital camera, you don't need to worry about filters because the camera can adjust its electronic circuitry to correct the "white balance," which is the term used in the context of digital photography for balancing color temperature.

The RX100 II, like most current digital cameras, has a setting for Auto White Balance, which lets the camera choose the proper color correction to account for any given light source. The Auto White Balance setting works well, and it probably will do the job for you in many situations, especially if you are taking snapshots whose colors are not critical.

If you need more precision in the white balance of your shots, though, the RX100 II has fixed settings available for several common light sources, as well as options for setting the white balance by color temperature and for setting a custom white balance by evaluating the light source currently in use.

Here is how to make the White Balance setting on the RX100 II through the Shooting menu.

Once you have highlighted this menu option, press the Center button to bring up the vertical menu at the left of the screen, shown in FIGURE 4-53.

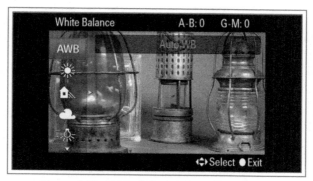

Figure 4-53. White Balance Menu: First Screen

Then, by using the Up and Down buttons or by turning the Control wheel, you can scroll through the icons on that menu, which correspond to the following choices that take up more than a full screen. The choices on the first screen are the following: Auto White Balance (AWB), Daylight (sun icon), Shade (house icon), Cloudy (cloud icon), and Incandescent (round light bulb icon).

The choices on the second screen, shown in FIGURE 4-54, are the following: Fluorescent Warm White (fluorescent bulb icon with -1), Fluorescent Cool White (same, with 0), Fluorescent Day White (same, with +1), Fluorescent Daylight (same, with +2), and Flash (WB with lightning bolt icon).

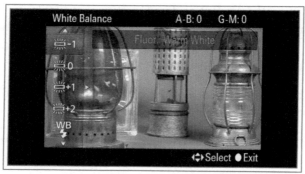

Figure 4-54. White Balance Menu: Second Screen

The last choices, shown in FIGURE 4-55, are the following: Color Temperature/Filter (K and filter icon) and Custom (special icon). Below the Custom icon is one more icon with the word "SET," which represents the option for setting the Custom value.

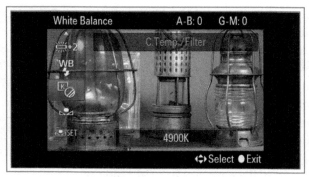

Figure 4-55. White Balance Menu: Third Screen

To select one of the settings on this list, just scroll to it and press the Center button to select it. These settings should be largely self-explanatory because most of them describe a particular light source in common use. There are four different settings for fluorescent bulbs, so you should be able to find a good setting for any such bulbs you encounter, though you may need to experiment a bit to find the best setting for a given bulb. For settings such as Daylight, Shade, Cloudy, and Incandescent, just select the setting that matches the light that is dominant in your location. If you are indoors at night and using only incandescent lights, this decision will be easy. If you are indoors with a variety of electric lights turned on and sunlight coming in through the windows, the situation may be more uncertain. In that case, you may want to use either the Color Temperature/Filter setting or the Custom option.

The Color Temperature/Filter option lets you set the camera's white balance according to the numerical color temperature of the light source. One way to determine that setting is to use a color temperature meter like the Sekonic Prodigi Color meter shown in Figure 4-56.

That meter works well, and I find it convenient to use it when I need extra accuracy in my white balance settings. This device is fairly expensive, though, and you may not want to use that option. In that case, you can still use the Color Temperature/Filter option, but you will have to do some guesswork or use your own sense of color. For example, if you are shooting under lighting that is largely from incandescent bulbs, you can use the value of 3,000 K as a starting point, because, as noted earlier in this discussion, that is an approximate value for the color temperature of that light source. Then you can try setting the color temperature figure higher or lower, and watch

Figure 4-56.
Sekonic Prodigi
Color Meter

the camera's display to see how natural the colors look. As you lower the color temperature setting, the image will become more "cool," or bluish; as you raise it, the image will appear more "warm," or reddish. Once you have found the best setting, leave it in place and take your shots.

To make this setting, after you highlight the icon for Color Temperature/Filter, press the Right button to move the orange highlight to the right side of the camera's screen, so that it highlights the color temperature value, as shown in FIGURE 4-57.

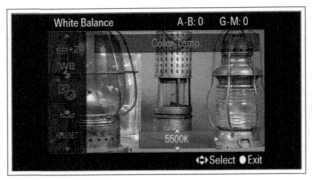

Figure 4-57. White Balance Color Temperature Setting Screen

Then raise or lower that number using the Up and Down buttons or by turning the Control wheel.

If you don't want to work with numerical color temperatures, you can use the RX100 II's ability to set a custom white balance. Using this setting can be a bit confusing with the RX100 II because the Custom setting has two icons on the White Balance menu. The first Custom icon, located just below the Color Temperature/Filter icon, is the one to select when you want to set the camera to use the currently stored Custom White Balance setting. The second icon, below that one, with the word "SET" included, is the one to select when you want to obtain a new reading for the Custom White Balance setting by using the camera's special procedure for setting that value. So, before you can use the upper Custom icon, you need to make sure that you have used the lower Custom icon to set the Custom White Balance value as you want it.

Here is the procedure for setting the Custom White Balance. First, highlight the Custom SET icon at the bottom of the White Balance menu. Press the Center button to select this option, and the camera will display a message saying "Use spot focus area data. Press shutter to load." (as shown in FIGURE 4-58).

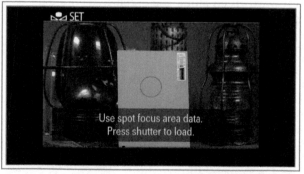

Figure 4-58. Screen for Setting Custom White Balance

At this point, aim the camera so the small spot circle in the center of the screen is filled with a solid white or gray color from a

sheet of paper or a photographic gray card, like the one shown in
FIGURE 4-59 (and used in FIGURE 4-58).

Figure 4-59. Photographic Gray Card

Then press the Shutter button, and the camera will set the white
balance according to the light source illuminating the surface
you photographed. The display will show the measured color
temperature along with values for variations along two color
axes. You will see a number displayed next to the letters "A-B,"
representing the amber-blue axis, and "G-M," for green-magenta.
If there is no variation along either of these axes, you will see the
number 0 next to the pair of letters. If there is some variation,
you will see an indication such as G-M: G2, meaning 2 degrees of
variation toward green along the green-magenta axis, as shown in
FIGURE 4-60.

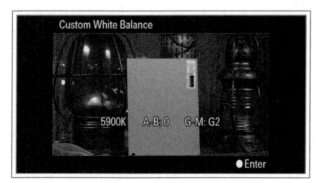

Figure 4-60. Results Screen for Setting Custom White Balance

Whenever you want to use the custom white balance you have just saved, just select the next-to-last icon on the White Balance menu, the one without the word "SET" next to it. Of course, you can change the custom setting whenever you want to, if you are shooting under different lighting conditions.

There is one more way in which you can adjust the White Balance setting by taking advantage of the two color axes discussed above. If you really want to tweak the White Balance setting to the nth degree, after you have selected your desired setting (whether a preset or the Custom setting), press the Right button, and you will be presented with a screen for fine adjustments, as shown in FIGURE 4-61.

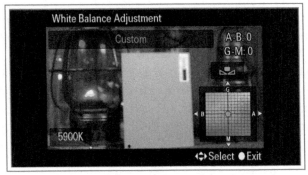

Figure 4-61. White Balance Fine Adjustment Screen

You will see a pair of axes that intersect at a zero point, marked by an orange dot. The four axes are labeled G, B, M, and A for green, blue, magenta, and amber. You can now use all four direction buttons to move the orange dot away from the center along any of the axes to adjust these four values until you have the color balance exactly how you want it. If you prefer, you can turn the Control wheel to adjust the G-M axis, but you still need to press the Left and Right buttons to adjust the B-A axis. Be careful to undo any adjustments using these axes when they are no longer needed; otherwise, the adjustments will alter the colors of all of your images that are shot in a shooting mode for which White

Balance can be adjusted, even after the camera has been powered off and then back on.

White Balance can't be adjusted in this way for the Scene or Auto modes, but it can be for the Movie and Sweep Panorama modes.

Two final notes about white balance: First, if you shoot using Raw quality, you can always correct the white balance setting after the fact in your Raw software. So, if you are using Raw, you don't have to worry so much about what setting you are using for white balance. Still, it's a good idea always to check the setting before shooting to avoid getting caught with incorrect white balance when you are not using the Raw format.

Second, before you decide to use the "correct" white balance in every situation, consider whether that is the best course of action to get the results you ultimately want. For example, I know of one photographer who generally keeps his camera set for Daylight white balance even when shooting indoors because he likes the "warmer" appearance that comes from using that setting. I don't necessarily recommend that approach, but it's not a bad idea to give some thought to straying from a strict approach to white balance, at least on occasion.

Before I leave this topic, I am going to include a chart in FIGURE 4-62 that shows how the different White Balance settings affect the images taken by the RX100 II. The images in this chart were taken under incandescent light with the camera set for each available White Balance setting, as indicated on the chart. In my opinion, the best results were obtained with the Incandescent, Color Temperature/Filter, and Custom settings. The Fluorescent Day White setting also appeared to match the actual color temperature quite closely. In this particular case, it seems to me that the Auto White Balance setting was somewhat off the mark, though its result was not too bad. In my experience, the Auto White Balance setting does quite well in daylight, but not always so well with indoor lighting.

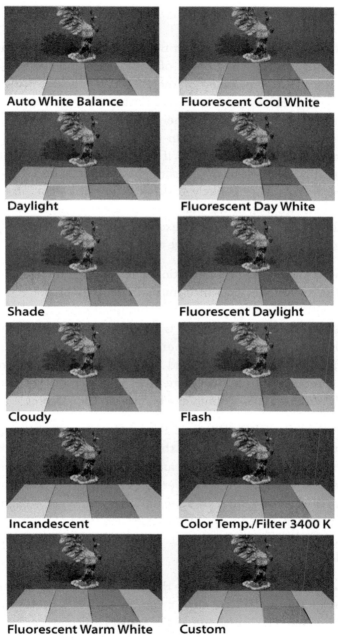

Figure 4-62. White Balance Comparison Chart

DRO/Auto HDR

The next setting on the Shooting menu gives you options for controlling the dynamic range of your shots and for using the in-camera HDR processing of the RX100 II. These settings can help avoid problems with excessive contrast in your images. Such issues arise because digital cameras cannot easily process a wide range of dark and light areas in the same image—that is, their "dynamic range" is limited. So, if you are taking a picture in an area that is partly lit by bright sunlight and partly in deep shade, the resulting image is likely to have some dark areas in which the details are lost in the shadows, or some areas in which the highlights, or bright areas, are excessively bright, or "blown out," so, again, the details of the image are lost.

One way to deal with this situation is to use high dynamic range, or HDR, techniques, in which multiple photographs of the same scene with different exposures are combined into one composite image that is properly exposed throughout the entire scene. The RX100 II can take HDR shots on its own, or you can take the separate exposures yourself and combine them in software on your computer into a composite HDR image. I will discuss the details of these HDR techniques a bit later in this chapter.

The RX100 II's DRO (Dynamic Range Optimizer) setting gives you another way to deal with the problem of uneven lighting, with special processing in the camera that can boost the details in the dark areas and reduce overexposure in the bright areas at the same time, resulting in a single image with better-balanced exposure than would be possible otherwise. To do this, the DRO setting uses digital processing to reduce highlight blowout and pull details out of the shadows.

To use the DRO feature, here are the steps. Press the Menu button and highlight this option, then press the Center button to bring the DRO/Auto HDR menu up on the camera's display, as shown in FIGURE 4-63.

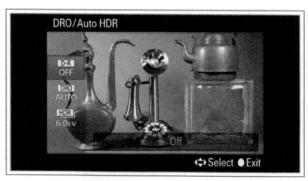

Figure 4-63. DRO/Auto HDR Menu Option

Then scroll down through the options on that menu, using the up and direction buttons or turning the Control wheel.

With the first option, D-R Off, no special processing is used. If you select the second choice, you can then press the Right and Left buttons to move through the choices for the DRO setting: Auto, or Level 1 through Level 5. With the Auto setting, the camera will analyze the scene and attempt to pick an appropriate amount of DR processing. Otherwise, you can pick the level; the higher the number, the greater the degree of processing to even out the contrast between the light and dark parts of the image. In FIGURE 4-64 through FIGURE 4-66, there are examples of the use of the various levels of DRO processing, ranging from Off to Level 5.

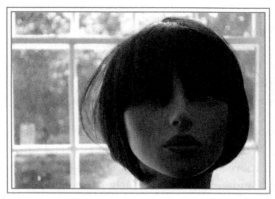

Figure 4-64. DRO Off

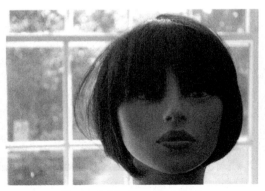

Figure 4-65. DRO Set to LV3

Figure 4-66. DRO Set to LV5

As you can see, the greater the level of DRO used, the more evenly the RX100 II processed the lighting in the scene, primarily by selectively enhancing details in the shadowy areas and brightening the mannequin's face. There is some risk of increasing visual noise in the dark areas with this sort of processing, but the RX100 II does not seem to do badly in this respect; I have not seen increased noise levels in images processed with the DRO feature.

The final option for this item, HDR, involves in-camera HDR processing. With traditional HDR processing, the photographer takes two or more shots of a scene that has a wide dynamic range, some shots underexposed and others overexposed, and then merges them together using Photoshop or special HDR software

to blend differently exposed portions from all of the images. The end result is a composite HDR image that can exhibit clear details throughout all parts of the image.

Because of the popularity of HDR, many makers have incorporated some degree of DR processing into their cameras in an attempt to help the cameras even out areas of excessive brightness and darkness to preserve details. With the RX100 II, as with many modern cameras, Sony has provided an automatic method for taking multiple shots that the camera combines internally to achieve one HDR composite image.

To use this feature, highlight the bottom option on the DRO/Auto HDR menu, as shown in Figure 4-67.

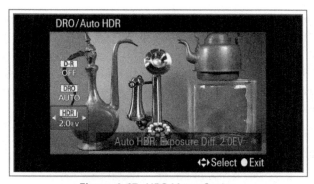

Figure 4-67. HDR Menu Option

Press the Right and Left buttons to scroll through the various options for the HDR setting until you have highlighted the one you want, and then press the Center button to select that option and exit back to the shooting screen. The available options are Auto HDR and HDR with EV settings from 1.0 through 6.0.

If you select Auto HDR, the camera will analyze the scene and the lighting conditions and select a level of exposure difference on its own. If you select a specific level from 1.0 to 6.0, the camera will use that level as the overall difference among the three shots it takes.

For example, if you select 1.0 EV for the exposure difference, the camera will take three shots in a rapid burst, each 1/3 of an EV level (f-stop) different in exposure from the next—one shot at the metered EV level, one shot at 1/3 EV lower, and one shot at 1/3 EV higher. If you choose the maximum exposure difference of 6.0 EV, then the shots will be 2.0 EV apart in their brightness levels.

When you press the Shutter button, the camera will take three shots in a quick burst; you should either use a tripod or hold the camera very steady. When it has finished processing the shots, the camera will save the composite image as well as the single image that was taken at the metered exposure.

For FIGURE 4-68 through FIGURE 4-71, I set the RX100 II on a tripod and took a series of images with a large tree in a shadowy area in the foreground and a canal in the background in bright sunlight. I took the first three shots with varied HDR settings on the RX100 II, and I created the final image by taking several shots using manual exposure and then combining them with HDR software.

Figure 4-68. HDR Off

Figure 4-69. HDR Set to 3.0 EV

Figure 4-70. HDR Set to 6.0 EV

Figure 4-71. Composite HDR Image from Photomatix Pro

For FIGURE 4-68, HDR was turned off; for FIGURE 4-69, HDR was set to Level 3; and for FIGURE 4-70, HDR was set to its highest value, Level 6. The differences are not as dramatic as I might have expected, though I can definitely see that the tree becomes brighter, with additional details in the shots with HDR turned on. There also are some different effects in the shading and lighting of the background areas. However, neither of the two shots with HDR turned on produced an image with evenly balanced lighting.

For comparison, I took several shots of the same scene using a range of exposure levels by varying the shutter speeds in Manual exposure mode. I merged those images together in Photomatix Pro software and tweaked the result until I got what seemed to be the optimal appearance of the tree and the background. In my opinion, the HDR image done in software, shown in FIGURE 4-71, provides a more evenly illuminated view of the scene than either of the in-camera HDR shots taken by the RX100 II.

However, these images were taken under fairly extreme conditions. The in-camera HDR option is an excellent tool to use when you need to take pictures of scenes that are partly shaded and partly in bright sunlight, and you don't have the time or the inclination to take multiple pictures and combine them later with HDR software into a composite image.

My recommendation is to leave the DRO Auto setting turned on when you are taking general shots of a trip or for pleasure, especially if you don't plan to do any post-processing of the images using software. If the contrast in lighting for a given scene is extreme, then try at least some shots using the Auto HDR feature.

If you are planning to do post-processing, then you may want to shoot using the Raw quality setting, so you can work with the shots later using post-processing software to achieve evenly exposed final images. You also might want to use Manual exposure mode or exposure bracketing to take a series of shots at different exposures, so you can blend them together using

Photoshop, Photomatix, or some other HDR software. One great feature of the RX100 II is that it provides unusually high levels of dynamic range in its Raw files, particularly if you shoot with low ISO settings. Therefore, you very well may be able to bring details out of the shadows and reduce overexposure in highlighted areas using your Raw processing software.

Note that the Auto HDR setting cannot be set if you are using Raw quality for your images. The DRO settings do work with Raw images, but they will have no effect on the Raw images unless you process them with Sony's Image Data Converter software.

In addition, DRO and Auto HDR settings are unavailable in any of the Auto, Scene, or Sweep Panorama modes. You can use the flash with these settings, but it will fire only for the first HDR shot, and it defeats the purpose of the settings to use flash, so you probably should not do so.

Creative Style

The Creative Style setting provides options for altering the appearance of your images with in-camera adjustments to their contrast, saturation (color intensity), and sharpness. Using the variety of settings available with this option, you can add or subtract intensity of color or work in subtle changes to the look of your images, as well as shooting in monochrome. Of course, if you plan to edit your images on a computer using software such as Photoshop, you can duplicate these effects readily at that stage. But, if you don't want to spend time processing your images in that way, having the ability to alter the look of your shots using this menu option can add a good deal to the enjoyment of your photos.

Using this feature is straightforward. First, highlight Creative Style, the next-to-last item on the third screen of the Shooting menu, and press the Center button to move to the next screen, as shown in FIGURE 4-72.

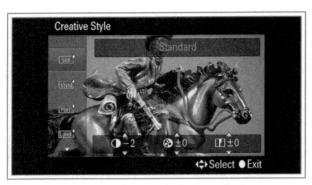

Figure 4-72. Creative Style Menu Option

Using the Up and Down buttons or turning the Control wheel, scroll through the six major available settings: Standard, Vivid, Portrait, Landscape, Sunset, and Black and White. If you want to choose one of these settings with no further adjustment, just press the Center button when your chosen option is highlighted.

If you want to fine-tune the contrast, saturation, and sharpness for one of these settings, here are the steps to take. Move the orange highlight bar onto the desired setting, such as Vivid or Portrait, and then press the Right button to move a second orange highlight bar into the right side of the screen.

You will see a label above a line of three icons accompanied by numbers at the bottom of the screen, as shown in FIGURE 4-73.

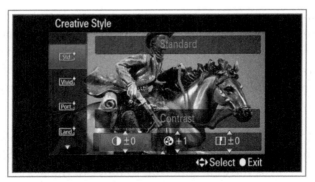

Figure 4-73. Creative Style Parameters Adjustment Screen

As you move the orange highlight left and right through those icons, the label will change to show which value is currently active and ready to be adjusted. When the chosen value (contrast, saturation, or sharpness) is highlighted, use the Up and Down buttons or turn the Control wheel to adjust the value upward or downward by up to 3 units. When the Black and White setting is active, there are only two adjustments available—contrast and sharpness; saturation is not available because saturation adjusts the intensity of colors and there are no colors to adjust.

Figure 4-74. Top Image: Standard Creative Style, Bottom Image: with Adjustments

By varying the amounts of these three parameters, you can achieve a considerable range of different appearances for your images. For example, by increasing saturation, you can add punch and make colors stand out. By adding contrast and/or sharpness, you can impose a "harder" appearance on your images, making them look grittier and more realistic. FIGURE 4-74 is a composite image in which the top shot was taken with the Standard Creative Style using its normal settings, and the bottom shot was taken with the same setting, but with the contrast, sharpness, and saturation all adjusted to their maximum levels of +3 units. As you can see, although the difference in appearance is not all that dramatic, the bottom image is noticeably darker, with a grittier look than the top one.

The Creative Style option works with all shooting modes except the Auto modes and Scene mode. You can use it with the Raw format, but the results will vary depending on the Raw-conversion software you use. For example, I just shot a Raw image in Program mode using the Black and White setting. The image showed up in black and white on the camera's screen. However, when I opened the image in Adobe Camera Raw and then in Photoshop, the image was in color; the Adobe software ignored the information in the image's data about the Creative Style setting. When I opened the image using Sony's Image Data Converter software, though, the image appeared in black and white because Sony's software recognized the Creative Style information. So, if you want to use this menu option with Raw files, you need to be aware that not all software will use that information when processing the images.

In FIGURE 4-75, I provide comparison photos showing each setting as applied to the same scene under the same lighting conditions to illustrate the different effects you can achieve with each variation. General descriptions of these effects are provided after the comparison chart.

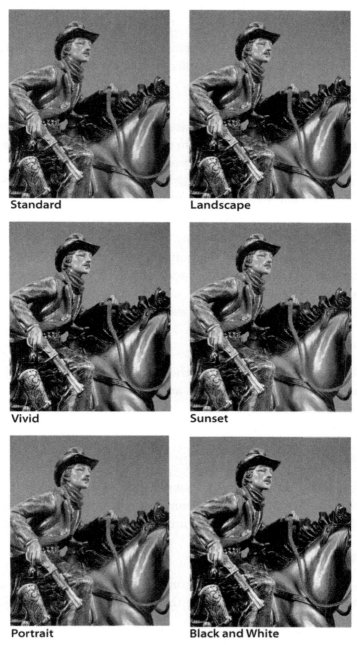

Standard

Landscape

Vivid

Sunset

Portrait

Black and White

Figure 4-75. Creative Styles Comparison Chart

STANDARD

The Standard setting is equivalent to having this feature turned off; no special processing is applied to your images.

VIVID

The Vivid setting increases the saturation, or intensity, of all colors in the image. As you can see from the samples, it calls attention to the scene, though it does not produce very dramatic effects. The Vivid setting might work well if you want to emphasize the colors in a birthday party scene or a carnival.

PORTRAIT

The main feature of the Portrait setting is a reduction in the saturation and sharpness of colors to soften the appearance of skin tones. You might want to use this setting to take portraits that are flattering rather than harsh and realistic.

LANDSCAPE

With the Landscape setting, the RX100 II increases all three values—contrast, saturation, and sharpness—to make the features of a landscape, such as trees and mountains, stand out with clear, sharp outlines.

SUNSET

With the Sunset option, the camera increases the saturation to emphasize the red hues of the sunset. In my opinion, this setting produces more changes in color images than any of the others.

B/W

This setting removes all color, converting the scene to black and white. Some photographers use this setting to achieve a realistic look for their street photography.

Note that the RX100 II also has specific settings for Portrait, Landscape, and Sunset in the Scene mode, discussed in CHAPTER 3. However, the similarly named settings of the Creative Style menu item have the advantage of being available in the more advanced shooting modes, including Program, Aperture Priority, Shutter Priority, and Manual Exposure, so you have access to other settings, such as ISO, Metering Mode, White Balance, DRO/Auto HDR, and others. In addition, as noted above, you can tweak the Creative Style settings by fine-tuning contrast, saturation, and sharpness. If you want to exercise full creative control over your photography, there are advantages to using the Creative Style settings, instead of the Scene mode settings, for those shots.

Picture Effect

The Picture Effect menu option includes a rich array of settings for shooting images with in-camera special effects. The Sony RX100 II gives you a terrific variety of ways in which to add creative touches to your shots, and the Picture Effect settings are probably my favorites. Of course, there is a lot of competition in the arena of special-effects photography nowadays from apps for cameras that are built into smartphones (such as Instagram, Hipstamatic, and others), and there also is competition from the trend for using cameras like the Holga—film-based models whose images are purposely degraded to look old-fashioned, with low resolution, grain, and other attributes of images taken by cheap, plastic cameras.

The Picture Effect option lets you delve into this area and other types of creative photo-making with considerable flexibility. The Picture Effect settings do not work with Raw images. If you set a Picture Effect option and then select Raw quality, the Picture Effect setting will be canceled. However, you still have control over many of the most important settings on the camera, including Image Size, White Balance, ISO, and even, in most cases, Drive

Mode. So, unlike the situation with the Scene mode settings, when you select a Picture Effect option, you are still free to control the means of taking your images as well as other aspects of their appearance.

To use any of these effects, select the Picture Effect menu option as shown in FIGURE 4-76, and as with other menu screens, scroll through the choices at the left of the screen.

Figure 4-76. Picture Effect Menu Option

Some selections have no further options, and some have additional settings that you can make by pressing the Left and Right buttons.

I will discuss each option in turn. In FIGURE 4-77, I provide a chart with one example image taken with each effect, all taken of the same scene—a lineup of model vehicles of different colors and textures. Clearly, this scene does not fit well with all of the Picture Effect settings because some settings are more suited for subjects like flowers and plants, some for buildings, and some, like the Miniature Effect feature, for specialized situations. However, I believe it is useful to see how the various settings affect the same scene, so that is how the chart is set up. After the chart, I will discuss each of the settings and provide larger illustrations for some of them.

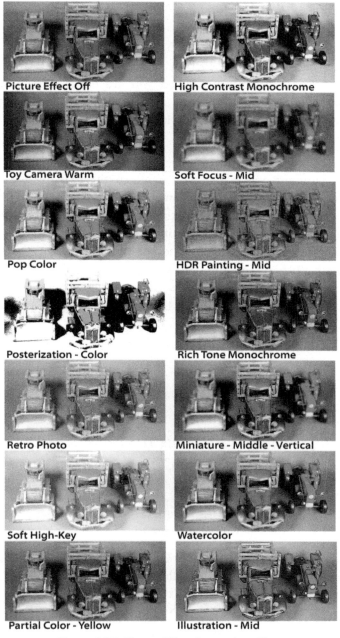

Figure 4-77. Picture Effect Comparison Chart

Following are details about each of the settings.

OFF

The top setting on the Picture Effect menu is used to cancel all Picture Effect settings. When you are engaged in ordinary picture-taking, you should make sure the Off setting is selected so that no unwanted special effects interfere with your images.

TOY CAMERA

The Toy Camera option gives you an alternative to using one of the popular models of "toy" film cameras such as the Holga, Diana, or Lomo, which are popular with hobbyists and artists who use them to take photos with grainy, low-resolution appearances. ("Lomography" is a genre of photography named for the Lomo camera.) With all of the Toy Camera settings, the RX100 II processes the image so it looks as if it were taken by a camera with a cheap lens: the image is dark at the corners and somewhat blurry.

Figure 4-78. Toy Camera: Cool Setting

The several sub-settings for Toy Camera, reached by pressing the Right and Left buttons, act as follows:

Normal: No additional processing.

Cool: Adjusts color to the "cool" side, resulting in a bluish tint.

Warm: Uses a "warm" white balance, giving a reddish hue.

Green: Adds a green tint, similar to dialing in an adjustment on the green axis for white balance.

Magenta: Similar to the Green setting, but adjustment is along the magenta axis.

FIGURE 4-78 is an image of an old bridge at the river taken with the Toy Camera feature using its Cool setting. Many people really enjoy the stylized, purposely cheapened look of images taken with the Holga and similar cameras. The RX100 II comes with a built-in ability to let you experiment with this genre, so you might give it a try if you have any interest.

POP COLOR

This next setting, according to Sony, is intended to give a "pop art" feel to your images through emphasis on bright colors. I don't have much background in art history, but I'm not sure that pop art is distinguished primarily by bright colors; I thought it had more to do with the subject matter, including images that originated from advertising and comic strips.

Figure 4-79. Pop Color Setting

Be that as it may, as you can see in FIGURE 4-79, which shows a quilt from a museum exhibit, what you get with this setting is another way to add "punch" and intensity, along with added brightness, to your color images. I have not found that this effect adds anything more to my images than the Vivid setting of the Creative Style option.

POSTERIZATION

The Posterization setting adds a fairly dramatic effect to your images. Using the right and left direction buttons, you can choose to apply this effect in color or in black and white. In either case, with this effect the camera applies a distinctive form of processing that results in heightened emphasis on colors (or dark and light areas if you select black and white) and imbues the image with a high-contrast, pastel-like look. It is somewhat like one of the more exotic types of HDR processing. The number of different colors (or shades of gray) used in the image is decreased to make it look as if the image were created from just a few poster paints; the result has an unrealistic but dramatic effect, as you can see in the chart in FIGURE 4-77.

It's a good idea to remember that with all of the Picture Effect settings, you can still make additional settings, including White Balance, Exposure Compensation, and others. With Posterization, you might try using some positive or negative exposure compensation, which can change the appearance of this effect dramatically. I have often found the results with this setting are improved by using negative exposure compensation to reduce the excessive brightness of the effect. In general, I recommend using the Posterization setting only when you want to achieve a striking artistic effect, perhaps to create a distinctive-looking poster or greeting card.

RETRO PHOTO

With the Retro Photo setting, the RX100 II uses sepia coloring and reduced contrast to mimic the appearance of an aging photo.

This effect is not as pronounced as the sepia effects I have seen on other cameras; with the RX100 II, a good deal of the image's original color still shows up, but there is a subtle softening of the image with the sepia coloration. In FIGURE 4-80 I used this effect to emphasize the antique qualities of a phonograph on exhibit in a museum.

Figure 4-80. Retro Setting

SOFT HIGH-KEY

"High key" is a technique in which a photographer uses bright lighting throughout the scene striving for a bright overall look with light colors and few shadows. This technique often is used in fashion and advertising photography. With the RX100 II, Sony has added softness to give the image a bright, light appearance without the harshness that might otherwise result from the overexposed appearance. I enjoy the pleasant, relaxing look of images taken with this effect.

PARTIAL COLOR

The Partial Color effect lets you choose a single color to retain in an image; the camera then reduces the saturation of all other colors to monochrome, so that only objects of that single color

remain in color in the image. I really enjoy this setting, which can be used to isolate a particular object with great dramatic effect.

In FIGURE 4-81, I used the Red setting to emphasize the colorful antique gasoline pump on display in the historical museum.

Figure 4-81. Partial Color Setting: Red

The choices for the color to be retained are red, green, blue, and yellow; use the Left and Right buttons to select one of those colors. Then, just aim the camera at your subject; you will see on the LCD display what objects will show up in color. There is no direct way to adjust the color tolerance of this setting, so you cannot, for example, set the camera to accept a broad range of reds to be retained in the image. However, if you change the White Balance setting, the camera will perceive colors differently. So, if there is a particular object that you want to depict in color, but the camera does not "see" it as red, green, blue, or yellow, you can try selecting a different White Balance setting and see if the color will be retained. You also can fine-tune the white balance using the color axes to add or subtract these hues if you want to bring a particular object within the range of the color that will be retained. Also, by choosing a color that does not appear in the scene at all, you can take a straight monochrome photograph.

HIGH CONTRAST MONOCHROME

This next setting is well explained by its label; it provides you with an easy way to take black and white photographs that have a stark, high-contrast appearance. You might want to consider this setting for street photography or any other situation in which you are not looking for a soft or flattering appearance. I used this setting for FIGURE 4-82, an image of an antique washing machine.

SOFT FOCUS

The Soft Focus effect is another setting that is variable; you can select either Low, Mid, or High by pressing the Right and Left buttons to scroll through those options. This effect is quite straightforward; the camera blurs the focus to achieve a dreamlike aura. Note that this is the first of several Picture Effect settings that cannot be previewed on the screen; you have to take the picture and then play it back to see the results of the Soft Focus setting. As I noted earlier in this chapter, you also have the option of selecting manual focus and de-focusing the image to your own taste to achieve a similar effect.

Figure 4-82. High Contrast Monochrome

For FIGURE 4-83, I used this effect for an image of a shadowy area among the trees in a local park, hoping it would convey a sense of mystery or fantasy.

Figure 4-83. Soft Focus Setting: Mid

HDR PAINTING

The HDR Painting setting is similar to the HDR setting of the DRO/Auto HDR menu option. With this option, the camera takes a burst of three shots at different exposure settings and combines them internally into a single image with HDR processing to achieve even exposure over a wide range of areas with respect to light and shadow. Unlike the more standard HDR setting, this one does not let you select the specific exposure differential for the three shots, but it lets you choose Low, Mid, or High for the intensity of the effect. Also, it adds stylized processing to give the final image a painterly appearance. I like this setting quite a bit; you can achieve some very clear, dramatic images with this option. For example, in FIGURE 4-84, I shot a picture of a tractor in a museum exhibit; the Picture Effect setting emphasized the contrasting colors and heightened the impact of the scene.

Figure 4-84. HDR Painting Setting: High

In FIGURE 4-85, I took a different approach with this effect, using it for a shot of the downtown area along a busy street. Here, the result to me seems somewhat like a painting, even though the objects in the image were all photographed; everything is real but looks somewhat unreal.

Figure 4-85. HDR Painting Setting: Mid

Because the camera takes multiple images with this effect, you can't preview the results on the screen before taking the picture. In addition, using a tripod is advisable to avoid blur from camera motion while the three shots are being taken.

RICH-TONE MONOCHROME

The Rich-tone Monochrome setting can be considered as a black and white version of the HDR Painting setting. With this option, like that one, the RX100 II takes a burst of three shots at different exposures and combines them digitally into a single composite photo with a broader dynamic range than would otherwise be possible. Unlike the color setting, though, this one does not let you select the intensity of the effect. I used it in FIGURE 4-86 for a landscape shot at the river. I like the deep, rich grayscale tones, reminiscent of images from high-quality black-and-white film.

Figure 4-86. Rich-Tone Monochrome Example

MINIATURE

The next Picture Effect setting is called the Miniature effect. When you apply this option to an image, the camera adds blurring at one or more sides of an image or at the image's top or bottom to simulate the appearance of a photograph of a tabletop model or miniature. Such images often appear hazy in one or more areas, either because of the narrow depth of field of these closeup photos, or because of the use of a tilt-and-shift lens, which causes blurring at the edges.

For this feature to work well, you need an appropriate subject. I have found that this effect looks interesting when applied to

something like a street scene or a train, which might actually be reproduced in a tabletop model. For example, if you are able to get a high vantage point above a road intersection or a railroad, you may be able to use this processing to make it look as if you had photographed a high-quality tabletop display.

After highlighting this option on the Shooting menu, press the Right and Left buttons to choose either Top, Middle (Horizontal), Bottom, Right, Middle (Vertical), Left, or Auto for the configuration of the effect. If you choose a specific area, that area will remain sharp. For example, if you choose Top, then, after you take the picture, the top area (roughly one-third) will remain sharp, and the rest of the image below that area will appear blurred. If you choose Auto, then the camera will select the area to remain sharp based on the area that was focused on by the autofocus system and by the camera's sensing how you are holding the camera. You will not see how the effect will alter your image while viewing the scene, although the camera will place gray areas on the parts of the image that will ultimately be blurred to give you a general idea of how the final product will look. I used the RX100 II for an image of this sort in FIGURE 4-87, with the Miniature effect set to its Top orientation, with only the buildings near the top in focus.

Figure 4-87. Miniature Setting: Top

This effect can provide a lot of fun if you are willing to experiment with it; it can take some work to find the right subject and the best arrangement of sharp and blurry areas to achieve a satisfying result.

One disappointing note is that this effect cannot be used for movies with the RX100 II. I was surprised to find this because miniature effects are often used for making movies with subjects that look like speeded-up models of trains, cars, and the like. But not with the RX100 II, for some reason.

WATERCOLOR

The Watercolor effect is designed to blur the colors of an image somewhat and make it look as if it were painted with watercolors that are bleeding together. You need to choose a subject that lends itself to this sort of distortion. For example, I have found that the faces of dolls and other figures can be pleasantly altered to have an impressionistic appearance; larger objects may not be affected significantly by this somewhat subtle effect. I have also had some pleasing results with plants and trees. In FIGURE 4-88, I thought this effect worked well for a view of a forest with the colorful shirts of a strolling couple adding some contrast.

Figure 4-88. Watercolor Setting

ILLUSTRATION

The final option for the Picture Effect setting, Illustration, is one of my favorites. This effect finds edges of objects within the scene and adds contrast to them, making it appear as if they are outlined with dark ink as in a pen-and-ink illustration that has been colored in. You can set the intensity of the effect to Low, Mid, or High using the Right and Left buttons. If you choose a subject that has a fair number of edges that can be outlined and has a repeating pattern, you can achieve a very pleasing appearance. This is another one of the effects whose final result you cannot judge while viewing the live scene; you need to see the recorded image to know what the actual effect will look like.

Figure 4-89. Illustration Example: High

As you can see in FIGURE 4-89, which was shot with Illustration set to High level, this effect can transform an ordinary view into a stylized image while leaving the scene recognizable. The images produced with this effect may be more suited as decorative items than as depictions of actual objects or locations, but their appearance can be very striking and unusual.

Here are some more notes about the Picture Effect settings. First, as noted for the Miniature effect, several of the options are not available when you are shooting movies. Besides Miniature, these settings are Soft Focus, HDR Painting, Rich-tone Monochrome,

Watercolor, and Illustration. If one of these effects is turned on when you press the red Movie button, the camera will turn off the effect while the movie is being recorded, and turn it back on after the recording has ended. You cannot use Drive Mode with any of these effects. Also, even for the other effects, which can be used when shooting movies, you cannot take still images while shooting video. Finally, note that there are two other ways to activate some of these effects: with the Photo Creativity feature in the Auto shooting modes, as discussed in CHAPTER 2, and with the Picture Effect setting in Playback mode, as discussed in CHAPTER 6.

Clear Image Zoom and Digital Zoom

The first option on the fourth screen of the Shooting menu, Clear Image Zoom, gives the RX100 II extra zoom range without compromising the quality of your images very much. Digital Zoom, the next item on the menu, is a more conventional feature that magnifies the image but reduces the quality. To explain these features in context, I will discuss all three zoom methods that the camera offers—optical zoom, Clear Image Zoom, and Digital Zoom.

Optical zoom is what could be called the camera's "natural" zoom capability—that is, moving the lens elements so they magnify the light that reaches the sensor, just as binoculars or a telescope do. You might call optical zoom a "pure" or "real" zoom because it actually increases the amount of information that the lens gathers. The optical zoom of the RX100 II operates within a range from 28mm at the wide-angle setting to the fully zoomed-in telephoto setting of about 100mm.

Just to complicate matters a bit, I should point out that the actual optical zoom range of the RX100 II's lens is 10.4mm to 37.1mm; you can see those numbers on the end of the lens. But the numbers that are almost always used to describe the zoom range of a compact camera's lens are the "35mm-equivalent"

figures, which translate the actual zoom range into what the range would be if this were a lens on a camera that uses 35mm film. This translation is done because so many photographers are more familiar with the zoom ranges and focal lengths of lenses for traditional 35mm cameras, on which a 50mm lens is considered "normal." I use the 35mm-equivalent figures throughout this book.

The Digital Zoom feature on the RX100 II magnifies the image electronically without any special processing to improve the quality. This type of zoom does not really increase the information gathered by the lens; rather, it just increases the apparent size of the image by enlarging the pixels within the area captured by the lens. On some cameras, the amount of digital zoom can be very large, such as 50 times normal, but those large figures should be considered as marketing ploys to lure customers, rather than as a feature of real value to the photographer.

The third option on the RX100 II, Clear Image Zoom, is a special type of digital zoom developed by Sony. With this feature, the RX100 II does not just magnify the area of the image; rather, the camera uses an algorithm based on analysis of the image to add pixels through interpolation, so the pixels are not just multiplied. Instead, the enlargement is performed in a way that produces a smoother, more realistic enlargement than the standard Digital Zoom feature. Therefore, with Clear Image Zoom, the camera achieves greater quality than with Digital Zoom, though not as much as with the "pure" optical zoom.

Finally, there is one more way in which the RX100 II can achieve a zoom range greater than the normal range of 28mm to 100mm, with no reduction in image quality. The standard zoom range of 28mm to 100mm is available when Image Size is set to Large. However, if Image Size is set to Medium or Small, then the camera needs only a portion of the pixels on the image sensor to create the image at the reduced size. It can use the "extra" pixels to enlarge the view of the scene. This process is similar to what you

can do using editing software such as Photoshop. If the overall image size does not need to be of the Large size, you can crop out some pixels from the center (or other area) of the image and enlarge them, thereby retaining the same overall image size with a magnified view of the scene.

So, if you set Image Size to M or S, the camera can zoom to a greater range than with Image Size set to L, and still retain the full quality of the optical zoom. You will, of course, end up with lower-resolution images, but that may not be a problem if you are going to post them on a website or share them via e-mail.

In summary, optical zoom provides the best quality for magnifying the camera's view of a scene; Clear Image Zoom provides excellent quality; and Digital Zoom provides magnification that is accompanied by deterioration of the image.

With that introduction, here is how to use these settings. I will assume for this discussion that you are leaving Image Size set to L, because that is ordinarily the best setting to use to achieve excellent results in printing and otherwise distributing your images. Clear Image Zoom and Digital Zoom, the first two options at the top of the fourth screen of the Shooting menu, both have only two settings: Off and On. If you turn on Clear Image Zoom, you will achieve a greater zoom range than normal, as discussed above, and with minimal loss in quality. If you also turn on Digital Zoom, you will achieve an even greater zoom range, but the quality will deteriorate as the lens is zoomed past the range in which Clear Image Zoom operates. If you turn on Digital Zoom but leave Clear Image Zoom turned off, you will achieve a greater zoom range, but the image quality will deteriorate as soon as you pass the range for optical zoom.

When these various settings are in effect, you will see different indications in the viewfinder.

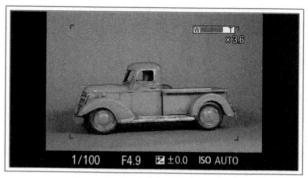

Figure 4-90. Optical Zoom in Use

In FIGURE 4-90, Image Size is set to L and both Clear Image Zoom and Digital Zoom are turned off. The zoom indicator at the top of the screen goes only as far as 3.6 times normal.

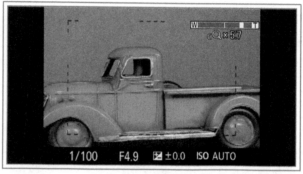

Figure 4-91. Optical Zoom with Clear Image Zoom Turned On

In FIGURE 4-91, Clear Image Zoom is turned on. In this case, the zoom indicator goes up to 7.2 times normal. There is a small vertical line in the center of the zoom scale; that line indicates the point at which the zoom changes from optical-only to expanded (either Clear Image Zoom or Digital Zoom, depending on the settings). The icon of a magnifying glass with the letter "C" beneath the scale means that Clear Digital Zoom is turned on.

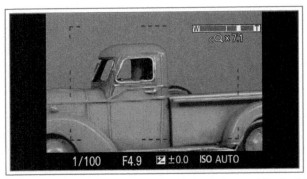

Figure 4-92. Clear Image Zoom and Digital Zoom Turned On: In C Range

In FIGURE 4-92, both Clear Image Zoom and Digital Zoom are turned on, and the zoom indicator goes up to 14 times normal. Up to a certain point in the zoom range, the magnifying glass icon will have a C next to it showing that Clear Image Zoom is in effect, as shown in FIGURE 4-92.

Figure 4-93. Clear Image Zoom and Digital Zoom Turned On: In D Range

When the zoom range extends beyond that point, the C will change to a D, showing that Digital Zoom is in effect, as shown in FIGURE 4-93.

TABLE 4-2 shows the zoom ranges that are available when Image Size is set to Large, Medium, and Small, with settings of Optical Zoom, Clear Image Zoom, and Digital Zoom. In all cases, Aspect Ratio is set to 3:2; with other settings, results would be different.

Table 4-2. **Zoom Range at Various Image Sizes**

	Large	Medium	Small
Optical Zoom (with no deterioration)	100mm	143mm	200mm
Clear Image Zoom (with minimal deterioration)	200mm	280mm	392mm
Digital Zoom (with significant deterioration)	392mm	560mm	784mm

To summarize the situation with zoom, when Image Size is set to L, you can zoom up to 100mm with no deterioration using optical zoom; you can zoom to about 200mm with minimal deterioration using Clear Image Zoom; and you can zoom to about 400mm using Digital Zoom but with significant deterioration.

My preference, and that of quite a few photographers, is to limit the camera to optical zoom and avoid any deterioration. However, many photographers have found that Clear Image Zoom yields surprisingly good results, and it is certainly worth trying when you cannot get close to your subject and you need to get a magnified view. I do not like to ever use Digital Zoom to take a picture. However, it can be useful to zoom in on a subject to meter a specific area of a distant subject, or to check the composition of your shot before zooming back out and taking the shot using Clear Image Zoom or optical zoom.

Note that Clear Image Zoom and Digital Zoom are not available in several situations, including when shooting Raw images and in Sweep Panorama mode. Clear Image Zoom is unavailable with continuous shooting (you can turn it on in the menu, but the camera will use only optical zoom and Digital Zoom.)

Note that Digital Zoom is always active when shooting movies or when continuous shooting is active, and it cannot be turned off. If you don't want to use it, you need to be careful to avoid zooming beyond the optical range in those cases.

Long Exposure Noise Reduction

This option, when activated, uses special processing to reduce the "noise" or graininess that affects images during exposures of 1/3 second or longer. This option is turned on by default. When it is turned on, the camera processes your shot for a time equal to the time of the exposure. So, if your exposure is for 2 seconds, the camera will process the shot for an additional 2 seconds, creating a delay before you can shoot again.

In some cases, this processing may remove details from your image. In addition, in certain situations you may prefer to leave the noise in the image for aesthetic reasons because the graininess can be pleasing in some contexts. Or, you may prefer to remove the noise using post-processing software. If you want to turn off this option, use this menu item to do so. This option is not effective, even when turned on, when the camera is set for continuous shooting, exposure bracketing, panorama shooting, or when using the Scene mode settings of Sports Action or Hand-held Twilight.

High ISO Noise Reduction

This option has three settings: Low, Normal, or High; the default is Normal. This menu option, like the previous one, removes noise that is caused when the camera is set to a high ISO level. One problem with this sort of noise reduction is that it takes time to process your images after they are captured. So you may want to set this option to Low to minimize the delay before you can take another picture. If Quality is set to Raw, this option will be unavailable on the menu screen because this processing is not available for Raw images.

AF Illuminator

The AF Illuminator menu item gives you the option of disabling the use of the reddish lamp on the front of the camera for

autofocusing. By default, this option is set to Auto, which means that when you are shooting in a dim area, the camera will turn on the lamp briefly if needed to light up the subject and assist the autofocus mechanism in gauging the distance to the subject. If you would rather make sure the light never comes on for that purpose—to avoid causing distractions in a museum or other sensitive area, or to avoid alerting a subject of candid photography—you can set this option to Off. In that case, the lamp will never light up for focusing assistance, though it will still illuminate if the self-timer, Smile Shutter, or another option that uses the lamp is activated.

SteadyShot

SteadyShot is Sony's optical image stabilization system, which compensates for small movements of the camera to avoid motion blur, especially during exposures of longer than about 1/30 second. This setting is turned on by default, and I recommend leaving it on at all times, except when the camera is on a tripod. In that case, SteadyShot is not needed, and there is some chance it can "fool" the camera and result in an attempt to correct for motion that does not exist, resulting in image blur. Note that there is a different SteadyShot setting for movies; I will discuss that Movie menu item in CHAPTER 8.

Color Space

With this option, you can choose to record your images using the sRGB "color space," the more common choice and the default, or the Adobe RGB color space. The sRGB color space has fewer colors than Adobe RGB; therefore, it is more suitable for producing images for the web and other forms of digital display than for printing. If your images are likely to be printed commercially in a book or magazine or it is critical that you be able to match a great many different color variations, you might want to consider using the Adobe RGB color space. I always leave the color space set to

sRGB, and I recommend that you do so as well unless you have a specific need to use Adobe RGB, such as a requirement from a printing company that you are using to print your images.

Shooting Tip List

This first menu item at the top of the fifth Shooting menu screen does not control any function. Instead, it is a collection of helpful tips about photography. To use it, press the Center button when this option is highlighted, then scroll using the Up and Down buttons or the Control wheel through the six main categories on the screen, including Basic techniques for shooting, Portraits and animals, and four others, as shown in FIGURE 4-94. Press the Center button to bring up sub-categories for each topic.

Figure 4-94. Shooting Tip List: Six Categories of Topics

Some tips are generic and apply to any camera, and some discuss the use of a particular feature, such as the Smile Shutter. This guide can be of some use if you are new to photography and need a few suggestions to get you started.

Write Date

This setting can be used to embed the current date in orange type in the lower-right corner of your images, as shown in FIGURE 4-95.

This embedding is permanent, which means that the information will appear as part of your image that cannot be deleted, other than through cropping or other editing procedures. You should not use this function unless you are certain that you want the date recorded on your images, perhaps for pictures that are part of a scientific research project.

Figure 4-95. Write Date Feature in Use

You can always add the date in other ways after the fact in editing software if you want to because the camera always records the date and time internally with each image (if the date and time have been set accurately), so think twice before using this function. When you are shooting with this option activated, the word "DATE" appears in the upper-right corner of the screen as you compose your shot if you are using a shooting screen that displays detailed information. This option is not available when Quality is set to Raw or Raw & JPEG, with panoramas, bracketing, continuous shooting, or in Movie mode.

Scene Selection

This menu option is included here just because it is next on the final screen of the Shooting menu. As discussed in CHAPTER 3, this option is used only when the camera is set to Scene mode; you use this menu item to select one of the settings in that shooting

mode, including Portrait, Anti Motion Blur, Sunset, Night Scene, and others. Note that you also can use the Control ring to change Scene types, as long as the Control Ring option on the Custom menu is set to Standard and you are not using manual focus or DMF. In addition, the Scene Selection menu screen appears automatically when you turn the Mode dial to the SCN position if the Mode Dial Guide option on the Setup menu is turned on.

Memory Recall

The Memory Recall menu option is used only when the Mode dial is set to MR, for Memory Recall mode. When the dial is turned to that setting, this option's main screen appears automatically on the camera's display with one of the three numbers at the upper right highlighted, as shown in FIGURE 4-96.

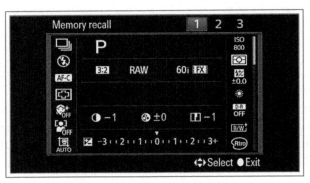

Figure 4-96. Memory Recall Screen

You can then turn the Control wheel or use the Right and Left buttons to choose 1, 2, or 3 for the Memory Recall register setting. Next, press the Center button, and the camera will be set up with all of the shooting settings that were assigned to that numbered register of the Memory Recall shooting mode. I discussed this procedure in CHAPTER 3.

If the camera is set to Memory Recall mode and you want to change to one of the other memory registers, then that is when you have

to use the menu system to call up this option. Select this item to bring up the main menu screen, and use the direction buttons or turn the Control wheel to select memory register 1, 2, or 3 at the upper right of the screen. Then press the Center button, and the new set of shooting settings for that register will take effect.

Memory

The final option on the Shooting menu, Memory, was discussed in CHAPTER 3 in connection with the Memory Recall shooting mode. Once you have set up the RX100 II with the menu options and other settings you want to store to a register of the Memory Recall shooting mode, you select the Memory menu option, and choose one of the numbered registers, as shown in FIGURE 4-97.

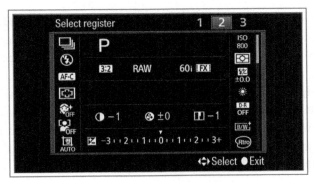

Figure 4-97. Memory Menu Option

Finally, press the Center button, and all of the camera's current settings will be stored to that register for the Memory Recall mode. You then recall those settings by turning the Mode dial to the MR position (or selecting the Memory Recall menu option) and selecting register 1, 2, or 3.

With either the Memory Recall or Memory option, you can scroll down to additional screens using the Down button to see other settings currently in effect, such as ISO Auto Maximum and Minimum, Clear Image Zoom, High ISO NR, and several others.

CHAPTER 5:
Other Controls

The Sony RX100 II, like many compact cameras, does not have a great number of physical controls. It relies to a large extent on its system of menus to give you the ability to change settings. But the RX100 II is at the upper end of the scale of high-quality compact cameras, and one aspect of its quality is that although it does not have more actual controls than many cameras of its size, its controls can be configured to adjust many settings on the camera. Advanced photographers often prefer to be able to make settings with a knob or a dial for speed of access, and Sony has made it possible to set up the camera's controls in a way that suits your preferences. In this chapter, I'll discuss each of the camera's physical controls and how they can be used to best advantage, starting with the controls on top of the camera, shown in FIGURE 5-1.

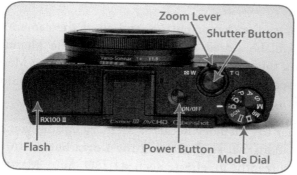

Figure 5-1. Controls on Top of Camera

Mode Dial

The Mode dial, at the right side of the camera's top, has just one function—to change the camera from one shooting mode to another. I discussed the shooting modes in CHAPTER 3. To take a quick still picture, turn this dial to the setting marked by the green camera icon and fire away. To take a quick video sequence, turn the dial to that same position and then press the red Movie button, just below the Mode dial at the top of the camera's back. It is important to remember that you can record a movie with the Mode dial set to any position. There is a Movie mode on this dial, marked by a movie-film icon, but you do not have to select that icon to record movies.

Note, though, that the Custom menu has an option for locking out the use of the Movie button unless the camera is set to Movie mode. So, if the Mode dial is set to Intelligent Auto, Program, or any other setting other than Movie mode, the Movie button will not work if that menu option is turned on.

Shutter Button

The Shutter button is the single most important control on the camera. When you press it halfway, the camera evaluates exposure and focus (unless you're using manual exposure or manual focus). Once you are satisfied with the settings, press the button all the way to take the picture. When the camera is set for continuous shooting, you hold this button down while the camera fires repeatedly. You also can press this button halfway to exit from playback mode, menu screens, and help screens to get the camera set to take its next picture. Also, you can press this button to take a still picture while the camera is recording a movie.

Zoom Lever

The Zoom lever is a small ring with a short handle surrounding the Shutter button. Its primary function is to change the focal length of the lens between its wide-angle setting of 28mm and its telephoto setting of 100mm. If you have the camera set for Clear Image Zoom or Digital Zoom, the lever will take the zoom to higher levels, as discussed in CHAPTER 4.

Note that you can also use the Control ring to zoom the lens if you have the camera set up with that function using the Control Ring option on the Custom menu. You also can set the Control ring to use the Step Zoom function, which causes the lens to zoom in a predefined step each time you operate the ring. (That function is controlled by the Zoom Function on Ring option on the second screen of the Custom menu.) The Step Zoom function does not work with the Zoom lever, though. When you use the Zoom lever, the lens zooms continuously, even if Step Zoom is turned on for the Control ring.

In playback mode, moving the Zoom lever to the left produces index screens with increasing numbers of images, and moving the lever to the right enlarges your current image. Those operations are discussed in CHAPTER 6.

Power Button

This button in the middle of the camera's top is used to turn the camera on and off. An orange light in the center of the button glows when the battery is being charged in the camera. You also can turn the camera's power on by pressing the Playback button, which places the camera into playback mode.

Built-in Flash

The camera's built-in flash unit is normally retracted and hidden in the left side of the camera's top. To set the flash so it will pop

up, you have to use the Flash button, which is the right edge of the Control wheel on the back of the camera. Even after you have selected a flash mode that will require the use of flash, such as the Fill-flash mode, the flash will not pop up into place until you press the Shutter button halfway to evaluate the exposure. (An exception is when you are using an automatic shutter release option, such as the Smile Shutter; the camera will pop up the flash if it needs to, even though you are not touching the Shutter button.)

If you want the flash to be stowed away again, you need to press it gently back down into the camera until it clicks into place. If you want to use "bounce flash," which causes the flash to be reflected by the ceiling to reduce its intensity, you can pull the flash unit back carefully with your finger and hold the flash so that it is aiming upward while it fires.

Next, I will discuss two items on the front of the camera, as seen in FIGURE 5-2, before turning to the controls on the back.

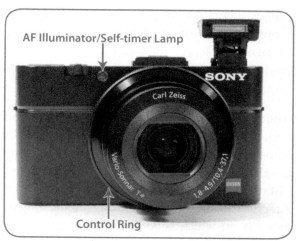

Figure 5-2. Controls and Other Items on Front of Camera

AF Illuminator/Self-Timer Lamp

The small lamp on the front of the camera next to the Control ring has multiple functions. Its reddish light blinks to signal the operation of the Self-timer, Self-portrait Timer, and Smile Shutter. It also turns on in dark environments to assist with autofocusing. You can control its function for helping with autofocus through the AF Illuminator item on the fourth screen of the Shooting menu, as discussed in CHAPTER 4. If you set that menu item to Auto, the lamp will light as needed for autofocus; if you set it to Off, the lamp will never light for that purpose, though it will still illuminate for the Self-timer and other timers such as the Smile Shutter and Self-portrait Timer.

Control Ring

The Control ring is the ridged circle that surrounds the lens, where the lens connects with the camera. As I noted earlier, it is a sign of a more advanced camera to have physical controls that let you make adjustments without navigating through menus. This particular control is of great use: first, because it is large, it is easy to find and turn by feel; second, because you have the option of assigning various functions to it, it can suit your particular needs as a photographer.

To assign functions to the Control ring, you use the Control Ring menu option, the first item on the second screen of the Custom menu (the menu whose icon is a gear). When the camera is set up with its original, default settings, this item is set to Standard. When the Standard setting is in effect, the Control ring controls just one function in any given shooting mode; the function it controls depends on which shooting mode the camera is set to. For example, if the camera is set to the Aperture Priority mode, the Control ring controls aperture; in Shutter Priority mode, the ring controls shutter speed. In the Scene shooting mode, the ring controls Scene setting selection.

I usually leave the Control Ring menu item set to Standard because the functions the ring controls in the various shooting modes in that case are quite useful. However, if you want to use the ring for one dedicated function no matter what shooting mode is in effect, you can use the Control Ring item on the Custom menu to choose one of the following items that will stay assigned to the ring until you make another change: Exposure Compensation, ISO, White Balance, Creative Style, Picture Effect, Zoom, Shutter Speed, or Aperture. You also can choose Not Set, in which case turning the ring will have no effect (unless you activate a function, such as manual focus, that requires use of the ring).

A function assigned to the ring only works if the context permits it. For example, if you assign Aperture to the Control ring, the ring will control aperture if the camera is set to Aperture Priority or Manual exposure mode. In any other shooting mode, turning the ring will have no effect (except for adjusting manual focus) because aperture cannot be controlled manually in other modes.

TABLE 5-1 lists the functions that are assigned to the Control ring with the Standard setting.

Table 5-1. **Control Ring: Standard Setting—Shooting Modes vs. Assigned Functions**

Shooting Mode	Assigned Function
Intelligent Auto	Zoom
Superior Auto	Zoom
Program	Program Shift
Aperture Priority	Aperture
Shutter Priority	Shutter Speed
Manual Exposure	Aperture
Scene	Scene Selection
Sweep Panorama	Direction
Memory Recall	Depends on Saved Setting

The Control ring also is used in two other situations regardless of how you have set its assigned function. When you press the Function button (discussed later in this chapter), the camera activates a menu that shows several options—including items such as White Balance, ISO, Exposure Compensation, etc.—depending on the settings you have chosen for that menu. Once you have pressed the Function button to display that menu, you can then turn the Control ring (or the Control wheel) to select the value for the setting that is active.

Finally, whenever the camera is set to manual focus or DMF (direct manual focus), you use the Control ring to adjust the focus. In addition, if the MF Assist option is turned on through the third screen of the Custom menu, the display will be magnified to assist with focusing as soon as you start turning the Control ring. When the camera is set to either of those focus modes, you cannot use the Control ring for any other function.

Now it is time to discuss the several important controls on the back of the RX100 II, as seen in FIGURE 5-3.

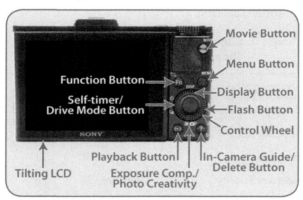

Figure 5-3. Controls on Back of Camera

Playback Button

This button to the lower left of the Control wheel, marked with a small triangle, is used to put the camera into playback mode,

which allows you to view your images on the LCD screen and gives you access to the Playback menu. It also can be used instead of the Power button to turn the camera on, placing the RX100 II immediately into playback mode with the lens retracted. When the camera is in playback mode, you can press the Shutter button halfway or press the Playback button again to switch the camera into shooting mode.

Movie Button

The red button at the upper right of the camera's back has just one function—to start and stop the recording of movie sequences. As I noted in discussing the Mode dial earlier in this chapter, you can control how the Movie button operates. If you want to be able to start recording a movie in any shooting mode, go to the Custom menu and select the first option on the third menu screen, which is called Movie Button. If you set that menu option to Always (the default setting), then the Movie button will operate in any shooting mode. If you set that option to Movie Mode Only, then the Movie button will not operate unless the camera is set to Movie mode using the Mode dial. (Movie mode is the mode marked by movie-film icon.)

This is a fairly important decision to make, and it really depends on your preferences and likely uses of the camera. If you want to be able to start recording a video at any time without delay, you should leave the Movie Button option set to Always. The reason you might not want to do this is that it is very easy to press the Movie button by mistake. I have done that often myself, particularly with the earlier model, the RX100, that does not have the option to limit the use of the Movie button to Movie mode. When you press the button by mistake, you have to press it again to stop the recording, and then wait for the camera to finish processing the movie before you can use any other controls. And, of course, the camera will have an unwanted file cluttering the memory card.

My own preference is to limit use of the Movie button to when the camera is in Movie mode, but if I were going on a vacation and wanted to be able to start recording a movie in Intelligent Auto mode without delay, I probably would enable the button for use in all modes.

There are differences in how the camera operates for video recording in different shooting modes. I will discuss movie-making in detail in CHAPTER 8.

Menu Button

The Menu button, to the upper right of the Control wheel, is straightforward in its basic function. Press it to enter the menu system, and press it once more to exit back to whatever mode the camera was in previously (shooting mode or playback mode). The button also cancels out of sub-menus, taking you back to the main menu screen.

Function Button

The button marked Fn, for Function, is a control that gives you considerable flexibility for setting up the RX100 II according to your own preferences. Using the Function Button menu option on the second screen of the Custom menu (discussed in CHAPTER 7), you can assign up to seven functions to this button, from among 17 possibilities. The functions that can be assigned include important settings such as ISO, Drive Mode, White Balance, Metering Mode, and Picture Effect.

Once you have assigned your seven (or fewer) chosen options to this button, it is ready for action. To use an option, just press the button when the camera is in shooting mode, and a menu of choices will appear along the bottom of the display with matching choices in a circular menu at the top, as shown in FIGURE 5-4.

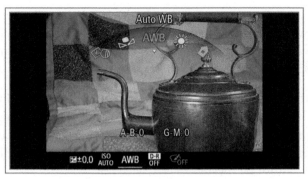

Figure 5-4. Circular Display for Function Button Menu

To scroll through these options, press the Left and Right buttons moving the orange cursor at the bottom of the display underneath the one you want to select and moving through the matching choices at the top of the display. Do not press the Center button to change the setting for the selected item; pressing that button will dismiss the menu without changing the setting. Instead, just turn either the Control wheel or the Control ring to change the value of the selected item.

For example, if you have moved the cursor under the ISO item, then while the cursor and the ISO icon are on the screen, turn the wheel or the ring until the ISO setting you want to make appears. Then, press the Center button to confirm the setting and exit from the Function button screen. Or, if you want to make multiple settings from the Function button options, you can scroll to another of the items in the horizontal menu at the bottom of the screen and change its value also before exiting from the Function button screen.

Note that there may be some items at the bottom of the screen whose icons will be dimmed because the item is unavailable for selection in the current context. If you move the orange cursor under one of those items and then try to change the setting, the camera will display an error message.

The Function button system on the RX100 II is well thought out and convenient. I strongly recommend that you experiment and develop a list of seven items to assign to this button and make use of this speedy way to change important settings.

When the camera is in playback mode, pressing the Function button brings up a screen allowing you to rotate the image that is currently displayed, as shown in FIGURE 5-5. If the currently displayed image is a movie, you will see an error message because the item cannot be rotated.

Figure 5-5. Function Button Rotate Screen

In-Camera Guide/Delete Button

The button marked with a question mark, to the right of the Playback button, is officially called the In-Camera Guide button or the Delete button. I prefer to call it the Help button or the Trash button. When the camera is in shooting mode, you can press this button to bring up a brief help screen with guidance or tips about the use of the camera. The help screen that is shown varies depending on the context. If the camera is ready to shoot, displaying the live view of the scene, pressing the Help button brings up the Shooting Tip List, the same option that is available from the fifth screen of the Shooting menu. FIGURE 5-6 is an example of the various types of photography tips that are available through this help system.

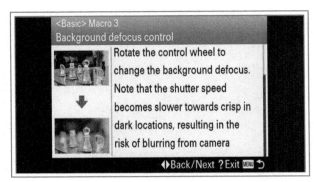

Figure 5-6. Shooting Tip List Screen from Pressing Help Button

When you are viewing these screens, you can scroll through the pages of tips using the Control wheel or the Up and Down buttons. To dismiss the tip screen, press the Help button again. Press the Menu button to return to a previous screen. You also can press the Shutter button halfway to return to the shooting screen.

The Help button also has a special function when the camera is set to the Intelligent Auto or Superior Auto shooting mode. When you are using the Photo Creativity option in either of these modes and you have moved the indicator along the curved scale on the screen to change a setting (such as Brightness or Color), you can press the Help button to reset the option to its default value.

If the camera is displaying the main page of a menu screen with the highlight on a particular feature, then pressing the Help button will bring up a screen with a brief message explaining the use of that feature.

For example, FIGURE 5-7 shows the message that is displayed when the camera is displaying the third screen of the Shooting menu, with the Drive Mode item highlighted.

Figure 5-7. Shooting Tip List Screen for Drive Mode

If you select a sub-option for that menu item and then press the Help button, the camera will display a different message providing details about that particular option. For example, FIGURE 5-8 shows the help screen that was displayed when I pressed the Help button after highlighting the Speed Priority Continuous Shooting option for the Drive Mode item.

Figure 5-8. Shooting Tip List Screen for Speed Priority Continuous Shooting

This help system is quite detailed; for example, it provides varying guidance even for different ISO settings, such as ISO 100, 160, and 1600, with tips about what shooting conditions might call for that setting. The shooting tips function operates with all of the RX100 II menu systems, including Custom, Playback, Setup, and the others, not just the Shooting menu.

If the camera is in playback mode, displaying a recorded image or movie (and not a menu screen), then this button becomes the Delete button (Trash button), as indicated by the trash can icon to the lower right of the button. If you press the button, the camera displays the message shown in FIGURE 5-9, prompting you to select Delete or Cancel.

Figure 5-9. Delete Screen for Single Image

If you highlight Delete and then press the Center button, the camera will delete the image or video that was displayed on the screen. If you choose Cancel, the camera will return to the playback mode screen.

Control Wheel and Its Buttons

Several of the most important controls are within the perimeter of the Control wheel, the ridged wheel with icons around its outer edges. In the middle of the wheel is the Center button, a much-used control. At the four points of the wheel (up, down, left, and right), the edges function as buttons. That is, if you press the wheel's rim at any of those four points, you are, in effect, pressing a button. Each button has at least two functions—as a direction control along with one or more other specific assignments. When they act as direction controls, the buttons are used to navigate through menu options and other choices for controlling the camera's settings. The other main functions of the buttons are

indicated by one or more icons at each button's position on the Control wheel. I will discuss all of these controls in turn.

CONTROL WHEEL

In many cases, to choose a menu item or a setting, you can turn this wheel. In some cases, you have the choice of using this wheel or pressing the direction buttons. One helpful feature of the RX100 II is that it places a round icon on the screen representing the Control wheel when there is a value that can be adjusted at that point by the wheel. (If you don't see the icon, press the Display button until it appears.)

For example, in FIGURE 5-10, the icon, which looks like a gray ring lying flat on the screen, is positioned next to the Av indicator, meaning the Control wheel can now control aperture. (The more three-dimensional icon above that one shows that the Control ring also can control aperture at this time.)

Figure 5-10. Control Wheel Icon on Screen in Aperture Priority Mode

FIGURE 5-11 shows the camera in Manual exposure mode, and the icon for the Control wheel is next to the Tv indicator, standing for time value or shutter speed, indicating you can adjust the shutter speed by turning the Control wheel. (In this case, the icon above this one shows that the Control ring can now adjust aperture.)

Figure 5-11. Control Wheel Icon on Screen in Manual Mode

The Control wheel also has many other functions. When you are viewing a menu screen, you can navigate up and down through the lists of options by turning the wheel. When you are adjusting items using the Function button, you can change the value for the selected setting by turning the Control wheel. When you are using manual focus and you have the Focus Magnifier option turned on, you can turn the Control wheel to vary the area of the scene that is being magnified.

In playback mode, you can turn the Control wheel to navigate from one image to the next on the LCD screen. Also, when a video is being played on the screen and has been paused, you can turn the Control wheel to play the video slowly, frame-by-frame, either forward or in reverse.

CENTER BUTTON

This button in the center of the Control wheel serves many purposes. On menu screens that have additional options, such as the Image Size screen, this button takes you to the next screen to view the other options. It also acts as a selection button when you choose certain options. For example, after you select Focus Mode from the second screen of the Shooting menu and then navigate to your desired focus option, you can press the Center button to confirm your selection and exit from the menu screen back to the shooting screen.

The Center button also has several other possible uses depending on how it is set up. The second screen of the Custom menu (discussed in CHAPTER 7) has an item called Function of Center Button. Using that option, you can set the Center button to have its normal default functions by selecting the Standard option for Function of Center Button.

If you select the Standard option, then the Center button is used to enable the Tracking Focus option when the camera is set to an autofocus mode (either Single-shot AF or Continuous AF), as long as the Autofocus Area is set to Multi or Center. If the Autofocus Area is set to Flexible Spot, then pressing the Center button activates the screen for adjusting the location of the spot-focusing bracket. When the camera is set to manual focus and the MF Assist option is turned on, then pressing the Center button roughly doubles the magnification of the Focus Magnifier display: from 8.6 times to 17.1 times. Pressing the button again toggles the display back to the 8.6 times magnification level.

If you would prefer not to use the Standard option, you can use the Function of Center Button option to set the Center button to carry out any one of the following functions: AEL Toggle, AF/MF Control Toggle, or Focus Magnifier. I will discuss each of these options in turn.

AEL Toggle

If you set the Center button to the AEL (Autoexposure Lock) Toggle option, then when the camera is in shooting mode, pressing the Center button will lock the exposure at the current setting as metered and set by the camera. If the camera is set to Manual exposure mode, pressing the Center button as the AEL Toggle will lock the M.M. (Metered Manual) setting. The exposure will already be "locked" because you have set it manually so using the AEL Toggle function will just keep the M.M. setting from changing further.

When the exposure is locked in this way, a large asterisk icon will appear in the lower-right corner of the display and remain there until the lock is canceled. You will still be able to use the Center button for changing the magnification on the MF Assist screen without affecting the exposure lock. To cancel the exposure lock, press the Center button again when the shooting screen is in its normal mode (that is, when the MF Assist magnification screen is not displayed).

Here is an example to illustrate the use of the AEL Toggle function. You might want to do this if you want to make sure your exposure will be calibrated for a particular object that is part of a larger scene, such as a dark painting on a light-colored wall. You could move close to the wall and lock the exposure while aiming the camera only at the painting, then move back to take the overall picture of the wall with that locked exposure ensuring that the painting will be properly exposed.

To do this, assuming the camera is in Program mode, hold the camera close to the painting until the proper aperture and shutter speed appear on the screen. Press and release the Center button and an asterisk (*) will appear on the screen, as shown in FIGURE 5-12, indicating that exposure lock is in effect.

Figure 5-12. Asterisk on Screen for Auto Exposure Lock

Now you can move back (or anywhere else) and take your photograph using the exposure setting that you locked in. Once

you have finished using the locked exposure setting, press the Center button to make the asterisk disappear. The camera is now ready to obtain a new exposure reading.

AF/MF Control Toggle

If you select AF/MF Control Toggle for the setting of the Center button's function, then pressing the button switches the camera between autofocus and manual focus. If the camera is set to any autofocus mode, then pressing the Center button will switch the camera into manual focus mode. Pressing it again will switch to the autofocus mode that was originally set. If the camera is set to manual focus mode, then pressing this button will switch the camera to Single-shot AF mode. Pressing it again will switch to manual focus mode. If the camera is set to DMF mode, the button will toggle between DMF and manual focus.

This function is useful in situations when it is difficult to use autofocus, such as dark areas, extreme close-ups, or areas where you have to shoot through obstructions such as glass or wire cages. You can switch very quickly into manual focus mode and back again, as conditions warrant.

Also, this capability is helpful if you want to set "zone" focusing, so you can shoot quickly without having to wait for the autofocus mechanism to operate. For example, if you are doing street photography, you can set the camera to autofocus and focus on a subject at about the distance you expect to be shooting from—say, 25 feet (7.6 meters). Then, once focus is locked on that subject, press the Center button to switch the camera to manual focus mode, and the focus will be locked at that distance in manual focus mode. You can then take shots of subjects at that distance without having to refocus. If you need to set another focus distance, just press the Center button to toggle back to autofocus mode and repeat the process.

Focus Magnifier

If you select the third option, Focus Magnifier, for the Center button's function, then the button is used to magnify the focus area in manual focus mode. This option can be a bit confusing because, as I noted above, even when the Center button is set to any of its other functions—Standard, AEL Toggle, or AF/MF Control Toggle—it always acts to magnify the focus area once you have started to focus using the Control ring for the MF Assist function in manual focus mode. If you select the Focus Magnifier option, the main difference is that pressing the Center button will magnify the display before you start focusing with the Control ring.

And there is another difference: with this option, pressing the Center button once does not magnify the screen; rather, it changes the display to show that the magnification factor is 1.0 (no magnification) and places an orange frame in the middle of the screen. You can then move that frame around the screen using the Control wheel (for vertical movement) or by pressing the direction buttons (for all directions). In this way, you can select exactly what part of the image you want to enlarge by moving the frame over that area. Then, when you press the Center button again, that part of the image will be enlarged to 8.6 times normal. If you press the button again, that part of the display will be enlarged to 17.1 times normal. Throughout this process, you can still adjust the position of the orange frame, which will appear smaller as the display is enlarged. Another press of the Center button returns the display to normal size, with the orange frame still displayed. To cancel out of the Focus Magnifier display, press the Shutter button halfway to return to the shooting screen.

In playback mode, you press the Center button to start playing a video whose first frame is displayed on the camera's screen. Once the video is playing, press the Center button to pause the playback and then to toggle between play and pause. When a panoramic image is displayed, press the Center button to make it

scroll on the screen at a larger size using the full expanse of the display screen. When you have enlarged an image using the Zoom lever, you can return it immediately to its normal size by pressing the Center button, and when you are viewing a slide show, you can end the show by pressing the Center button. When you are selecting images for deletion or protection using the appropriate Playback menu options, you use the Center button to mark or unmark an image for that purpose.

DIRECTION BUTTONS

Each of the four edges of the Control wheel—up, down, left, and right—is also a "button" that you can press to access a setting or operation. This is not immediately obvious, and sometimes it can be tricky to press in exactly the right spot, but these four direction buttons are very important to your control of the camera. You use them to navigate through menus and through screens for settings, whether moving left and right or up and down.

You also use them in playback mode to move through your images and when you have enlarged an image using the Zoom lever to scroll around within the magnified image.

In addition to these navigational duties, the direction buttons are used for several miscellaneous functions in connection with various settings. For example, when the camera is set to Manual exposure mode, you can press the Down button to toggle the action of the Control wheel between setting aperture and setting shutter speed. And, as with the Center button, the Right and Left buttons can be assigned to carry out other functions through the Custom menu, as discussed in CHAPTER 7.

Finally, each of the direction buttons has its own separate identity, as indicated by the one or two icons that appear on or near each of the buttons, as discussed below.

Up Button: Display

The Up button, marked "DISP," is used to switch among the various displays of information on the camera's LCD screen, in both shooting and playback modes. As is discussed in CHAPTER 7, you can change the contents of the shooting mode screens using the Display Button setting on the first screen of the Custom menu. The various display screens that are available in playback mode are discussed in CHAPTER 6.

The Display button also controls the display of information in the optional electronic viewfinder if you have it installed in the camera's accessory shoe. The display items are the same for the LCD screen and the viewfinder in both shooting and playback modes. The electronic viewfinder is discussed in APPENDIX A.

Right Button: Flash Mode

When the camera is in shooting mode, pressing the Right button brings up a menu on the left of the display showing the options for setting the behavior of the flash unit. The options are Flash Off, Autoflash, Fill-flash, Slow Sync, and Rear Sync, although not all of them are available in any one shooting mode. This menu can also be summoned from the second screen of the Shooting menu. I discussed the use of these settings in Chapter 4. These settings affect both the built-in flash unit and a compatible Sony flash, such as the HVL-F20M, if you have one installed in the accessory shoe. I discuss external flash options in Appendix A.

One important point about the built-in flash is that you have to use the Flash Mode menu item to bring the flash unit up into firing position. With some cameras, there is a physical button to pop up the flash, but that is not the case with the RX100 II—you have to use the settings on the menu that displays when you press this button or when you select the Flash Mode menu item from the Shooting menu. There is no way to pull the flash unit up by hand.

You can reassign the function of the Right button using the Function of Right Button option on the second screen of the

Custom menu. You can choose any one of 23 options, including Flash Mode, Focus Mode, Autofocus Area, and others; I will discuss that menu option in CHAPTER 7.

Down Button: Photo Creativity/Exposure Compensation

The Down button has two icons directly below it, indicating that it has two different functions depending on the shooting mode. In the Intelligent Auto and Superior Auto modes, pressing this button brings up the Photo Creativity options, which I discussed in CHAPTER 2. In the Program, Aperture Priority, Shutter Priority, Movie, and Sweep Panorama modes, this button controls exposure compensation, discussed below. In Manual exposure mode, in which exposure compensation is not available, this button is used to toggle the Control wheel's function between controlling aperture and controlling shutter speed. In Scene mode, the button has no function other than as a direction button.

Exposure Compensation

Let's consider a specific situation in which you might use the exposure compensation control to adjust the camera's exposure to account for an unusual, or non-optimal, lighting situation. For example, consider FIGURE 5-13 in which I photographed a horse figurine using the Program shooting mode.

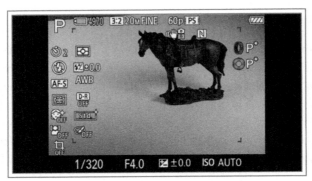

Figure 5-13. Exposure Compensation Example: Before Adjustment

The horse was dark, but the background was bright white. The camera's autoexposure system measured the large, bright area, and because of that bright background, it reduced the exposure making the horse appear too dark.

One solution to this problem is to use exposure compensation to decrease the overall exposure of the image, so the subject will not be underexposed. To accomplish this with the RX100 II, press the Down button to bring the exposure compensation scale up on the display, as shown in FIGURE 5-14.

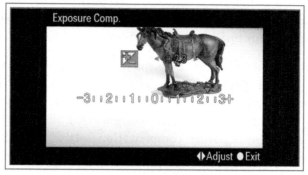

Figure 5-14. Exposure Compensation Example: After Adjustment

Adjust the amount of exposure compensation, positive or negative, by turning the Control wheel or pressing the Left and Right buttons to move the orange triangle above the scale, so it points to a value to the left or right of the zero point.

As you do this, you will see the orange numbers change near the top of the display. With a negative value, the image will be darker than it otherwise would; with a positive value, it will be brighter. The camera's display will grow brighter or darker to indicate the effect of the adjustment.

In this case, with exposure compensation adjusted upward by 2.3 EV (exposure value) units, the horse becomes lighter and is no longer underexposed, as shown in FIGURE 5-14.

Photographer's Guide to the Sony DSC-RX100 II

You also might want to consider using exposure compensation on a more routine basis. Some photographers follow the practice of generally leaving exposure compensation set at a particular amount, such as at negative 0.6 EV. You might want to do this if you find that your images generally look slightly overexposed or if you see that the highlights are clipping in many cases. (You can tell if highlights are clipping by checking the histogram, as discussed in CHAPTER 6. If the histogram chart is bunched all the way to the right, with no space between the data lines and the right side of the chart, the highlights are clipping, or reaching the maximum value.) It is difficult to recover details from images whose highlights have clipped, so it can be a safety measure to underexpose your images slightly to avoid that situation.

If you don't plan to leave a permanent exposure compensation setting in place, you should return the setting back to the zero point when you are finished with it, so you won't inadvertently change the exposure of later images that don't need the adjustment. (The exposure compensation setting will remain in place even after the camera has been turned off and back on again.)

If you use exposure compensation often, you can assign it to the Control ring using the Control Ring option on the second screen of the Custom menu. In that case, you can just turn the ring to start adjusting exposure compensation using a circular scale on the screen, as shown in FIGURE 5-15.

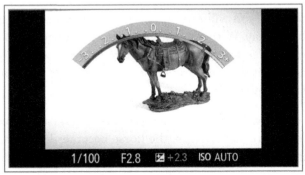

Figure 5-15. Control Ring Display for Exposure Compensation

(The ring will not adjust exposure compensation if the camera is set for manual focus or DMF because the ring is used to adjust focus with those settings.)

There is one other duty performed by the Down button: in playback mode, when a movie is being played, the Down button can be used to get access to a screen for adjusting the sound level of the movie.

Left Button: Self-Timer/Drive Mode

The Left button is labeled with the timer dial icon that indicates the Self-timer and the stack-of-frames icon that represents Continuous Shooting. When you press this button, the camera brings up the Drive Mode menu with its options for Self-timer, Self-portrait Timer, Continuous Shooting, and Exposure Bracketing. I discussed these options in CHAPTER 4 in connection with the Drive Mode option on the Shooting menu.

You can reassign the function of the Left button using the Function of Left Button option on the second screen of the Custom menu. As with the Right button, you can choose any one of 23 options, as discussed in CHAPTER 7.

Tilting LCD Screen

The last item to be discussed in this chapter is not really a "control," but it does allow some physical adjustment, so I will discuss it here. This is the tilting LCD screen on the back of the camera. This screen, even without its tilting ability, is a notable feature of the camera. It has a diagonal span of 3 inches (7.5 cm) and provides a resolution of 1.2 million dots using Sony's "WhiteMagic" technology, which adds a white sub-pixel to the normal red, green, and blue ones giving a very clear and sharp view of your images before and after you capture them.

The screen can tilt downward as much as 45 degrees, as shown in FIGURE 5-16.

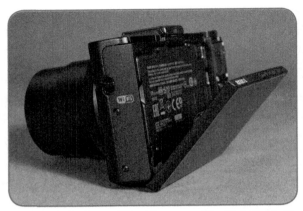

Figure 5-16. LCD Screen Tilted Downward for High-Angle Shots

When it is tilted in this way, you can hold the camera high above your head and view the scene as if you were an arm's-length taller or were standing on a small ladder. If you attach the camera to a monopod or other support and hold it up in the air, you can extend the camera's vertical height even further and still view the LCD screen quite well. You can activate the self-timer before raising the camera up in the air to take the photo. You also can use a smartphone or tablet connected to the camera by Wi-Fi to trigger the camera by remote control while it is raised overhead, as discussed in CHAPTER 9, or you can use Sony's wired remote control, which is discussed in APPENDIX A.

On the other hand, if you need to take images from a vantage point near ground level, you can rotate the screen so it tilts upward toward your eye, as shown in FIGURE 5-17, and hold the camera down as far as you need to get a mole's-eye view of the world.

Figure 5-17. LCD Screen Tilted Upward for Low-Angle Shots

It can be helpful to shoot upward like this when your subject is in an area with a busy, distracting background. You can hold the camera down low and shoot with the sky as your background to reduce or eliminate the distractions. (Similarly, you may be able to shoot from a high angle to place your subject against the ground or floor to have a less-cluttered background.)

The tilting display also can be useful for street photography: you can fold the screen upward and look down at the camera while taking photos of people on the street without drawing undue attention to yourself.

CHAPTER 6:
Playback and Printing

When I return from a shooting session, I usually import the images I've shot into my computer using a memory card reader, and then process them with software. After editing, I post the images on the web, print them out, e-mail them, or do whatever else the occasion calls for. I don't spend a lot of time viewing the pictures in the camera. But it's useful to know how the various in-camera playback functions work. Depending on your needs, there may be times when you take a picture and then need to examine it closely in the camera to check focus, composition, and other aspects. Also, the camera can serve as a viewing device like an iPod or other gadget that is designed, at least in part, for storing and viewing photos. So it's worth taking a good look at the various playback functions of the Sony RX100 II. I'll also discuss options for printing images in this chapter.

Normal Playback

I'll start with a brief rundown of basic playback techniques. First, you should be aware of your setting for the Auto Review function, which is found on the first screen of the Custom menu. This setting determines whether and for how long the image stays on the screen for review when you take a new picture. If your major concern with viewing images in the camera is to check them right after they are taken, this setting is all you need to be concerned with. As discussed in CHAPTER 7, you can leave Auto Review turned off or set it to 2, 5, or 10 seconds.

If you want to control how your images are viewed later on, though, you need to work with the options that are available in playback mode. For plain review of images, the process is simple. Just press the Playback button, marked by a small triangle to the lower left of the Control wheel on the back of the camera. Once you press that button, the camera is in playback mode, and you will see the most recent image saved to the memory card that is in the camera. To move back through older images, press the Left button or turn the Control wheel to the left. To see more recent images, use the Right button or turn the Control wheel to the right. To speed through the images, hold down the Left or Right button.

INDEX VIEW AND ENLARGING IMAGES

In normal playback mode, you can press the Zoom lever on top of the camera to view an index screen of your images or to enlarge a single image. When you are viewing an individual image, press the Zoom lever once to the left, and you will see a screen showing four images, one of which is outlined by an orange frame, as shown in FIGURE 6-1.

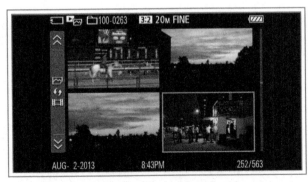

Figure 6-1. Playback Index View: Four Images

You can then press the Center button to bring up the outlined image as the single image on the screen, or you can move through your images with the four-image index screen by pressing the Left and Right buttons or turning the Control wheel.

If you press the Zoom lever to the left once more, the camera will display an index screen of nine images. When either the four- or nine-image index screen is displayed, you will see a thin vertical strip at the far left of the display. If you navigate to that strip by turning the Control wheel or pressing the Left button, it will become highlighted with an orange tint, as shown in FIGURE 6-2.

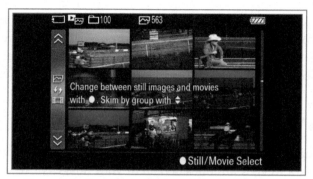

Figure 6-2. Gray Control Strip at Left of Index Screen
Highlighted Orange When Selected

Then you can use the Up and Down buttons to choose a different folder of images if there is one on your memory card. Also, you can press the Center button while the strip is highlighted; that action will bring up the menu screen shown in FIGURE 6-3, which lets you choose to view still images, MP4 videos, or AVCHD videos. (The video formats are discussed in CHAPTER 8.)

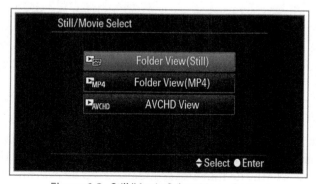

Figure 6-3. Still/Movie Select Menu Option

Highlight one of those options and press the Center button to select it to limit the camera's display to that one type of file.

When you are viewing a single image, one press of the Zoom lever to the right enlarges that image. You will then see a display in the lower-left corner of the image showing a thumbnail of the image with an inset orange frame that represents the portion of the image that is now filling the screen in enlarged view, as shown in FIGURE 6-4.

Figure 6-4. Enlarged View of Image

If you press the Zoom lever to the right repeatedly, the image will be enlarged to increasing levels. While it is magnified, you can scroll in it with the four direction buttons; you will see the orange frame move around within the thumbnail image. To reduce the image size again, just press the Zoom lever to the left as many times as necessary or press the Center button to revert immediately to normal size. To move to other images while the display is magnified, turn the Control wheel.

DIFFERENT PLAYBACK SCREENS

When you are viewing an image in single-image display mode, pressing the Display button (Up button) repeatedly cycles through the three different screens that are available: (1) the full image with no added information; (2) the full image with basic information, including date and time it was taken, image number, aspect ratio, aperture, shutter speed, ISO, and image size and

quality, as shown in FIGURE 6-5; and (3) a reduced-size image with detailed recording information, including aperture, shutter speed, ISO, shooting mode, white balance, and other data, plus a histogram, as shown in FIGURE 6-6.

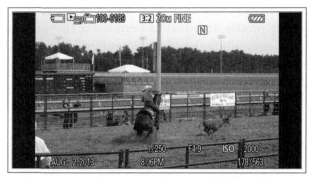

Figure 6-5. Playback Screen: Basic Information

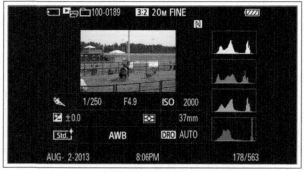

Figure 6-6. Playback Screen: Detailed Information

A histogram is a graph showing the distribution of dark and bright areas in the image displayed on the screen. The darkest blacks are represented by peaks on the left and the brightest whites by peaks on the right, with continuous gradations in between. With the RX100 II, the histogram displayed in playback mode includes four boxes with information. The top box provides information about the overall brightness of the image. The three lower boxes provide information about the brightness of the basic colors that make up the image: red, green, and blue.

If you have a histogram in which the brightness values are clearly bunched toward the left side of the scale, it means there is an excessive amount of black and dark areas (high points on the left side of the histogram) and very few bright and white areas (no high points on the right). If the graph area runs into the left side of the chart, it means the shadow areas are "clipped"; that is, the image is so dark that some details have been lost in the dark areas. The histogram in FIGURE 6-7 illustrates this degree of underexposure.

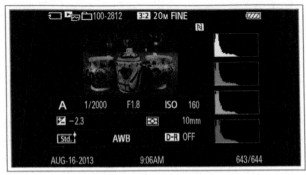

Figure 6-7. Histogram of an Underexposed Image

A histogram with its high points bunched on the right side of the screen means the opposite—too bright, as shown in FIGURE 6-8. If the lines of the graph run into the right side of the chart, that means the highlights are clipped and the image has lost some details in the bright areas.

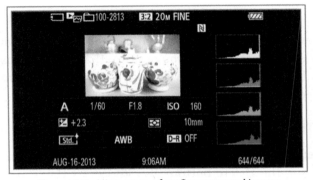

Figure 6-8. Histogram of an Overexposed Image

A histogram that is "just right" has high points arranged evenly in the middle of the chart. That pattern, as illustrated by FIGURE 6-9, indicates a good balance of light, dark, and medium tones.

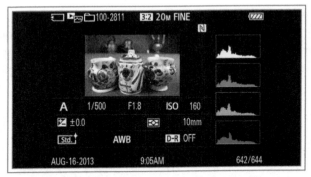

Figure 6-9. Histogram of a Normally Exposed Image

When the playback histogram is on the screen, any areas containing highlights that are excessively bright will blink to indicate possible overexposure, thereby alerting you that you might need to take another shot with the exposure adjusted to avoid that situation.

The histogram is an approximation and should not be relied on too heavily. It may be useful to give you some feedback as to how evenly exposed your image is likely to be. Also, there may be instances in which it is appropriate to have a histogram skewed to the left or right for intentionally "low-key" (dark) or "high-key" (brightly lit) scenes.

If you want to see the histogram for the live view when the camera is in shooting mode, you can turn that option on using the Display Button option on the first screen of the Custom menu, as discussed in CHAPTER 7.

DELETING IMAGES WITH THE DELETE BUTTON

As I mentioned in CHAPTER 5, you can delete individual images by pressing the Delete button, also known as the Trash button

or Help button. This is the small, round button with a question mark on it at the far lower right of the camera's back. If you press this button when a still image or a video is displayed, whether individually or highlighted on an index screen, the camera will display the Delete/Cancel box shown in FIGURE 6-10.

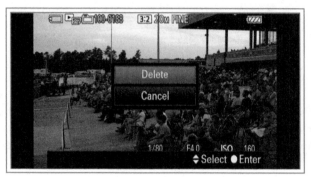

Figure 6-10. Delete Screen for Single Image

Highlight your choice and press the Center button to confirm. You can delete only single images or videos in this way. If you want to delete multiple items, you need to use the Delete option on the Playback menu, discussed later in this chapter.

ROTATING IMAGES WITH THE FUNCTION BUTTON

As I mentioned in CHAPTER 5, you can rotate a still image by pressing the Function button when the image is displayed on the camera's screen, either individually or on an index screen. When you press this button, you will see a screen like that in FIGURE 6-11 in which the camera prompts you to press the Center button to rotate the image or to press the Function button again to cancel.

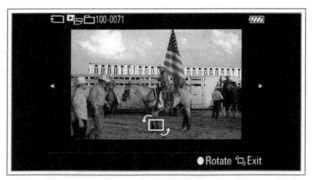

Figure 6-11. Function Button Rotate Screen

Each time you press the Center button, the image will rotate counterclockwise 90 degrees. After it has rotated, the image will be in the new position whenever it is displayed on the screen.

Playback Menu

The other options that are available for controlling playback on the RX100 II appear as items on the Playback menu, whose first screen is shown in FIGURE 6-12.

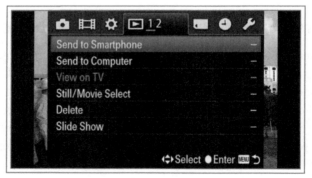

Figure 6-12. Playback Menu: First Screen

You get access to this menu by pressing the Menu button when the camera is in playback mode. You enter playback mode by pressing the Playback button when the camera is turned on in shooting mode. Or, if the camera is turned off, you can turn it on

in playback mode by pressing the Playback button instead of the Power button.

Here is information about the items on the Playback menu:

SEND TO SMARTPHONE

This first option on the Playback menu lets you use the RX100 II's built-in Wi-Fi capability to send still images or MP4 videos from the camera to an iOS (Apple) or Android device, including phones and tablets. I discuss the Wi-Fi features of the camera in CHAPTER 9, so you may want to consult that chapter for further details. The steps are not very complicated; just follow the procedure outlined below.

1. Put the camera into playback mode, display a still image or an MP4 movie (not an AVCHD movie), and then select the Send to Smartphone menu option.

2. On the next screen, choose either Select on This Device or Select on Smartphone, as shown in FIGURE 6-13.

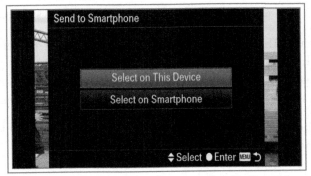

Figure 6-13. Options to Select Images to Send to Smartphone

If you choose Select on This Device, proceed to STEP 3.

–or–

If you choose Select on Smartphone, proceed to STEP 8.

3. On the next screen, choose This Image, All Still Images (or Movie MP4) on Date, or Multiple Images. If you choose This Image, the camera will send just the image that is displayed. If you choose All Still Images (or Movie MP4) on Date, the camera will send all images or MP4 files from the same date as this one. If you select Multiple Images, the camera will place a check box at the left of the image and put arrows at the left and right of the image, as shown in FIGURE 6-14. (If you have an index screen displayed instead of a single image, the display will be somewhat different.)

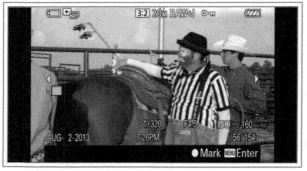

Figure 6-14. Screen to Select Images to Send to Smartphone

4. Scroll through the images and mark those to send to the phone by pressing the Center button. When you are done marking them, press the Menu button. On the next screen, select Execute and press the Center button to confirm.

5. The camera will display a screen like that in FIGURE 6-15 with the identity of the camera's internal Wi-Fi network.

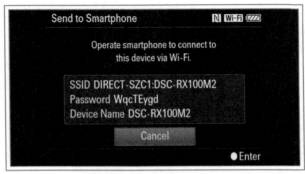

Figure 6-15. Screen with Information for Camera's Internal Wi-Fi Network

6. If you are using an iPhone or iPad, go to the Wi-Fi area under Settings and connect the device to that network.

 –or–

 If you are using an Android phone or tablet with NFC, touch the NFC point on the device to the NFC point on the bottom of the camera (the N mark). Or, if necessary, connect through the device's settings options.

7. On an Apple device, open the PlayMemories Mobile app. You will see a screen showing the selected images being copied to the phone or tablet. When copying is complete, the images or videos will appear in the Camera Roll area.

 –or–

 On an Android device, once the camera is connected to the device, you should see screens showing that the copying is taking place. When it is complete, the files will appear in the Album app on the Android phone or tablet.

8. In STEP 2, if you chose Select on Smartphone, then proceed immediately to connect the camera to the phone or tablet using Wi-Fi, as described above.

9. With an iPhone or iPad, start the PlayMemories Mobile app. You will soon see screens that display the images from the

camera, as shown in FIGURE 6-16. Mark the check box in the upper-left corner of each image you want the camera to send to the phone or tablet, then select the Copy command at the bottom of the screen. The camera will send the selected images to the device.

Figure 6-16. iPhone Screen

–or–

With an Android device, the procedure is essentially the same, though, if you connect with NFC, the PlayMemories Mobile app may start by itself. You will then see the screens with check boxes for selecting the images to be copied.

SEND TO COMPUTER

This next option lets you send still images or movies directly from the RX100 II to your computer via a Wi-Fi network connected to your computer. Before you can use this option, you have to register your network and computer with the camera using the WPS Push or Access Point Settings menu option on the third screen of the Setup menu. That process is described in CHAPTER 9. You also have to install Sony's PlayMemories Home software if you are using a Windows-based computer or Sony's Wireless Auto Import software if you are using a Macintosh. Then follow these steps:

1. Select the Send to Computer menu option from the Playback menu.

2. The camera will display a screen like that shown in FIGURE 6-17 showing that it is searching for and connecting to a wireless network that was previously registered with the camera.

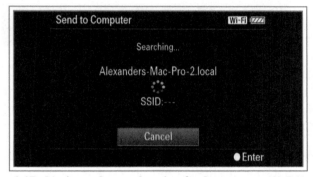

Figure 6-17. Display as Camera Searches for Computer on Wi-Fi Network

3. Once the connection is established, the appropriate software (PlayMemories Home or Wireless Auto Import) should start automatically on the computer, and the camera should copy to the computer all images and movies that were not previously transferred to that computer. (There is no way to select what images or movies are copied using this process.)

VIEW ON TV

This option allows the camera to transmit still images (not movies) wirelessly to a Wi-Fi–enabled TV, such as a Sony Bravia TV. The procedure to follow will vary with the TV set you are using. Once the TV is set up properly, select this menu option and the camera will display a screen showing that it is attempting to connect to a TV. If it finds a TV with a Wi-Fi connection, it will display the name of the device, as shown in FIGURE 6-18.

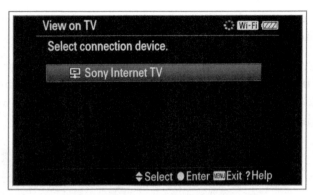

Figure 6-18. View on TV Menu Option in Use

Once the connection is established, you can browse through the images using the controls on the camera or the remote control of the TV if the TV is compatible with this setup.

I don't recommend you try this option unless you already have set up an Internet-enabled TV on your home network and are quite familiar with its operation. I worked for a considerable time to configure a Sony NSZ-GT1 Wi-Fi–enabled Blu-ray player and Internet TV device to use this option. I eventually was able to get a single image from my RX100 II camera to appear on the TV screen that was connected to the Sony Internet TV device, but I never was able to get the rest of the images to appear in a slide show on the TV, even though they did appear in a slide show on the camera itself.

To get this menu option to work properly, you have to set up a DLNA server on your computer, which I found to be difficult to do successfully with my Macintosh. (DLNA stands for Digital Living Network Alliance; see www.dlna.org.) If you are familiar with setting up a DLNA server, then this option may be great for you. Otherwise, I recommend that you view your images on a TV using an HDMI cable, a USB flash drive, or some other direct connection.

STILL/MOVIE SELECT

This next option on the Playback menu gives you a way to select whether to view just still images, MP4 movies, or AVCHD movies, as shown in FIGURE 6-19.

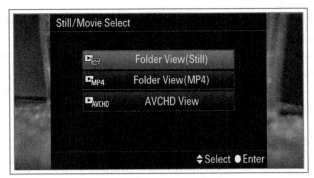

Figure 6-19. Still/Movie Select Menu Option

(MP4 and AVCHD are the two different movie formats available with the RX100 II; I will discuss those formats in CHAPTER 8.) The use of this menu option may not be immediately obvious because it may seem to you that when you take a still image, you are immediately able to view it by pressing the Playback button, and if you then take a video, you can immediately view the video by pressing the Playback button. In other words, it does not seem as if you have to switch the camera between viewing still images and viewing movies; it appears to do this switching automatically.

Actually, the camera does switch automatically between these two viewing modes. However, that does not mean that this menu option is unnecessary. Whenever you take a still picture or record a movie, the camera automatically switches into the proper mode for viewing that item. For example, suppose your memory card has an assortment of 50 videos and 50 still images stored on it. If you now take a still image, you can immediately press the Playback button and view that image. However, you will not be able to view any of the videos that are stored on the memory card. To view the videos, you would have to switch back to the mode for viewing

those videos in one of two ways: using the Still/Movie Select option or by recording another video, which will automatically switch the camera back into the mode for viewing videos.

To put this another way, the camera has to be switched into either still-viewing mode or video-viewing mode for viewing either stills or videos. When you take a still or a video, that action automatically does this switching; otherwise, you have to use the Playback menu option to make the switch, or you have to go to the index screen, as discussed earlier in this chapter, and move to the far left of that screen, where you can press the Center button to get access to the Still/Movie Select option.

DELETE

The Delete command is available for you to use when you want to delete multiple images from your memory card in one operation. (If you just want to delete one or two images, it's usually easier to display each image on the screen, then press the Trash button and confirm the erasure.) When you select the Delete command, the menu offers you various choices, as shown in FIGURE 6-20.

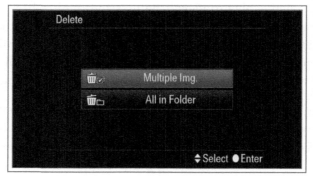

Figure 6-20. Delete Menu Option

These choices may include Multiple Images, All in Folder, or if the current folder contains movies in the AVCHD format, All AVCHD View Files depending on the current setting for the Still/Movie Select option, discussed above.

If you choose Multiple Images, the camera will display an index screen showing the still images or videos with a check box at the left side of each image, as shown in FIGURE 6-21.

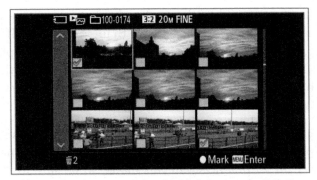

Figure 6-21. Screen to Select Multiple Images for Deletion

The images and videos may be shown individually or on an index screen depending on current settings. You can change between full-screen and index views using the Zoom lever.

Scroll through the images with the Control wheel or direction buttons. When you reach an image you want to delete, press the Center button to place a check mark in the check box on that image. Continue with this process until you have marked all images you want to delete. Then, press the Menu button to move to the next screen, where the camera will prompt you to highlight OK or Cancel, and press the Center button to confirm. If you select OK, all of the marked images will be deleted.

If, instead of Multiple Images, you choose All in Folder, the camera will display a screen asking you to confirm deletion of all files in the current folder. Note that because of the RX100 II's limitation of showing only still images or movies at any one time, this command will delete only stills or movies, not both.

Finally, if you select All AVCHD view files, you will have the opportunity to delete just the AVCHD-format video files.

SLIDE SHOW

This feature lets you play your still images in sequence at an interval you specify and with transitions that you can choose. (This menu option will be dimmed and unavailable if the camera is currently displaying movies rather than still images. If that is the case, use the Still/Movie Select menu option to display still images.) When you select the Slide Show menu item, the next screen has three options that you can set: Repeat, Interval, and Image Type, as shown in FIGURE 6-22.

Repeat can be set either on or off. If it is turned on, the show will keep repeating; otherwise, it will play only once. The camera will not power off automatically in this mode, so be sure to stop the show when you are done with it. Interval, which controls how long each image stays on the screen, can be set to 1, 3, 5, 10, or 30 seconds. The Image Type setting lets you choose whether to display all still images or only 3D images. (This option seems somewhat odd given that the RX100 II has no built-in ability to shoot 3D images. However, the camera can display 3D images shot with other cameras.) You cannot include movies in the slide show.

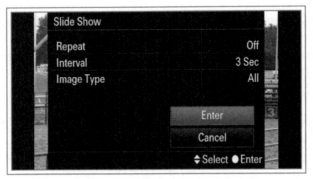

Figure 6-22. Slide Show Menu Option

Once the options are set, navigate to the Enter box at the bottom of the screen using the Control wheel or the direction buttons, and then press the Center button to start the show. You can move forward or backward through the images with the Right and Left

buttons. Hold those buttons down to fast-forward or fast-reverse through the images. You can stop the show by pressing the Center button or the Playback button.

The Slide Show menu option does not provide any elaborate settings such as different transitions, effects, or music for the show. You cannot select which images to play; this option just lets you play all of your still images (or only 3D images if you happen to have some from another camera).

IMAGE INDEX

This menu option does not add anything new to what you can already do in playback mode. It just lets you select and view either the four-image or the nine-image index screen. This option does not change how the Zoom lever calls up index screens; no matter how this menu option is set, pressing the Zoom lever to the left in playback mode will call up the four-image screen first, and then with one more press of the lever, the nine-image screen. This menu option just gives you another way to get access to one or the other of those index screens, in case you prefer to use menu options rather than pressing the Zoom lever. The index screen will display either still images or videos depending on how the Still/Movie Select option is currently set.

PROTECT

With the Protect feature, you can "lock" selected images or videos, so they cannot be erased with the normal erase functions, including using the Delete button and using the Delete option on the Playback menu, discussed above. However, if you format the memory card using the Format command, all data on the card will be erased, including protected images.

To protect images or videos using this menu option, the procedure is similar to the one for deleting images, discussed above, but the only available option is to mark images for protection individually; there is no option for selecting all images. Once you select this

menu option, the camera will display an image, and you can mark its check box for protection by pressing the Center button. Any image that is protected will have a key icon in the upper-right corner, to the left of the battery icon, as shown in FIGURE 6-23.

Figure 6-23. Protected Image with Key Icon in Upper-Right Corner

The key icon will be visible when the image is viewed with the detailed information screen or the basic information screen, but it will not appear in the image-only view.

If you want to unprotect all images or videos in one operation, you can select the appropriate Cancel option from the Protect item on the Playback menu. The option will prompt you to Cancel All Images, Cancel All Movies (MP4), or Cancel All AVCHD View Files depending on which type of file is currently being displayed with the Still/Movie Select option.

SPECIFY PRINTING

This menu option lets you use the DPOF (Digital Print Order Format) function, which is built into the camera. The DPOF system lets you mark various images on your memory card to be added to a print list, which can then be sent to your own printer. Or, you can take the memory card to a commercial printing company to print out the selected images.

To add images to the DPOF print list, select the Specify Printing option from the Playback menu. On the next screen, shown in FIGURE 6-24, set the DPOF Setup option to Multiple Images.

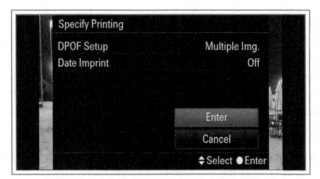

Figure 6-24. Specify Printing Menu Option

You also can turn the Date Imprint option on or off to specify whether or not the pictures will be printed with the dates they were taken. Then highlight the Enter option at the bottom of this screen and press the Center button to confirm.

The camera will then display the first image with a check box at the left, as shown in FIGURE 6-25, or an index screen of images with an orange frame around the currently selected image and a check box in the lower-left corner of each image thumbnail.

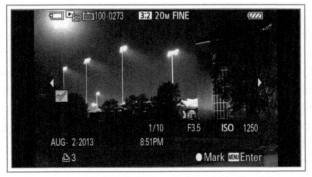

Figure 6-25. DPOF Selection Screen with Check Box

(You can display individual images or index screens using the Zoom lever.) There will be a small printer icon in the lower left with a zero beside it at first meaning no copies of any images have been set for printing yet. Use the Control wheel or direction buttons to move through the images. When an image you want to have printed is displayed, press the Center button to mark it for printing or to unmark it. You can then keep browsing through your images and adding (or subtracting) them from the print list. As you add various images to the print list, the DPOF counter in the lower-left corner of the display will show the total number of images selected for printing.

When you have finished selecting images to be printed, press the Menu button to confirm your choices and exit from the selection screen. Then confirm the OK message on the screen by pressing the Center button. You can then take the memory card to a service that prints photos using the DPOF system, or you can connect the camera to a PictBridge compatible printer to print the selected images.

If you want to cancel a DPOF order, go to the Specify Printing menu item, select DPOF Setup, and select the Cancel All option instead of Multiple Images.

PICTURE EFFECT

Picture Effect, the first selection on the second screen of the Playback menu, gives you a very limited selection of the options that are available through the Picture Effect item on the Shooting menu. Only two of the many effects from that menu are available: Watercolor and Illustration. When you select this option, if a compatible image is being displayed, the camera will display a screen giving you the option to apply one or the other of these effects. Highlight the one you want and press the Center button to confirm. The camera will process the image for a while and then display the new version of the image.

At that point, press the Menu button, and the camera will ask whether you want to save a copy of the image with that effect. The result is similar to what you get with the Picture Effect option in shooting mode; an example of the Watercolor effect applied in Playback mode is shown in FIGURE 6-26.

Figure 6-26. Watercolor Effect Applied in Playback Mode

You can select OK or Cancel. If you go ahead, the camera will save a copy of the processed image and leave the original image intact, so there is no harm in using with this procedure.

There are no adjustments available for intensity or other options. Also, these effects will not work with videos, panoramas, or Raw images. However, these two effects can produce very pleasing results, so there may be situations in which it would be worthwhile to try them out.

VOLUME SETTINGS

This menu option lets you set the volume for playback of movies in the camera, anywhere from 0 to 7. You can also set this level from the movie playback screen by pressing the Down button to get access to the volume setting screen.

PLAYBACK DISPLAY

This final item on the Playback menu controls whether images shot with the camera held vertically appear that way when you play them back on the camera's screen. By default, this option is set to Auto Rotate, meaning the images taken vertically are automatically rotated so that the vertical shot appears in portrait orientation on the horizontal display, as shown in FIGURE 6-27.

If you change the setting to Manual Rotate, then the images will appear in landscape orientation on the screen, as shown in FIGURE 6-28.

Figure 6-27.
Image Displayed Vertically

Figure 6-28. Image Shot Vertically and Displayed Horizontally

If you use the Auto Rotate option, vertical images will be displayed at a fairly small size. So you might want to set the Playback Display option to Manual Rotate and just rotate the camera itself, so you can see the image at a size that uses most or all of the display area on the screen. Also, if you use the Manual Rotate setting, you can always press the Function button to rotate an image manually, as discussed earlier in this chapter.

CHAPTER 7:
Custom, Setup, and Other Menus

In earlier chapters, I discussed the options available in the Shooting and Playback menu systems. The Sony RX100 II has several other menu systems that help you set up the camera and customize its operation. In this chapter, I will discuss all of the options on those menus: Custom, Memory Card Tool, Clock Setup, and Setup. (I'll discuss menu options for Movie mode in CHAPTER 8.)

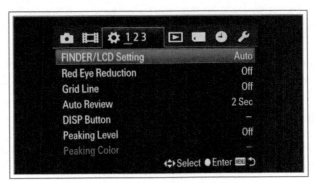

Figure 7-1. Custom Menu: First Screen

Custom Menu

The Custom menu, whose first screen is shown in FIGURE 7-1, gives you control over numerous items that affect the ways you use the camera to take pictures and videos, but that do not change the

photographic settings such as white balance, ISO, focus modes, and matters of that nature. With this menu, the items to be adjusted are more in the categories of control and display options. Details about the options on the three screens of this menu follow.

FINDER/LCD SETTING

This first option on the Custom menu, shown in FIGURE 7-2, is available for selection only if you have installed the optional electronic viewfinder, Sony model number FDA-EV1MK, which is discussed in APPENDIX A.

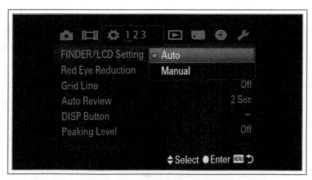

Figure 7-2. Finder/LCD Menu Option

That viewfinder provides the same information as the camera's LCD screen, but its display is viewed inside an eye-level window that is shaded from daylight giving you a very clear view of the shooting, playback, and menu screens.

By default, this option is set to Auto, which means the camera switches the view to the viewfinder automatically when you move your head near the camera. The camera turns on the viewfinder display and blacks out the LCD display. (The viewfinder has sensors that detect the presence of an object nearby.) If you prefer to switch the view between the viewfinder and LCD screen manually, just set this menu option to Manual. Then, to make the switch, just press the small button on the left side of the viewfinder.

Even if you set this option to Auto, you can still switch the view between the two devices manually by pressing the button. If you do that, the switching will still operate automatically the next time your head approaches or moves away from the viewfinder. You can use this button to blank out the LCD display if you are using the camera in an area where that display could be distracting, such as in a museum or darkened theater.

I have found the Auto option to work very well and have not found a reason to use the Manual setting. But if you will be working with your head (or another object) very close to the camera's viewfinder, you might want to use the Manual option, so the screen does not blank out unexpectedly.

RED EYE REDUCTION

The second option on the Custom menu lets you set up the RX100 II's flash so as to combat "red-eye" in your images—the eerie red glow in human eyes that results when on-camera flash lights up the blood vessels on the retina. The way Sony has chosen to deal with this issue in the RX100 II is through this menu item, which can be set either to On or Off. If it is turned on, then whenever the flash is used, it fires a few pre-flashes before the actual flash that illuminates the image. The pre-flashes are intended to cause the subject's pupils to narrow, thereby reducing the ability of the later, full flash to enter the eyes, bounce off the retinas, and produce the unwanted red glow in the eyes.

My own preference is to leave this menu option turned off and to deal with red-eye effects by removing them with editing software, if necessary. However, if you will be taking flash photos at a party, you may want to use this menu option to minimize the occurrence of red-eye effects in the first place.

GRID LINE

With this next option, you can select one of four settings for a grid to be superimposed on the shooting screen. By default, there

is no grid. If you choose one of the options to use a grid, the lines will appear in your chosen configuration whenever the camera is in shooting mode whether the detailed display screen is selected or not. The four options are seen in FIGURE 7-3.

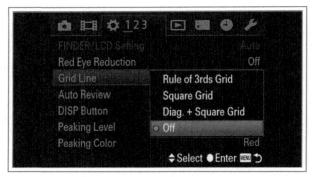

Figure 7-3. Grid Line Menu Option

Here are descriptions of these choices, other than Off, which leaves the screen with no grid.

Rule of Thirds Grid

This arrangement has two vertical lines and two horizontal lines, dividing the screen into nine blocks, as shown in FIGURE 7-4.

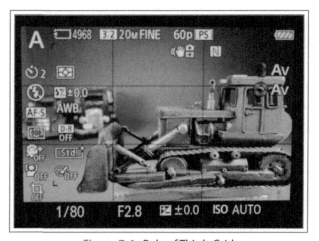

Figure 7-4. Rule of Thirds Grid

The concept behind this grid is the Rule of Thirds: a classical rule of composition that calls for placing the most important subject at the intersection of two of these lines, which will place the subject one-third of the way from the edge of the image. This arrangement can provide a pleasing amount of interest and asymmetry to an image.

Square Grid

With this setting, the camera sets up 5 vertical lines and 3 horizontal lines, dividing the display into 24 blocks, as seen in FIGURE 7-5.

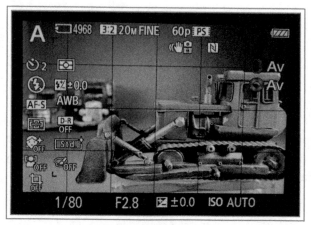

Figure 7-5. Square Grid

In this way, you can still use the Rule of Thirds, but you have additional lines available for lining up items, such as the horizon or the edge of a building, that need to be straight.

Diagonal Plus Square Grid

The last option gives you a square grid of four blocks in each direction and adds two diagonal lines, as shown in FIGURE 7-6.

The idea with this option is that placing a subject or, more likely, a string of subjects along one of the diagonals can add interest to

the image by drawing the viewer's eye into the image along the diagonal line.

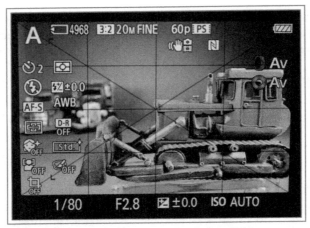

Figure 7-6. Diagonal Plus Square Grid

Auto Review

The Auto Review option, shown in FIGURE 7-7, lets you set the length of time that an image appears on the display screen immediately after you take a still picture.

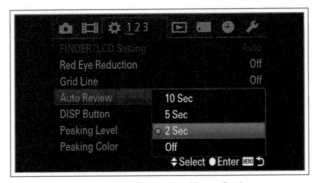

Figure 7-7. Auto Review Menu Option

The default choice is 2 seconds, but you can set this time to 5 or 10 seconds, or you can turn the function off altogether. If you turn it off, the camera will return to shooting mode as soon as

you have finished taking an image once the camera has saved it to the memory card. When this option is in use, you can always return to the live view by pressing the Shutter button halfway. The Auto Review option does not apply to movies; the camera does not display the beginning frame of a movie that was just recorded until you press the Playback button.

DISPLAY BUTTON

With this option, you can choose which of several available display screens appear in turn when the camera is in shooting mode as you press the Display button. There are five available display screens that you can select, four of which are shown in FIGURE 7-8 through FIGURE 7-11. (The screen displaying just the image with no information [No Display Information] is not shown here.)

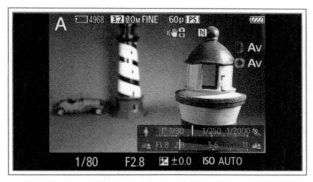

Figure 7-8. Graphic Display

FIGURE 7-8 shows the version of the screen with the Graphic Display in the lower-right corner of the screen; that display is supposed to illustrate the use of faster shutter speeds to stop action and the use of wider apertures to blur backgrounds. I find it distracting and not especially helpful, but if it is useful to you, by all means select it.

I find the Display All Information screen, shown in FIGURE 7-9, to be rather cluttered and busy, but it does contain a lot of useful information about the camera's settings. You can always move

away from this screen by pressing the Display button (if there is at least one other display screen available through this menu option), so I like to have it available for those times when I need to check to see what settings are in effect.

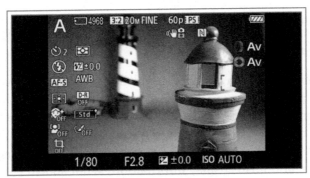

Figure 7-9. Display All Information

The third screen displaying only the image (No Display Information) isn't shown here. This display can be of great value in focusing and composing your shot, so I always include it in the cycle of display screens.

The fourth screen, shown in FIGURE 7-10, displays the RX100 II's Level, which is a useful tool for leveling the camera both side-to-side and front-to-back.

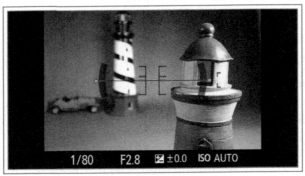

Figure 7-10. Level Display

You need to watch the small orange lines on the screen; when the outer two ones have turned green, the camera is level side-to-side; when the inner two lines have turned green, the camera is level front-to-back.

The fifth screen, shown in FIGURE 7-11, is a screen with the Histogram.

Figure 7-11. Histogram Display

This shooting-mode histogram, unlike the one displayed in Playback mode, shows only basic exposure information with no color data. However, it can give you an idea of whether your image will be well exposed, letting you adjust exposure compensation and other settings as appropriate while watching the live histogram on the screen. If you can make the histogram display look like a triangular mountain centered in the box, you are likely to have a good result.

You should try to keep the shape of the histogram away from the right and left edges of the graph, in most cases. If the body of the histogram runs into the left edge, that means the shadow areas are clipping, and image details in the shadow areas are being lost. If it runs into the right edge, you are losing details by having highlights clipped. If you have to choose, it is best to keep the graph away from the right edge because it is harder to recover image data from clipped highlights than from clipped shadows.

Once you have selected the Display Button menu option and
pressed the Center button to get to the selection screen, you can
scroll through the five choices using the Control wheel or the Up
and Down buttons. When a screen you want to have displayed
is highlighted, press the Center button to place an orange check
mark in the small box to the left of the screen's label, as seen in
FIGURE 7-12.

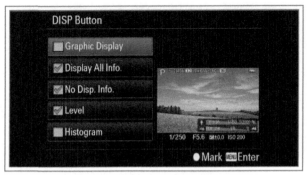

Figure 7-12. Display Button Menu Option

You can also press that button to un-mark a box. The camera
will let you un-check all five of the items, but if you do that, the
camera will display an error message as you try to exit the menu
screen. You have to check at least one box so that some screen will
display when the camera is in shooting mode.

After you have selected from one to five screens to be displayed,
exit the menu by pressing the Menu button. Then, whenever the
camera is in shooting mode, the selected screens will be displayed;
you cycle through them by pressing the Display button (Up
button). If you have selected only one screen, then pressing the
Display button will have no effect in shooting mode when the live
view is on the screen.

Note that even if you select only the single screen that includes no
information, the camera will still always display the shutter speed,
aperture, exposure compensation, and ISO; all of those values

are displayed in the black strip below the area where the image is displayed.

PEAKING LEVEL

The Peaking Level option, shown in FIGURE 7-13, controls the camera's use of the Peaking display to assist with manual focus.

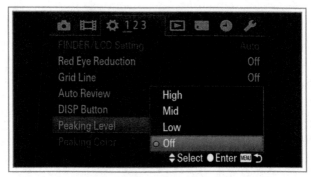

Figure 7-13. Peaking Level Menu Option

By default, this option is turned off. With this menu item, you can turn the feature on with a level of Low, Mid, or High. When it is turned on and you are using manual focus, the camera places an outline with the selected intensity around any area of the image that has edges that the camera can distinguish, as shown in FIGURE 7-14, in which Peaking Level is set to the Low setting.

The idea is that these lines provide a more definite indication that the focus is sharp than just relying on your judgment of sharpness. When I first used a camera with this feature, I found it distracting and not as useful as options such as MF Assist and Focus Magnifier that enlarge the screen for a clearer view when using manual focus. However, after some further experience, I have come to appreciate the usefulness of the Peaking feature for some situations.

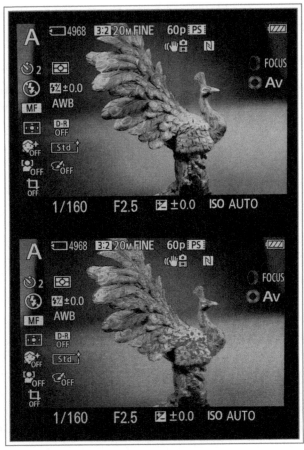

Figure 7-14. Top Image: Peaking Level Off, Bottom Image: Peaking Level Low

For example, as discussed in CHAPTER 9, I took some shots of the moon through a telescope connected to the RX100 II. I used manual focus mode and had to finish adjusting the focus using the controls on the telescope. The image on the camera's screen was unsteady because of the high magnification, and the moon did not have any features with edges that I could see clearly in the enlarged view. When I turned on Peaking with the red color selected, I found it much easier to focus; the camera displayed a broad band of red around the edge of the moon when focus was sharp.

Similarly, when I was taking pictures of water drop collisions, as seen in FIGURE 3-21, I had to use manual focus to pre-focus on the area where the drops would land, using a small bell as a stand-in for the drops. The room was dark, and I found it to be easier to get the focus sharp using the Peaking option.

So, at least in my experience, Peaking works very well in certain situations, such as dark environments. Some photographers set Creative Style to black and white while focusing, so the Peaking color will stand out, and some like to set Peaking Level to Low, so the color is not overwhelming, letting you see when the color just starts to appear. Some like to turn on MF Assist to enlarge the screen when using Peaking. You probably should experiment to find what approach works best for you.

For an excellent demonstration of how Peaking works, see this YouTube video posted by a participant in the Sony Cyber-shot Talk forum at dpreview.com at http://youtu.be/jMAlMQev7Kw.

Note that Peaking also works with DMF, even if you are using the autofocus function of that setting.

PEAKING COLOR

This option lets you choose red, yellow, or white for the color of the lines that the Peaking feature places around the edges of in-focus items when you are using manual focus. It works along with the Peaking Level option, discussed above, which controls the intensity of the effect. The default color is white. It is useful to be able to change the color depending on the colors present in your image. The Peaking feature is likely to be most useful when the color you choose for the effect contrasts with the main colors in your subject. As noted above, I found that the red color worked very well for shots of the moon; yellow or white may work well with darker subjects.

Control Ring

The Control Ring menu option, shown in FIGURE 7-15, is the first item on the second screen of the Custom menu.

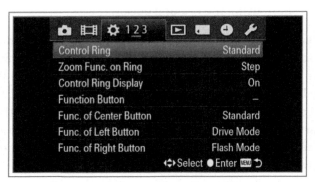

Figure 7-15. Custom Menu: Second Screen

This option lets you choose the function or functions of the Control ring. As I noted in CHAPTER 5 in discussing the Control ring, by default this option is set to Standard. In that case, the Control ring controls various functions in the various shooting modes, as shown in TABLE 5-1.

If you prefer to set the Control ring to control a single function instead of the Standard setting's group of functions, you can use this menu item to set the ring to control either Exposure Compensation, ISO, White Balance, Creative Style, Picture Effect, Zoom, Shutter Speed, or Aperture. The first seven settings for the ring are shown in FIGURE 7-16.

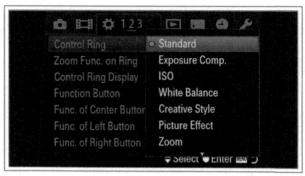

Figure 7-16. Control Ring Menu Option

Or you can choose the final option, Not Set, in which case the ring will control only manual focus. In my opinion, the Standard option is the most useful, but you might prefer to use the Control ring for one specific purpose, such as controlling exposure compensation, ISO, or zoom for all shooting modes.

ZOOM FUNCTION ON RING

With this menu option, shown in FIGURE 7-17, you can set the way in which the Control ring zooms the lens. There are two choices: Standard (the default) and Step.

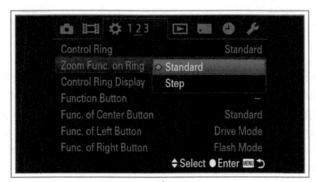

Figure 7-17. Zoom Function on Ring Menu Option

With Standard, when the Control ring is used to zoom the lens, it does so continuously, just as the Zoom lever does. That is, as

you turn the ring, the lens zooms through all focal lengths that are available. With the optical zoom, that means it will zoom from the 28mm wide-angle setting to the 100mm telephoto setting in continuous increments. With Clear Image Zoom, and Digital Zoom, the zoom levels increase beyond the 100mm point.

If, instead, you set this option to Step, then the Control ring zooms the lens only to certain preset values. Those values are 28mm, 35mm, 50mm, 70mm, and 100mm, as shown in FIGURE 7-18. When you nudge the Control ring toward the wide-angle or telephoto side, the zoom will move to the next preset focal length. You should give the ring a quick nudge and then release it; if you keep turning it, it will move past the next value and go on to the one after that.

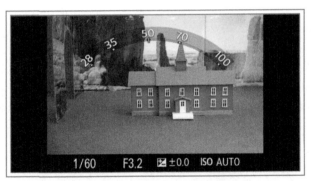

Figure 7-18. Circular Scale for Step Zoom Feature

There are some important limitations to note about the step zoom function on the RX100 II. First, even when you have set this menu option to Step, the feature operates only when the Control ring is set for zooming. If the Control Ring menu option is set to Standard, the Control ring is set for zooming only in Intelligent Auto and Superior Auto modes. If you want to use step zoom in other shooting modes, you need to set the Control Ring menu option to Zoom. Even then, if you set the camera for manual focus or DMF using the Focus Mode menu option on the Shooting

menu, the Control ring will control manual focus and will not zoom the lens.

It's also important to note that the step zoom feature works only for the Control ring; the Zoom lever will always zoom the lens continuously. Also, the step zoom feature does not work when shooting movies.

Finally, if you turn on Clear Image Zoom or Optical Zoom on the fourth screen of the Shooting menu, the step zoom feature will not include specific increments for the zoom range beyond the optical limit of 100mm. Instead, as shown in FIGURE 7-19, the camera will display the range of preset increments with an area at the right side of the range extending from the 100mm mark to a magnifying glass icon at the far right, showing a general area of extended zoom range.

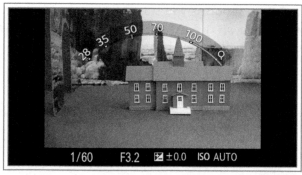

Figure 7-19. Step Zoom Display with Clear Image Zoom and Digital Zoom

Having the ability to turn on step zoom is a valuable feature in some situations. For example, if you want to set a specific focal length for a shot, using the step zoom feature is an excellent way to make sure you have the lens zoomed to the exact focal length you want. Of course, this feature is of use only if your desired focal length is 35mm, 50mm, or 70mm; it is easy to set the focal length to 28mm or 100mm using the normal zoom method because those focal lengths are at the two extremes of the camera's optical zoom range.

You might want to choose a focal length of 35mm, for example, if you obtain an optical viewfinder of that focal length, as discussed in APPENDIX A. Or, you might want to compare shots from the RX100 II against shots from another camera using a specific focal length for the comparisons.

I do not often use the step zoom feature, but it is good to have it available as an option for those few times when it is useful.

CONTROL RING DISPLAY

This option lets you choose whether or not a special circular display appears on the screen when you turn the Control ring to control one of its assigned functions other than manual focus. For example, if the Control Ring menu option is set to Standard and you have the camera set to Aperture Priority mode, turning the Control ring will change the camera's aperture setting. As shown in FIGURE 7-20, as soon as you start turning the ring, the circular display will appear on the screen with the current aperture value, f/5.6 in this case, highlighted in orange.

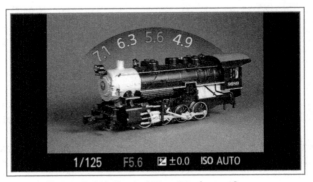

Figure 7-20. Control Ring Display on Screen

At the same time, the normal aperture figure at the bottom of the display will change, providing the same information.

To my mind, this feature is usually a distraction, and I prefer to turn it off in most cases. However, if I am using the step zoom

feature, discussed directly above, I find it helpful to turn on the Control Ring Display option because the camera then displays the specific focal length that is being set as you turn the Control ring to zoom the lens. If you leave this display option turned off, then the camera displays in the upper-right corner of the screen a small rectangle with dots that indicate the specific focal lengths for the step zoom increments, as shown in FIGURE 7-21. I find it harder to tell what zoom range has been set by looking at that small display, which does not include the numerical focal length values. So, in that one situation, I like to have Control Ring Display turned on.

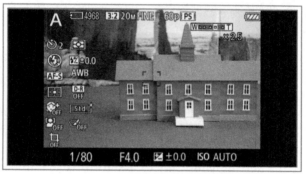

Figure 7-21. Step Zoom Display Without Control Ring Display

If you find that this additional display of information about the Control ring's operation is helpful to you more generally, by all means leave it turned on. (It is turned on by default.)

FUNCTION BUTTON

The Function Button menu option is the means for selecting up to seven operations that can be controlled by pressing the Function button. As I explained in CHAPTER 5, pressing this button calls up a horizontal menu at the bottom of the display with up to seven options. Using this menu item, you can select which options are included out of 17 possibilities: Exposure Compensation, Focus Mode, Autofocus Area, ISO, Drive Mode, Metering Mode, Flash Mode, Flash Compensation, White Balance, DRO/Auto HDR, Creative Style, Picture Effect, Soft Skin Effect, Quality, Image Size,

Smile/Face Detection, and Aspect Ratio. You also can choose Not Set, leaving one or more of the seven slots unassigned.

To use this menu item, scroll down through the entries for Function 1 through Function 7 by turning the Control wheel or pressing the Up and Down buttons. When a function number is highlighted, press the Center button to select it and display a list of all 17 possible settings for that slot, as shown in FIGURE 7-22.

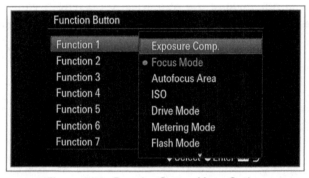

Figure 7-22. Function Button Menu Option

Highlight the setting you want to assign to that numbered slot, and press the Center button to exit back to the main screen.

The default settings for the Function button are shown in TABLE 7-1.

Table 7-1. **Default Settings for Function Button**

Function 1	Exposure Compensation
Function 2	ISO
Function 3	White Balance
Function 4	DRO/Auto HDR
Function 5	Picture Effect
Function 6	Not Set
Function 7	Not Set

I suggest you experiment with the settings for the Function button until you find those that are most useful to you. I certainly wouldn't leave any slots with the "Not Set" choice. I would include Focus Mode, ISO, Picture Effect, Creative Style, Quality, Image Size, and DRO/Auto HDR as my choices, but that is just because those are settings I happen to use quite often. I would not include Exposure Compensation because it is available with a press of the Down button, and I find that Auto White Balance usually works quite well, so I don't change White Balance that often.

FUNCTION OF CENTER BUTTON

The next three options on the second screen of the Custom menu give you the ability to assign specific operations to the Center, Left, and Right buttons on the Control wheel. First is the Center button. It can be assigned one of the following settings: Standard, AEL Toggle, AF/MF Control Toggle, or Focus Magnifier, as shown in FIGURE 7-23.

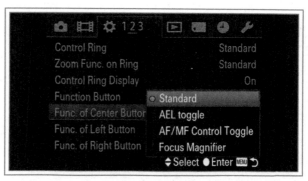

Figure 7-23. Function of Center Button Choices

I discussed these settings in CHAPTER 5, in the discussion of the Center button. If you plan to use the Tracking Focus option or will often need to quickly adjust the location of the Flexible Spot autofocus frame, you should leave this setting on Standard because those options will not be available otherwise. If you don't need Tracking Focus too often, then you need to decide which function is most useful to you of those listed above. When

I am doing photography through a telescope, as discussed in CHAPTER 9, I often use the Focus Magnifier option. In other situations, I usually leave the Center button set to its Standard option. However, AEL Toggle can be helpful if you will need to lock exposure frequently, and AF/MF Control Toggle is a powerful feature if you need to switch between manual focus and autofocus.

FUNCTION OF LEFT BUTTON

The Left button is, of course, ordinarily assigned to be the Drive Mode/Self-timer button, as indicated by the icons next to it on the camera's back. Using this menu option, as shown in FIGURE 7-24, you can assign any one of the following functions to it instead: Exposure Compensation, Flash Mode, Focus Mode, Autofocus Area, Smile/Face Detection, Auto Object Framing, Soft Skin Effect, ISO, Metering Mode, Flash Compensation, White Balance, DRO/Auto HDR, Creative Style, Picture Effect, Image Size, Aspect Ratio, Quality, Memory, AEL Toggle, AF/MF Control Toggle, Focus Magnifier, or Control with Smartphone.

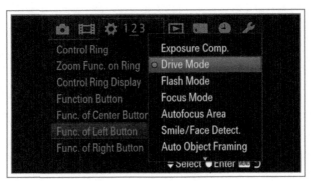

Figure 7-24. Function of Left Button Choices

My preference is to leave this button assigned to its standard function as the Drive Mode/Self-timer button, but it certainly gives you a lot of flexibility to have the other options available. If you will be using the ability of the camera to be controlled remotely by a smartphone or tablet, it could be useful to assign the Control with Smartphone function to the Left button.

For example, if you have attached the RX100 II to a pole for pole aerial photography (discussed in CHAPTER 9), you are likely to need the Control with Smartphone option multiple times to get the camera set up to be controlled while it is out of your physical reach. Being able to activate this option with the press of a single button could be of great assistance in that case.

FUNCTION OF RIGHT BUTTON

The Right button, which normally is the Flash button, also can be reassigned to any of the options listed above for the Left button. My preference is to leave this button set for Flash Mode, but it could be convenient to reset it to handle a setting such as DRO/Auto HDR, perhaps when you are on a photo shoot and you know you will not be using flash, but you will be encountering situations with wide variations in contrast, such as bright sunlight mixed with dark shadows, and you may need to quickly call up the dynamic range settings.

MOVIE BUTTON

This option, shown in FIGURE 7-25, lets you lock out the operation of the red Movie button to avoid the problem of accidentally activating it and starting an unwanted video recording.

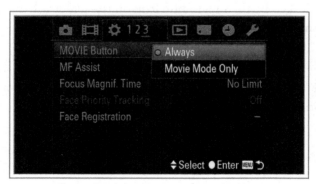

Figure 7-25. Movie Button Menu Option

I find that I often press this button by mistake, either when I am trying to press the Menu button or sometimes when I am just picking up the camera and I happen to grab it where this button is located.

Of course, if you press the button accidentally, that does not usually cause a big problem; you just need to press it again to stop the recording and then wait a few seconds for the camera to process the recording. Those few seconds could cause a problem, though, if you need to use the camera immediately to take another picture. Also, the unwanted recordings can add up and clutter your memory card.

If you don't believe this issue will bother you, just leave this menu option set to its default value of Always. Then, whenever you press the Movie button, a video will start recording no matter what shooting mode is set on the Mode dial. This setup is convenient when you are on a sightseeing trip and may want to record quick videos, even when the camera is set to Intelligent Auto or one of the Scene mode settings.

If you would like to limit the operation of the Movie button, select the Movie Mode Only setting for this menu option. In that case, the button will operate only when the Mode dial is set to Movie mode, marked by the movie-film icon on the dial. I will discuss the Movie mode options in CHAPTER 8.

MF ASSIST

The MF Assist option, shown in FIGURE 7-26, provides a useful function when manual focus is in effect.

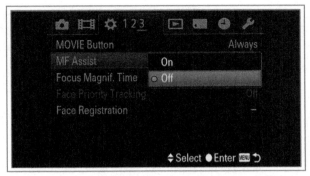

Figure 7-26. MF Assist Menu Option

When MF Assist is turned on, the camera enlarges the image on the display screen as soon as you start turning the Control ring to focus manually. This enlargement is helpful when you are trying to judge whether a particular part of the scene is in sharp focus. If you turn this option off, you can use another focusing aid, such as Peaking or Focus Magnifier, discussed earlier in this chapter. I find MF Assist to be very helpful, especially because you can set the camera to leave the enlarged screen in place indefinitely using the Focus Magnifier Time option, discussed immediately below. However, I find the Focus Magnifier option to be just as helpful, and preferable in a way, because the screen does not become magnified until you press the Center button, select the area to be magnified using the orange frame, and then magnify the screen.

As I noted earlier, though, in some cases, where the subject (such as the moon) does not have clear edges or other features to focus on, enlarging the view may not be that much help. In those situations, Peaking may be more useful. Or, you may find that using Peaking in conjunction with MF Assist is the most useful approach of all. You should experiment with the various options to find what works best for you.

Focus Magnifier Time

This option lets you select how long the display will stay magnified when you use either the MF Assist option, discussed directly

above, or the Focus Magnifier option, which is available only if you have set the Center, Left, or Right button to control that function. The choices are 2 or 5 seconds or No Limit, as shown in FIGURE 7-27.

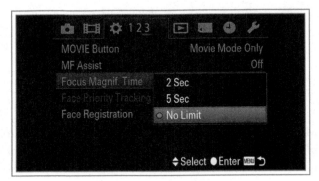

Figure 7-27. Focus Magnifier Time Menu Option

If you choose No Limit, then the image will stay magnified until you press the Shutter button all the way to take the picture, or press it halfway to dismiss the enlarged view.

My preference is to use the No Limit option, so I can take my time in adjusting manual focus precisely.

FACE PRIORITY TRACKING

This menu option performs a very specific function that is available for selection only if the camera is set for autofocus with the Smile/Face Detection option on the Shooting menu turned on. If you turn Face Priority Tracking on, then when you use the Tracking Focus option (activated by pressing the Center button), the focus-tracking feature will give priority to any human face it detects. If this option is turned off, then the focus-tracking feature will give priority to the subject that is closest to the camera when you activate tracking.

FACE REGISTRATION

This last option on the Custom menu lets you register human faces, so the RX100 II can give those faces priority when it uses face detection. You can register up to eight faces and assign each one a priority from one to eight, with one being the highest priority. Then, when you set the option for Smile/Face Detection to On (Registered Faces), the camera will try to detect the registered faces first in the order you have assigned them.

This feature is not one that I find any need for, but it could be useful if, for example, you take pictures at school functions and you want to make sure the camera focuses on your own children rather than on other kids.

To use this setting, select this menu option, and then on the next screen select New Registration. Press the Center button, and the camera will place a large square on the screen. Compose your shot with the face to be registered inside that frame, as shown in FIGURE 7-28, and then press the Shutter button to take a picture of that face.

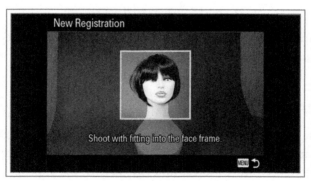

Figure 7-28. Face Registration: Screen for Shooting Face

If that process is successful, the camera will display a screen with that face inside the frame with the message "Register face?" Highlight the Enter bar and press the Menu button to complete the registration process.

Later, you can use the Order Exchanging menu option to change the priorities of the faces that have been registered, and you can delete registered faces individually or all at once using the other menu options.

Memory Card Tool Menu

The next menu to be discussed, whose tab is found to the right of the tab for the Playback menu, is the Memory Card Tool menu, shown in FIGURE 7-29.

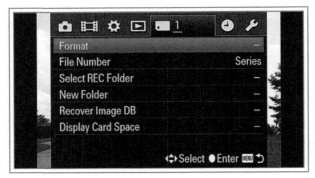

Figure 7-29. Memory Card Tool Menu

This single-screen menu contains several commands whose functions have to do with setting up and managing your memory card. I will discuss them all below.

FORMAT

The first option at the top of the screen—Format—is an extremely important command. This command is used to prepare a new memory card to store images and videos with the appropriate data format. The Format command also is useful when you want to wipe all the data off a card that has become full or you have copied a card's images to your computer or other storage device. Choose this process only when you want or need to completely wipe all of the data from a memory card. When you select the Format option,

as shown in FIGURE 7-30, the camera will warn you that all data currently on the card will be deleted if you proceed.

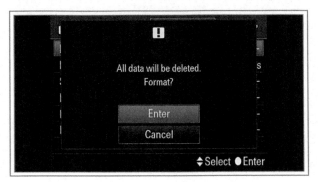

Figure 7-30. Format Confirmation Screen

If you reply by highlighting Enter and pressing the Center button to confirm, the camera will format the card that is in the camera, and the result will be a card that is empty and properly formatted to store new images recorded by the camera.

With this procedure, the camera will erase all images, including those that have been protected from accidental erasure with the Protect function on the Playback menu. It's a good idea to periodically save your images and videos to your computer or other storage device and then re-format your memory card to make sure it is properly set up for recording new images and videos. It's also a good idea to use the Format command on any new memory card when you first insert it into the camera. Even though it likely will work without that procedure, it's best to make sure the card is set up with Sony's own particular method of formatting for the RX100 II.

FILE NUMBER

This option gives you control over the way the camera assigns numbers to your images and videos. There are two choices: Series and Reset, as shown in FIGURE 7-31.

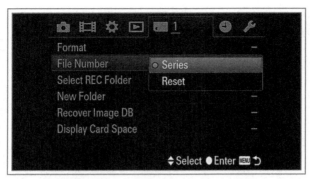

Figure 7-31. File Number Menu Option

If you choose Series, then the camera continues numbering where it left off, even if you put a new memory card in the camera. For example, if you have shot 112 images on your first memory card, the last image likely will be numbered 100-0112: 100 for the folder number (the first folder number available) and 0112 for the image number. If you then switch to a new memory card with no images on it, the first image on that card will be numbered 100-0113 because the numbering scheme continues in the same sequence. If you choose Reset instead, the first image on the new card will be numbered 100-0001 because the camera resets the numbering to the first number.

SELECT REC FOLDER

When you select this menu item, the camera puts an orange bar on the screen with the name of the current folder, as shown in FIGURE 7-32.

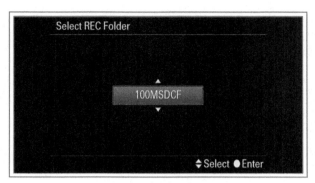

Figure 7-32. Select REC Folder Menu Option

You can then use the Up and Down buttons or turn the Control wheel to scroll to the name of another folder on the memory card if one exists, so you can store future images and videos in that folder. It might be worthwhile to use this function if you are taking photos or movies for different purposes during the same outing. For example, if you are taking some photos for business and some for pleasure, you could create a new folder for the business-related shots (see the next menu item, below). The camera would then use that folder. Afterward, you could use the Select REC Folder option to select the folder where your personal images are stored and take more personal images that will be stored there.

NEW FOLDER

This menu item lets you create a new folder on your memory card for storing images and videos. Just highlight this item on the menu screen and press the Center button; you will then see a message announcing that a new folder has been created, as shown in FIGURE 7-33.

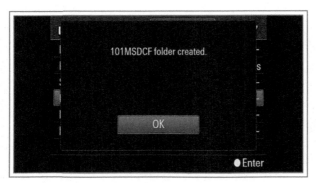

Figure 7-33. Create New Folder Menu Option

The camera will then begin storing new images and videos in that folder until you select another folder using the Select REC Folder option, discussed above, or create another new folder using this option. The camera also will create a new folder automatically once a folder contains 4,000 images.

I have not used this option much, but I am glad it is available. Recently I have been using a SanDisk Ultra 64 GB SDXC memory card in my RX100 II, and right now I have 1,573 images in the 100MSDCF folder. (That folder is contained within the DCIM folder on the card when viewed on a computer.) It is becoming unwieldy to scroll through that many images in a single folder when I look at the images on my computer, and I plan to start creating new folders after each 500 or so images in the future to make the files more manageable.

RECOVER IMAGE DATABASE

This menu item activates the Recover Image Database function. If you select this option and then press the Center button to confirm it on the next screen, as shown in FIGURE 7-34, the camera runs a check to test the integrity of the file system on the memory card.

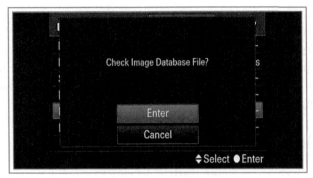

Figure 7-34. Recover Image Database Menu Option

This option displays automatically when you place a brand new memory card in the camera or a card that has previously been used in a different camera. I have never chosen this menu, but if the camera is having difficulty reading the images on a card, using this option might recover the data.

DISPLAY CARD SPACE

The final item on the Memory Card Tool menu screen gives you another way to see how much storage space is remaining on the memory card that is currently inserted in the camera.

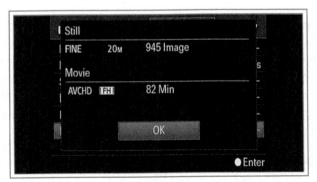

Figure 7-35. Display Card Space Menu Option

When you select Display Card Space and press the Center button, the camera displays a screen, like that in FIGURE 7-35, with

Photographer's Guide to the Sony DSC-RX100 II

information about the number of still images or the minutes of video that can be recorded. It may be nice to have this option available, although the number of images that can be recorded is also displayed on the detailed shooting screen, and the number of minutes of video that can be recorded is displayed on the video recording screen once a recording has been started.

Clock Setup Menu

Sony has created a menu with only two items for setting up the date and time and the area, shown in FIGURE 7-36.

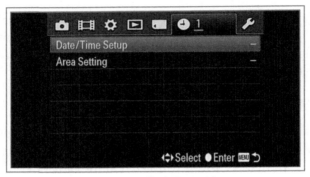

Figure 7-36. Clock Setup Menu

DATE/TIME SETUP

I briefly discussed the first item, Date/Time Setup, in CHAPTER 1. When the camera is new or has not been used for a long time, it will prompt you to set the date and time and will display this menu option. If you want to call up these settings on your own, you can do so at any time.

Once you have chosen this item and pressed the Center button, the camera will display a screen like that shown in FIGURE 7-37.

You scroll through the various options for setting Daylight Saving Time, month, day, year, and other items by turning the Control wheel or pressing the Left and Right buttons. As you reach each

item, adjust its value using the Up and Down buttons. When all of the settings are correct, press the Center button to confirm them and exit from this screen.

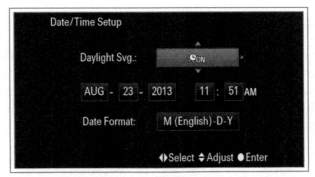

Figure 7-37. Date and Time Settings Screen

AREA SETTING

The other option on this menu, Area Setting, lets you select your current location; thereby, adjusting the date and time for a different time zone when you are traveling. When you highlight this item and press the Center button, the camera displays the map shown in FIGURE 7-38.

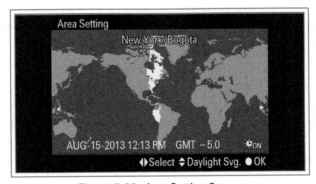

Figure 7-38. Area Setting Screen

Just turn the Control wheel or press the Left and Right buttons to move the light-colored highlight over the map until it covers the

area of your current location, then press the Center button. The date and time will be adjusted for that location until you change the location again using this menu item.

Setup Menu

The Setup menu, reached through the last menu tab on the right of the menu screen, gives you choices for housekeeping matters like screen brightness and operational sounds. This menu is designated by the wrench icon at the top of the screen, as shown in FIGURE 7-39.

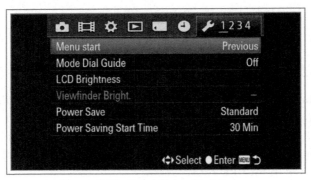

Figure 7-39. Setup Menu: First Screen

Following are details about the items on the four menu screens.

MENU START

This first menu option provides an important capability: it lets you choose what screen the RX100 II displays when you press the Menu button to get access to the menu system. There are two choices, Top and Previous, as shown in FIGURE 7-40.

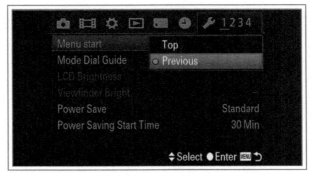

Figure 7-40. Menu Start Menu Option

If you choose Top, the camera always displays the first screen of the first menu for the camera's current mode (Shooting or Playback). So, for example, if the camera is in shooting mode and you press the Menu button, you will see the first screen of the Shooting menu. If the camera is in Playback mode, you will see the first screen of the Playback menu.

On the other hand, if you choose Previous, the behavior will be different. In that case, the camera will always display whatever menu screen it was last displaying whenever you press the Menu button. I prefer the Previous setting because I find that I am likely to work in the same area of the menus for a while, and there is a good chance it will be convenient to return to the most recent menu screen I was using. Of course, your habits may be different, and you may prefer the predictability of starting from a known location in the menu system whenever the Menu button is pressed.

Mode Dial Guide

This menu item gives you a way to turn on or off the Mode Dial Guide, a graphic display that appears on the camera's screen when you turn the Mode dial to select a different shooting mode, as shown in Figure 7-41.

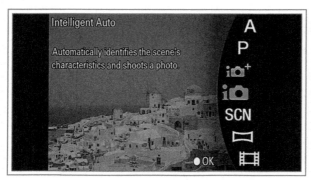

Figure 7-41. Mode Dial Guide Screen

This guide can be helpful when you first get the camera, or if you appreciate seeing advice or reminders about each mode as you select it, but it can be annoying if you don't need the information, and you have to press the Center button or press the Shutter button halfway to dismiss the screen. I leave this option turned off to speed up my shooting.

LCD BRIGHTNESS

This option lets you control the brightness of the LCD display using one of three available settings: Auto, Manual, or Sunny Weather, as seen in FIGURE 7-42.

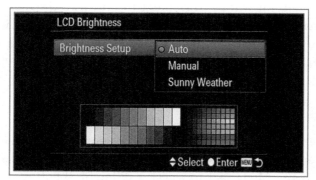

Figure 7-42. LCD Brightness Menu Option

If you choose Auto, the camera adjusts the screen's brightness using a small light sensor at the upper-left corner of the LCD screen to gauge the amount of ambient light.

If you choose Manual, the camera displays the screen shown in FIGURE 7-43.

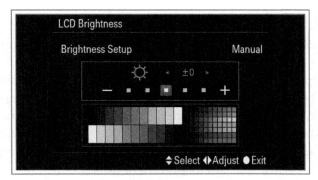

Figure 7-43. LCD Brightness Adjustment: Manual

Using the controls on this screen, you can change the brightness to one or two units above or below normal. With the orange highlight block in the scale with a plus and minus sign, use the Left or Right button to make your desired adjustment. If your battery is running low and you don't have a spare, you may want to set the viewfinder to its minimum brightness to conserve power. Conversely, you can increase the brightness if you're finding it difficult to compose the image on the screen.

If you are shooting outdoors in bright conditions, you can choose the Sunny Weather setting, which sets the display to a very bright level, so you can see the screen despite the bright sunshine. I have found the Sunny Weather setting to be useful in that situation because the screen can be very difficult to see when the sun is shining and the RX100 II does not have a built-in viewfinder for you to use.

See APPENDIX A for a discussion of the optional viewfinders that are available. If you purchase Sony's electronic viewfinder, you

should have no problems composing images on sunny days, but that viewfinder is quite expensive.

The Sunny Weather setting drains the camera's battery fairly rapidly, so you should turn it off when it is no longer needed. For everyday shooting, I use the Auto setting, which is quite adequate.

VIEWFINDER BRIGHTNESS

This option is available for selection only if you have installed Sony's electronic viewfinder, which is discussed in APPENDIX A. The menu option is similar to the LCD Brightness selection, discussed above, but it has some differences. With this option, there is no Sunny Weather setting because the viewfinder is shaded from the sun and there is no need for a super-bright setting. You can set the brightness to Auto or to Manual. If you select Manual, the only adjustments available are to increase or decrease the brightness by one unit, rather than the two units available for the LCD screen. Again, there is not much need for brightness adjustments because the view is always shielded from outside light.

POWER SAVE

This menu option is similar to Power Saving Start Time, the next option on the Setup menu. Both give you ways to set the camera to power down automatically after a set time. The Power Save option has just two settings: Max and Standard, as shown in FIGURE 7-44.

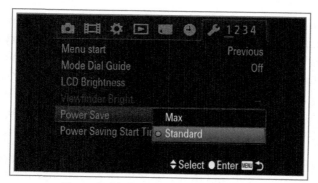

Figure 7-44. Power Save Menu Option

With Max, the camera turns off after one minute; with Standard, it shuts down after the period specified in Power Saving Start Time, discussed below. In effect, Power Save is a shortcut option for quickly setting the camera to power off after one minute, so you can quickly set it to conserve power.

POWER SAVING START TIME

As noted above, this menu option lets you set the amount of time before the camera turns off automatically to save power, when no controls have been operated. The default setting is 2 minutes; with this option you can also choose 1, 5, or 30 minutes, as shown in FIGURE 7-45.

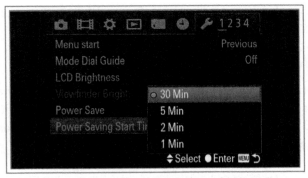

Figure 7-45. Power Saving Start Time Menu Option

You cannot turn the power-saving function off. However, the camera will not power off automatically when you are recording movies, when a slide show is playing, or when the camera is connected to a computer.

It is somewhat puzzling that Sony has provided two power-saving menu options that overlap in their operation. My recommendation is to set the Power Save option to Standard and then set the time before automatic shutoff using the Power Saving Start Time option.

HDMI Resolution

The HDMI Resolution menu item can be set to Auto, 1080p, or 1080i. Ordinarily, the Auto setting will work best; the camera will set itself for the optimum display according to the resolution of the HDTV it is connected to. If you experience difficulties with that connection, you may be able to improve the image on the HDTV's screen by trying one of the other settings.

CTRL for HDMI

This menu option is of use only when you have connected the camera to an HDTV and you want to control the camera with the TV's remote control, which is possible in some situations. If you want to do that, set this option to On, and follow the instructions for the TV and its remote control.

Upload Settings

This option is the first item on the second screen of the Setup menu as shown in Figure 7-46, but only when an Eye-Fi card is inserted in the camera. If no Eye-Fi card is present, this menu option is not dimmed; it just does not display at all.

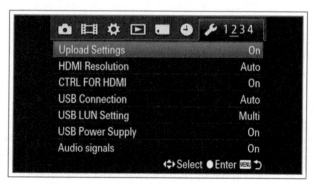

Figure 7-46. Upload Settings Menu Option

As discussed in Chapter 1, an Eye-Fi card is a special type of memory card that includes a transmitter to send your images to a computer over a Wi-Fi network or directly to a wireless device if

you use Direct Mode. This menu item has only two settings—On and Off. You might want to use the Off setting if you are on an airplane where you may be required to turn off radio transmitters. Or, if you know you will not be using the Eye-Fi uploading capability for a while, you can turn this menu option off to save some battery power.

Of course, the RX100 II has its own built-in Wi-Fi capability, which makes it less likely that you will need to use an Eye-Fi card for the transfer of images.

PAL/NTSC SELECTOR

This menu option appears only on cameras that are sold in areas that use the PAL video standard and that therefore use the 1080 50i video format rather than the 1080 60i format that is used in the United States, Canada, and other areas that use the NTSC video standard. As I noted in the INTRODUCTION, I live in the United States and have the NTSC version of the RX100 II, so my information about this menu option is secondhand.

The 50i version of the camera, which has a "50i" label on the bottom, can be switched to record video with the NTSC standard, using the 60i format, using the PAL/NTSC Selector menu option. So, if you purchased your camera in Europe or another area where the PAL version is sold, you will have the option to record your videos in either the PAL (50i) or NTSC (60i) format. However, if, like me, you have the 60i (NTSC) version of the camera, you can record and play back video only in the NTSC formats.

If you have the PAL version of the camera, you should note that you cannot record NTSC video on a memory card that was previously formatted using the PAL system. If you try to do so, you will receive an error message. You will have to re-format the card with the PAL/NTSC Selector set to NTSC or use a different card that has been formatted under that system.

USB CONNECTION

This menu item sets the technical standard that the camera uses for transferring images and videos to your computer when the camera is connected to it by the USB cable. This option has three choices, as shown in FIGURE 7-47: Auto, Mass Storage, and MTP, which stands for Media Transfer Protocol, a standard developed by Microsoft for transferring media files over a USB connection.

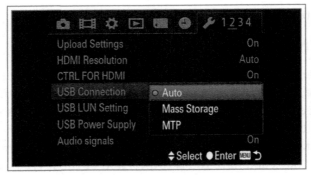

Figure 7-47. USB Connection Menu Option

You ordinarily should select Auto for this setting, and the RX100 II should be able to detect which standard is used by the computer you are connecting the camera to. If the camera does not automatically select a standard and start transferring images, you can try one of the other settings to see if it works better than the Auto setting.

USB LUN SETTING

This menu option is a rather technical one that will probably not often be used. LUN stands for logical unit number. This option has two possible settings—Multi or Single. Ordinarily, it should be set to Multi, the default setting. In particular, it should be set to Multi when you have the RX100 II connected to a Windows-based computer and are using Sony's PlayMemories Home software to manage your images. If you ever encounter a problem with a USB

connection to a computer, you can try the Single setting to see if it helps rectify the problem.

USB POWER SUPPLY

The USB Power Supply option, which can be turned either on or off, controls whether or not the camera's battery will be charged when the camera is connected to a computer or other USB device. This option also can be used if you have a portable USB charger available—a device that uses battery power to charge your cell phone and other portable gadgets.

Turning this option on gives you another avenue for keeping the RX100 II's battery charged. The only problem is that if your computer is running on its battery, then that battery will be discharged more rapidly than usual. If you are plugging the camera into a computer that is plugged into a wall power outlet, then there should be no problem in using this option.

Of course, as I will discuss in APPENDIX A, in my opinion, you should get an external battery charger and at least one extra battery for the RX100 II because even if you can charge the battery in the camera using the USB cable, you don't have the ability to insert a fully charged battery into the camera when the first battery is exhausted.

I recommend leaving this option at its default setting of On, unless you will be connecting the camera to a battery-powered computer or other device and you don't want to run down the battery on that device.

AUDIO SIGNALS

This option lets you choose whether or not to activate the various sounds the RX100 II makes when an operation takes place, such as pressing the Shutter button, confirming focus, or pressing a control button. By default, the sounds are turned on, but it can be helpful to turn them off when you are shooting in a quiet area

or during a religious ceremony, or when you are doing street photography and want to avoid alerting your subjects that a camera is being used.

WPS PUSH

The entire third screen of the Setup menu, starting with this item, consists of options relating to the built-in Wi-Fi capability of the RX100 II. I discuss how to use these options in the section on Wi-Fi in CHAPTER 9. In this chapter, I will provide some details about each of the Wi-Fi–related menu selections.

The WPS Push option gives you an easy way to set up your camera to connect to a computer over a Wi-Fi network. Ordinarily, to connect to a wireless network, you have to set your device to find the network and then enter the network password to establish the connection. The WPS Push option gives you a shortcut if the wireless access point or wireless router you are connecting to has a WPS button. This option, if it is present, is likely to be a small button on the back or top of the router, and it is likely to have the WPS label next to it or on it. For example, the router I connect to has the button shown in FIGURE 7-48.

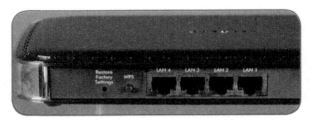

Figure 7-48. WPS Button on Router

If the router has such a button, you will not have to make any manual settings or enter a password. All you have to do is select the WPS Push menu option on the RX100 II, and then within two minutes after that, press the WPS button on the router. If the operation is successful, the camera's display screen will show that the connection has been established, as shown in FIGURE 7-49.

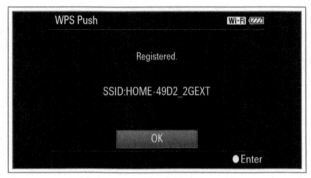

Figure 7-49. Camera Display When WPS Connection Established

Once that connection has been made, you will be able to connect your camera to a computer on that network in the future to transfer images using the Send to Computer option on the first screen of the Playback menu.

If the connection does not succeed using the WPS Push option, you will need to use the Access Point Settings option, discussed next.

ACCESS POINT SETTINGS

This option on the third screen of the Setup menu is for connecting your camera to a wireless router if the WPS Push option, discussed above, is not available or does not work. To use this option, you will need to know the SSID (service set identifier or identifying name) of the Wi-Fi network you will be connecting the camera to. For routers that are provided by a service provider such as Comcast or Verizon, this name may be printed on the bottom or back of the router. In other cases, the name may be one you or a system administrator has assigned.

Once you know the SSID of the network, select the Access Point Settings menu option, and the camera will display a screen showing that it is searching for networks. Once it finds one or more networks, it will display a single name, as shown in FIGURE 7-50, or a list of networks, and you should select the network you want to connect to.

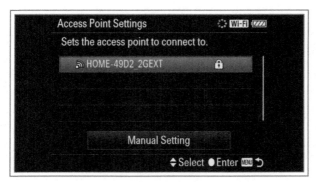

Figure 7-50. Screen for Finding Computer Network

If you have not previously connected to it, the camera will display a screen asking you to enter the network password, as shown in FIGURE 7-51.

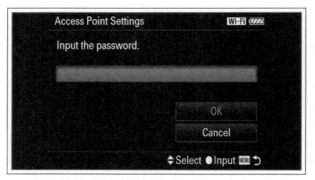

Figure 7-51. Screen for Entering Network Password

To do that, use the text-entry functions of the camera's on-screen keyboard, shown in FIGURE 7-52, which operates somewhat like the data-entry options on a cell phone.

Figure 7-52. Keyboard Screen for Entering Password

Once the password has been entered, the connection will be established, just as if you had used the WPS Push option, and you can proceed to use the Send to Computer option on the first screen of the Playback menu, as discussed in CHAPTER 6.

EDIT DEVICE NAME

This next option, shown in FIGURE 7-53, lets you change the name of your camera as it is displayed on the network.

Figure 7-53. Edit Device Name Menu Option

The default name is DSC-RX100M2, and I have found no reason to change it, especially because doing so would require me to use the camera's laborious data-entry system. This option could be useful if you are in an environment where other RX100 II cameras

are present and you need to distinguish one camera from another with different names.

Display MAC Address

If you select this menu option, the camera will display a screen like that seen in FIGURE 7-54, which provides the MAC address of your camera. MAC stands for media access control.

Figure 7-54. Display MAC Address Menu Option

The MAC address is a string of numbers that identifies a physical device that can connect to a network. In some cases, a wireless router can be configured to reject or accept devices with specified MAC addresses. If you are having difficulty connecting your camera to your Wi-Fi router using the menu options discussed above, you may want to try configuring your router to specifically recognize the MAC address of your camera. With this menu option, you can find out what that MAC address is. I have not had to use this option, but it is good to have it available in case it is needed.

SSID/PW Reset

When you connect your RX100 II to a smartphone or tablet, either to transfer images or to have the camera controlled remotely by the other device, the camera generates its own Wi-Fi network internally. With this option, whose main screen is shown

in FIGURE 7-55, you can force the camera to change the SSID (name) and password of its own wireless network.

Figure 7-55. SSID-PW Reset Menu Option

You might want to do this if, for example, you have been to a conference where you allowed other people to connect their smartphones to your camera, and now you want to reset the camera's network ID, so they will no longer have access to the camera's network.

AIRPLANE MODE

This option gives you a quick way to disable all of the camera's functions related to Wi-Fi, including Eye-Fi card activity and the camera's own internal Wi-Fi network. As indicated by its name, this option is useful when you are on an airplane and you are required to disable electronic devices. In addition, this setting can save battery power, so it may be useful to activate it when you are on an outing with the camera and you won't be needing to use any Wi-Fi capabilities for a period of time.

If you are trying to use any of the camera's built-in Wi-Fi functions, such as Control with Smartphone, Send to Computer, and the like, and notice that the menu options are dimmed, it may be because this option is turned on. Just turn it back off and the Wi-Fi options should be available again.

VERSION

This menu option gives you a way to find out the current version of the firmware installed in your camera. The Sony Cyber-shot DSC-RX100 II, like other digital cameras, is programmed at the factory with firmware, which is a semi-permanent set of computer instructions electronically implanted in the camera. These instructions control all aspects of the camera's operation, including the menu system, functioning of the controls, and in-camera processing of your images. The reason you may want to check to see what version is installed is that, in many cases, the manufacturer will release an updated version of the firmware that may fix problems or bugs in the system, provide minor enhancements, or in some cases, even provide major improvements, such as adding new shooting modes or menu options.

To determine the firmware version installed in your camera, highlight this menu option, then press the Center button, and the camera will display the version number, as shown in FIGURE 7-56.

Figure 7-56. Firmware Version Displayed on Screen

To see if firmware upgrades have been released, I recommend you visit Sony's support website at http://esupport.sony.com. Find the link for Drivers and Software, then the link for Cyber-shot Cameras, and then a link to any updated version for the RX100 II (often referred to by Sony as the RX100M2). The site will provide instructions for downloading and installing the new firmware.

LANGUAGE

This option gives you the choice of language for the display of commands and information on the camera's LCD screen. Once you have selected this menu item, as shown in FIGURE 7-57, scroll through the language choices using the Control wheel or the direction buttons and press the Center button when your chosen language is highlighted.

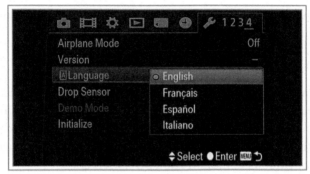

Figure 7-57. Language Menu Option

DROP SENSOR

The Drop Sensor option is turned on by default. This feature is an internal monitoring system that detects the motion of the camera if it is dropped and quickly retracts the lens to avoid damage. Once dropped, the camera displays the message shown in FIGURE 7-58.

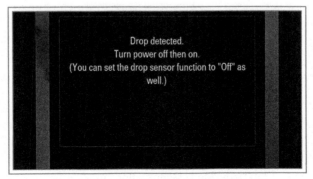

Figure 7-58. Drop Sensor Message Screen

This is an excellent safety measure, and I recommend leaving it on in all normal situations. The only time you might want to turn it off is if you are doing activities in which the camera will be subjected to strong forces, such as skydiving, bungee jumping, mountain climbing, and the like, and you want to avoid having the camera shut down in this way.

By the way, this item is not particularly concerned with the camera's image sensor; the word "sensor" in the title of this item is used generically to describe the system that senses the gravitational force the camera is being subjected to.

DEMO MODE

The Demo Mode menu item is intended to provide an automated demonstration of movie playback if the camera has not had any controls operated for about one minute. This feature is designed for use by retail stores, so they can leave the camera turned on with a continuous demonstration on its screen.

For this feature to be available for selection on the menu screen, as shown in FIGURE 7-59, the camera has to be plugged into AC power using an AC adapter. (As noted in CHAPTER 1 and APPENDIX A, the charger that ships with the RX100 II does not work as an AC adapter; you can purchase one from Sony as an optional accessory.)

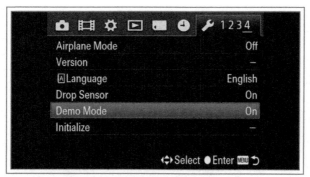

Figure 7-59. Demo Mode Menu Option Available for Selection

When the Demo Mode option is turned on and the camera is in shooting mode, after one minute of inactivity, the camera enters Demo Mode. At that point, the camera will automatically play a movie, which you have to provide. It cannot be just any movie. The movie the camera will play in Demo Mode must be recorded in the AVCHD format, it must be protected using the Protect option on the Playback menu, and it must be the oldest AVCHD movie on the memory card. So, if you have a reason to use this option, you may want to use a fresh memory card and record a single AVCHD movie on the card, and then use the Protect function to protect it. When the movie plays, it plays audio as well as video, and it will keep repeating in a loop. To exit from Demo Mode, you can press the Center button or just turn the camera off.

INITIALIZE

This final option on the Setup menu is useful when you want to reset some or all of the camera's settings to their original (default) values. This action can be helpful if you have been playing around with different settings and you find that something is not working as expected.

When you select this item, the camera presents you with four choices: Reset Default, Record Mode Reset, Custom Reset, and Reset Network Settings, as shown in FIGURE 7-60.

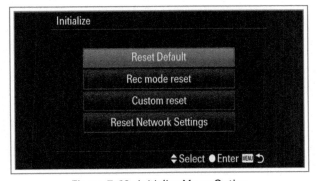

Figure 7-60. Initialize Menu Option

If you choose Reset Default, the camera resets all major settings to their original values. With Record Mode Reset, only the values from the Shooting menu are reset. If you select Custom Reset, only the values from the Custom menu are reset. If you select Reset Network Settings, the camera will reset all network settings that have been made, such as information for the connection to your local Wi-Fi network.

CHAPTER 8:
Motion Pictures

You may have purchased the Sony RX100 II because of its superb capabilities for capturing still images, but you should not overlook the camera's options for recording video footage. The RX100 II's video abilities are quite strong for a camera this small; they provide you with an excellent level of flexibility in capturing video. Before I get into the specific settings you can make for your movies, I'll begin with a brief overview of the process.

Movie-Making Overview

In one sense, the fundamentals of making videos with the RX100 II can be reduced to four words: "Push the red button." (That is, the red Movie button at the upper-right corner of the camera's back.) Having a dedicated motion picture recording button makes things easy for users of this camera. Anytime you see a reason to take some video footage, you can just press and release that easily accessible red button while aiming at your subject, and you will get results that are likely to be quite usable. You do not need to worry about making any particular settings, particularly if you have set the camera to one of the Auto modes. To stop recording, press the red button again. (If you prefer not to run the risk of recording unwanted movies by pressing the red button accidentally, you can change the button's operation, so it activates movie recording only when the camera is in Movie mode, as discussed in CHAPTER 7.)

If you want to take a still photo while a movie is being recorded, go right ahead and press the Shutter button and a still image will be recorded. (There are some limitations, which I will discuss later in this chapter.)

If you're mainly a still photographer and not that interested in movie-making, you don't need to read any further. Be aware that the red button exists, and if a newsworthy event starts to unfold before your eyes, you can get some excellent footage to post on YouTube or elsewhere with a minimum of effort.

But for those RX100 II users who would like to delve further into their camera's excellent motion picture capabilities, there is considerably more information to discuss.

Before I get into details about how to record videos, I should note that the RX100 II, like most cameras in its class, has built-in limitations that prevent it from recording any sequence longer than about 29 minutes (15 minutes for the MP4 HD format). You can, of course, record multiple sequences adding up to any length depending on the amount of storage space available on your memory cards. If you plan on recording a significant amount of HD video, you should get one of the highest-capacity and fastest memory cards you can find. For example, a 16 GB card can hold about 80 minutes of the highest quality of AVCHD video, about 2 hours of lower-quality AVCHD video, or about 2 hours 50 minutes of MP4 HD video. (I will discuss these video formats later in this chapter.)

If you want to fit both still images and HD video sequences on a card, you might be better off with a 32 GB card or even an SDXC card with a capacity of up to 128 GB. (As noted in CHAPTER 1, there are 256 GB cards available, but they are very expensive.) You should try to get a card rated at Class 6 or higher, so it will have the necessary speed for recording HD video. I like to use a card rated at Class 10; that speed helps not only with recording video but with shooting continuous still images at the best possible rate.

Details of Settings for Shooting Movies

As I noted above, the one step that is a necessity for recording a movie with the RX100 II is to press the red Movie button. However, there are numerous settings that affect the way in which the camera records a movie when that button is pressed. I will discuss four categories of settings: (1) the selections you make on the Movie menu; (2) the position of the Mode dial on top of the camera; (3) the selections you make on the Shooting menu; and (4) the selections you make with the camera's physical controls. I will discuss these four areas in turn, below.

MOVIE MENU

First, I will discuss the Movie menu, which is important because the items on this menu control the format and other options for all movies you record with the RX100 II. This is the one menu system I have not discussed previously. It is designated by the movie-film icon, just to the right of the Shooting menu in the line of menu icons, as shown in FIGURE 8-1.

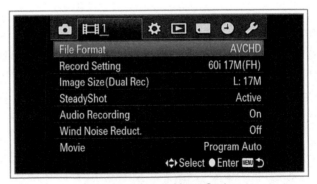

Figure 8-1. Movie Menu Option

The Movie menu is available in every shooting mode, including all of the modes for shooting still images and Movie mode itself. So, no matter what position the Mode dial is set to, you can access the Movie menu and make settings for video recordings. Those settings will affect only video recordings, not still images, with one

exception: the Image Size (Dual Recording) item, which sets the size of still images captured during movie recording.

While I'm mentioning still images, I need to point out one limitation that might not be obvious and could lead to problems: when the Mode dial is set to Movie mode, you cannot shoot still images until you have started recording a movie. When the Mode dial is set to any other position, you can pick up the RX100 II, turn it on, press the Shutter button, and get some sort of still image. When the Mode dial is turned to the movie-film icon, though, pressing the Shutter button will have no effect until a movie is being recorded. At that point, the camera will use the special setting for recording still images during video recording.

As noted above, you can press the Movie button to start a video recording any time and in any shooting mode as long as the Movie Button menu option on the third screen of the Custom menu is set to Always. Because of this ability to shoot movies in any shooting mode, you can always change the settings for movie recording using the Movie menu no matter what shooting mode the camera is set to. I will discuss each item on the Movie menu below.

File Format

The first item on the single screen of the Movie menu, File Format, gives you a choice of the two available movie recording formats on the RX100 II—AVCHD and MP4, as shown in FIGURE 8-2.

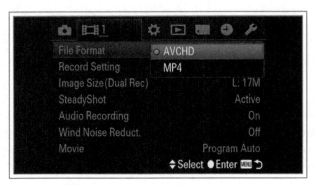

Figure 8-2. File Format Menu Option

If you want the highest-possible quality of video for viewing on an HDTV set, you should choose AVCHD. This format, developed jointly by Sony and Panasonic, has become increasingly common in advanced digital cameras. As noted, it provides excellent quality, and movies recorded in this format on the RX100 II can be used to create Blu-ray discs.

However, files recorded in the AVCHD format can be complicated to edit on a computer. In fact, just finding the AVCHD video files on a memory card can be a challenge. When you take a memory card from the RX100 II camera and insert it into a memory card reader for viewing on your computer, you can find the still-image files within the folder labeled DCIM and then within sub-folders with names such as 100MSDCF. The AVCHD files, however, are not within that folder; they are within a different folder named PRIVATE. Inside that folder you will find another one called AVCHD, and within that one another one called BDMV. Open that folder and you will see more files or folders, including a folder called STREAM. With the card whose contents I am looking at now on my Macintosh, that folder contains numerous files with the extension .mts. Those .mts files are the actual AVCHD files that can be edited with compatible software packages, such as Adobe Premiere Pro. (You don't have to worry about finding the file names if you connect your camera to the computer using the USB cable or the Send to Computer menu option, only if you use a card reader, as I do.)

If you want to record movies with excellent video quality but in a video format that is easier to edit with a computer, you can choose MP4. The MP4 format is compatible with Apple Computer's QuickTime software, and it can be edited with various software programs, including QuickTime, iMovie, Windows Movie Maker, and many others. The MP4 files also are found in a different folder on your memory card, not within the DCIM folder. On my memory card, the MP4 files are located in a folder named 100ANV01, which is inside a folder named MP_ROOT.

Record Setting

The Record Setting item on the Movie menu lets you set another quality-related option for recording video. (The accent is on the second syllable of "Record.") The choices for this item are different depending on whether you choose AVCHD or MP4 for File Format. (I will be discussing these formats for cameras sold in the United States and other areas that use the NTSC video system, which uses the 1080 60i format. Cameras sold in Europe and other areas that use the PAL video system will have different options, although they can be switched to use NTSC video formats using the PAL/NTSC Selector option on the Setup menu, as discussed in CHAPTER 7.)

If you choose AVCHD, the five choices for Record Setting are 60i 24M(FX), 60i 17M(FH), 60p 28M(PS), 24p 24M(FX), and 24p 17M(FH), as shown in FIGURE 8-3. In each case, the number 60 or 24 stands for the number of video fields or frames recorded per second. (Cameras sold in countries using PAL video rather than NTSC use 50i and 50p formats instead of 60i and 60p.)

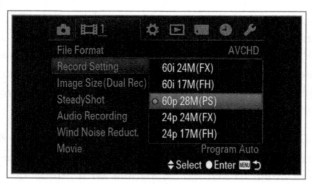

Figure 8-3. Record Setting Menu Option for AVCHD

60i and 60p Video Formats

First, I will discuss the three formats using 60 fields, or frames per second. The letter that comes after the number 60, either "i" or "p," stands for interlaced or progressive. With interlaced video, the camera records 60 fields per second; a field is equal to one-half

of a frame, and the two halves are interlaced together to form 30 full frames. The video frame rate of about 30 frames per second (fps) is the standard video playback rate in the United States.

If the letter is "p," for progressive, that means that the camera records 60 full fps, which yields higher quality than interlaced video. The 60 frames are later translated into 30 frames for playback at the standard rate of 30 fps. However, if you want to and your video-editing software has this capability, you can play back your 60p footage in slow motion at one-half the normal speed and still maintain full HD quality. This possibility exists because, as noted above, the 60p footage is recorded with twice the number of full frames as 60i footage, so the quality of the video does not suffer if it is played back at one-half speed. (With other video formats, playback at half speed will appear choppy or jerky because not enough frames were recorded to play back smoothly at that speed.) So, if you think you may want to slow down your footage significantly for playback, you should choose the 60p setting.

The next number-letter combination, either 28M, 24M, or 17M, provides the "bit rate," or volume, of video information that is recorded—either 24 megabits per second or 17 megabits per second. Not surprisingly, the higher-numbered settings provide greater quality at the cost of using more storage capacity on the memory card and requiring greater computer resources to edit.

The final designations, FH, FX, and PS, are proprietary labels used by Sony for these various qualities of video. They have no particular meanings; they are just labels for various levels of video quality—PS is the highest, then FX, and then FH.

Choose 60p 28M if you want the highest quality (including slow-motion capability), 60i 24M for excellent quality, or 60i 17M for excellent quality that takes up fewer resources.

24p Video Formats

If you select either of the 24p video formats, your video will be recorded at 24 fps. This is not a substantially slower rate than for

the 60i and 60p formats because the video playback rate in the United States is about 30 fps, and the 60i and 60p formats are converted to about 30 fps for playback. The 24p rate is considered by some people to be more "cinematic" than the 60i and 60p formats. This may be because 24 fps is the standard speed for movie cameras that shoot with film. My personal practice is to use the 60p format, but if you find that 24p suits your purposes better, you have that option with the RX100 II.

MP4 Formats

If, instead of AVCHD, you choose MP4 for File Format, then you are presented with just two choices for Record Setting: 1440 x 1080 12M and VGA 3M, as shown in FIGURE 8-4.

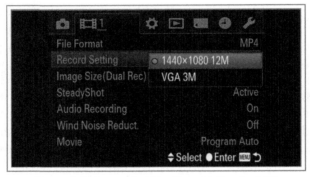

Figure 8-4. Record Setting Menu Option for MP4

For the 1440 x 1080 setting, the numbers represent the numbers of horizontal and vertical pixels in the image. An image with 1440 pixels horizontally and 1080 vertically is considered to be widescreen. The other choice, listed on the menu as VGA, has only 640 x 480 pixels; this format produces images in the shape of traditional computer monitors, which are often designated as VGA, for video graphics array. As you can see from the last numbers for these settings, 12M and 3M, they both have considerably lower data rates than any of the AVCHD settings. Therefore, the quality is not as great as for AVCHD, but the MP4 formats take up less space than AVCHD on a memory card and,

as noted above, are easier to manipulate with a computer and to send by e-mail.

If you decide to choose the MP4 file format, I recommend you always select the 1440 x 1080 setting because the quality of VGA video is very low. You should use that setting only if you have a drastic shortage of space on your memory card or you are recording the video for a purpose that does not require high quality, such as making a record of household possessions for an inventory.

You also should recall that because of a 2 GB limitation on file size, the RX100 II can record only 15 minutes of MP4 in the HD format (1440 x 1080) in one continuous file. Of course, you can record any number of 15-minute segments, up to the storage limits of your memory card.

Image Size (Dual Recording)

The next item on the Movie menu is different from the other settings because it does not control the appearance or nature of your videos. Instead, this option sets the image size for still images that you capture while the camera is recording a video. The RX100 II has an excellent capability in this regard. After you have pressed the red Movie button to start a video recording, you can, while the video is being recorded, press the camera's Shutter button to take a still picture without interrupting the movie recording. This function works very well, though it is not available when the Record Setting option is set to 60p 28M(PS). However, for every other video setting it works well.

There are two choices for the Image Size (Dual Recording) option, which vary depending on what video setting you select. For all video settings other than the MP4-VGA setting, the choices are L: 17M and S: 4.2M, as shown in FIGURE 8-5.

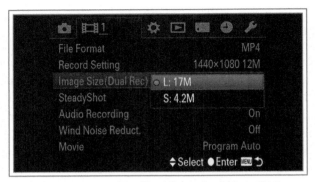

Figure 8-5. Image Size (Dual Recording) Menu Option

The Large option is suitable for printing at large sizes, including A3 (297 by 420 mm) or 11 by 17 inches; the Small option is best only for smaller prints or for viewing on a TV screen.

If you have selected the MP4-VGA setting, the choices for Image Size for the still image change to L: 13M and S: 3.2M. The printing considerations for these image sizes are the same as for the larger sizes, except that the quality will be reduced somewhat.

My recommendation is to always choose the Large setting for this menu option unless you want the still image only for a technical record or some other non-critical purpose.

SteadyShot

The SteadyShot item on the Movie menu, shown in Figure 8-6, is somewhat different from the same-named option on the Shooting menu that applies only for still photography.

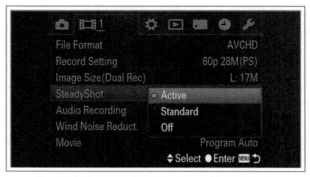

Figure 8-6. SteadyShot Option on Movie Menu

The Movie menu version provides three options: Off, Standard, and Active; whereas, the Shooting menu version of SteadyShot is limited to being turned on or off. With the Movie menu option, if you select Standard, the camera uses the same optical stabilization system used for shooting stills. If you select Active, the camera also uses an additional electronic stabilizing system that can compensate for unwanted camera movement to some extent. With this feature, the camera will crop out parts of the image at the edges to compensate for the required processing of the image.

If you are using a tripod, as I recommend for all movie shooting whenever possible, you probably should set the SteadyShot option to Off. If you are hand-holding the camera, I advise you to use the Active setting. I would use the Standard setting only if you find that the Active setting does not provide good results or if you object to the cropping that results from using this setting.

Audio Recording

The Audio Recording item on the Movie menu can be set either on or off. If you are certain you won't need the sound recorded by the camera, then you can turn this option off. I would never turn it off because you can always turn down the volume of the recorded sound when playing the video, or if you are editing the video on a computer, you can delete the sound and replace it as needed—but you can never recapture the original audio after the fact.

Wind Noise Reduction

This option activates an electronic filter designed to reduce the volume of sounds in the frequencies of wind noise. Here, again, as with the previous item, I recommend not using this feature unless you are certain it will help because you are reducing the sounds that are recorded. With video (or audio) editing software, you can remove sounds in the frequencies that may cause problems for the sound track, but using the camera's built-in wind noise filter may permanently remove or alter some wanted sounds.

Movie (Exposure Mode)

The final item on the Movie menu, some-what confusingly called simply Movie, is one of the most important options for advanced video shooting with the RX100 II because it lets you choose an exposure mode, giving you control over aperture and shutter speed. This menu item is not available for selection except when the camera's Mode dial is set to Movie mode, represented by the movie-film icon, as shown in Figure 8-7.

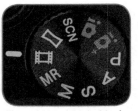

Figure 8-7. Movie Mode

In all other shooting modes, this menu option is dimmed and cannot be selected.

When the camera is set to Movie mode, the Movie option on the Movie menu gives you the ability to select an exposure mode for shooting movies. If you have the Mode Dial Guide option turned on through the first screen of the Setup menu, the choices for the Movie menu item, as shown in Figure 8-8, will appear automatically when you select Movie mode with the Mode dial and then press the Center button after the initial Mode Dial Guide screen appears.

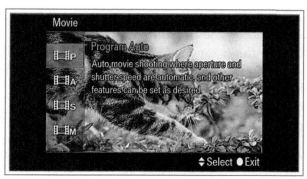

Figure 8-8. Movie Exposure Mode Choices on Movie Menu

If you do not have the Mode Dial Guide option turned on, then this menu screen will not appear unless you select it from the Movie menu. Navigate to the Movie menu and select the bottom item, Movie, and the same screen will appear with its four options: Program Auto, Aperture Priority, Shutter Priority, and Manual Exposure, as shown in FIGURE 8-8. Move through these choices by turning the Control wheel or pressing the Up and Down buttons. Following are details about the behavior of the RX100 II when shooting movies with each of these settings.

Program Auto

With the Program Auto setting, the RX100 II handles video recording the same way it does when it is set to any of the more advanced modes for still photography—Program, Aperture Priority, Shutter Priority, or Manual Exposure. In other words, the camera sets the aperture and shutter speed according to its metering system, and it uses the several settings from the Shooting menu that carry over to video recording, including ISO, White Balance, Metering Mode, Face Detection, and DRO.

With one caveat, noted below, I don't recommend using this setting. It doesn't provide any options beyond those that are available when the camera is set to a still-shooting mode, such as Intelligent Auto, Program, Aperture Priority, or Shutter Priority. And it has the disadvantage that the Mode dial must be set to the

Movie mode. In that mode, you cannot shoot still images, unless you take one during the recording of a video. So, if you want to shoot movies with the camera making all of the exposure decisions for you, I recommend that you set the camera to the Intelligent Auto or P position on the Mode dial. With that setup, you have the option of taking still images with the settings you want, and you still can press the red Movie button at any time to record a video.

The one exception to this recommendation is if you use the Movie Button option on the third screen of the Custom menu to lock out the functioning of the Movie button unless the camera is set to Movie mode. You might want to do that to avoid accidentally recording a movie by pressing the Movie button inadvertently. If you have made that setting, then, of course, you cannot start recording a movie unless the camera is set to Movie mode. In that situation, you may want to have the Movie (exposure mode) menu option set to Program Auto, so you can turn the Mode dial to Movie mode and start recording a movie with automatic exposure in effect.

Aperture Priority

With this setting for Movie mode, you are able to set the aperture, just as in the same-named mode for shooting still images, and the camera will set the shutter speed based on the exposure metering. There are some important differences to how the camera operates in this mode for recording videos, though. You still can set the aperture anywhere from the fully open f/1.8 to the most narrow f/11.0 depending on the zoom level. However, when the video format is set to 60p or 60i, the camera will never set the shutter speed slower than 1/60 second in Aperture Priority mode. With the 24p formats, the shutter speed will not become slower than 1/50 second. With the MP4 formats, the slowest shutter speed available is 1/30 second. (These shutter speed limitations correspond to the frame rates of the video formats; allowing slower shutter speeds could result in unnaturally blurry or distorted video.)

Also, it is important to note that the ISO setting when shooting movies cannot be higher than 3200. As a result, the low-light performance of the RX100 II for video is somewhat limited. However, if you set the aperture at f/1.8 and ISO to Auto ISO with an upper limit of 3200, the camera will do very well in normal conditions.

Another feature of the RX100 II that is very useful and somewhat unusual for cameras in this class is that you can adjust the aperture during the recording. This may not be something you need to do very often, but it can be useful in some situations. For example, you may be recording at a location with a variety of subjects, such as a garden show, and at some point, you may want to open the aperture wide to achieve a blurred background as you focus on a small plant or other object. Afterward, you may want to close the aperture down to a narrow value to achieve a broad depth of field to keep a large area in focus.

In general, as was discussed in CHAPTER 3, Aperture Priority can be an excellent mode to use when you need to have either a wide depth of field, as when shooting landscapes, or a shallow depth of field, when you want to blur the background.

Shutter Priority

The Shutter Priority exposure mode for movies lets you set the shutter speed, and the camera will set the aperture. Unlike the situation with Aperture Priority mode, in which the camera will not set the shutter speed slower than 1/60 second (for 60i or 60p video formats), you are able to set the shutter speed as slow as 1/4 second in this mode. You can select any shutter speed from that rate all the way to the maximum shutter speed of 1/2000 second. Of course, to expose your video normally at a shutter speed of 1/2000 second, you must have bright lighting or a high ISO setting, or both. Using a fast shutter speed for video can yield a crisper appearance to your shots, especially when there is considerable movement in them, as when shooting sports or other fast-moving events.

With the slower shutter speeds, particularly those below the normal video speed of 1/60 second (equivalent to 60 fps), the footage can become somewhat blurry with the appearance of smearing, particularly with panning motions. If you are shooting a scene in which you want to have a drifting, dreamy appearance that looks like motion underwater, this option may be appropriate. Note, though, that you will not be able to achieve good lip sync at the slower shutter speeds, so this technique would not work well for realistic recordings of people talking or singing.

One interesting point is that you can preview this effect on the camera's display even before you press the Movie button to start recording. If you have the shutter speed set to 1/4 second in Movie mode, you will see any action on the screen looking blurry as if it had already been recorded with this slow shutter speed.

Manual Exposure

The last setting for the Movie item on the Movie menu gives you full control over the exposure of your videos. Just as with the Manual Exposure mode for shooting stills, you can adjust both the aperture and the shutter speed to achieve your desired effect. With video shooting, you can adjust the aperture from f/1.8 to f/11.0, and you can adjust shutter speed from 1/2000 second to 1/4 second. Using these settings, you can create effects such as fades to and from black as well as similar fades to and from white.

For example, if you begin a recording in normal indoor lighting using settings of 1/60 second at f/3.2 with ISO set to 800, you can record your scene, and then when you want to fade out, start turning the Control wheel slowly clockwise increasing the shutter speed smoothly until it reaches 1/2000 second. Depending on how bright the lighting is, the result may be complete blackness. Of course, you can reverse this process to fade in from black.

If you want to fade to white, here is one possible scenario. Suppose you are recording video with shutter speed set to 1/400 second and aperture to f/1.8 at ISO 3200. When you want to start a fade

to white, turn the Control wheel smoothly to the left until the shutter speed decreases all the way to 1/4 second. In fairly normal lighting conditions, as in my office as I write this, the result will be a fade to a bright white screen.

There are, of course, many other uses for Manual Exposure mode when recording videos, such as shooting "day for night" footage, in which you underexpose the scene by using a fast shutter speed, narrow aperture, or both, to turn day into night for creative purposes. Also, you might want to use Manual Exposure mode when you are recording a scene in which the lighting may change, but you do not want the exposure to change. In other words, for creative purposes, you may want some areas to remain in the dark and some to be unusually bright, rather than have the camera automatically adjust the exposure. In some cases, having a constant exposure setting can be preferable to seeing the scene's brightness change as the metering system adjusts the exposure.

To adjust the aperture and shutter speed when shooting videos, you use the same controls as for still images. That is, you adjust both aperture and shutter speed using the Control wheel on the back of the camera and switch between those functions by pressing the Down button. Also, if the Control Ring menu item (on the second screen of the Custom menu) is set to Standard, you can adjust the aperture by turning the Control ring around the lens.

One important point to remember when shooting movies in Manual Exposure mode is that just as with Manual Exposure mode for shooting still images, you cannot set ISO to Auto. You have to set it to a specific value. If it was set to Auto before you select this exposure mode, the camera will set it to the default of 160, which may be fine in bright conditions, but will limit your options if the lighting is dim. Therefore, you may want to reset the ISO to a higher value when recording videos using this exposure mode. I tend to use an ISO of 400 or 800 in most cases, so there is some leeway for adjusting exposure with both aperture and shutter speed.

EFFECTS OF MODE DIAL POSITION ON RECORDING MOVIES

The second type of setting that has an effect on the recording of movies with the RX100 II is the position of the camera's Mode dial. As I discussed above, you can shoot movies no matter what position this dial is set to (if the Movie Button menu option is set that way), and you can get access to the Movie menu no matter what position the dial is in. However, as I also noted above, the shooting mode the camera is set to does make some difference for your movie options. I will provide more details here.

First, as noted earlier, you cannot access the Movie option—the final option on the Movie menu—unless the Mode dial is set to Movie mode. The Movie option, which I would prefer to call Movie Exposure Mode, lets you select one of the four special exposure modes for shooting movies: Program Auto, Aperture Priority, Shutter Priority, or Manual Exposure. In the last three of those modes, you have the ability to set the camera's aperture, shutter speed, or both for movie recording.

Second, the mode the camera is set to has an effect on what options are available on the Shooting menu and with the control buttons, as discussed in the next two sections. For example, if the shooting mode is set to Intelligent Auto, Superior Auto, or Scene, the Shooting menu options are limited. However, if the shooting mode is set to Program, Aperture Priority, Shutter Priority, or Manual Exposure, the options are greater. This point is important for video shooting because, as discussed below, several important Shooting menu options carry over to movie recording. In other words, if the camera is set to Program mode (P on the Mode dial), you are able to make several settings that will control the recording of videos if you press the Movie button to start a recording while the Mode dial is in that position.

Next, I will discuss the details of which Shooting menu options have an effect on the recording of movies.

EFFECTS OF SHOOTING MENU SETTINGS ON RECORDING MOVIES

As I discussed above, one of the factors that affect how the RX100 II handles video recording is the shooting mode the camera is set to using the Mode dial. One of the main reasons the shooting mode is important is that just as with still photography as discussed in CHAPTER 4, some Shooting menu options are not available in some shooting modes. For example, if the camera is set to a mode such as Aperture Priority or Program, video recording will be affected by the current settings for White Balance, ISO, Metering Mode, Face Detection, DRO, Focus Mode, and some others of less importance for movie shooting (such as Shooting Tip List).

Note that all of these settings have to be made before you press the Movie button to start recording the movie, and once the recording is underway, you cannot get access to the menu system to change the settings unless you end the recording. In addition, there are some built-in limitations. For example, the ISO cannot be set any higher than 3200, and not surprisingly, you cannot set ISO to Multi Frame Noise Reduction, which would cause the camera to take multiple shots.

There are some other settings on the Shooting menu that have no effect for recording movies. Some of these settings are clearly incompatible with shooting movies, such as Drive Mode, Flash Mode, and Auto Object Framing. Some are less obvious, including Autofocus Area, Soft Skin Effect, and Write Date. Also note that the Clear Image Zoom and Digital Zoom options cannot be turned on for movie shooting, but there is a twist. Digital Zoom is always active when you are shooting movies; you cannot turn it on, but you also cannot turn it off. I recommend that you be careful to stop zooming before Digital Zoom takes effect because of the image quality reduction.

There are two other settings that are worth some additional discussion. First, the Creative Style setting is available for shooting movies whenever the camera is set to a shooting mode that supports Creative Style (that is, all modes except the Scene and Auto modes). So, for example, if you have been shooting black-and-white still images using the Creative Style setting in Program mode or Sweep Panorama mode, and you then record a movie by pressing the Movie button, your movie will be in black and white.

The situation is somewhat different with the Picture Effect menu option. Here, again, if a Picture Effect setting was selected while the camera was set to a shooting mode that supports this option (all modes other than the Scene, Auto, and Sweep Panorama modes), then, in some cases, that effect will still be active if you press the red button to record a movie. Some of these settings do not work for recording movies. Specifically, only the following Picture Effect settings will carry over to your movies: Toy Camera, Pop Color, Posterization, Retro Photo, Soft High-key, Partial Color, and High Contrast Monochrome. None of the other effects will work for movies; if one of them was set before you press the red button, the camera will turn it off. The effects that do not work for movies are Soft Focus, HDR Painting, Rich-tone Monochrome, Miniature, Watercolor, and Illustration.

There are two other points that should be made about the ability of the RX100 II to use Shooting menu settings for movies while the camera is set to a still-shooting mode. First, on the positive side, you have a great deal of flexibility in choosing settings for your movies, even when the camera is not set to the Movie position on the Mode dial. You can set up the camera with the ISO, Metering Mode, White Balance, Creative Style, Picture Effect (to some extent), and other settings of your choice, and then press the Movie button to record using those same settings. In this way, you could, for example, record a black-and-white movie in a dark environment using a high ISO setting. Or, you could record a movie that is monochrome except for a broad selection

of red objects, using the Partial Color-Red effect from the Picture Effect option, with the red color expanded using the color axis adjustments of the White Balance setting.

Second, on the negative side, you have to be careful to check the settings that are in effect for still photos before you press the Movie button. For example, if you have been shooting stills using the Posterization setting from the Picture Effect menu option and then suddenly see an event that you want to record on video, if you press the Movie button, the movie will be recorded using the Posterization effect, making the resulting footage hard to use as a clear record of the events. Of course, you may notice this problem as you record the video, but it takes time to stop the recording, change the menu setting to turn off the Picture Effect option, and then start recording again, and you may have missed a crucial part of the action you wanted to record by the time you have started recording again.

One way to lessen the risk of recording video with unwanted Shooting menu options is to switch the Mode dial to the Intelligent Auto position (green camera icon) before pressing the red Movie button; that action will cause the camera to use more automatic settings and will disable the Creative Style and Picture Effect options altogether. (Of course, you have to have the Movie Button item on the Custom menu set to Always for this approach to work.)

In fact, shooting movies in the more automatic still-shooting modes, such as Intelligent Auto, Superior Auto, and the Scene mode types, works quite well. You can press the Movie button and record your video in any of those modes. Note, though, that any special aspect of a Scene shooting mode will have no effect on your movies. For example, if you turn the Mode dial to the Scene setting and then select Sunset as the Scene type on the Shooting menu, any movies you record with that setting will not have the emphasis on reddish hues that the Sunset setting gives to still photographs.

EFFECTS OF PHYSICAL CONTROLS WHEN RECORDING MOVIES

The last group of settings that carry over to some extent from still-shooting modes to video recording is the category of functions controlled by the physical controls. In this situation, as with Shooting menu items, there are differences depending on what shooting mode the camera is set to. Some of the behavior of the physical controls is quite variable, and I will not attempt to describe every possible combination of shooting mode and physical control. I will give some examples and discuss the most important settings to be aware of.

For example, consider the behavior of the direction buttons and the Control wheel when the camera is set to the Intelligent Auto shooting mode. When the camera is set to this mode for shooting still images, as discussed in CHAPTER 2, the Down button activates the Photo Creativity feature, and the Left and Right buttons scroll through the various options on the Photo Creativity menu at the bottom of the screen: Background Defocus, Brightness, Color, Vividness, and Picture Effect. Once one of these options is selected, turning the Control wheel or pressing the Up and Down buttons adjusts the value of the setting for that option.

If you press the Movie button to start recording a video in Intelligent Auto mode, and then press the Down button, the camera displays an error message and the button has no effect. However, if you activate one of the Photo Creativity options using the Down button before pressing the red Movie button, then that effect will carry over after you press the red button. For example, if you turn on one of the Picture Effect settings, such as Toy Camera or Posterization, that effect will be active when you press the Movie button, and it will remain in effect while the movie is recorded. And, what is more, if you activated one of those settings (or just called up the Photo Creativity menu) before starting the video recording, then the control slider will appear at the right side of the screen, and it will control the Background Defocus

option even though you may have selected a different option. In that case, you could have both a Picture Effect and the Background Defocus feature being used at the same time while recording your video. See FIGURE 8-9 for an example of this situation.

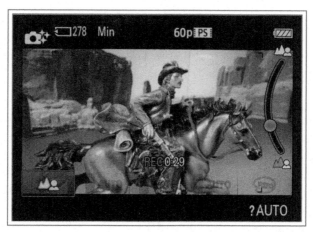

Figure 8-9. Photo Creativity Option in Use While Recording Movie

I don't recommend that you try using any of the settings described above because of the fairly complicated relationships among them. If you want to use a Picture Effect setting while shooting a movie, you should set the camera to Movie mode and select Picture Effect from the Shooting menu. However, it is useful to be aware that some of the settings made with the various physical controls will still operate when the camera is shooting movies, even in the most automatic shooting modes.

Without attempting to catalog the behavior of every physical control in every possible combination of shooting mode with menu options, here are what I consider to be the major points about these controls.

First, you can use exposure compensation while recording movies by pressing the Down button when the Mode dial is set to the P, A, S, M, Movie, or Sweep Panorama setting. (Note that you can use exposure compensation even with the Mode dial set to M

when recording movies, even though you cannot do so for still images. You cannot use exposure compensation in Movie mode when the Movie menu option is set to Manual Exposure, though.) The range of exposure compensation adjustments for movies is only plus or minus 2.0 EV, rather than the plus or minus 3.0 EV that is available when shooting still images. If you set exposure compensation to a value greater than 2.0 (plus or minus), the camera will set it back to 2.0 after you press the red Movie button to start shooting a movie.

Second, the Function button operates normally depending on the shooting mode that is currently set. So, for example, if the camera's Mode dial is set to the P position for Program mode, then after you have pressed the Movie button to start recording a movie, you can press the Function button, and it will bring up the Function Button menu on the screen. This menu will let you control only those items that can be controlled under current conditions, as seen in FIGURE 8-10.

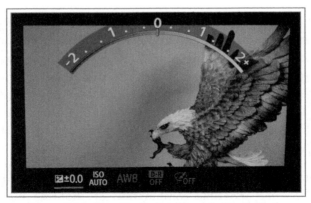

Figure 8-10. Function Button Menu in Movie Mode

If you start recording a movie while the Mode dial is set to a mode such as Superior Auto in which the various functions on the Function Button menu are not available, the RX100 II will display the menu, but none of the items can be selected, as shown in FIGURE 8-11.

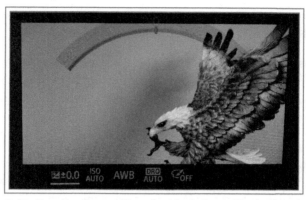

Figure 8-11. Function Button Menu for Movie Recording in Superior Auto Mode

Third, if you assign the Center, Left, or Right button to carry out a particular operation using the Function of Center Button and related options on the Custom menu, you can use that button to perform the operation while recording a movie if the action is compatible with movie recording.

For example, if the Function of Center Button option is set to Standard, you can press the Center button to activate Tracking Focus for shooting movies when the Mode dial is set to any position other than Sweep Panorama. As a matter of fact, you can even use this option in certain varieties of Scene mode in which you cannot use Tracking Focus for shooting stills: Anti Motion Blur, Hand-held Twilight, and Fireworks. This is because when you are shooting movies, the special features of Scene settings are disabled, so the multi-shot or long shutter speed characteristics of these settings do not interfere with the Tracking Focus feature, as they do for still shooting. Of course, to use Tracking Focus, you have to have an autofocus mode selected using the Focus Mode option on the Shooting menu.

If you set the Center button to the AEL Toggle function, you can press that button while recording a movie to lock the exposure setting. This ability can be quite useful when recording a movie,

if you don't want the exposure to change as you move the camera over different areas of a scene.

Other useful functions that can be assigned to the Center, Left, or Right button and that will function during movie recording include AF/MF Control Toggle, Exposure Compensation, Focus Mode, Smile/Face Detection, and ISO.

It is very useful to be able to assign these functions to a direction button because you cannot use the Menu button while recording a video. So, for example, if you want to change the Focus Mode setting while a recording is in progress, you cannot do so using the Shooting menu. However, if you have assigned Focus Mode to the Left or Right button, you can press that button during the recording and change the focus mode. (For videos, the only choices are Continuous Autofocus and Manual Focus.)

Note that a button will activate a feature during a video recording only if that feature is available under the current conditions, including the shooting mode. For example, if you assign the Right button to call up the ISO menu and you press it while recording a video in Intelligent Auto mode, the camera will display an error message because you cannot control ISO in that shooting mode. But if the Mode dial is set to Program mode, the button will call up the ISO menu, and you can set ISO while recording your movie.

Summary of Options for Recording Movies

As I have discussed, there is a considerable degree of complication in trying to explain all of the relationships among the controls and settings of the RX100 II for recording movies. To cut through that complication, here is a summary of your options for recording movies with the RX100 II.

If you just want to record a quick video clip with standard settings, you can leave the Mode dial set to either of the Auto modes or the

Scene position and fire away with the red button. The camera will adjust the exposure automatically, and you can set Focus Mode to Continuous AF or Manual Focus. (If you select Single-shot AF, the camera will use Continuous AF for video recording.) Other menu options cannot be adjusted.

If you want a bit more control over your video shooting, you can set the Mode dial to the P, A, S, or M position. In those cases, you can control several additional Shooting menu options, including ISO, White Balance, Metering Mode, Creative Style, and Picture Effect, among others. You can also choose either Continuous AF or Manual Focus in the same way as for the Auto modes. However, the camera will still adjust the exposure automatically.

If you want the maximum control for movie recording, set the Mode dial to the movie-film icon that represents Movie mode. Then select an option from the Movie item, which is the last item on the Movie menu. If you want to control the aperture, choose Aperture Priority; to control shutter speed, choose Shutter Priority; to control both aperture and shutter speed, choose Manual Exposure. Other options can be selected from the Shooting menu.

Control buttons operate during movie recording if the context permits. The main buttons that will be of use during movie recording are the Down button (Exposure Compensation), Center button (Tracking Focus), and Function button (various options as set by you). You also can assign certain functions to the Center, Left, and Right buttons using the appropriate options on the Custom menu, as discussed earlier in this chapter.

If you want the RX100 II ready to record good, standard video footage at a moment's notice without having to remember a lot of settings, I recommend that you set up one of the three registers (I use Register 3) of the Memory Recall shooting mode with a solid set of movie-recording settings. TABLE 8-1 lists the settings I recommend (settings not listed here can be set however you like).

Table 8-1. Suggested Settings for Recording Movies

Mode Dial	Program Mode (P)
Shooting	**Menu**
Image Size	L: 20M
Aspect Ratio	3:2
Quality	Fine
Focus Mode	Continuous AF
Smile/Face Detection	Off
ISO	ISO Auto
Metering Mode	Multi
White Balance	Auto White Balance
DRO/AUTO HDR	DR Off
Creative Style	Standard
Picture Effect	Off
Movie	**Menu**
File Format	AVCHD
Record Setting	60p 28M(PS)
Image Size (Dual Rec) [1]	L: 17M
SteadyShot	Active
Audio Recording	On
Wind Noise Reduction	Off

(1) The Image Size (Dual Rec) menu option will not be of use if you are using the 60p 28M option for Record Setting, as noted in the table. I listed that setting because it gives the highest quality. If you want to take still images while recording a video, you will have to switch to another option for Record Setting; I recommend using 60i 17M for that purpose.

Movie Playback

As with still images, you have the option of transferring your movies to your computer for editing and playback, or playing them back in the camera, for displaying either on the camera's LCD screen or on a TV when the camera is connected via an optional HDMI cable.

If you want to play your movies in the camera, there is one basic aspect of this camera you need to be mindful of. As I discussed in CHAPTER 6, the RX100 II cannot play both movies and still images in a single sequence; you have to set the camera to play one or the other type of file. In other words, if you scroll through the saved items on your memory card by pressing the Left and Right buttons or by turning the Control wheel, you will see either all still images or all videos, never a mixture. To switch from stills to videos or vice-versa, you need to switch the camera into the proper mode for displaying the selected type of file.

There are three ways to switch the camera between viewing still images and viewing movies. First, you can use the Still/Movie Select option, which is the fourth item on the first screen of the Playback menu. This option lets you choose to view either still images, MP4 videos, or AVCHD videos.

Second, you can make the switch between stills and movies from a playback index screen. To do this, press the Playback button to enter playback mode. Then press the Zoom lever once to the left to bring up an index screen showing four images (if that many exist). Press the Left button to move the highlight into the narrow strip at the far left of the screen. At that point, the camera will display a message at the lower right of the display telling you to press the Center button for the Still/Movie Select option. If you press the Center button, you will get access to that menu option, and you can choose which kind of file to view.

The third, and sometimes the quickest, way to switch playback modes is just to take a still photo by pressing the Shutter button or record a very short video by pressing the red Movie button twice in fairly rapid succession. Either of these actions will automatically switch the camera into the respective viewing mode, for stills or movies. Of course, this method has the disadvantage of cluttering your memory card with unnecessary files, though you can delete them later if you want to.

Once you have selected the proper mode to view your videos, the only files you will see in playback mode will be files of that type. Once the first frame of a video is displayed on the screen, you will see the word "Play" next to an icon representing the Center button, as shown in FIGURE 8-12.

Figure 8-12. Movie Ready for Playback

(If you don't see the Play message, press the Display button to switch to the more detailed information screen.)

Once you press the Center button to start the movie playing, you will see additional icons at the bottom of the screen, as shown in FIGURE 8-13.

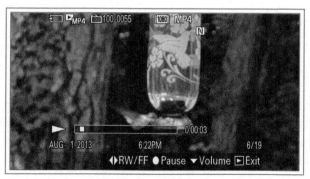

Figure 8-13. Movie Playback Controls on Screen

These icons indicate, from left to right, that you can press the Left/Right buttons for Rewind/Fast Forward; Center button for Pause; Down button for Volume; and Playback button to Exit from the playback. If you press the Down button for the volume control, you can then turn the Control wheel or press the Up and Down buttons to set the volume level. If you press the Center button to pause the playback, you will see a slightly different screen, as shown in FIGURE 8-14.

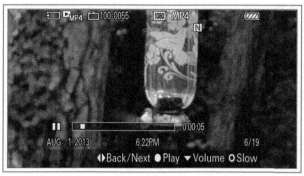

Figure 8-14. Additional Movie Playback Controls

In this case, the icons are the same except the last icon on the right indicates you can turn the Control wheel in either direction to play the movie back slowly, one frame at a time. When you are finished with frame-by-frame playback, press the Center button to

pause, and then press the Center button again to resume normal playback.

Editing Movies

The RX100 II does not have any capability for editing your movies in the camera. If you want to do any editing, you will have to do it with a computer. For Windows, you can use software such as Windows Movie Maker or the PlayMemories Home software that comes with the RX100 II. To install PlayMemories Home on your computer, you need to connect the camera to the computer using the USB cable that comes with the camera and follow the prompts that appear on your computer. (If you do not see the prompts, consult the online Sony Cyber-Shot User Guide, see Appendix C for the link.) This software does not work with Macintosh computers. If you are using a Mac, you will have to use iMovie or any other movie editing software that can deal with MP4 and AVCHD files. I use Adobe Premiere Pro on my Mac, and it handles these files very well.

One issue you may encounter when first starting to edit movie files from the RX100 II is finding the files. When you insert a memory card into a card reader, the still images are easy to find; on my computer, the SD card shows up as No Name or Untitled; then, beneath that level, there is a folder called DCIM; inside it are folders with names such as 100MSDCF, which contain the still images.

The movie files are a bit trickier to find. As I mentioned earlier in this chapter, the AVCHD files that you need to find and import into your software are the files with the .mts extension. Here is the pathway to a sample file, assuming the file name at the level of the SD card is Untitled: Untitled\Private\AVCHD\BDMV\Stream\ 0006.MTS. The file called 0006.MTS is an AVCHD file that can be imported directly into compatible software for editing.

To find your MP4 files, locate the files using a pathway such as Untitled\MP_ROOT\100ANV01\MAH1430.MP4. The file named MAH1430.MP4 is an MP4 file that can be played by Apple's QuickTime software or imported into iMovie for editing.

You can avoid the complications of finding the movie files on a memory card by connecting the camera to your computer using the USB cable. With most video-editing software, the camera should be detected and the software should import the movie files automatically, ready for you to edit them.

Also, of course, with the RX100 II, you can transfer your files to your computer using the Wi-Fi capabilities that are built into the camera, as discussed in CHAPTER 9.

CHAPTER 9:
Other Topics

Connections Using Wi-Fi and NFC

One very useful feature that Sony included in the RX100 II is the camera's ability to connect to computers and other devices using a Wi-Fi network. As noted in CHAPTER 1, you can transfer images wirelessly using an Eye-Fi card or other memory card that includes Wi-Fi connectivity, but having the Wi-Fi circuitry built into the camera gives you features that are not available with a card. In addition, with some devices, the RX100 II can use NFC technology to establish a Wi-Fi connection without going through the steps that are ordinarily required. In this section, I will provide an introduction to these features and give some examples of how you can use them.

First, here is one note to remember when using any of the camera's Wi-Fi features: The Setup menu has an option called Airplane Mode at the top of its fourth screen. If that option is turned on, no Wi-Fi features will work. Make sure that menu setting is turned off when using the Wi-Fi options.

SENDING IMAGES TO A COMPUTER

If you want to print your images on a personal printer, edit them extensively, or organize them for long-term storage, you need to transfer the images to a computer. The traditional way to do this involves connecting the camera to the computer using the

camera's USB cable or connecting a memory card reader to the computer using a USB port and inserting the camera's memory card into the reader for the transfer operation. However, there are two methods you can use to transfer your images to a computer over a wireless network, eliminating the need for any USB connection.

First, as discussed in CHAPTER 1, you can use an Eye-Fi card or a similar memory card with the capability to transfer your images wirelessly to the computer. This system works well, but it requires the purchase and use of this special type of memory card. One drawback of that system is that you cannot use one of the high-capacity or high-speed memory cards that are now available; you must use one of the Wi-Fi–enabled cards.

The other approach for wireless transfer is to take advantage of the Wi-Fi capability that is built into the RX100 II. Once you have the camera and computer set up to communicate over a wireless network, you can use the Send to Computer menu option to transfer images and videos from the camera's memory card over that network, regardless of what type of memory card is installed. The steps to set up the camera and computer are quite straightforward; here are the actions to take:

1. Install the appropriate Sony software on the computer.

 For Windows-based computers, the software is PlayMemories Home, available for download at http://www.sony.net/pm/.

 –or–

 For Macintosh computers, you need to install Wireless Auto Import, available for download at http://www.sony.co.jp/imsoft/Mac/.

2. Make sure the camera is within range of a wireless access point, also known as a Wi-Fi router. Normally, this will be a private, secured network at your home or office.

3. If the router has a button labeled WPS (for Wi-Fi–protected setup), you can use the button to connect. First, select the WPS Push option on the Setup menu, as shown in FIGURE 9-1.

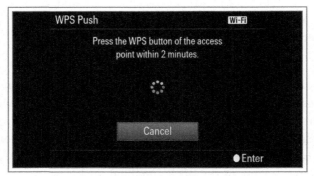

Figure 9-1. WPS Push Menu Option

4. Then, within two minutes, press the WPS button on the router. FIGURE 9-2 shows an example of that sort of button.

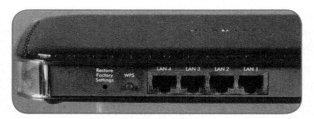

Figure 9-2. WPS Button on Router

If the setup is successful, proceed to STEP 7.

–or–

If the router does not have a WPS button, or if pushing the button does not work, proceed to STEP 5.

5. Locate the name of the network and its password. (This information may be on a label on the bottom or side of the router or modem, particularly if the device is provided by your Internet company, such as Comcast, Verizon, or others.)

6. Select the Access Point Settings option on the third screen of the Setup menu, as shown in FIGURE 9-3.

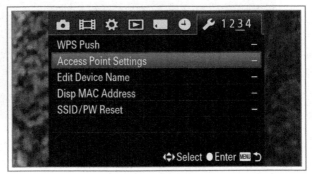

Figure 9-3. Access Point Settings Menu Option

If the name of your network soon appears on the camera's screen, as shown in FIGURE 9-4, enter the network's password, as shown in FIGURE 9-5.

–or–

If the access point does not appear on the camera's screen, manually enter its SSID (service set identifier, the technical term for the network's name), using the Manual Setting option on the menu screen, as shown in FIGURE 9-4, and then enter the network's password, as shown in FIGURE 9-5.

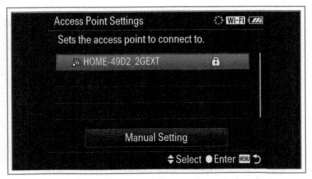

Figure 9-4. Access Point Settings Connection Screen

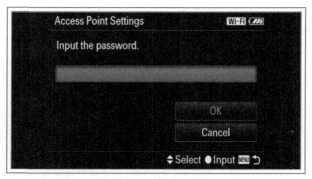

Figure 9-5. Screen to Input Network Password

7. To start sending images from the RX100 II to the computer, first, you have to set the computer as the device to receive images. To do that start up the computer software you downloaded in STEP 1 (PlayMemories Home or Wireless Auto Import). Then connect the camera to the computer using the camera's USB cable, and select the option to designate this computer as the device to receive images from the camera. (That step needs to be done only once, unless you later want to switch to a different device to receive images.) Then you can disconnect the USB cable.

8. Put the camera into playback mode, and then on the Playback menu select Send to Computer, as seen in FIGURE 9-6.

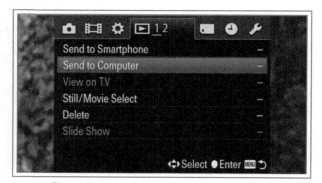

Figure 9-6. Send to Computer Menu Option

9. The camera will display a screen like that in FIGURE 9-7, reporting the name of the computer it is connecting to.

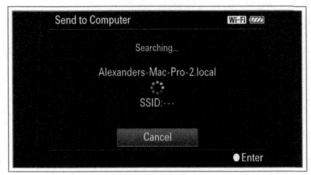

Figure 9-7. Screen When Camera Searching for Computer to Connect To

10. The computer will display an Importing dialog box. The images and videos will be uploaded to the appropriate folder on your computer. (You can designate what folder they are transferred to using the software installed in STEP 1. On my Macintosh, the default folder was the Pictures folder; the computer placed the images in a folder bearing the date of the transfer.) The camera will only transfer images that have not previously been transferred wirelessly to the computer. The transfer may take a long time.

SENDING IMAGES TO A SMARTPHONE

If you don't need to print your images or do heavy editing, you may want to transfer them to a smartphone or tablet, so you can send them to social networks, display them on the larger screen of your tablet, or otherwise share and enjoy them.

You can transfer your images and MP4 videos (not AVCHD videos) wirelessly from the RX100 II to a smartphone or tablet that uses either the iOS (iPhone and iPad) or Android operating system. These two systems have different capabilities. With the iPhone and other iOS devices (such as the iPad), you have to use the camera's menu system to connect, just as with a computer, as

discussed above. With many Android devices, you can use NFC technology, which establishes a Wi-Fi connection automatically when the camera is placed very close to, or touching, the smartphone.

Here are the steps for connecting using the menu system, using an iPhone as an illustration:

1. Install Sony's PlayMemories Mobile app on the phone; it can be downloaded from the App Store for the iPhone and from Google Play for Android devices.

2. Put the camera into playback mode and select an image or MP4 video to be transferred to the phone.

3. On the Playback menu, select Send to Smartphone, and then from that option choose Select on This Device, as shown in FIGURE 9-8. On the next screen, you can choose to transfer This Image, All Still Images (or All Movie (MP4)) on Date, or Multiple Images. (Details of those menu options are discussed in CHAPTER 6.)

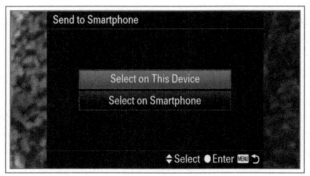

Figure 9-8. Options to Select Images to Send to Smartphone

4. On the next screen, as shown in FIGURE 9-9, the camera will display the SSID (name) of the Wi-Fi network it is generating.

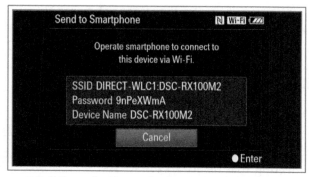

Figure 9-9. Information Screen for Camera's Internal Wi-Fi Network

5. On the iPhone, go to the Settings app, select Wi-Fi, and then select the network that displays on the camera's screen, as shown in FIGURE 9-10. The first time you connect to that network, you will have to enter the password displayed on the camera's screen. After that initial connection, you can connect to that network without entering the password.

6. The camera will then display a message saying "Connecting." At this point, start the PlayMemories Mobile app, shown by the arrow in FIGURE 9-11 on the iPhone.

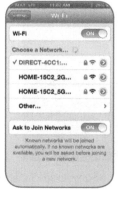

Figure 9-10.
Wi-Fi Screen on iPhone

Figure 9-11.
PlayMemories Mobile App

7. The phone will display a message showing that it is copying the selected images or videos from the camera to the phone, as shown in FIGURE 9-12. The images or videos will appear in the Camera Roll area on an iPhone; you can see them by selecting the Camera app on the phone.

Connecting with NFC

If you are using an Android phone or tablet that has NFC capability built in, the steps for connecting that device to the RX100 II are considerably easier. I tested the procedure using a Sony Xperia Tablet Z, but the same process should work with many Android devices that have NFC included. Here are the steps:

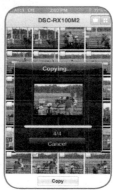

Figure 9-12.
iPhone: Copying
Images

1. On the Android device, go to the Google Play Store and find and install the PlayMemories Mobile app, as shown in FIGURE 9-13.

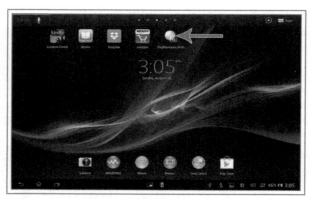

Figure 9-13. PlayMemories Mobile App Icon on Sony Xperia Tablet Z

2. On the Android device, go to the Settings app, and under the Wireless and Networks area, choose More. On the next screen, make sure there is a check mark next to the NFC item, as shown in FIGURE 9-14.

Figure 9-14. NFC Item Checked on Screen of Xperia Tablet Z

3. Put the RX100 II into playback mode and display an image that you want to send to the Android device.

4. Find the NFC icon on the bottom of the camera, which looks like a fancy "N," as shown in FIGURE 9-15.

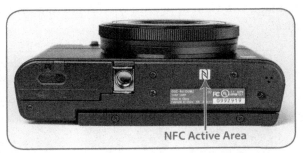

Figure 9-15. NFC Active Area on Bottom of Camera

5. While both devices have their screens active, touch the N on the camera to the similarly marked NFC area on the Android device. (On the Xperia Tablet Z, this area is on the back of the tablet, as shown in FIGURE 9-16.) Be sure these two areas actually touch; the distance tolerance for NFC is tight, and you cannot have the two NFC spots separated by anything more than about a millimeter, if that.

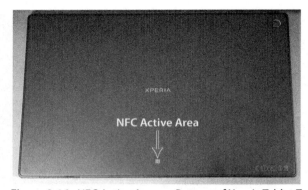

Figure 9-16. NFC Active Area on Bottom of Xperia Tablet Z

6. Hold the devices together without moving them, and within a couple of seconds, you should hear a sound, and the camera will transfer the image to the Android device; you should see a display on its screen announcing that the transfer is complete, as shown in FIGURE 9-17.

7. The image will then appear in the Album app on the Android device.

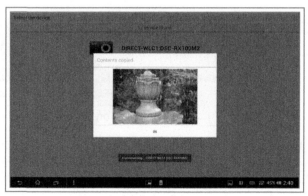

Figure 9-17. Message on Xperia Tablet Z When Image Transfer Complete

If you want to transfer a single image, you can use a simpler method. Just play that image on the camera's display, and then touch the NFC areas of the camera and tablet (or phone) together. The transfer should begin immediately. If the PlayMemories

Mobile app is not already installed on the Android device, the device should display a screen that prompts you to install the app. (I have not tried this with devices other than the Xperia Tablet Z, so I'm not certain it works with all NFC-enabled devices in the same way.)

By default, when you transfer images to a smartphone or tablet, the maximum image size will be 2 MP. That is, if the image originally was larger than that, it will be reduced to that size. You can change this setting to send the images at their original size or at the smaller VGA size, if you want. To do that on your device, find the settings for the PlayMemories Mobile app. (On an iPhone, go to Settings, then scroll to find PlayMemories Mobile. On an Android device, open PlayMemories Mobile, then tap the Settings icon.) If the images were taken with Raw quality, they will be converted to JPEG format before being transferred to the smartphone or tablet, even if the device is set for transfer at the original size.

USING A SMARTPHONE OR TABLET AS A REMOTE CONTROL

You can use a smartphone or tablet as a remote control to operate the RX100 II in a few limited ways from a distance of up to about 33 feet (10 meters), as long as the devices are in sight of each other. Here are the steps to do this with an iPhone:

1. On the first screen of the camera's Shooting menu, select Control with Smartphone, as shown in FIGURE 9-18. The camera will display a screen with the identification information for its own Wi-Fi network, as shown in FIGURE 9-19. (You can assign Control with Smartphone to the Left or Right button on the Control wheel for quicker access to this menu option.)

Figure 9-18. Control with Smartphone Menu Option

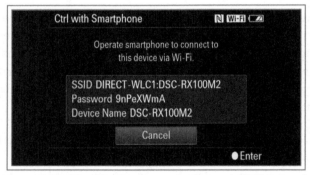

Figure 9-19. Identification Screen for Camera's Wi-Fi Network

2. On the phone, go to the Wi-Fi tab of the Settings app, and select the network ID displayed by the camera, as shown in FIGURE 9-20. If this is the first time you are making this connection, you will have to enter the network password on the phone; you will not have to enter the password for future connections unless the network ID is changed.

Figure 9-20.
Wi-Fi Screen
on iPhone

3. The camera will display a screen like that shown in FIGURE 9-21, announcing that the camera is now being controlled by the phone, and you cannot control the camera with its own controls.

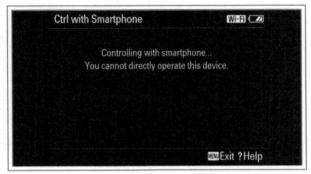

Figure 9-21. Message Displayed When Camera Controlled by Smartphone

4. Set up the camera on a tripod or just place it where you want it aiming at your intended subject.

5. Open the PlayMemories Mobile app on the iPhone, as shown in FIGURE 9-22.

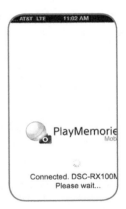

Figure 9-22.
PlayMemories Mobile App

6. After a few seconds, the phone will display a screen like that in FIGURE 9-23, with the view from the camera's lens and several control icons.

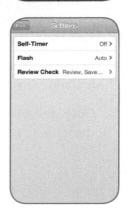

Figure 9-23.
Camera Controls on iPhone

7. Using these controls, you can zoom the lens in and out and switch between still and movie modes. In addition, for still images only, you can use the settings icon and its sub-menu to control the self-timer, flash, and options for reviewing and saving the images on the phone, as shown in FIGURE 9-24.

Figure 9-24.
iPhone Controls for Stills

8. If you select Review—Save Image, the image will display on the phone after you take it and will be saved on the phone as well as on the camera. If you select Review Only, the image will appear on the phone's screen for review only, and it will be saved only to the camera. If you select Off, the image will not display on the phone's screen, but it will still be saved to the camera.

9. By default, images saved to the phone will be resized down to 2 MP unless they already were that small or smaller. Movies will be saved only to the camera; they cannot be displayed or shown on the phone.

10. When you have set up the shot as you want it, press the camera icon to take the picture.

If you are using an Android device with NFC capability, you can connect to the camera by touching the device to the camera, as discussed above in connection with transferring images. Once the connection has been made, you can separate the devices to the standard remote-control distance of up to about 33 feet (10 meters). The camera can then be controlled using the PlayMemories Mobile app on the Android device, as noted in the numbered steps above.

Obviously, the remote-control function using Wi-Fi is quite limited. You cannot use any menu settings at all; the camera will shoot as if in Intelligent Auto mode. You can control only the zoom level, flash (turning it off or setting it to Auto), and self-timer, apart from the review and saving options. So, for example, even if you have the camera set to Aperture Priority mode with a Picture Effect such as Posterization selected, the camera will take a picture with no special effect, just as if it were set to Intelligent Auto mode. If you have the camera set for manual focus, though, the manual focus setting will not be changed by the camera when you take the picture.

Despite its considerable limitations, this wireless remote capability is quite useful for certain situations.

For example, you can use this setup if you want to place your camera on a tripod in an area where birds or other wildlife may appear, so you can control the camera from a distance without disturbing the animals. (The wireless remote will work through glass if you are indoors behind a window.) I used this system to take some video of hummingbirds at a bird feeder; the setup and the video can be seen at http://youtu.be/SgGwkbVDJhg.

Also, you might want to try pole aerial photography, which involves attaching the camera to a painter's pole or other pole about 10 to 16 feet (3 to 5 meters) tall, as shown in FIGURE 9-25, to get shots from a higher vantage point than would otherwise be possible.

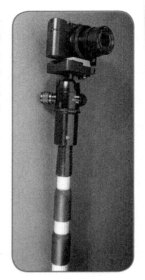

Figure 9-25.
RX100 II Attached to Pole

I took the image shown in FIGURE 9-26 using this pole, which allowed me to get a shot from directly above a fountain.

Figure 9-26. Image Taken Remotely with Camera on Pole

I controlled the camera using my iPhone. With this system, I could see exactly where the camera was being aimed. I had some difficulty holding the pole steady while using the iPhone, but if you have another person to assist, this setup can be helpful for higher-angle photos of properties being sold, viewing above crowds, and other

applications. Being able to control the camera remotely also might be useful in other situations in which you want to have the camera set up unattended, such as when you want to capture images in a classroom or other group setting without calling attention to the camera.

Macro (Closeup) Shooting

Macro photography is the art or science of taking photographs when the subject is shown at actual size (1:1 ratio between size of subject and size of unenlarged image) or slightly magnified (greater than 1:1 ratio). So, if you photograph a flower using macro techniques, the image on the camera's sensor will be about the same size as the actual flower. You can get wonderful detail in your images using macro photography, and you may discover things about the subject you hadn't noticed before taking the photograph.

There are several ways to take macro photographs with the RX100 II. First, you can set the Mode dial to the Scene mode setting and select the Macro option, as shown in FIGURE 9-27.

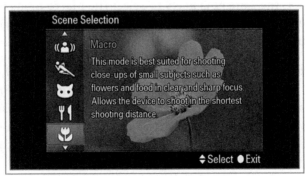

Figure 9-27. Macro Setting of Scene Mode

With this setting, as discussed in CHAPTER 3, the camera will be set up for good closeup shots, and you can still make a number of advanced settings, including choosing Raw or Raw & JPEG for the Quality setting. However, you will not be able to select several

other important Shooting menu items, including Continuous Shooting, Autofocus Area, ISO, White Balance, Metering Mode, Creative Style, and others. I took the shot of the flower in FIGURE 9-28 using this setting. The camera exposed the image for 1/640 second at f/5.0 using ISO 160.

Figure 9-28. Image Taken Using Macro Setting of Scene Mode

Another way to take close-ups is to set the camera to the Intelligent Auto or Superior Auto mode, in which case, when you get close to the subject, the camera is likely to select the Macro mode using its Scene Selection technology. Here, again, you will likely get good results, but you will not be able to make advanced settings.

The best way to take macro shots with the RX100 II, in my opinion, is to use one of the advanced shooting modes—Program, Aperture Priority, Shutter Priority, or Manual Exposure. In that way, you will have the full range of Shooting menu options available. Also, depending on the subject, you can choose a shooting mode that makes the most sense.

For example, if you are photographing flowers or other items that are not moving significantly, you may want to use Aperture Priority for one of two reasons: so you can use a wide aperture to focus sharply on the subject while blurring the background, or so you can use a more narrow aperture to get the whole subject in

focus, with expanded depth of field. In other cases you may prefer to use another shooting mode.

I took the shot in Figure 9-29 using Manual Exposure mode with a shutter speed of 1/250 second, aperture of f/11.0, and ISO set to 100. I wanted good depth of field with a narrow aperture, I wanted to maximize image quality with a low ISO setting, and I was using off-camera flash, so I could not rely on the camera's automatic exposure system.

Figure 9-29. Macro Example: Manual Exposure Mode

There is one aspect of the RX100 II's focusing system that makes macro photography particularly easy: there is no special "macro" focusing mode, as there is on many other cameras. If you just set the camera to one of its autofocus modes—either Single-shot AF or Continuous AF—it will focus on objects as close as 2 inches (5 cm) when the lens is zoomed out and as close as 22 inches (55 cm) when the lens is zoomed in to its maximum telephoto range.

You don't have to use any autofocus setting at all to take macro shots if you don't want to; if you set the camera to manual focus, you can focus on objects very close to the lens. You do, however, lose the benefit of automatic focus, and it can be tricky finding the correct focus manually. If you use the DMF setting, though, you have the ability to check your manual focusing by

pressing the Shutter button halfway and having the camera use its autofocus system. You also can take advantage of the several excellent aids to manual focusing that the RX100 II provides: Peaking, MF Assist, and the Focus Magnifier option, discussed in CHAPTER 4 and CHAPTER 7.

When shooting extreme close-ups, you should use a tripod if possible because the depth of field is very shallow and you need to keep the camera steady to take a usable photograph. It's also a good idea to take advantage of the 2-second self-timer setting. If you take the picture using the self-timer, you will not be touching the camera when the shutter is activated, so the chance of camera shake is minimized. You also can use Sony's wired remote control, discussed in APPENDIX A.

If you need artificial illumination, consider using some sort of diffuser over the built-in flash, such as a handkerchief or piece of translucent plastic. Using the flash without some diffusion is likely to result in uneven illumination at such a close range. You might consider using a small lamp that can illuminate the subject without overwhelming it. Another approach is to use off-camera flash triggered by a radio transmitter or optical slave system with a softbox to diffuse the light, as discussed in APPENDIX A.

Using Raw Quality

I've discussed Raw a couple of times. Raw is an available setting for Quality on the Shooting menu. It applies only to still images, not to movies. When you set the image type to Raw, as opposed to JPEG, the camera records the image without any in-camera processing; essentially, it just takes in the "raw" data and records it.

There are both advantages and drawbacks to using Raw in this camera. First, the drawbacks. A Raw file takes up a lot of space on your memory card, and if you copy it to your computer, it takes up a lot of space on your hard drive. Second, there are various functions of the RX100 II that won't work when you're using Raw.

The menu options that don't work with Raw mode include Image Size, Soft Skin Effect, Auto HDR, Picture Effect, Clear Image Zoom, Digital Zoom, High ISO Noise Reduction, and Write Date. In addition, you cannot use Raw quality with the Sweep Panorama mode, and you cannot use the DPOF feature to mark Raw images for printing directly from a memory card.

The main advantage is that Raw files give you an amazing amount of control and flexibility with your images. When you open up a Raw file (those from this camera have an .arw extension) in a compatible software program, the software gives you the opportunity to correct problems with exposure, white balance, contrast, color tints, and other settings.

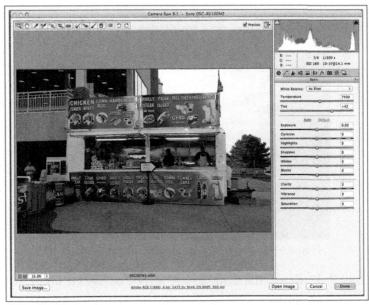

Figure 9-30. Image Being Opened in Adobe Camera Raw

For example, the image in FIGURE 9-30 is shown as it is being opened in Adobe Camera Raw before being opened in Photoshop. On the right side of the image, you may be able to see the broad

range of control sliders available for adjusting various aspects of the image before it is even opened in Photoshop for editing.

If you had the aperture of the camera too narrow when you took the picture and it looks underexposed, you can manipulate the Exposure slider in the software and recover the image to a proper exposure level. Similarly, you can adjust the white balance after the fact and correct color tints. You can even change the amount of fill lighting. In effect, you get a second chance at making the correct settings, rather than being stuck with an unusable image because of unfortunate settings when you pushed the Shutter button.

For example, FIGURE 9-31 is an image I took with the RX100 II using the Raw format, with the exposure purposely set much too dark and the white balance set to Incandescent, even though I took the picture outdoors on a sunny day.

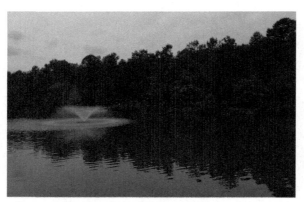

Figure 9-31. Raw Image Taken with Incorrect Settings

FIGURE 9-32 shows the same image after I opened it up in Adobe Camera Raw software and adjusted the settings to correct the exposure and white balance. The result was an image that looked just as it would have if I had used the correct settings when I shot it.

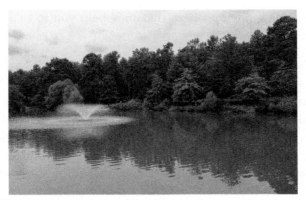

Figure 9-32. Raw Image After Settings Corrected in Software

The drawbacks of using the Raw format are either not too severe or they are counterbalanced by the great flexibility Raw gives you. The large file size may be inconvenient, but the increasing size of hard drives and SD cards with steadily dropping prices makes file size less of a concern than previously.

I have had problems with Raw files not loading when I didn't have the latest Camera Raw plug-in for Adobe Photoshop or Photoshop Elements, but with a little effort, you can download an updated plug-in and the software will then process and display your Raw images. Sony provides users of the RX100 II with Image Data Converter, a computer program for processing Raw files and converting them to JPEG or other formats that you can use for sending photos by e-mail and manipulating them with editing software. The bottom line is you certainly don't have to use Raw, but you may be missing some opportunities if you avoid it.

Low-Light Photography

The RX100 II is equipped with a generous assortment of features for taking still images and movies in dimly lighted environments. With so many options, it sometimes can be confusing to decide which ones may work best in a particular situation. I am going to

provide some guidelines here that may help you in making such decisions.

First, it's worth noting some aspects of the RX100 II that make it so well suited for this sort of photography. The camera's lens has a maximum aperture of f/1.8, which is quite "fast" for a camera in this class. In other words, this aperture is a relatively wide one that lets in a lot of light. Because the aperture lets in a good deal of light, the camera is able to use relatively fast shutter speeds. The result is that the RX100 II can stop action in fairly dim light by using shutter speeds of 1/30 second or faster, thereby avoiding the blurry images that come from using slow shutter speeds.

In addition, the RX100 II, with its back-side illuminated sensor, has a broad range of high ISO values available, up to ISO 3200 in all situations (that is the upper limit for movies), up to 12800 for still images, and up to a stratospheric 25600 in limited cases. The image quality at ISO 3200 and above may suffer because of the noise that results from such high ISO settings, but the images can be quite usable.

Finally, the RX100 II has several special settings for use in dim light. When the Mode dial is turned to the Scene position, you will find several options for low-light photography: Anti Motion Blur, Night Scene, Hand-held Twilight, and Night Portrait. (The Night Portrait setting involves the use of flash, but it is included here because it involves low-light conditions.) You also can set the Mode dial to the Superior Auto position in which the camera may automatically use one of the above settings as conditions dictate.

Apart from shooting modes designed for dim light, the RX100 II has a special ISO setting, Multi Frame Noise Reduction, that is actually more like a shooting mode than an ISO setting. With this feature, the camera takes a rapid burst of exposures at ISO settings up to 25600 and combines those shots internally to create a single composite image with reduced noise. Using this

special setting is the only way to directly set ISO above 12800 with the RX100 II.

Now that I have mentioned the special features of the RX100 II that make it an excellent camera for low-light photography, I will provide some guidelines for using these features. For this discussion, I will assume that you are not going to use flash or other artificial lighting (except when the camera needs flash for a special night setting, as discussed below).

I also will assume that you are not going to use one of the more advanced shooting modes, such as Program or Shutter Priority. (If you do use one of those modes, you can make several settings that will affect your low-light images, including shutter speed, ISO, and Long Exposure Noise Reduction.) Instead, I will assume that you are going to choose one of the shooting modes designed specifically for low-light shooting.

First, if you can use a tripod for a particular shot, you should consider using the Night Scene setting of Scene mode. With this option, the camera will use a low ISO value to maximize image quality and reduce noise, and it will take a long exposure if necessary.

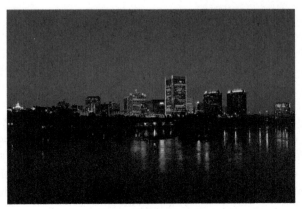

Figure 9-33. Night Scene Example

For example, in FIGURE 9-33, using this setting, the RX100 II exposed the image for 0.5 second at f/1.8 with an ISO setting of 160. The picture was taken well after dark using a tripod because I could not have held the camera steady during that long exposure.

Second, you may have a situation in which you are taking a portrait when the lighting is very dim. With the Night Portrait setting of Scene mode, the camera will use the flash for the portrait, and it will set the flash mode to Slow Sync, so the ambient lighting will have a chance to light up the background, as shown in FIGURE 9-34.

Figure 9-34. Night Portrait Example

In this case, the RX100 II used a shutter speed of 1/5 second to allow the background to be visible, with an aperture of f/3.2 and a low ISO of 160 to avoid noise.

Third, you may have a situation in which the lighting is dim, but you cannot use a tripod or flash, and you want to record the scene as clearly as possible. For this sort of shot, you have several options with the RX100 II. These were discussed in CHAPTER 3 and CHAPTER 4, but I will mention them again to provide a brief comparison.

If you turn the Mode dial to the SCN position, you have three options for handheld use without flash in dim lighting: Anti Motion Blur, Hand-held Twilight, and High Sensitivity. If you choose Anti Motion Blur, as in FIGURE 9-35, the RX100 II will set the ISO as high as necessary to allow the use of a relatively fast shutter speed, so it can avoid motion blur.

Figure 9-35. Anti Motion Blur Example

The camera takes six shots that it combines into a single image to reduce noise; therefore, this setting does not work well with subjects in rapid motion, which could change positions while the six shots are being taken. For scenes with moderate motion, however, the camera is able to reject the images with the most motion blur, thereby optimizing the final composite image. In the example shown here, which was taken after sunset but with some light still coming from the sky, this setting worked well. The camera boosted the ISO to 2500 and therefore was able to use a fast shutter speed of 1/250 second.

With the Hand-held Twilight setting, as seen in FIGURE 9-36, the camera places more emphasis on image quality and therefore will

use a slower shutter speed, so it can use a lower ISO and minimize image noise.

Figure 9-36. Hand-Held Twilight Example

Again, the camera combines six shots into one, so this setting works best for still or slow-moving subjects. In my experience, this setting works well when there is a fair amount of ambient lighting. For example, in the image shown here, the light areas of the building are quite visible, but details get lost in the shadows. The camera used an ISO of 800 with a shutter speed of 1/80 second at f/4.9.

The third scene type for this situation is High Sensitivity. With that option, the camera is likely to set the ISO level quite high. In FIGURE 9-37, shot on the street after sunset, the camera boosted the ISO to 3200 and exposed the image for 1/60 second at f/3.5. With such a high ISO level, there was sufficient ambient light to bring out the details throughout the scene.

With this setting, the camera does not try to avoid using a slow shutter speed if needed to expose the image well. In this case, the camera takes only a single shot, rather than combining multiple images as it does with Anti Motion Blur and Hand-held Twilight. Therefore, this setting can work for moving subjects, as long as there is sufficient light for the camera to use a relatively fast

shutter speed. Because of the enhanced sensitivity of the sensor in the RX100 II, I have found that the High Sensitivity setting is an excellent one to use for street photography in dim lighting. You cannot use special settings such as Creative Style, so you cannot capture images in black and white using this setting. However, you can always convert your images to black and white later using Photoshop, Lightroom, or some other editing program.

Figure 9-37. High Sensitivity Example

Finally, there is one more special setting to consider for use in dimly lit environments—the Auto ISO Multi Frame Noise Reduction setting. This option, which was discussed in CHAPTER 4 in connection with the ISO menu item, is not a shooting mode, though it acts like one to some extent. When you make this choice on the ISO menu, the camera will let you set the ISO anywhere from 200 all the way up to the expanded setting of ISO 25600. As the setting's name implies, the camera takes six shots and combines them to reduce the noise that results from high ISO settings. In FIGURE 9-38, I used this setting with the ISO set to 3200; the image was captured at f/4.9 with a shutter speed of 1/100 second.

The potential advantage of using this option is that it is selected from the Shooting menu when the camera is set to one of the more advanced shooting modes such as Program or Shutter Priority. Therefore, many of the other choices on the Shooting menu are available for selection, including White Balance, Metering Mode, and Creative Style. So you might want to use this setting when the lighting is so low that you need the highest possible ISO settings or when you need to make other settings, such as Creative Style and the others available on the Shooting menu. (You cannot use the Raw quality or Picture Effect options with this setting, however.)

Figure 9-38. Multi Frame Noise Reduction Example

For FIGURE 9-38, taken after sunset, I had the RX100 II set to Multi Frame NR setting, with an ISO value of 3200. The camera exposed this shot at f/4.9 with a shutter speed of 1/100 second. Even though the camera took six shots to create the composite image, it managed to capture the scene without noticeable motion blur because the multiple shots were taken in very rapid succession.

To summarize, TABLE 9-1 has suggested guidelines for using the various special settings for low-light shooting.

Table 9-1. **Suggested Guidelines for Low-Light Shooting Modes**

Night Scene	High image quality with use of a tripod.
Night Portrait	Portrait using flash, with background illuminated through use of slow shutter speed.
Anti Motion Blur	Takes multiple shots using higher ISO; results in good, clear exposure for non-moving objects; also reduces motion blur for subjects in moderate motion.
Hand-held Twilight	Takes multiple shots using lower ISO; more emphasis on image quality for non-moving objects.
High Sensitivity	Can use high ISO and slow shutter speed; takes only a single shot, so can be used with moving objects in brighter light.
High ISO Multi Frame Noise Reduction	Can use ISO as high as 25600; takes multiple shots; allows use of advanced settings from Shooting menu.

Street Photography

Many users find the RX100 II well suited for street photography—that is, for shooting candid pictures in public settings, often without the subject being aware of your activity. The camera has several features that make it well suited for this type of work. It is small, lightweight, and unobtrusive in appearance, so it can easily be held casually or hidden in the photographer's hand. Its 28mm equivalent wide-angle lens takes in a broad field of view, so you can shoot from the hip without framing the image carefully on the screen. You can tilt up the LCD screen and look down at it to frame your shot, which further hides your actions. The f/1.8 lens lets in plenty of light, and it performs well at high ISO settings, so you can use a fast shutter speed to avoid motion blur. You can silence the camera by turning off its beeps and shutter sounds.

As far as guidelines for street photography settings are concerned, I will give you some suggestions as a starting point. The settings you use depend in part on your style of shooting, such as whether you will talk to your subjects and get their agreement to be photographed before you start shooting, or whether you will fire away from some distance with the camera at your waist and hope you are getting a usable image.

One technique that some photographers use is to shoot in Raw, and then use post-processing software such as Photoshop or Lightroom to convert their images to black and white, along with any other effects they are looking for, such as extra grain to achieve a gritty look. (Of course, you don't have to produce your street photography in black and white, but that is a common practice.) If you decide to shoot using Raw quality, you can't take advantage of the various image-altering settings of the Picture Effect menu option. You can, however, use the Creative Style option on the Shooting menu. You might want to try using the Black and White setting; you can tweak it further by increasing contrast and sharpening if you want. (Of course, you may prefer a different look, so try reducing contrast and sharpening if that effect appeals to you.)

You also can experiment with your basic exposure settings. I recommend you shoot in Shutter Priority mode at a fairly fast shutter speed, 1/100 second or faster, to stop action on the street and to avoid blur from camera movement. You can set ISO to Auto, or use a high ISO setting, in the range of 800 or so, if you don't mind some noise. Or, you can rely on the more automatic settings. For FIGURE 9-39, I used Program mode because I didn't have much time to make settings as this runner approached me on a pedestrian bridge. There was plenty of light, and the camera took the image at 1/500 second, using ISO 160 at f/4.9. I had Creative Style set to Black and White.

Figure 9-39. Street Photography Example

In the alternative, you can set the image type to JPEG at Large size and Fine quality to take advantage of the camera's image-processing capabilities. To get the gritty "street" look, try using the High Contrast Monochrome setting of the Picture Effect item on the Shooting menu, with ISO set somewhat high, in the range of 800 or above, to include some grain in the image while boosting sensitivity enough to stop action with a fast shutter speed. Or, as discussed earlier in this chapter, consider using the High Sensitivity setting, which I have found to be excellent for capturing detail and stopping action in dim light. FIGURE 9-40 is another example of using that setting after dark; the image was shot using ISO 3200 with an exposure of 1/160 second at f/4.9.

Figure 9-40. Street Photograph Using High Sensitivity Setting

Also, try turning on Continuous Shooting, so you'll get several images to choose from for each shutter press. I used continuous shooting for the shot in FIGURE 9-39, so I could catch a good pose of the runner as he sped toward me.

Finally, although you are likely to get fine results using the RX100 II's autofocus system, you may want to try focusing manually. Here is one approach to try. In preparation for shooting, use autofocus and focus on a practice subject at about the distance where you expect your actual subjects to be. Then switch the camera to manual focus; the focus distance will remain at this range for all future shots, so you will not have to refocus as long as you keep shooting subjects at the same distance. You should try to use a somewhat narrow aperture (f/4.0 or higher) to keep the depth of field broad. Also, for any of this sort of shooting, I suggest that you leave the lens zoomed back to its full wide-angle position, unless a specific situation comes up when you have time to hold the camera very steady and zoom in on a specific subject.

Astrophotography and Digiscoping

Astrophotography involves photographing the stars, planets, and other celestial objects using a camera connected to (or aiming through) a telescope. Digiscoping is the practice of attaching a digital camera to a spotting scope to get clear shots of distant objects, often birds and other wildlife. I can't say the RX100 II is the best camera for either of these activities; if you want to take close-ups of wildlife, you could do better with a DSLR using a long telephoto lens, and for astrophotography, you could do better with a special imaging device that is designed for long exposures through a telescope. However, this book is about the RX100 II, and my goal is to make suggestions about useful and enjoyable ways to use this camera, not to find the best possible methods for long-distance photography. That's not to say the RX100 II is a bad camera for these types of photography; it has some features that equip it nicely for taking pictures through a scope, including light

weight, a large sensor for a camera of its size, a high-quality f/1.8 lens, manual exposure, manual focus with good focusing aids, Raw quality, a self-timer, and a connection for a wired remote control.

One of the less-helpful features of the RX100 II when it comes to astrophotography is that it has a permanently attached lens. You cannot remove the lens and attach the camera's body directly to a telescope as you can with a DSLR. You have to use the lens of the RX100 II in conjunction with the eyepiece and main lens or mirror of the scope. There are many different types of scope and several different ways to align the scope with the RX100 II's lens. I will not describe all of the various methods; I will discuss the approach I have experience with and hope that it gives you enough general guidance to explore the area further if you want to pursue it.

I used a Meade ETX-90/AT telescope with the RX100 II connected to its eyepiece. To make that connection, you need a filter adapter, such as the one sold by Sony, model number VFA-49R1, or a similar one sold by Lensmate, as discussed in APPENDIX A, as well as adapter rings that let you connect the filter adapter to the telescope's eyepiece. You can get the proper adapter rings for the Sony filter adapter by purchasing the 49mm Digi-Kit, part number DKSR49T, from the online site telescopeadapters.com. That is the setup shown in FIGURE 9-41.

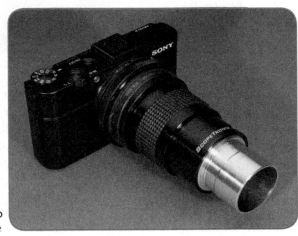

Figure 9-41.
Camera Attached to
Telescope Eyepiece

I took the image of the moon shown in FIGURE 9-42 with the RX100 II connected to a 40mm eyepiece on the telescope using the adapter rings. The camera was set to Manual exposure mode; through experimentation I arrived at an exposure of 1/100 second at f/5.0, with the ISO set to 200. I used Manual focus mode on the camera, setting the focus approximately at first, and then adjusting the telescope's focusing control until the image appeared sharp on the camera's LCD display. At first I used the MF Assist option, so I could fine-tune the focus with an enlarged view of the moon's craters. After some experimenting, though, I found that I got better results for focusing on the moon using the Peaking function, with the Peaking Color set to red. When focus was sharp, I saw a bright, red outline on the outer edge of the moon, which made focusing much easier than relying on the normal manual focus mechanism, even with MF Assist activated.

Figure 9-42. Moon: f/5.0, 1/100 Second, ISO 200

I used the self-timer set to 2 seconds to minimize camera shake as the exposure was taken and had SteadyShot turned on. I set the image quality to Raw & JPEG, so I would have a Raw image to give some extra latitude in case the exposure seemed incorrect. As you can see in FIGURE 9-42, the RX100 II did a good job of capturing the half moon. Because of the large sensor and relatively high resolution of the RX100 II, this image can be enlarged to a fair degree without deteriorating.

You can also use this setup for digiscoping. I tried this out by attaching the RX100 II to a Celestron Regal 80F-ED spotting scope using the same eyepiece I used with the telescope. FIGURE 9-43 is a shot of ducks on the other side of a large pond taken with the RX100 II through this scope. I used Program mode with an exposure of 1/125 second at f/4.9 and ISO 200. The trickiest part was getting the focus sharp. I used manual focus with Peaking at its mid level and set to red, and that worked quite well.

Figure 9-43.
Digiscoping
Example Image

FIGURE 9-44 is a shot I took from the same location as the digiscoping image using the full optical zoom of the RX100 II to show how much magnification the Celestron scope provided. (The ducks had flown away by then, but you can see the shoreline where they were wading.)

Figure 9-44.
Comparison Image
for Digiscoping,
Taken with
Full Optical Zoom

Infrared Photography

Infrared photography involves recording images that are illuminated by infrared light, which is invisible to the human eye because it occupies a place on the spectrum of light waves that is beyond our ability to see. The resulting photographs can be quite spectacular, producing scenes in which green foliage appears white and blue skies appear eerily dark.

To take infrared photographs, you need a camera that can "see" infrared light. Many modern cameras include internal filters that block infrared light. However, some cameras do not, or block it only partially. (You can do a quick test of any digital camera by aiming it at the light-emitting end of an infrared remote control and taking a photograph while pressing a button on the remote; if the remote's light shows up as bright white, the camera can "see" infrared light at least to some extent.)

The RX100 II is quite capable of taking infrared photographs. To unleash this capability, you need to get a filter that blocks most visible light but lets infrared light reach the camera's light sensor. (If you don't, the infrared light will be overwhelmed by the visible light, and you'll get an ordinary picture based on visible light.)

The infrared filter I use is the Hoya R72. As discussed above in connection with astrophotography and in APPENDIX A, you can obtain a filter adapter for the RX100 II that lets you attach various filters and other accessories. When you attach the very dark red R72 filter to the RX100 II, a great deal of the light from the scene is blocked. I have found that this reduction in light causes some problems for the camera's ability to set automatic exposure and white balance. With experimentation, though, you can get an interesting result.

For the image in FIGURE 9-45, I aimed the camera at green trees in bright sunlight to set a custom white balance that would yield the characteristic white appearance of green grass and leaves. The

camera displayed an error message for setting the white balance each time I tried, but it still appeared to set a usable white balance.

Figure 9-45. Infrared Shot: Hoya R72 Filter, 8.0 Sec., f/1.8, ISO 100

For exposure, I first tried Aperture Priority, but the camera underexposed the images heavily. I eventually used Manual exposure mode and adjusted the shutter speed until I could see the image clearly on the LCD display. I ended up with an exposure for 8 seconds at f/1.8 with ISO set at 100.

This sort of infrared photography often is most successful in the spring or summer when there is a rich variety of green subjects available outdoors.

Connecting to a Television Set

The RX100 II can play back its still images and videos on an external television set, as long as the TV has an HDMI input. The camera does not come with any audio-video cable as standard equipment, so you have to purchase your own cable.

To connect directly to a TV, you need a cable with a micro-HDMI connector at the camera end and a standard HDMI connector at the TV end. These cables are widely available through retailers such as Amazon.com.

| Photographer's Guide to the Sony DSC-RX100 II

To connect the cable to the camera, you need to open the little flap marked HDMI on the right side of the camera and plug the micro-HDMI connector into the port that is underneath that flap, as shown in FIGURE 9-46.

Figure 9-46. HDMI Cable Attached to Camera

Then connect the large connector at the other end of the cable to an HDMI input port on an HDTV set.

Once you have connected the camera to the set, the camera not only can play back images and videos; it also can record. When the RX100 II is hooked up to a TV while in recording mode, you can see on the TV screen the live image being seen by the camera. In that way, you can use the TV as a large monitor to help you compose your photographs and videos.

As noted in CHAPTER 6, the RX100 II also has an option on the Playback menu, View on TV, that is intended to let you view your images on a Wi-Fi–enabled TV. As I discussed in that chapter, I have found this option to be difficult to use effectively. Unless

you are familiar with setting up the special type of network that is needed for this sort of connection, I recommend that you stick to using an HDMI cable for the connection.

Appendix A:
Accessories

When people buy a new camera, especially a fairly expensive model like the Sony RX100 II, they often ask what accessories they should buy to go with it. I will hit the highlights, sticking mostly with discussing items I have used personally.

Cases

The RX100 II is such a compact camera that you may find that you don't need a case. There is no separate lens cap to deal with as there is with some models in this class, and when the camera turns off and its lens retracts, the RX100 II is ready to stow easily in your pocket, purse, or other handy location.

But I do use a case with my RX100 II, and I know that other users do also, so I will provide some suggestions. One problem in doing so is that it would be hard to find a case that will not work for the RX100 II because the camera is so compact.

The first case I will mention is the Sony case that was made for the original RX100 camera, model number LCJ-RXA, shown in FIGURE A-1. I tried this case first because I purchased it with my RX100 and wanted to see if it would fit the RX100 II. The answer is that the original case does fit on the RX100 II, but it is a tight fit because of the accessory shoe and tilting LCD screen, neither of which the original RX100 has. If I were buying this case today,

I probably would be unhappy with it because I had to force it slightly to make it fit. However, it does snap on securely and protects the camera well.

Figure A-1. RX100 II in Sony Case for Original RX100

If you can find this case at a good price, it is not a bad option. It is made of polyurethane that looks like leather, and it has a tripod screw that secures the camera to the rear half of the case. Sony includes a matching shoulder strap with the case.

One problem with this case, besides the tight fit, is that you cannot store anything but the camera itself in the case. There is no room for an extra battery, memory card, filters, or anything else. But if you want a very attractive case that does a fine job of protecting the camera, this one is an excellent choice.

Of course, if you want the official Sony case that is designed to accommodate the camera more readily, you should get the newer case, model number LCJ-RXC.

Another case I have used often with my RX100 II is the Lowepro Tahoe 30, shown in FIGURE A-2.

Figure A-2. Lowepro Tahoe 30 Case

There is nothing fancy about this case; it is soft with a cushioned interior, and it zips closed. It has a large belt loop and a small exterior pocket that also closes with a zipper. I carry my extra battery in that pocket. If I need to carry a tripod and other large items, I still keep the RX100 II in this case and place the case and camera inside a larger bag or case along with the other items.

If you want to consider other small cases, try the Tamrac Digital 2, model number 5692, shown in FIGURE A-3. Of course, there are numerous other options for cases in this point-and-shoot size.

Figure A-3. Tamrac Digital 2 5692 Case

If you want a case with room for other items besides the camera, there are many choices. I occasionally go on a day trip using the Lowepro Inverse 100 AW waist pack, shown in FIGURE A-4, which has room for the camera, some accessories, and a couple of small water bottles in the two side pouches.

Figure A-4. Lowepro Inverse 100 AW Camera Bag

Batteries and Chargers

Here's one area where I recommend you go shopping either when you get the camera or right afterward. I use the camera heavily, and I find it runs through batteries fairly quickly. You can't use disposable batteries, so if you're out taking pictures and the battery dies, you're out of luck unless you have a spare battery (or the AC adapter and a place to plug it in, as discussed below). The model number of the Sony battery is NP-BX1. You can get a spare Sony battery for about $50 as I write this. It won't do you a great deal of good by itself, though, because the battery is designed to be charged in the camera.

There is an easy solution to this problem. You can find generic replacement batteries, as well as chargers to charge the batteries outside the camera, very inexpensively on Amazon.com, eBay, and elsewhere. I purchased a package including a generic replacement battery and a charger, shown in FIGURE A-5, for about $20 on eBay.

Figure A-5. Generic Travel Charger and Battery

The charger worked well, both for that battery and for the original Sony battery. The battery itself seemed fine, but I found that it was giving me a shorter time between recharges than the genuine Sony battery, so I purchased another Sony one for daily use.

There is another type of third-party charger that some users have tried—a wall charger with a micro-USB plug. You may have a charger of this type that came with another electronic device, such as a tablet PC or a cell phone. I have not tried using that sort of charger myself, and I have read that users have had mixed results with using other chargers. I have found no reason to use any in-camera charger other than the one that came with the camera. However, if you are confident that the voltage and amperage of your charger match the specifications of the Sony charger (5V and 0.5A), then that may be a good way to obtain an extra charger for the RX100 II.

One option that I have read about but have not yet tried is the Sony ACC-TRBX Cyber-shot Accessory Kit, which includes a charger that can charge a battery outside the camera in 1.5 hours as well as an extra NP-BX1 battery and a USB charging cable.

While I am on the subject of batteries and power, I should mention one other aspect of the power supply for the RX100 II. The AC adapter that comes with the camera (in the United States), model number AC-UB10, cannot be used to power the camera when it is in operation; it only serves to charge a battery inside the camera. If you want to use an adapter that provides power to the camera, so you can operate the camera for long periods of time while recording videos, transferring images, or for other applications, you need to use a different Sony adapter, either model number AC-UD10 or AC-UD11, which is shown in FIGURE A-6.

Figure A-6. Sony AC-UD11 AC Adapter

Actually, model AC-UD11 is the AC adapter that came with the original RX100 camera. So, if you happen to own that camera and its power adapter, you can use that adapter to power the RX100 II, even when no battery is installed in the camera.

Add-On Filters and Lenses

There is no way to attach a filter or other add-on item, such as a closeup lens, directly to the RX100 II lens, as you can with DSLRs and other cameras whose lenses are threaded to accept filters and auxiliary lenses. With the RX100 II, to add such accessory items, you need to get an adapter. Sony provides an adapter designed for the RX100 and the RX100 II, model number VFA-49R1.

The adapter has two parts. The first part, shown at the left in FIGURE A-7, is a plastic ring called the "base ring" that you glue onto the front of the lens barrel. This piece stays in place and does not interfere with the lens or the automatic lens cover.

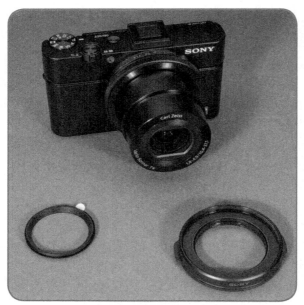

Figure A-7. Sony Filter Adapter Ready to Install

To use a filter, you attach a larger piece, the actual "filter adapter," at the right in FIGURE A-7, which bayonets onto the base ring. Then you can screw any 49mm diameter filter or other auxiliary lens into the holder. FIGURE A-8 shows an infrared filter attached to the RX100 II with this adapter.

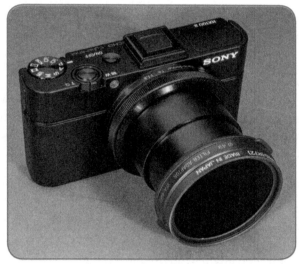

Figure A-8. Infrared Filter Attached to Camera with Sony Filter Adapter

The base ring is removable if you later want to take it off the lens; Sony includes a "remover," which is a pair of plastic rings attached to a thread; you work the thread under the base ring and pull it through to remove the ring from the lens.

As you might expect, this system is not as sturdy as the natural screw-on capability of other cameras because everything depends on a plastic ring that is glued in place. So don't expect to attach large items like teleconverters or anything heavier than a standard 49mm filter. Having the ability to attach filters, however, enhances the usefulness of the camera greatly. You can use infrared filters, neutral density filters, polarizers, or any of a wide assortment of closeup lenses, among others. Also, as discussed in CHAPTER 9, I used this system to attach the RX100 II to the eyepiece of a telescope and spotting scope to take pictures

through the scopes. You have to be careful not to put too much stress on the adapter in this situation, but the adapter worked well for that purpose.

There is a similar system sold for the RX100 and RX100 II by Lensmate, a company that developed this system before Sony used it. Lensmate sells two versions—one for 49mm filters and one for 52mm filters. Details are at lensmateonline.com.

There also is at least one other option available for attaching filters to the RX100 II—the "Magfilter" system, which involves gluing a very thin metallic ring to the front of the lens and then attaching a magnetic filter holder to that ring. I have not tried this system myself, but I have read good things about it. You can get more details at www.carryspeed.com.

Grip

Some users say it can be difficult to get a firm grasp of the RX100 II because it is small and has a smooth front surface with no place to take hold of it. Lensmate, who provides the filter adapter discussed above, also offers a solution to this issue—the custom-made grip designed by Richard Franiec, shown in FIGURE A-9.

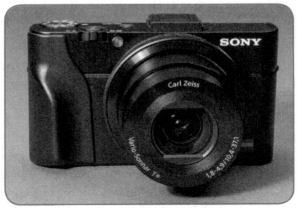

Figure A-9. Franiec Grip on RX100 II

The Franiec grip is well crafted from aluminum and contoured to fit on the camera's body with a low profile. It is attached with a strong adhesive supplied by Lensmate. This grip offers you a solid ridge for keeping a tight hold on the camera. I do not find it necessary, but this is a matter of personal taste.

Here again, as with the filter adapter, Sony later adopted the technology sold by Lensmate, and now offers a grip of its own, model number AGR1, shown in FIGURE A-10.

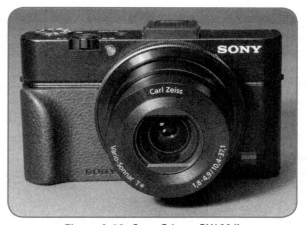

Figure A-10. Sony Grip on RX100 II

This grip has a different shape, appearance, and texture from the Franiec grip, and it is less expensive. There also are other grips available, but I have not tried any of them. Again, I do not use an add-on grip myself, but it is good to have these options available.

Remote Control

In several situations, it is useful to control a camera remotely. For example, when you are using slow shutter speeds, holding the shutter open with the BULB setting, doing closeup photography, or taking pictures through a telescope, any camera motion during the exposure is likely to blur the image. If you can control the

camera remotely, you can avoid the danger of moving the camera as you press down on the Shutter button.

As I discussed in CHAPTER 9, the RX100 II has a built-in Wi-Fi capability that lets you connect a computer, smartphone, or tablet to the camera wirelessly. Besides using that feature to transfer images from the camera to the other device, you can use a smartphone or tablet as a wireless remote control. However, as I noted earlier, you can control the camera remotely only in limited ways with that option, and the camera will ignore most advanced settings while being controlled by a smartphone. Therefore, the Wi-Fi remote control option, although useful for some purposes, does not give you the functionality of a traditional remote control.

Fortunately, with the RX100 II, Sony has included another option for remote control. You can connect a Sony wired remote, model number RM-VPR1, to the Multi port on the right side of the camera. With this device, you can turn the camera on and off, use the autofocus system, zoom the lens in and out, take a still image, lock the shutter down for a long exposure, and start and stop video recording.

The remote control comes with two cables—one for cameras with a Remote terminal and one for cameras like the RX100 II, which has the Multi terminal. Take the cable that has identical connectors at each end, and plug the end with the smaller plastic housing into the camera, as shown in FIGURE A-11.

Figure A-11.
Sony Remote Control, RM-VPR1,
with RX100 II

Plug the other end of the cable, which has a larger housing, into the remote. You also can attach the included clip to the underside of the remote, as shown in FIGURE A-12, if you want to clip the remote to a tripod or other support.

Figure A-12. Clip Attached to Sony Remote Control

Now, you can control the camera using the buttons on the remote control, as shown in FIGURE A-13.

You can half-press the Shutter button to cause the autofocus system to operate (if the camera is in an autofocus mode), and press the button fully to take a still picture. You can press the Shutter button down and then slide it back toward the other controls to lock it in place. This locking is useful when you are taking continuous shots using the Drive Mode settings, or when you want to hold the shutter open using the BULB setting in Manual exposure mode. Press the Shutter button back up in its original direction to release it.

Figure A-13.
Sony Remote RM-VPR1

The red button labeled Start/Stop is similar to the Movie button on the RX100 II camera. Press it once to start recording a movie and press it once more to stop the recording.

The Power button on the side of the remote control can be used to turn the camera on and off, and to wake it up from power-saving mode. Press the switch back toward yourself as you hold the control to activate for powering the camera either on or off.

External Flash

In producing the DSC-RX100 II, one of the major enhancements Sony made to the earlier model was to add an accessory shoe on top of the camera. With the original RX100, there was no easy way to attach an external flash when you needed more powerful illumination. (There were some ways to deal with this issue, such as using an optical slave unit.) Now, with the RX100 II, you have several options.

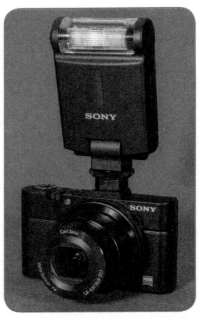

The most direct choice for using external flash is to use one of the units offered by Sony. The flash that Sony designates

Figure A-14. Sony HVL-F20M Flash

for use with the RX100 II is model number HVL-F20M, shown in FIGURE A-14. This unit is very small and fits with the camera nicely. It has a guide number of up to 20 at f/2.8 and ISO 800, meaning it can reach up to 20 meters (66 feet) with those settings; it has a shorter range at higher apertures and with lower ISO values. It has a Bounce switch, which rotates the flash head upward by 75 degrees to let you bounce the flash off a ceiling or high wall. You also can use Sony's larger units, such as the HVL-F43M.

There also are several non-Sony flash units that will work with the hot shoe of the DSC-RX100 II and will fire whenever the camera's Shutter button is pressed. FIGURE A-15 shows the Panasonic DMW-FL220, a small flash I have had for several years. It fits nicely with the Sony camera in terms of size and appearance, and when it is attached to the hot shoe, it fires whenever the shutter is triggered.

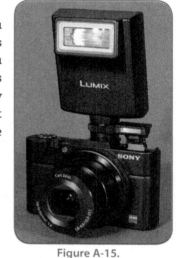

With the Panasonic DMW-FL220, you don't have to activate the camera's built-in flash, although you can if you want to. You can have the camera's flash mode set to Off, Fill-flash, or any other value, but that setting will affect only the built-in flash when you are using a non-Sony external flash.

Figure A-15.
Panasonic DMW-FL220 Flash

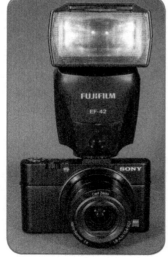

The Fujifilm EF-42, shown in FIGURE A-16, is another external flash that works in the same manner with the RX100 II.

Like the Panasonic flash, it fires when the camera's shutter is activated, even when the built-in flash is turned off. This unit is somewhat large for the camera but is not overwhelming, and if you already have one, as I did, it provides a good deal of illumination.

Figure A-16.
Fujifilm EF-42 Flash

A smaller Fujifilm model, EF-20, shown in FIGURE A-17, is a better fit for the RX100 II in terms of size. It works well with the camera and has a simple adjustment for flash power that is very convenient.

Another model that works when the built-in flash is turned off is the Zeikos Digital Slave Flash, also discussed below for use as an optical slave unit. If you set that unit's mode to Normal rather than Slave On, it will fire whenever the Shutter button is pressed, regardless of whether the built-in flash is activated.

With any of these flash units, you have to set the camera to Manual exposure

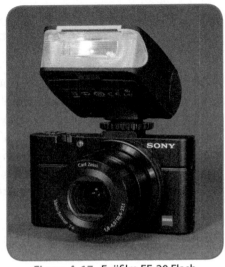

Figure A-17. Fujifilm EF-20 Flash

mode and find the correct aperture and shutter speed settings on your own, either using a flash meter or through trial and error.

If you are not using the built-in flash, you probably will want to set White Balance to its Flash setting because the Auto White Balance setting will not take account of the use of flash unless you have the built-in unit firing also. The external flash also needs to be set to its manual mode.

Here is one other issue you need to be aware of when using a non-Sony external flash unit. When you set the camera to Manual exposure mode, the camera's display screen (or electronic viewfinder display) is likely to be black or very dark because your manual settings would result in a dark image if you were not using flash, and the camera will not "know" about the effects of the non-Sony flash. Therefore, it may be difficult to compose the shot. There are at least two ways to deal with this issue.

One way is to switch the camera into Shutter Priority mode for a few moments to compose the shot; the display should become visible with that setting. (You could use another automatic mode, but I chose Shutter Priority because it is next to Manual on the Mode dial.) Then, turn the Mode dial back to M to take the shot. This system works best if you are using a tripod and have a steady view of your scene.

Another way to deal with the issue of the darkened display is to activate the built-in flash on the RX100 II. When that flash is active, the camera will brighten its display, even in Manual mode and even if the resulting image will be very dark because of the exposure settings that are in place. Of course, in that case you have to allow for the extra illumination from the built-in flash, and you may have to adjust the camera's exposure settings somewhat to account for that extra light.

There are several other external flash units that can be used with the RX100 II, but that work only as optical slave units. With these units, you have to have the camera's built-in flash set to fire, so that flash will trigger the external flash.

The most powerful optical slave flash I tested is the Yongnuo YN560 III, a versatile and relatively inexpensive unit, shown in FIGURE A-18.

Although the Yongnuo flash was not triggered by the RX100 II's hot shoe, it fired reliably when set to either of its two optical slave modes, S1 or S2. As you can see from FIGURE A-18, the Yongnuo unit partly blocks the camera's built-in flash, but the built-in flash still fires, and the light from that flash triggers the bigger flash. One advantage of the Yongnuo

Figure A-18.
Yongnuo YN560 III Flash

is that it has a simple push-button control for adjusting its flash power in increments from 1/128 to full power, so you can easily find a good amount of flash illumination for a given situation.

A smaller unit, the Zeikos Digital Slave Flash, shown in FIGURE A-19, comes with a bracket for attaching it to the camera, and it has a switch to choose an optical slave mode that synchronizes with the flash fired by the built-in flash of the RX100 II. With this external flash's switch at the S2 setting, it worked well and fired its flash in sync with that of the RX100 II. The Zeikos flash is very inexpensive and is worth considering as an external unit for the RX100 II. (As noted

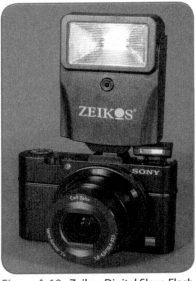

Figure A-19. Zeikos Digital Slave Flash

earlier, this unit can have its mode set to Normal, in which case it fires even when the built-in flash is turned off.)

The High-Power Flash HF-DC2, a small unit made by Canon, also works with the RX100 II. A flash with a built-in optical slave, the HF-DC2 fits well with the RX100 II in terms of looks and function.

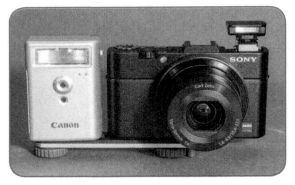

Figure A-20. Canon High-Power Flash HF-DC2

This unit comes with a bracket that attaches to the underside of the camera, using the tripod socket. The flash is then screwed into the bracket, right up against the camera, as shown in FIGURE A-20.

One limitation of the HF-DC2 is that it is a single unit with no rotating flash head, so if you mount it right next to the camera on its bracket, there is no possibility of bouncing the flash off of the ceiling or pointing it anywhere other than where the camera is pointing. However, because there is no direct connection between this flash unit and the camera, the flash can be mounted away from the camera, at any location within about 20 feet (6 meters). So you can place the flash with its bracket on a separate tripod, or even hold it in your hand and aim it at the ceiling for a bounce effect.

I have had the best results with the HF-DC2 by setting it to its Auto mode, setting the camera to Manual exposure mode, and taking several test shots until I found the correct exposure.

I also tested two external flash units that would not fire when attached to the hot shoe of the camera—the Canon 430EX II and the Metz Mecablitz 36 AF-4, in the version for Panasonic and Olympus cameras. As noted above, another unit, the Yongnuo YN-560 III, would not fire in its normal mode, although it worked well in its optical slave modes.

Another way to deal with external flash is to use a radio flash trigger system, such as model number NPT-04, by CowboyStudio. As seen in FIGURE A-21 and FIGURE A-22, I mounted the transmitter in the camera's hot shoe and attached the receiver to the Panasonic DMW-FL220, an external flash unit discussed above, which I placed on a tripod. I made sure the transmitter and receiver were turned to the same channel, and turned on the power of the receiver. (The transmitter does not have a power switch, but it does have a battery that needs replacement about once a year.) Then, with the camera in Manual exposure mode and the camera's

flash mode set to Off, when I pressed the Shutter button, the external flash fired.

With this system, you can use any flash unit that is compatible with the receiver. I have found that you need to use a flash that has a manual mode, like the Panasonic unit. The Yongnuo YN-560 III, discussed earlier, also worked well with this system. External flash units that have only automatic (TTL) exposure systems do not work, in my experience.

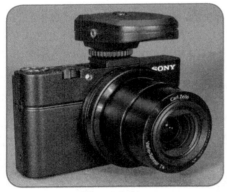

Figure A-21.
CowboyStudio Radio Flash Trigger

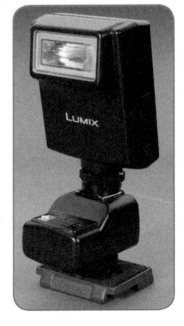

Figure A-22. Flash on Radio Receiver

I also tested another radio transmitter, the Hensel Strobe Wizard Plus, shown in FIGURE A-23, which I use for triggering moonlight flash units for photography with a DSLR. It worked well in the hot shoe of the RX100 II, triggering the monolights perfectly.

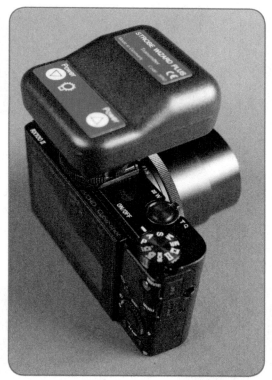

Figure A-23. Hensel Strobe Wizard Plus

You may want to consider one other accessory for use with any external flash unit—a softbox, like the one shown in FIGURE A-24. A softbox is an enclosure that surrounds a flash unit and diffuses the light through a white, translucent surface, enlarging the area that lights up the subject. The effect of using a softbox is to soften the light because the larger the light source, the less harsh the light will be, with softer shadows. This softbox is a Photoflex LiteDome XS, whose enclosure is about 12 by 16 inches (30 by 40 cm).

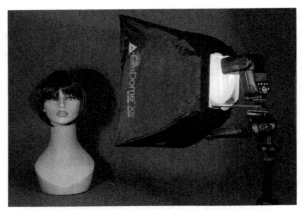

Figure A-24. Softbox Attached to Yongnuo Flash

As you can see in FIGURE A-24, I placed the softbox on a tripod over the Yongnuo YN 560 III flash unit. I set up the Yongnuo flash in its S1 slave mode, so it would fire when I pressed the Shutter button on the RX100 II, with the camera's flash mode set to Fill-flash. I took one image of my mannequin head with that setup and another with only the camera's built-in flash. The results are shown in FIGURE A-25 and FIGURE A-26, respectively.

Figure A-25. Shot Taken with Yonguno Flash and Softbox

To me, the shot in FIGURE A-25, taken in Manual exposure mode with the softbox flash complementing the built-in flash, has a softer and more pleasant appearance than that of FIGURE A-26, with just the built-in flash aimed directly at the subject.

Figure A-26. Shot Taken with Camera's Built-In Flash

Finally, one other item that is not a flash unit can be useful for supplemental lighting, especially for taking video—a continuous lighting unit like the one shown in Figure A-27.

This battery-powered light, which fits nicely in the camera's accessory shoe, has 160 LEDs that can be continuously dimmed or brightened using a rotary control on the side. The light is larger than the camera, but it is not very heavy, so it doesn't overwhelm it. It is relatively inexpensive and, it is available under various brand names; search for it using the term CN-160.

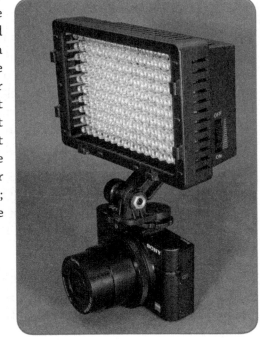

Figure A-27.
CN-160 LED Lighting Unit

Viewfinders

One other item that some users like to add to their RX100 II is a viewfinder, so they can hold the camera up to their eye rather than holding it at a distance to view the LCD screen. It can be convenient to be able to view the scene through the bright window of one of these devices, rather than trying to make out an image on the LCD display that is washed out by bright sunlight. I have managed all right by occasionally using the Sunny Weather setting of the LCD Brightness option on the Setup menu. Also, one of the great virtues of the RX100 II is its portability, and you may not want to add a device that makes it difficult to fit the camera into a pocket or purse.

If you don't mind a slight addition to the camera's size and weight, Sony sells an excellent, though expensive, electronic viewfinder that integrates well with the RX100 II, model number FDA-EV1MK, which also works with Sony's high-end compact cameras, the full-frame RX1 and RX1R.

The Sony electronic viewfinder (EVF) is a sophisticated (but expensive) piece of equipment that provides the same information as the LCD screen, both for shooting and for playback, including letting you check focus and depth of field. The difference is that the EVF lets you view all of this information in the sheltered environment of a window rather than in the daylight. And with this system, you get the stability that comes from holding the camera against your forehead.

Using organic light-emitting diode (OLED) technology, the viewfinder provides about 2.3 million dots of resolution, resulting in a high-contrast, very detailed view of the images being viewed by the camera or being played back.

The device includes eye sensors that detect when your eyes and head are approaching it, so it turns on when your eye gets near, and it switches the view back to the LCD screen when you move

your eye away from it. You also can press a small button on the left side of the viewfinder to switch the view manually. You can use the Finder/LCD setting on the Custom menu to change this behavior; if you set that option to Manual instead of Auto, you will have to use the button to switch the view between the LCD display and the viewfinder. The right side of the EVF has a small diopter-adjustment switch that you can slide back and forth to adjust the view according to your vision. If you wear glasses, you may be able to see clearly through the viewfinder without your glasses after making this adjustment.

As you can see in FIGURE A-28, the Sony EVF is small and fits well with the appearance of the camera. As shown in FIGURE A-29, you can flip the viewfinder up 90 degrees to use it as a right-angle finder, so you can hold the camera down at waist level to take shots closer to ground level and from low angles.

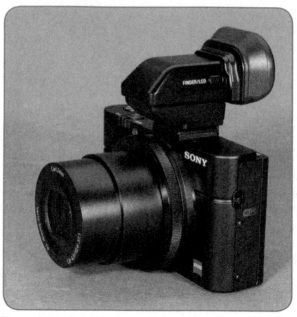

Figure A-28. Sony Electronic Viewfinder in Normal Position

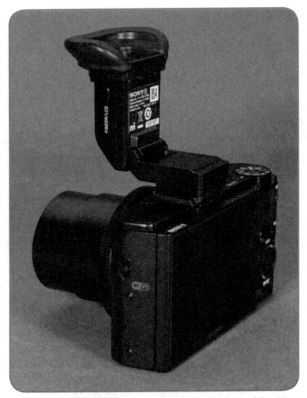

Figure A-29. Sony Electronic Viewfinder in Raised Position

Another option that is less expensive than the Sony EVF but considerably more unwieldy is the Hoodman HoodLoupe 3.0. This is a viewing device that you hold up against the camera's LCD screen, shading the display and giving you a magnified view of the screen through an eyepiece, as shown in FIGURE A-30 and FIGURE A-31.

With this setup, you can put the loupe's eyepiece up to your eye and see the screen clearly without having it washed out by sunlight. Details are available at hoodmanusa.com.

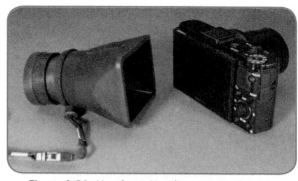

Figure A-30. Hoodman HoodLoupe near Camera

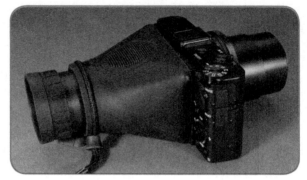

Figure A-31. Hoodman HoodLoupe Against Camera

You also might want to consider an optical viewfinder, though, of course, that option is useful only if you are planning to shoot your images at the single focal length provided by the viewfinder. Sony does provide an optical viewfinder that is intended for the high-end RX1 and RX1R cameras, model number FDA-V1K. This viewfinder is of very high quality, using Zeiss optics, and comes with a correspondingly high price tag of $598. The viewfinder provides a 35mm focal length.

If you want to use an optical viewfinder with your RX100 II, you can find less-expensive options. For example, I tried a Voigtlander 28mm optical viewfinder, shown in FIGURE A-32. This simple viewfinder fits nicely in the accessory shoe and has the advantage of providing the same focal length as the camera's wide-angle

setting of 28mm. There are, of course, many other optical viewfinders available if you want to use that option.

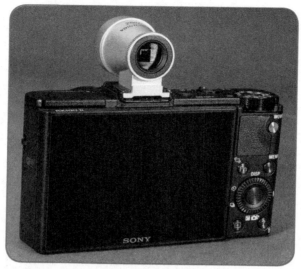

Figure A-32. Voigtlander 28mm Optical Viewfinder

Another possibility is to use the ClearViewer, a device that fits into the accessory shoe and folds down a magnifying lens behind the LCD screen, as shown in FIGURE A-33.

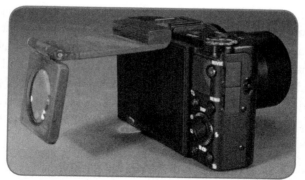

Figure A-33. ClearViewer Attached to Camera

You get a clear, magnified view of the display through this device. It is a very lightweight item that you can easily slip on and off;

it is worth considering if you like to hold the camera up to your face for composition, and the magnified view can be useful for focusing. Details are at clearviewer.com.

Finally, there is another accessory you might want to consider for viewing live and recorded images with the RX100 II. The Sony Clip-On LCD Monitor, model number CLM-V55, is an add-on unit with a 5-inch (12-cm) screen. This small monitor, shown in FIGURE A-34, comes with a foot that attaches securely to the accessory shoe of the RX100 II. It comes with a short HDMI cable; however, the connector at the camera end of that cable is the wrong size for the RX100 II; you will need to get either an adapter or a different cable that ends in a micro-HDMI plug at the camera end.

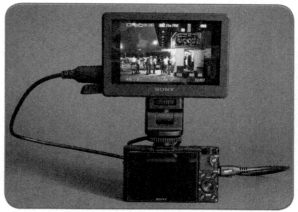

Figure A-34. Sony Clip-On LCD Monitor CLM-V55

The Sony monitor works very well with the RX100 II, although, not surprisingly, it is rather large for this very compact camera. It adds a good deal of visibility, both for viewing the live shooting screen and for playing back recorded images and videos. If you want, you can install it backward, so you can view the live scene from the front of the camera for taking self-portraits. This unit costs about $400 at this writing, but if you need the extra screen size or versatility, it is worth looking into. (And, as a bonus, if

you plug it into a Blu-ray player or other source of HD video and audio, it can function as a very small HDTV screen.)

External Microphone

With the inclusion of the accessory shoe, the DSC-RX100 II can use a Sony microphone that gets its power from that shoe. As of this writing, the only model that is available for use with the camera's hot shoe is Sony's model number ECM-XYST1M, shown in FIGURE A-35 and FIGURE A-36.

This compact device has two microphone units that can be kept together or separated by 120 degrees to pick up sounds from different directions. It comes with a windscreen as shown in FIGURE A-35.

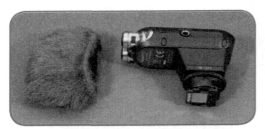

Figure A-35. Sony Microphone ECM-XYST1M

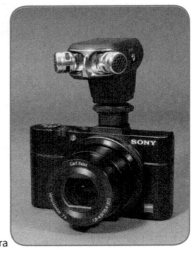

Figure A-36. Sony Microphone on Camera

I did some informal testing to see if I could hear a difference in sound quality with this microphone installed as opposed to using the built-in microphone. I perceived an increased amount of lower frequency sound and some added sensitivity. If you are recording a concert or other musical event, the external microphone might very well enhance the quality of the audio, but for everyday use, I find the sound quality with the built-in microphone to be fine.

Tripod Usage

Finally, I am going to discuss one last topic that is not really an accessory but a problem that can be solved with different accessories. Of course, it often is advisable to use a tripod with the RX100 II, as with any camera, especially for macro shots, low-light shots, and others where focus is critical, shutter speeds are longer than usual, and the like. When the camera is attached directly to a tripod with a standard release plate, as in FIGURE A-37, the Control ring fits very snugly against the tripod's plate and is difficult to turn.

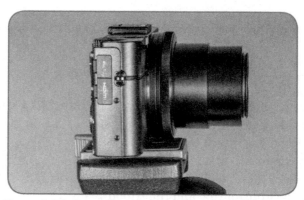

Figure A-37. Control Ring Impeded by Tripod Release Plate

There are several ways to deal with this problem. One way is to use a tripod whose plate is flat and hard and therefore does not screw up tightly against the Control ring. In many cases, though, those

tripods are not as strong and versatile as those that have release plates.

Another solution is to use the Sony case, discussed earlier, which includes a tripod screw at the bottom that screws into the camera and secures it in the case. Then, when the case is screwed onto a tripod, the extra thickness of the case and its screw elevate the RX100 II above the tripod's release plate and the Control ring can turn freely, as shown in FIGURE A-38.

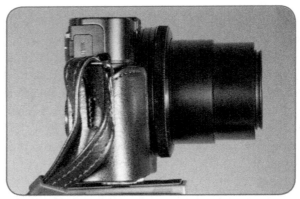

Figure A-38. Using Sony Camera Case to Raise Control Ring Above Tripod

One other way to deal with the problem of the Control ring and tripods is to use the accessory shown in FIGURE A-39.

This item is called a "tripod screw," sold by Hama in a set of five; I purchased a set from B&H Photo Video online. When you attach this screw to the camera's tripod socket and to the tripod's release plate, there is plenty of clearance between the Control ring and the tripod's plate, as shown in FIGURE A-40, using the same tripod and plate as in FIGURE A-37.

Figure A-39. Tripod Screw

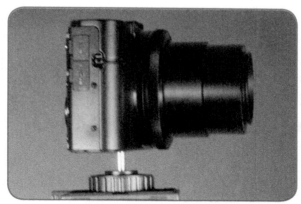

Figure A-40. Using Tripod Screw to Raise Camera Above Tripod

As a final note, there are hundreds of tripod models to choose from, and I won't attempt to narrow them down. However, I recently started using the Manfrotto BeFree lightweight tripod, shown in FIGURE A-41, and I have found it to be an excellent, lightweight tripod for traveling with a small camera such as the RX100 II.

Figure A-41.
Manfrotto BeFree Tripod

APPENDIX B:
Quick Tips

I n this section, I'm going to list some tips and facts that might be useful as reminders, especially if you are new to digital cameras like the Sony RX100 II. My goal is to give you small chunks of information that might help you in certain situations or that might not be obvious to everyone. I have tried to include points that you might not remember from day to day, especially if you don't use the RX100 II constantly.

Use Continuous Shooting. Consider turning Continuous Shooting on as a matter of routine, unless you are running out of storage space or battery power, or have a particular reason not to use it. Even with portraits, you may get the perfect expression on your subject's face with the fourth or fifth shot. Press the Left button (or use the menu system) to call up Drive Mode, scroll to Continuous Shooting, and turn it on. Continuous Shooting is not available when the camera is set to the Movie or Sweep Panorama mode or to any Scene mode setting other than Sports Action. You can shoot more rapidly if you use the Speed Priority setting, but the camera will not adjust its focus or exposure after the first shot.

Use shortcuts. You can speed up access to many settings by placing them on the Function Button menu for recall with a press of that button. In some cases, as with flash settings and Drive Mode, you can press a button (the Right and Left buttons, respectively) to get access to the features you need. When you use

the Shooting menu, speed through it by using the Control wheel to move rapidly through the items on each screen, and use the Right and Left buttons to move through the menu system a full screen at a time.

Use the Memory Recall shooting mode. The MR position on the Mode dial gives you a powerful way to customize the RX100 II by setting up your three most important groups of settings. You also can use it for more specific purposes. One thing I like to do is have one slot set up to remove all "special" settings, such as Creative Style, Picture Effect, and Self-timer, so I can quickly set up the camera to take a shot with no surprises. Another thing you can do is use one slot to set the camera at a particular zoom range, such as, say, 50mm. To do this, press the Zoom lever to move the lens, so you see the desired range below the zoom scale in the upper-right corner of the display. The camera does not display the range in millimeters; only in multiples of the wide-angle 28mm range. So 50mm is about 1.8X and 75mm is about 2.7X. When the range is set as you want it, save the settings to one of the MR slots. (Of course, you also can use the Step zoom feature to set a particular zoom amount; to do that, set the Zoom Function on Ring option on the Custom menu to Step.)

Remember the Extra Settings for White Balance and Creative Style. When you set White Balance, even to the Auto White Balance setting, you can press the Right button and then use the amber-blue and green-magenta axes to further adjust the color of your shots. This setting is not obvious on the menu screen, but it gives you a great way to alter the appearance of images. Just remember to undo any color shift when you no longer need it. Also, you can press the Right button after selecting a Creative Style option and then adjust the contrast, saturation, and sharpness settings. (Saturation is not adjustable for the Black and White setting.)

Consider using DMF as your standard focusing option. I originally did not consider DMF to be a very important setting;

Photographer's Guide to the Sony DSC-RX100 II

I viewed it as a somewhat exotic option to be used in difficult focusing situations when I needed to move back and forth between manual focus and autofocus. I later realized that DMF works just the way standard single-autofocus works on many other cameras: the camera does not start focusing until you press the Shutter button halfway. When you do, the camera uses its autofocus quickly; after that, you can still use manual focus to adjust further. For me, this is an excellent option because I do not want the camera to use autofocus constantly before I press the Shutter button. Using DMF saves battery power and gets the job done efficiently.

Don't forget the camera's audio capability. The RX100 II has a built-in stereo microphone that is quite capable of recording voices clearly. If you need an audio recorder to record a spoken memo or to keep a record of a meeting, go to the Movie menu and set File Format to MP4 and Record Setting to VGA (to give more recording time and use less space on the memory card). Try to aim the voices at the two small holes for the stereo microphone, on the top of the camera just behind the lens, and record a movie, even if all you need is the sound. (For greater sensitivity and quality, you can use the external microphone discussed in APPENDIX A.)

Play your movies in iTunes, and on iPods, iPhones, and iPads. If you set the RX100 II to record movies using the MP4 format (as opposed to AVCHD), the movie files are compatible with Apple Computer's QuickTime and iTunes software. You can use iTunes to copy your MP4 files to an iTunes-compatible device, such as an iPad. Open a window on your computer to display the icon for a movie file (using Windows Explorer or Macintosh Finder), then open iTunes on the same computer and drag the .mp4 file from the Explorer or Finder window to the panel for the Library in iTunes. You can then play the movie from iTunes. To play it on an iPod, iPhone, or iPad, select the video in iTunes, then select File on the iTunes menu, then from that menu item select Create New Version, and then choose Create iPod or iPhone version, or iPad or AppleTV version, as appropriate. Then you can sync iTunes with

your device, and the converted movie will play on that device. (If you have trouble locating the .mp4 files on your computer, see the last part of CHAPTER 8.)

Explore the RX100 II's creative potential. The RX100 II is a sophisticated camera, with advanced features that let you explore experimental techniques. Here are some suggestions: Use Manual exposure mode with shutter speeds as long as 30 seconds or the BULB setting to take nighttime shots with trails or other patterns of lights from automobiles, flashlights waved in the air for "light painting," and other sources. Use shutter speeds as fast as 1/2000 second to freeze moving motorcycles, athletes, and other subjects in mid-motion. Try panning or otherwise steadily moving the camera during a multi-second exposure. Use long exposures (on a tripod) to turn night into day. Take HDR images with partly blurred subjects, such as blowing flags.

Diffuse your flash. If the built-in flash produces light that's too harsh for macro or other shots, try using translucent plastic pieces from milk jugs or broken ping-pong balls as homemade diffusers. Hold the plastic between the flash and the subject. When using Fill-flash outdoors, use the Flash Compensation setting on the Shooting menu to reduce the intensity of the flash by -2/3 EV. Also, you can bounce the built-in flash by holding it back with a finger.

Use the Self-timer to avoid camera shake. The Self-timer is not just for group portraits; you can use the 2-second Self-timer whenever you use a slow shutter speed and need to avoid camera shake. It also is useful for macro photography. Don't forget that you can set the Self-timer to take multiple shots, which can increase your chances of getting more great images.

Try time-lapse photography. With time-lapse photography, a camera takes a series of still images at regular intervals, several seconds, minutes, or even hours apart, to record a slow-moving event such as the rising or setting of the moon or sun. The images

are played back at a much faster rate to show the whole event unfolding quickly. The RX100 II does not have this feature built in, but you can simulate interval shooting in a limited way. Turn on Continuous Shooting from the Drive Mode menu, and lock the Shutter button down using the Sony remote control, discussed in APPENDIX A. (You also can jury-rig your own device to hold down the Shutter button with a rubber band.) To force the camera to take a steady stream of shots at specific intervals, you have to use a long shutter speed, such as 2 seconds or longer. That interval will give the camera's memory buffer time to recover, so it can continue to record a full stream of shots without slowing down. This system can work in a dark area where the shutter speed will naturally be slow, or you can use a neutral density filter to force the use of a slow shutter speed. If the subject is not far away, you can set the flash to fire for each shot to slow down the shooting, so it can continue without slowing down. A participant in the Sony Cyber-shot Talk forum at dpreview.com created a series of videos showing how he used this technique. The initial video can be found at http://youtu.be/B8WlWj7cM9o.

APPENDIX C:
Resources for Further Information

Books

There are many excellent books about general subjects in photography. Rather than trying to compile a long bibliography, I will list a few especially useful books that I consulted while writing this guide.

- C. George, *Mastering Digital Flash Photography* (Lark Books, 2008)

- C. Harnischmacher, *Closeup Shooting* (Rocky Nook, 2007)

- H. Horenstein, *Digital Photography: A Basic Manual* (Little, Brown, 2011)

- H. Kamps, *The Rules of Photography and When to Break Them* (Focal Press, 2012)

- J. Paduano, *The Art of Infrared Photography* (4th ed., Amherst Media, 1998)

- S. Seip, *Digital Astrophotography* (Rocky Nook, 2008)

- C. White, *The Ultimate Guide to Water Drop Photography* (e-book available at www.liquiddropart.com, 2013)

Websites and Videos

Since websites come and go and change their addresses, it's impossible to compile a list of sites that discuss the RX100 II that will be accurate far into the future. One way to find the latest sites is to use a good search engine, such as Google or Bing, and type in "DSC-RX100 II." I just did so in Google and got more than 3 million results.

I will include below a list of some of the sites or links I have found useful, with the caveat that some of them may not be accessible by the time you read this.

DIGITAL PHOTOGRAPHY REVIEW

- Listed below is the current web address for the "Sony Cyber-shot Talk" forum within the dpreview.com site. Dpreview.com is one of the most established and authoritative sites for reviews, discussion forums, technical information, and other resources concerning digital cameras.

 ➤ http://www.dpreview.com/forums/1009

- For a useful compilation of tips and tricks for effective use of the RX100 II, see the following thread in this forum:

 ➤ http://www.dpreview.com/forums/post/51991398

REVIEWS AND DEMONSTRATIONS OF THE RX100 II

- The links below lead to reviews or previews of the RX100 II by dpreview.com, photographyblog.com, and others, as well as some YouTube videos with useful demonstrations.

 ➤ http://www.dpreview.com/previews/sony-cybershot-dsc-rx100-m2

 ➤ http://gizmodo.com/sony-rx100-ii-review-the-best-compact-camera-gets-a-li-1041384366

- http://www.pcmag.com/article2/0,2817,2422759,00.asp

- http://www.pocket-lint.com/review/122488-sony-cyber-shot-rx100-ii-review

- http://www.imaging-resource.com/PRODS/sony-rx100-ii/sony-rx100-iiA.HTM

- http://www.cameralabs.com/reviews/Sony_Cyber-shot_RX100_II/

- http://www.ephotozine.com/article/sony-cyber-shot-dsc-rx100-ii-review-22341

- http://www.amateurphotographer.co.uk/reviews/compacts/129419/1/sony-cyber-shot-dsc-rx100-ii-review

- http://www.whatdigitalcamera.com/equipment/reviews/compactcameras/129647/1/sony-rx100-ii-review.html

- The link below is to a short YouTube video made by a member of the dpreview.com forum on Sony Cyber-shot cameras, giving an excellent demonstration of how to use the Focus Peaking feature on the RX100 II.

 - http://www.youtube.com/watch?v=jMAlMQev7Kw

- The link below is to an excellent video presentation with Sony experts who discuss the new features of the RX100 II, along with some discussion of the full-frame compact, the RX1R.

 - http://youtu.be/ilhHiQgHZzg

- The link listed below is to video made by a member of the dpreview.com forum who shows how he uses the Sony RX100 to make time-lapse videos.

 - http://youtu.be/B8WlWj7cM9o

- Finally, my own site, White Knight Press, provides updates about this book and other books, offers support for download

of PDFs and eBooks, and provides a way for readers or potential readers to contact me with questions or comments.

> http://www.whiteknightpress.com

The Official Sony Site

■ The United States arm of Sony provides resources on its website, including the downloadable version of the user's manual for the RX100 II and other technical information.

> http://esupport.sony.com

> http://pdf.crse.com/manuals/4465969111/EN/index. html

> http://support.d-imaging.sony.co.jp/Wi-Fi/dsc/2013-2/

Information About Video Settings

■ The site listed below provides a useful article on settings to use for video shooting in several different situations with the RX100; the article is equally applicable to the RX100 II, which is very similar to the RX100 with respect to video capabilities.

> http://rungunshoot.com/how-to-set-up-your-sony-rx100-for-cinematic-video/

■ Another site, noted below, also provides detailed video settings advice for the RX100.

> http://www.eoshd.com/comments/topic/1955-sony-rx100-getting-the-best-video-out-of-it/

Equipment Suppliers

■ Cognisys, Inc. is the maker of StopShot, an electronic device for high-speed flash photography. I used the StopShot for the water drop collision image seen in CHAPTER 3 of this book.

> http://www.cognisys-inc.com

■ Eye-Fi is a company that makes the series of Eye-Fi cards, which are SD memory cards containing tiny transmitters. With these cards, your images are uploaded wirelessly to your computer or other device over a Wi-Fi network.

> http://www.eyefi.com/

■ Lensmate is a company that sells accessories for the RX100 II and other cameras, including an adapter for attaching filters and a grip that lets you take firm hold of the camera.

> http://www.lensmateonline.com/

■ Telescopeadapters.com is a site that sells adapters that let you connect the RX100 II (as well as other cameras) to the eyepiece of a telescope, provided that you have a filter adapter.

> http://www.telescopeadapters.com/

Abbreviations

AEL	Autoexposure Lock
AF	autofocus
AVCHD	Advanced Video Coding High Definition
AWB	Auto White Balance
cm	centimeter
DCIM	digital camera images
DLNA	Digital Living Network Alliance
DMF	Direct Manual Focus
DPOF	Digital Print Order Format
DRO	Dynamic Range Optimizer
DSLR	digital single-lens reflex
EVF	electronic viewfinder
fps	frames per second
GB	gigabytes
HC	high capacity
HD	high definition
HDMI	high-definition multimedia interface
HDR	high dynamic range
ISO	International Organization for Standardization
JPEG	Joint Photographic Experts Group
K	Kelvin
LED	light-emitting diode
LUN	logical unit number

M	megapixels
MAC	media access control
MB	megabytes
MF	manual focus
M.M.	Metered Manual
mm	millimeter
MP	megapixels
MR	Memory Recall
MTP	Media Transfer Protocol
NFC	near field communication
NTSC	National Television System Committee
OLED	organic light-emitting diode
PAL	Phase Alternating Line
PW	password
SD	secure digital
SDXC	secure digital extended capacity
SSID	service set identifier
TB	terabytes
TTL	through-the-lens
Tv	time value (or shutter speed)
UHS	ultra high speed
USB	universal serial bus
VGA	video graphics array
WPS	Wi-Fi protected setup
XC	extended capacity

Index

F

Q ═══════════════════════════════

CPSIA information can be obtained
at www.ICGtesting.com
Printed in the USA
BVOW10s0851051016

464209BV00016B/210/P